FLOWING TRACES

FLOWING TRACES

BUDDHISM IN THE LITERARY AND VISUAL
ARTS OF JAPAN

*Edited by James H. Sanford, William R. LaFleur,
and Masatoshi Nagatomi*

PRINCETON UNIVERSITY PRESS PRINCETON, NEW JERSEY

Library of Congress Cataloging-in-Publication Date

Flowing traces : Buddhism in the literary and visual arts of Japan /
edited by James H. Sanford, William R. LaFleur, and Masatoshi
Nagatomi.
p. cm.
Includes bibliographical references and index.
ISBN 0-691-07365-1 (alk. paper)
1. Japanese literature—To 1868—History and criticism. 2. Buddhism
in literature. 3. Buddhism and art—Japan. I. Sanford, James H.
II. LaFleur, William R. III. Nagatomi, M.
PL726.112.B8F56 1992
895.6'09382—dc20 91-29243 CIP

The costs of publishing this book have been defrayed in part by an
award from the Books on Japan Fund in respect of *Crisis and
Compensation: Public Policy and Political Stability in Japan, 1949–
1986* and *The Artistry of Aeschylus and Zeami: A Comparative Study
of Greek Tragedy and Nō*, both published by Princeton University
Press. The Fund is financed by The Japan Foundation from donations
contributed generously by Japanese companies.

To Bodhidharma ─────────────────────────

AND HIS GOOD FRIENDS EVERYWHERE

Contents

Illustrations

Acknowledgments _____

OUR GRATITUDE is extended to the National Endowment for the Humanities for granting us the funds to initiate the project represented here. We also profited greatly from the comments of Princeton University Press's two anonymous readers, and we thank them as well. Finally, we thank Dr. Julia M. Hardy for the expert help she provided in the early stages of the editing of this book and Mr. James Lowery Ford for his aid in indexing the book. The jacket illustration, *White Plum Blossoms and Moon* by Itō Jakuchū, is reproduced by permission of The Mary and Jackson Burke Collection.

FLOWING TRACES

Introduction _____

According to tradition, Buddhism was first introduced to the Japanese on the level of royal exchange when the monarch of the Korean realm of Paekche presented *sūtras*, banners, umbrellas, and an image of the Buddha Śākyamuni to the Japanese emperor in 538, or perhaps 552 C.E. Modern scholarship suggests, however, that the actual entry of Buddhism into Japan had both an earlier and a less formal beginning. It seems likely that at least a century before the official date, resident Korean artisans, themselves practicing Buddhists, were already fashioning art works in Japan—objects that fascinated the Japanese and made them curious about the religion expressed in or through such art. But, whether we begin with the traditional or the scholarly date, one basic point emerges: Buddhism's beginnings in Japan had the arts at their center. Ever since that time, now nearly a millennium and a half ago, it has proven difficult—some might say impossible—for the Japanese to conceive of Buddhism except in conjunction with concrete aesthetic embodiments.

Arts articulate beauty, of course, but in their own way they can also make arguments. One of the things that Buddhism in Japan seems to have been intent on demonstrating, in both its aesthetic and philosophical modes, was that Buddhism was entirely compatible with other spiritual traditions and philosophies—even those whose own partisans may have seen Buddhism as a rival. Over the centuries there were sporadic instances in Japan when Confucian thinkers or some representatives of what we now call "Shinto" objected to this Buddhist view of easy harmony or worried about the political and cultural power of the Buddhist clergy. But the Buddhists themselves usually sought to quiet such fears, and Buddhist arts, while expressive of internal piety, often performed the added role of making the case for Buddhism's fundamental compatibility with its potential rivals.

The formal, rationalized doctrine that was developed to support this notion was called *honji suijaku*. Its main premise was that the multiple dieties or *kami* usually identified with Shinto are, in fact, the "manifest traces" (*suijaku*) of primordial Buddhas and bodhisattvas who are their "original ground" (*honji*). This view, that Shinto and Buddhism, the two primary forms of religion in Japan, reflect a common reality, was widely accepted (in a number of variant interpretations, most of which maintained the priority of Buddhism) as a patent truth, at least until certain nativist Kokugaku scholars criticized it in the eighteenth century. It sub-

sequently ran into nearly fatal difficulties when in the late nineteenth century the Japanese government formally separated Buddhism and Shinto in order to delineate and then perpetuate that mostly artificial religiopolitical entity, State Shinto. Since the studies in this volume focus upon materials that predate this split, they investigate phenomena derived from the period when the *honji suijaku* construct either was so accepted that it seemed like common sense or held the upper hand over those who might have wanted to question it.

Although this volume is not, to be sure, designed to trace the historical vicissitudes of *honji suijaku*, we feel, nonetheless, that this principle was so crucial in the epoch covered by these studies that we have taken our title from one way of rendering the more dynamic half of the compound in English. "Flowing Traces" as a translation of *suijaku* signals the relationship of the Shinto deities to the eternal, and rather more static, Buddha-reality from which they purportedly arose, and it suggests that a parallel relationship between religion and art may also be discerned in certain literary and artistic embodiments of "Buddhist" culture in Japan.

Beyond this, "flowing traces" seems an apt term for characterizing what the Asian writing brush did in the hands of the Japanese artists discussed herein. Whether they were writing calligraphy (producing "writing" in the conventional Western sense), brushing paintings onto screens and scrolls (producing "texts" under a more modern and expanded definition of the term), or, as was commonly the case, doing both in an almost entirely undifferentiated manner on a single piece of cloth or paper, theirs was an art of the flowing brush.

If, even more metaphorically, the notion of flowing traces suggests to the reader an easy, almost effortless movement between and across conventional boundaries, we will be especially gratified, for that is precisely what we see happening again and again in the arts studied here. They seldom fit well within the boundaries to which we are accustomed. Whereas we are in the habit of classifying the arts into the metagenres of "literature" and "visual arts" (a choice that already ignores the place of music, declamatory speech, and kinematic motion in the "literary" form, drama), this is a disjunction that would have seemed forced, perhaps even unnatural, to most of the artists considered in this book.

We do not want to coerce these issues into a grand hypothesis about Japanese "uniqueness." Surely the Japanese brush itself was no different from those used in China or Korea, and a vast number of other cultural features are shared as well, including the creative conflation of "writing" and "painting." Even in medieval Europe, where religious expressions almost always gave ultimate primacy to text as word, there were "illuminated" manuscripts whose aesthetics went beyond concerns of either mere decoration or plain legibility.

Where we find a difference—one that is admittedly much greater when Europe rather than the rest of East Asia becomes the pole of comparison—is the degree to which Buddhist discourse about "original unity" (*honji* is but one of a number of relevant ciphers for this) played a crucial, formative role in Japanese intellectual life.[1] In addition, these discussions seem to have done much not only to shape the theoretical aesthetic of that era but also to influence what artists themselves did in their studios, at their writing desks, and when they emerged on the stages of the performing arts.

The corpus of theoretical work on aesthetics that derives from this period, most of it still untranslated into the languages of the West, is impressive for the range of arts considered.[2] But striking too is the frequency with which writers about the arts drew from Buddhist concepts and practices to explain much of what we would ordinarily call "artistic" goals. They had other sources as well, but Buddhist ones figured centrally. For instance, when depicting the mind of the artist at the pinnacle of his powers—whether composing and then "painting out" verse, performing sublime roles on the Nō stage, or executing the precise moves of the tea ceremony—the mental state of the artist was frequently compared to that of a monk involved in ascetic or yogic practices, or even to "enlightenment" itself. Not only the distinction between art and religion, but a second conventional boundary as well is thoroughly blurred here. For a "state of mind" that is defined in terms of precise motions and yoga-like body control is a state of mind that is at the outset as much physical as it is mental.[3]

The line between "religious" and "artistic" was crossed again and again, or made to seem superficial when informed by a perceived underlying unity at a more fundamental level. Since this undivision—or, as the

[1] The editors of this volume are drawn to the view that this rejection of a secondary instrumental status for the arts in Japan was bound up with the concept of "primordial enlightenment" (*hongaku*), a notion that played a huge role in the medieval period. This concept, closely associated with the Tendai school, had its own history, as detailed by the late Tamura Yoshirō and others. See, for example, Tamura Yoshirō, *Kamakura shin-bukkyō shisō no kenkyū* (Kyoto: Heirakuji Shoten, 1965), and Tamura Yoshirō and Umehara Takeshi, *Zettai no shinri: Tendai* (Tokyo: Kadokawa Shoten, 1970).

We are much less persuaded by the proposition advanced by some Japanese apologists that *hongaku*, or its near-equivalents in other schools, was a "quintessentially Japanese" construct to which the Japanese gravitated almost by instinct—as if it somehow matched certain features of an inherent, indeed virtually genetic, "national character."

[2] We have in mind treatises such as those collected in Hayashiya Tatsusaburō, ed., *Kodai chūsei geijutsu-ron* (Tokyo: Iwanami Shoten, 1973), or in Haga Kōshirō, ed., *Geidō shisō shū* (Tokyo: Chikuma Shobo, 1971).

[3] An important discussion of the general mis-fit of Western ideas of the mind-body relationship when they are applied to Japanese data is to be found in Yuasa Yasuo, *The Body: Toward an Eastern Mind-Body Theory*, ed., T. P. Kasulis; trans., Nagatomo Shigenori and T. P. Kasulis (Albany: State University of New York Press, 1987).

Buddhists might have it, nonduality—so neatly parallels the contempo-
raneous tendency to see Buddhist divinities and the native *kami* as also
unified on a deep level, we believe this indicates a mode of thinking cru-
cial to an entire epoch.

This modality of unity was not, of course, wholly uncontested. There
were Shinto theoreticians such as Yoshida Kanetomo (1435–1511), who
tried to turn *honji suijaku* on its head; Yoshida held that it is, in fact, the
Japanese *kami* who are universal and have priority—that Śākyamuni and
other Buddhist figures are merely the "traces" of those *kami* who have
chosen to appear in far-off places like India. Such thinking further blos-
somed in the nativist Kokugaku movement in the eighteenth century and
then reached full flower with the emergence of a State Shinto that was to
be sharply defined, institutionally separate, and free from all taint of Bud-
dhist contamination. In 1868 a government proclamation declared the
practices of *honji suijaku* officially at an end: Buddhism and Shinto were
at that point "divided" by fiat.[4] It is probably not insignificant that many
Buddhist images were smashed at precisely this time, in Japan's virtually
only known episode of iconoclasm.

Likewise from the Buddhist side there were, throughout Japanese his-
tory, scattered individuals who felt that interest in the arts might over-
whelm or sully intentions that should be more purely "religious." In the
tenth century Yoshishige Yasutane gave up the writing of poetry when he
took orders as a Buddhist monk, and even such a major poet as Saigyō
(1118–1190) worried at times about the potential conflict between his
religious goals and what he was doing with his writing brush. Soon there-
after the Zen master Dōgen (1200–1253), although himself an occasional
poet, cautioned against the deflection of energies away from the practice
of Zen and into the writing of verse.

These, however, tended to be occasional notes of discomfort and dis-
sent. They were never strong enough to challenge the assumption that the
path of the Buddha and that of the artist could with very little difficulty
be seen as one. If on an ontological level the Buddhas and the *kami* flowed
together at some point, so too on a more practical level, it was felt, did
the activities of the meditation hall and those of the atelier.

This volume deals with that convergence. Its editors judge the union to
have been so tight that the epoch in question would be misrepresented
unless a firm contrast with Europe were made. In the Christian West those
who articulated Scholastic theories had difficulty coming to recognize
what Umberto Eco has called "the dignity of art." Poetry to Aquinas was

[4] On this, see Tamamuro Fumio, *Shinbutsu bunri* (Tokyo: Tokyo Kyoikusha, 1979), and
Martin Collcutt, "Buddhism: The Threat of Eradication," in *Japan in Transition: From
Tokugawa to Meiji*, ed. Marius B. Jansen and Gilbert Rozman (Princeton: Princeton Uni-
versity Press, 1986).

merely a form of "making" and "inferior learning" (*infirma doctrina*).[5] Thus didactic theories and an instrumentalist notion of the graphic arts came quite naturally. Ideas of the arts as having inherent dignity, according to Eco, came into Europe really only as part of a modernizing and secularizing process.

Things were very different in Japan. There the notion that the arts were more than merely instruments seems to have arisen from within the heart of the medieval experience and often from religious thinkers trying to draw out the implications of Buddhism. For those who wanted to be consistently Buddhist, this ordinarily meant the arts could not be subordinate, could not be mere tools for lessons about "higher" realities. Therefore, many of our usual, Western-specific, analytic constructs—for example, that something is "religious in content" and "artistic in form"—become somehow inappropriate, excessively bounded, excessively dualistic, and excessively unflowing.

Most of the essays included in this book emerged from a set of conferences on the topic "Buddhism in Japanese Civilization: Humanistic Inquiries," which were part of a project sponsored by the John King Fairbank Center of Harvard University and funded by a grant from the National Endowment for the Humanities. Additional essays were derived from papers presented at annual meetings of the Association for Asian Studies and the American Academy of Religion.

The general arrangement of topics is chronological, but this is little more than a strategy of convenience. We have not tried to produce a volume that covers Buddhism in all the major periods of Japanese history; one that treats all the genres and subgenres of writing, painting, sculpture, and drama; or one that aims to examine features of every major school of Japanese Buddhism. To attempt such a project would have demanded multiple volumes or the placing of severe spatial and conceptual limitations on this one, virtually turning it into a small encyclopedia. Early on we opted instead for a smaller number of longer, fuller essays that might illuminate basic structures and issues, but not every structure or issue.

We have also deliberately mixed studies that individually focus primarily on the literary, visual, or dramatic arts. Nonetheless, in spite of what might seem to be a rather simple time-line arrangement, and in spite of our intentional crossing of genre lines, the various chapters do fall into a largely coherent overall order. Chapters whose data are temporally proximate tend, quite naturally, to "talk to" each other. Likewise, chapters that treat the same or closely related genres and figures tend to involve their authors in similar issues, if not similar resolutions. In at least one

[5] Umberto Eco, *Art and Beauty in the Middle Ages*, trans., Hugh Bredin (New Haven: Yale University Press, 1986), p. 105.

instance there are two chapters on the same basic set of data, the *Ippen Hijiri-e*, but approached from two considerably different perspectives.

Precisely because most of the studies deal with matters that fall within the long period when *honji suijaku* universalism was a presupposed truth, they do not deal with Buddhism in a narrow sense. It was, by definition, an epoch in which the Buddhist way tried to be comprehensive and inclusive: folk traditions, values that are often labeled "Confucian," and phenomena we now identify as "Shinto" all tended to be held within the iconic embrace of Buddhism. It was only later that they were separated out more sharply.

Although we do not wish to preempt the reader's own sense of discovery as to how these essays might interrelate, we offer here our account of certain connections among them.

William R. LaFleur's "Symbol and *Yūgen*: Shunzei's Use of Tendai Buddhism" opens a problem and states a theme that characterizes much of the book. In it he argues, as do the poets he is investigating, that poetry is as legitimate and as full a manifestation of the Buddhist Dharma as are sermons and *sūtras*. He does this through a close analysis that sees the poetry and poetic theory of Fujiwara Shunzei (1114–1204) as a manifestation of the nondual logic of Tendai Buddhism, a logic that leads not only to the collapse of the differentiation between sacred and profane literature, but also, says LaFleur, to the poetic collapse of the signifier and signified. From this logic emerges a powerful Japanese aesthetic that rejects the utilization of abstract symbol in favor of concrete image and within which religious and artistic expression become indistinguishable. The Buddhist poetry of Shunzei and later writers is, thus, shown to be not a poetry that expresses Buddhist doctrines but one that coheres Buddhist values.

Ippen Hijiri (1239–1289), the "founder" of the Jishū version of Pure Land teachings, has come into some prominence in Japanese scholarship of recent years. In the present volume are two essays that both derive from concrete investigations of the best-known source of early information about Ippen, the beautiful *emakimono* scroll known as the *Ippen Hijiri-e*. This masterpiece, completed in 1299, is an extraordinarily long scroll that, in alternating literary and visual segments, depicts key events in the life of its Amidist hero-pilgrim, Ippen Shōnin. Just who the patron of this expensive project was is unclear, as is the actual identity of its painter, one "Hōgen En'i." It is generally agreed, however, that the author of the textual passages was Ippen's close follower, Shōkai. In his descriptions of Ippen's life, Shōkai generally presents his master as a humble *hijiri* or ascetic-pilgrim, a figure close to the informal Buddhism of the masses. This fits nicely with the conventional consensus that Ippen and those who followed him on his journeys around Japan were ill-clad, ill-

housed, and ill-thought of, and it has allowed for a rather easy, possibly premature, reading of both Ippen and the *Hijiri-e*. For this view, if accepted too quickly, leaves as an inevitable problem the fact that the populist perspective of the written text seems inexplicably out of consonance with both the sophistication of the visual sections and the probable aims of the patron(s) of this costly scroll.

Laura Kaufman's essay challenges the usual view and shows that even in the written passages one can find plenty of evidence that composition of the *Ippen Hijiri-e* was a good deal more sophisticated than is usually admitted. She further suggests that Ippen himself may have been less rustic than convention would have it. She shows, for example, how in a single poem attributed to him one can find subtle but perfectly clear indications that Ippen wanted—along with presenting his new Amidist theology—to identify his own life with the lives of the earlier poet-pilgrims, Nōin Shōnin (988–1050?) and Saigyō (1118–1190). That this connection was intentional and unambiguous is demonstrated by the fact that the illustrator of the scene overtly echoes the poetry of Saigyō and Nōin in visual form.

Indeed, argues Kaufman, the *Hijiri-e* is hardly the biography of a roughly hewn sectarian founder on any level. In its visual aspects especially, the scroll is lyrical, full of the indirectness and suggestion that characterize so much of the Japanese classical tradition. Kaufman even extends her analysis of the visual structures to make a fascinating and convincing comparison of the *Ippen Hijiri-e* and the *ippon-kyō* style of *sūtra* decoration. This genre, which developed in the late twelfth century, transformed the older text-cum-illustration mode of *sūtra*-copying into an elegant technique in which text, illustration, calligraphy, paper decoration, and deliberate visual obscuration all served to deconstruct conventional boundaries and leave in place of simple illustration a new genre that was evocative and experimental, abstract and concrete, open and mysterious, sacred and humanistic, all at once. So too, she says, are the multiple, at times inconsistent, layers of the later work, the *Ippen Hijiri-e*.

Laura Kaufman's treatment of Ippen and the *Ippen Hijiri-e* deals with both the textual and pictorial elements of the scroll, but its deepest insights center on the visual aspects. James H. Foard's essay on the same materials likewise looks at both elements, but his major interests fall on the literary side, and his primary goal is to see the *Hijiri-e* as an example of the Japanese hagiographical tradition. In the early pages of his chapter he gives an overview of the scholarly debates over the patronage and authorship of the scroll. He then provides a full analysis of the constituent elements of its literary segments. This analysis, based on the methods of Western form criticism, allows Foard to conclude that the extant *Hijiri-e*

clearly followed earlier versions—written or oral—of Ippen's life, and that Shōkai was less the author of the biography than a redactor of already existing hagiographical fragments.

The most fascinating part of Foard's chapter is its third major segment in which he applies John White's literary-critical concepts of "prefiguration" and "condensation" to the image of Ippen presented in the *Hijiri-e*. "Prefiguration" is the reading into a later person of the life and character of an earlier, more important figure. This is not a case of imitation in the sense of the saint who "imitates the Life of Christ," nor is it a kind of purported incarnation or reincarnation. In White's usage, the later figure is, while presented as fully himself, also an exemplar of the possibilities prefigured by the original figure. The religious importance of this literary process is that the second figure can be seen to testify to the possibility— even the practicality—of embodying ideals that might otherwise seem too transcendent to be attained.

Condensation is the coherence in one figure of more than one prefigurative paradigm. The hagiographical image of Ippen, Foard argues, modulates two prefigurations. The first of these is obvious and expected: Ippen's life was in substance, though not in detail, a reenactment of the life of Śākyamuni Buddha. The other prefiguration is, from a modern point of view, more unusual, perhaps even bizarre. Ippen's life was prefigured by, and serves as a direct expression of, the six-syllable invocation of the Buddha Amida. From the Jishū perspective, when ten *kalpas* ago the bodhisattva Hōzō became the Buddha Amida and established this salvational chant or Nembutsu, he opened the possibility of salvation for all sentient beings. The commonsense distinction between that moment, ten aeons ago, and this moment, here and now, is in the Jishū view wholly misleading. The agent of salvation, the Nembutsu, is, in fact, the inner nature of all sentient beings. Ippen's inner nature is, therefore—although Ippen and his followers would not have phrased it in this fashion—likewise prefigured, indeed, given his importance, is *especially* prefigured, in the Nembutsu. Through the condensation of these two hagiographic prefigurations, Ippen, who would otherwise be but a human figure in a straightforward biography, comes to be transformed into a conduit of religious power that both validates his salvation and guarantees ours.

There was a time not too long ago when studies of Japanese religion regularly presented their data in unreflectively Western categories, split Japanese religion into Buddhist, Shinto, and Confucian components, and then divided the Buddhist component into clear and discrete sects whose equally clear and discrete doctrinal distinctions were seen to have been based on the emergence of charismatic figures whose religious tenets— their chief contribution to Japanese religious history—were then perpetuated in terms of dogmatic disagreement. "Nonessentials" or "peripher-

als" such as ritual praxis, popular movements, syncretic or synthetic tendencies, and asectarian patterns were often ignored. Fortunately, those days are now mostly gone.

In her chapter on Japanese afterworld conceptions, Barbara Ruch crosses both the boundaries of literary and artistic expression and the too easy separation of Japanese Buddhism and the indigenous tradition(s) into two hermetically sealed worldviews. The main burden of her study is to demonstrate that for Japanese the understanding of the Buddhist *rokudō* (Six Realms) afterlife structure—especially its ideas of Heaven and Hell—became something other than the expression of an approved theological exegesis of formal Buddhism. She argues that while Japanese culture adopted the language of the scriptural understanding, the actual internalized interpretations of the *rokudō* structure departed considerably from orthodox norms; instead of seeing the six realms as a primarily vertical structure of highly compartmentalized cosmic realms, Japanese assimilated the *rokudō* schema into the old horizontal cosmologies of *yomi no kuni*, "the land of gloom," and *tokoyo no kuni*, "the land over there."

In pressing for the validity of this thesis, Ruch argues that a careful distinction must be made between self-consciously didactic literature whose expression of orthodox values may be largely conventional lip-service, and the less self-conscious—and therefore more telling—expressions found in what Ruch calls the "intimate" literature. In the visual arts this distinction is somewhat muted by the problem of patronage interests, but even there Ruch points to a number of features of "*rokudō* scrolls" that suggest that the Japanese did not often take the *rokudō* structure as a whole as a serious cosmology (though its rich images did make for nice visual and literary tropes), and that when they did take its elements seriously they did so by reinterpreting them in terms of recognizably pre-Buddhist modalities.

To note that the Nō drama of Japan comprises a theater that is replete with Buddhist overtones and undertones is by now to utter a cliché. But to say just *how* the Nō embodies Buddhist meaning or just what sorts of Buddhist meaning it embodies is to raise issues that are a good deal less obvious.

Frank Hoff's chapter takes an unusual tack into the roiling sea of debate about Nō and its meanings. His study, which draws in the main on modern performance theory, follows the impact of certain performative recommendations made by Zeami (1363–1443) to his son, Motomasa—and by extension any other serious Nō player—about the ideal relationship between actor and audience. According to Zeami, the audience and the performer are to become, in a way that is more literal than metaphorical, one entity. Though some of the language describing the attainment of this unitive modality of relationship seems clearly derived from non-

dualist Buddhist metaphysics, the concreteness of Zeami's advice as a
practical aid to better performance implies that he intended the Nō player
to bridge, in a quite somatic way, a number of dualities—initially that of
actor and spectator, but finally those of subject and object and mind and
body as well. That the "secular" Nō training given by Zeami thus imme-
diately recalls the "religious" dicta of such figures as the Zen master Dō-
gen, who was famous for his insistence on a meditation of "just sitting"
and the belief that "practice is already enlightenment," is, Hoff offers, no
accident. In the end, the inclusion of Amidist or Shinto content, or even
the use of specifically Zen categories to form its theoretical base, may be
of no greater significance in understanding the religious qualities of the
Nō than are its physical and performative aspects.

Royall Tyler begins his highly innovative treatment of Nō by noting
that in both content and structure Nō clearly shows the traces of a variety
of religious inputs—traces left by Buddhism, by Shinto, and even by sha-
manism. In spite of its long-standing recognition of religious elements (es-
pecially the Buddhist features) in Nō, modern scholarship has never made
it very clear whether the crucial religious aspects of Nō were those of
sectarian content (Amidism versus Zen, for example) or those of broader
sensibility and mode ("Zen taste," "Zen aesthetics," and the like). Tyler
suggests that the application of such commonly used categories (generally
Buddhist, usually sectarian) is less than fully helpful. Part of the problem,
he allows, is that Buddhist contributions to Nō have usually been associ-
ated with the so-called Kamakura sects of Buddhism—Pure Land, Nichi-
ren, and Zen—that emerged at the same time that Nō did (presumably as
cognate expressions of the same underlying cultural processes). However,
while Nō as theater may have been radical or at least innovative in form,
its contents were, Tyler insists, much less innovative. To the extent that
Nō concepts and values are sourced in Buddhism at all, they do not rep-
resent the new Buddhisms of the Kamakura and Muromachi periods, but
hark back instead to the "old" Buddhism of Heian times (primarily the
Mikkyō esotericism of Shingon and Tendai), a Buddhism that had long
since settled so deeply into every level of society as to have become a
nearly universal and basically unexamined constituent of Japanese
thought and attitude.

From this base, Tyler proceeds in a measured and evocative manner to
bring a number of these perduring Buddhist and Shinto-Buddhist ele-
ments (some content-thematic and some involving more structurally ori-
ented issues) to the surface. The importance of numinous places (ubiqui-
tous in Japanese religion), themes of nondualism, the intertwining of
aspiration and "grace," transcendental worldliness, and a number of sim-
ilar motifs are exposed as powerful lineaments of the Buddhism of Nō, a
Buddhism that is syncretic, diffuse, more attitudinal than doctrinal,

largely asectarian, and in most ways very close to the archaic values of pre-Buddhist Japan.

Elizabeth ten Grotenhuis's investigation follows the legend of a single figure, "Princess" Chūjōhime, through a number of transformations, across the better part of a millennium, and in and out of a variety of "little tradition" and "great tradition" contexts. In the earliest stages of this development, Chūjōhime was presented as the pious eighth-century princess-donor of the Taima mandala, an important painting that depicts the Pure Land paradise of the Buddha Amida. By the late Middle Ages, however, she had been transformed into a Cinderella-like heroine whose story was now recounted in such popular genres as Nara-ehon painting and Jōruri and Kabuki drama. Finally, she was simultaneously both elevated and humanized to take on yet another role, that of a divinity whose principle raison d'être was as an image of, and a salvational agent for, the "female in distress," a development that led both to the emergence of a still-living devotional cult and to the invention of a kind of patent "Chūjōhime medicine" that was believed to cure a whole panoply of "female ailments." The range of this movement is fascinating in its own right, but the study of Chūjōhime is of further importance in the many links it makes to issues raised in the chapters of both James Foard and Susan Matisoff.

Yoshiaki Shimizu's essay elicits the religious dimensions of Japanese culture through a close analysis of the background and meanings of a single work of art, the Vegetable Nirvāṇa painting of Itō Jakuchū (1716–1800). This piece, in which a large radish takes the place of the deceased Buddha of the standard versions of the Mahāparinirvāṇa theme, seems at first glance to be a parody of that classic motif. Shimizu, however, convincingly shows it to be a serious (albeit not necessarily somber) expression of both fairly conventional Buddhist thematics and Jakuchū's life. In his investigation he teases out certain details of Mahāparinirvāṇa iconology; of the artistic, botanical, and religious associations of radishes; and of Itō Jakuchū's somewhat troubled artistic and spiritual biography.

Susan Matisoff's treatment of the semireligious, quasireligious, or once-religious genre of popular Japanese drama known as Sekkyō-bushi recalls in many ways Elizabeth ten Grotenhuis's earlier study of Chūjōhime. Like that tradition, the history of these "sermon-ballads" moves up and down the social scale and into and out of "religious" contexts.

Matisoff looks at the history of the genre from its early associations with certain Buddhist temples to its final, almost wholly secularized, concluding stages. But the main effort of her study is devoted to a recounting and analysis of three of the most important Sekkyō plays. Two of these, Karukaya and Sanshō Dayū, are framed by opening and closing honji passages that structure them as a sort of inversion of the honji suijaku concept. In the plays, divine manifestations of a later age are shown to

have been the human principals (and the characters of the play) of earlier, original events. Though the third play, *Shintokumaru*, lacks this formal structure, it too is full of Buddhist themes and is, indeed, in some ways the most "Buddhist" of the major sermon-ballads.

As well as being Buddhist, the Sekkyō-bushi were also popular literature. Replete with Buddhist ideas and images, their plots are also full of cruelty, sacrifice, drawn-out tragedy, and final happy endings. But there is more going on in them than just a somewhat loose fusion of Buddhism and melodrama. For as Matisoff points out, there are religious (and not especially Buddhist) meanings embedded even in the popular aspects of the pieces. Each of the three plays she analyzes in detail seems to manifest the same underlying set of paradigmatic events: abandonment, death, and rebirth or reunion. These events consistently center on adolescent, male "heroes" whose dramatic experiences seem symbolically to replicate virtually universal rite-of-passage patterns. Likewise, the plots all seem to contain self-sacrificing older sister figures who act as almost shamanic initiatrices for the rebirth processes of the male characters.

Thus, even after the sermon-ballads and their half-priest, half-laymen reciters had long since drifted away from the temples that may have first supported them, even after the plays had apparently become pure entertainment of a rather vulgar sort, it is possible to find within their plots and underneath the Buddhist themes perduring patterns of folk religiosity that may, even at the tradition's concluding stages, still have effected spiritually cathartic changes for their audiences.

It remains for us to make a few final observations. Although the essays here were not gathered in hopes of covering all kinds of art or every major school of Buddhism, some common features emerge with sufficient clarity to warrant extrapolating some general comments about religion in Japan.

First, when we as editors look at the materials discussed here, we are impressed not only by the way these data flow over and across many of the boundaries taken as expected in the West, but also at the ease with which in Japan a given phenomenon, figure, or motif seems able to slide willy-nilly up and down the social scale. The continuum between high culture and low culture is often reversed effortlessly and with alacrity. This works both ways—sometimes by a kind of trickle-down effect and at other times by the ascent of lower forms and even their triumph over better-bred rivals (*gekokujō*) in the artistic tastes of the time. Medieval Japan provides many examples of this flow. Perhaps this is related to the way that age relativized religion; many premodern Japanese seemed willing at a moment's notice to make a muddle of the distinctions between sacred and profane and to be all the while not only unashamed of this tendency but even eager to turn it into a virtue. We suggest that Japanese religion is itself generally characterized by this predisposition.

Second, much of Japanese religion seems to maintain an almost irresist-ible—or unresisted—propensity toward concreteness. The sacred, when this modality can be clearly identified at all, more often than not locates itself in specific things, places, utterances, or persons. Although this may not be uniquely Japanese, it is an important and typical dimension of Japanese religiosity that is reflected in most of the essays in this book.

Finally, we wish to hypothesize that much of the above has to do with the role that Mikkyō, the Japanese exemplar of the tradition of Esoteric Buddhism, took at a formative stage in the development of Japanese Bud-dhism. Less talked about in modern times than the newer schools identi-fied with the Kamakura era, Mikkyō ran like a deep, often submerged, river under much of what was going on in the epoch discussed in this book. And because the Mikkyō traditions took special concern to incor-porate pre-Buddhist elements into their own rites and formulations, it probably can be said that those native elements were at least partially protected and preserved in that fashion. Beyond this, Mikkyō was the matrix of religious sensibilities oriented toward praxis, embodiment, and the visual and nonverbal expressions of spiritual meaning.

There is much more still to be studied—and much more still to be said. But it is the editors' hope that the essays collected here will open new ground and suggest new issues both in the scholarly study of Japanese religion and arts and in the wider arena of the study of the interrelation-ships between religion and the arts generally.

James H. Sanford
William R. LaFleur
Masatoshi Nagatomi

One

Symbol and *Yūgen*: Shunzei's Use of Tendai Buddhism

WILLIAM R. LaFLEUR

> The beauty of holiness
> the beauty of a man's anger
> reflecting his sex
> or a woman's either,
> mountainous,
> or a little stone church
> from a height
> or
> close to the camera
> the apple tree in blossom
> or the far lake
> below
> in the distance
> are equal
> as they are unsurpassed.

> (*William Carlos Williams, "View by Color
> Photography on a Commercial Calendar"*)

THERE IS general agreement among both Japanese and Western literary historians that much of the verse of twelfth-century Japan is strikingly different from that written earlier, and that this change is best described as the presence of a new depth (*fukasa*) in the new poetry. According to Robert H. Brower and Earl Miner,

> to some degree the depth derives from a complexity of technique, but the subjectivity lent poetry by the preceding period is absorbed by the new techniques, and charges them with a kind of resonance often belied by what on the surface

is an easy intelligibility. When a poem seems to present us with description, we are apt to take the imagistic beauty of the poem at face value and to miss the deeper implications.[1]

These "resonances" and "deeper implications" certainly included a multilayered sequence of allusions—not only to earlier Japanese verse but also to the literature of China. A great deal of earlier literary history could now be compressed into a single poem. In this way, an individual poem often reflected a variety and wealth of earlier poetic worlds. Brower and Miner are justified in concluding that "such allusive depth shows the extent to which a poem of this age is often neoclassical, since it may be fully appreciated and understood only through a knowledge of earlier portions of the Sino-Japanese literary tradition."[2]

There is, however, another important ingredient that went into the development of the detectable "depth" in the poetry of this era, an element clearly drawn into poetry from moves and processes in the intellectual and religious world of the time. Noting its importance for poets such as Fujiwara Shunzei (1114–1204) and his son Teika (1162–1241), Brower and Miner write, "The adaptation of a religious ideal to poetic practice may seem remarkable, yet it is hardly surprising in this strongly religious age, when the art of poetry was regarded as a way of life and just as surely a means to the ultimate truth as the sermons of the Buddha."[3] The truth contained in this apt observation deserves more attention than it has been given in literary histories of Japan. To explore its significance in some detail will help to clarify some of the intellectual issues behind the major developments in medieval Japanese literary aesthetics.

The twelfth century was one of great social and political upheaval in Japan—a circumstance probably not unrelated to the achievement of a new depth in the verse of poets such as Shunzei, Saigyō, and Teika. This century was also one in which the problems and propositions of Tendai philosophy had a direct impact on an emerging literary aesthetic, and this was clearly of fundamental importance for the new depth in poetry.

The effect on aesthetics was especially profound. Sen'ichi Hisamatsu, one of Japan's most important literary scholars, has described it as the key to understanding not only certain poems of the era but also the shape and particular character of the era as a whole:

[1] Robert H. Brower and Earl Miner, *Japanese Court Poetry* (Stanford: Stanford University Press), p. 231. See also Yasuda Ayao, *Uta no fukasa* (Osaka: Sogensha, 1971), pp. 7–23, and Konishi Jin'ichi, *Michi: chūsei no rinen* (Tokyo: Kodansha, 1973), p. 47.

[2] Brower and Miner, *Japanese Court Poetry*, p. 233.

[3] Ibid., p. 257.

The literary concept known as *yūgen* is an important criterion in judging whether or not a thing is "medieval." *Yūgen* as an aesthetic quality was esteemed throughout the medieval period. In the subtle overtones of its symbolic statements, one discerns the influence of Buddhist philosophy, to which men turned for solace during the tremendous social upheavals of the late ancient and medieval period. Buddhism is the basic element in medieval literature.[4]

This chapter will focus on the Buddhist component in what I would call Japan's "high" medieval aesthetic and attempt to clarify some aspects of the much praised but always elusive aesthetic quality called *yūgen*.

Understanding *yūgen* involves entering a world whose intellectual presuppositions and values differ considerably from those of the modern West and also, in important and interesting ways, from those of the medieval West. To identify and clarify some of these values, we must take seriously the claim by poets such as Shunzei, Teika, Saigyō, and Jien that their minds and their literary ideals were shaped by certain texts and religious practices. It is important to read and interpret works they read, such as the *Lotus Sūtra* and the *Mo-ho chih-kuan* (Jpn: *Makashikan*; The great calming and contemplation). By so doing we may be able to reconstruct the intellectual and religious structure of this era; and by knowing better the mind of the era we will need to rely less on a host of separate, unrelated bits of information in our reading of ancient texts. The intention of this kind of study is to prevent rather than contribute to that dire state of affairs in which, according to George Steiner, "the 'text' is receding from immediacy, from vital personal recognition on stilts of footnotes, ever more rudimentary, ever more unashamed in their conveyance of information which was once the alphabet of reading."[5] The kind of exercise undertaken here should make the texts of the era—both scriptures and poems—more accessible and immediate even though they represent a considerable departure from Western modes of thought.

We are well aided in this by the superb scholarship of the Japanese. Konishi Jin'ichi, for example, has reminded us that there is a good deal of continuity between the Tendai Buddhism of the Heian period and the

[4] Sen'ichi Hisamatsu, *The Vocabulary of Japanese Literary Aesthetics* (Tokyo: Center for East Asian Cultural Studies, 1963), pp. 4–5. For more on the sociopolitical upheavals in this period, see Oscar Benl, *Die Entwicklung der japanischen Poetik bis zum 16. Jahrhundert* (Hamburg: Otto Harrassowitz, 1951), p. 63 especially; and the introduction to William R. LaFleur, trans., *Mirror for the Moon: A Selection of Poems by Saigyō (1118–1190)* (New York: New Directions, 1978).

[5] George Steiner, "Text and Context," in his *On Difficulty and Other Essays* (New York: Oxford University Press, 1978), p. 9. Although in what follows I assume that we can and must discuss Japanese verse as a kind of written "text," Clifton W. Royston has rightly reminded us of the "oral nature of Japanese verse." See Clifton W. Royston, "*Utaawase* Judgments as Poetry Criticism," *Journal of Asian Studies* 34, 1 (November 1974): 99–108.

much more famous Zen Buddhism of the Kamakura and Muromachi periods.[6] The point is significant since the periodization of history places the accent on change and discontinuity, with the direct consequence that we tend to attribute to Zen the aspects of the medieval aesthetic that we find most fascinating and culturally distinctive. Nevertheless, the crucial aesthetic value, *yūgen*, really had its matrix in the Heian period—that is, before the end of the twelfth century—and in the Buddhism of the Tendai school. It was already a part of the Japanese experience before the institutional implanting of Zen and the massive impact of Sung culture on Japan during the Kamakura and Muromachi periods. Konishi has called special attention to Shunzei's and Teika's use of a Chinese text, the *Moho chih-kuan* by Chih-i (538–597), for the forging of their contributions to the evolving medieval aesthetic.[7] A number of scholars concur with this judgment;[8] the thought and practice of Tendai, especially as expressed in this major treatise, cannot be dismissed or regarded lightly in any attempt to grasp the flowering of the arts in medieval Japan.

The Tendai school has been among the least studied by Western scholars,[9] and within the spectrum of Buddhist schools our knowledge of it seems to have a special degree of imprecision and obscurity. It is often thought of as merely eclectic and amorphous. We tend to portray it as a matrix, frequently by the metaphor of a mother known chiefly through her sons—the dynamic and much more sharply etched historical personalities of Dōgen, Hōnen, Shinran, and Nichiren. For a variety of reasons, these "sons" of Tendai and the "new" forms of Buddhism they established—forms that had their growth in the Kamakura era—have much more readily captured the attention of Western scholars and have been the subject of extensive research and study. The result has been that the Tendai "mother" out of which they all emerged has remained in relative obscurity, a figure whose role as genetrix is acknowledged but whose own

[6] In addition to Konishi's important studies in Japanese cited and employed in the following pages, I am also much indebted to Konishi Jin'ichi, "Image and Ambiguity: The Impact of Zen Buddhism on Japanese Literature" mimeograph (1973).

[7] Konishi Jin'ichi, "Shunzei no yūgen-fū to shikan," *Bungaku* 20, 2 (February 1952): 108–116.

[8] See Watanabe Shōichi, " 'Yūgen' no shisō-kōzō," *Tetsugaku-rinrigaku kenkyū* (March 1975): 112–134; Naka Seitetsu, "Korai fūteishō no karon to Bukkyō shumi," *Kenshin* 36, 12 (December 1941); and Manaka Fujiko, *Koku-bunkagu ni sesshu sareta Bukkyō* (Tokyo: Bun'ichi Shuppan, 1972). Professor Konishi brought Manaka's important work to my attention.

[9] Stanley Weinstein, "The Beginnings of Esoteric Buddhism in Japan: The Neglected Tendai Tradition," *Journal of Asian Studies* 34, 1 (November 1974): 177–191. See also Minoru Kiyota, "The Structure and Meaning of Tendai Thought," *Transactions of the International Conference of Orientalists in Japan* 5 (1960): 69–83; Paul Groner, *Saichō: The Establishment of the Japanese Tendai School* (Berkeley: Berkeley Buddhist Studies, 1984).

specific character has elicited little serious attention. The following discussion will not, to be sure, entirely redress this imbalance, but it should help to bring this very important school of Buddhism into somewhat sharper focus, as we attempt to understand the evolution of the medieval Japanese literary aesthetic.

The texts to be considered in this chapter are, first, the *Lotus Sūtra*, the foundation of the Tendai school and the most important Buddhist scripture for the people of the Heian period; second, the *Mo-ho chih-kuan*, the major treatise of the Chinese thinker Chih-i; third, a key section of the *Korai fūteishō* (Poetic styles past and present), the only full-length treatise on poetry by Fujiwara Shunzei; and, finally, a number of specific poems in which the new depth, the *yūgen*, of later Heian and early Kamakura verse is detectable. By demonstrating the interpretative continuity throughout these texts, perhaps both Tendai philosophy and the medieval Japanese aesthetic will be brought more clearly into view.

It is not difficult to understand why the literate people of the Heian period cherished the *Lotus Sūtra*. It is still commonly regarded as a literary gem,[10] and it was the stimulus for much later literature. Rich and varied, it functions on what Umehara Takeshi calls a level of high drama.[11] A number of its extended metaphors and parables are widely admired for their vividness of narrative and finesse of detail. The work is, in fact, so colorful and picturesque that modern readers have occasionally wondered if it is not mostly froth, with no substantial or philosophical dimension.[12] Though the question is a valid one, the suspicion is, I think, unfounded. This *sūtra* is both a literary tour de force and expressive of a fundamental philosophical perspective in Mahāyāna Buddhism.

In both its original intention and its subsequent uses, the *Lotus Sūtra*

[10] John M. Rosenfield, Fumiko E. Cranston, and Edwin A. Cranston, *The Courtly Tradition in Japanese Art and Literature: Selections from the Hofer and Hyde Collections* (Cambridge, Mass.: Fogg Art Museum, 1973), pp. 45ff. See also Robert E. Morrell, "The Buddhist Poetry in the *Goshūishū*," *Monumenta Nipponica* 28, 1 (Spring 1973): 87–100. For the *Lotus Sūtra* in Japan see Yoshiko K. Dykstra, *Miraculous Tales of the Lotus Sutra from Ancient Japan* (Honolulu: University of Hawaii Press, 1987), and George J. Tanabe, Jr., and Willa Jane Tanabe, eds., *The Lotus Sutra in Japanese Culture* (Honolulu: University of Hawaii Press, 1989).

[11] Umehara Takeshi in Tamura Yoshirō and Umehara Takeshi, *Zettai no shinri: Tendai* (Tokyo: Kadokawa Shoten, 1971), pp. 244ff.

[12] The origin of a low opinion of the *Lotus* among Western scholars appears to be Maurice Winternitz, *A History of Indian Literature*, trans. Subhadra Jhā (Calcutta: University of Calcutta, 1933) 2:295–305; unquestioning acceptance of this opinion can be found, for example, in Arthur Danto, *Mysticism and Morality: Oriental Thought and Moral Philosophy* (New York: Harper Torchbook, 1972), pp. 78–83. In spite of recent and valuable new translations of this *sūtra*, a real analysis of it as either a philosophical or a literary treatise remains to be done. An important work that may eventually change this situation is Ōchō Enichi, ed., *Hokke no shisō* (Kyoto: Heiraku Shoten, 1969).

was a harmonizing text; that is, it was useful in bringing unity and order into situations that were rife with conflict or in danger of disjunction. The text's origins in India seem to have been in an attempt to unite and pacify the Buddhist community at a time when there was serious disagreement over which of three "vehicles," or saintly ideals, was to be pursued.[13] That is, it addresses itself to a situation in which some Buddhists claim to follow the path of the bodhisattva by aiming at both their own and others' salvation; a second group pursues the way of the *pratyekabuddha* by trying to save oneself solely through one's own efforts; and a third group holds to the ideal of the *śrāvaka*, according to which one listens to the Buddha's sermons and, on the strength of these, works for self-salvation. Each recognizably different vehicle must have had its defenders as well as its detractors at the time the *Lotus* was composed in India—probably sometime during the first century c.e. In this context, the *Lotus* unhesitatingly declares the underlying unity of all three vehicles; it argues that all are variants of the one way, the way of Buddhahood. It was thus probably intended to serve a broadly ecumenical purpose by bringing greater unity to the Buddhist community. Later on, and in a very different way, it again served a harmonizing purpose when it was taken as the text that alone could bring order to the vast array of *sūtras* in T'ang China, *sūtras* that, at least in their modes of discourse, often seemed incompatible and contradictory.[14]

The reason for the *sūtra*'s ready utility in situations of disunity or disparity is that, from its opening sections, it directly addresses the problem of the relationship of the one and the many—that is, the relationship of unity and diversity. Its primary proposal, offered early in the text, is the notion of *upāya*, which Chinese call *fang pien* and Japanese, in their reading of the Chinese characters, *hōben*. This term has usually been translated into English as "skillful devices" or "expedient means," although it might be better, in order to disallow the notion of a duality, to translate it as "modes."[15] The core idea is present in the following excerpt from the chapter on *hōben*. (These words are supposed to have been spoken by The World Honored One to his disciple.)

> Śāriputra, since becoming a Buddha, I, in a variety of modes and through many kinds of metaphors, have been conversing and preaching very widely,

[13] The best study of this problem is Fujita Kōtatsu, "Ichijō to sanjō" in *Hokke no shisō*, ed. Ōchō.

[14] See Stanley Weinstein, "Imperial Patronage in the Formation of T'ang Buddhism," in *Perspectives on the T'ang*, ed. Arthur F. Wright and Denis Twitchett (New Haven: Yale University Press, 1973), pp. 283ff.

[15] See Kumoi Shōzen, "Hōben to shinjitsu," in *Hokke no shisō*, ed. Ōnchō, for a discussion of the hazards involved in translating *upāya* as "means."

thus in countless ways leading living beings and helping them abandon their attachments.[16]

The idea is that the various vehicles, even when they have resulted in sectarian developments, are compatible and fundamentally united on a deeper level. The different modes are the consequence of a genius for adaptability that translates the Dharma into a variety of forms for a variety of people.

What follows in the *sutra* is perhaps its most exciting, unique, and interesting development. The brief statement about *hōben* is followed by a sequence of chapters that exfoliate with parables and allegories, each purporting to be another way the *sutra*'s message can be concretely and dramatically grasped. The most famous example is the third chapter, on parable (*hiyu*). It narrates the story of a rich man who, seeing his children trapped in a burning house but so enchanted by their toys that they are oblivious to their own danger, promises them even more extravagant toys, of three types (corresponding to the three vehicles). These successfully entice the children out of the house and into safety. In a later chapter, another, almost equally famous, simile compares the three different vehicles to shrubs, plants, and trees of different heights, all of which receive the rain equally.

> A dense cloud, spreading over and everywhere covering the whole three-thousand-great-thousandfold world, pours down its rain equally at the same time. From the rain of one cloud each according to the nature of its kind acquires its development, opening its blossoms and bearing its fruit. Though produced in one soil and moistened by the same rain, yet these plants and trees are all different.
>
> Know, Kāśyapa! The Tathāgata is also like this; he appears in the world like the rising of the great cloud.[17]

Thus, the point about a single message mediated through a variety of modes is made again and again in the text.

All this seems quite straightforward, and for that reason, it is tempting to interpret the role and purpose of the parables and allegories in the *Lotus* as similar to those of rhetorical forms in Western sacred and secular literatures. But to do so is to miss the main point of the *Lotus*, as well as the opportunity to see how the text is both a literary and religious tour de force.

[16] Daizōkyō Kankōkai, ed., *Taishō shinshu Daizōkyō*, 85 vols. (Tokyo: Taisho Issaikyo Kankokai, 1924–1932) 9.5.c. (Hereafter cited as T.) Translation mine.

[17] T. 9.19.b. Translation by Bunnō Katō et al., *The Threefold Lotus Sutra* (New York and Tokyo: Weatherhill/Kosei, 1975), p. 127.

A direct comparison with the role and use of literary allegory in medieval Europe serves to highlight the difference. In recent decades scholars have produced some excellent studies of the history of interpretation and the use of literary modes in Europe. In his brilliant work *Mimesis*, Erich Auerbach called attention to the fact that "figural interpretation," while completely alien to what had been the literary norm in classical antiquity, was the principal mode in medieval Christendom. In figural interpretation, "sensory occurrence pales before the power of figural meaning" and there occurs "an antagonism between sensory appearance and meaning, an antagonism which permeates the early, and indeed the whole, Christian view of reality."[18] In his lucid discussion of the importance of allegory in the aesthetics of medieval Europe, D. W. Robertson, Jr. cites and approves the succinct definition of allegory given by Isidore of Seville, according to whom it is "the art of saying one thing to mean another."[19] For the medieval Christians, the important thing was to be able to decode literal and historical messages because these represented "a shadow of something else more real or more significant."[20] This decoding was thought to be possible through the faculty of reason; Robertson notes that in this context, "To eat the chaff is to be a beast of burden; to eat the grain is to be human. He who uses human reason, therefore, will cast off the chaff and hasten to eat the grain of the spirit."[21] As mediated through the hermeneutics of Augustine, the influence of Plato—especially of the *Republic*—was deep.[22] And since, according to Iris Murdoch, it is in the *Republic* that "the forms are transcendent and the objects of opinion diminish near the lower end of the scale from 'being' toward 'not being,' "[23] we can understand how it happened that in medieval Europe there was "an hierarchical mode of thought which emphasizes the reality of abstract values."[24]

[18] Erich Auerbach, *Mimesis: The Representation of Reality in Western Literature* (Princeton: Princeton University Press, 1953), p. 49.

[19] D. W. Robertson, Jr., *A Preface to Chaucer: Studies in Medieval Perspective* (Princeton: Princeton University Press, 1962), p. 57.

[20] Hans W. Frei, *The Eclipse of Biblical Narrative* (New Haven: Yale University Press, 1974), p. 14. In addition to Frei's important study, see also Karlfried Froehlich, " 'Always to Keep the Literal Sense in Holy Scripture Means to Kill One's Soul'; The State of Biblical Hermeneutics at the Beginning of the Fifteenth Century," in *Literary Uses of Typology: From the Late Middle Ages to the Present*, ed. Earl Miner (Princeton: Princeton University Press, 1977), pp. 20–48.

[21] Robertson, *A Preface to Chaucer*, p. 58.

[22] Ibid., p. 293.

[23] Iris Murdoch, *The Fire and the Sun: Why Plato Banished the Artists* (New York: Oxford University Press, 1977), p. 47.

[24] Robertson, *A Preface to Chaucer*, p. 293.

The result was a rich and creative use of symbol and allegory in medieval European literature, in which allegories, like parables, were understood to be "earthly stories with heavenly meanings." That is, the narrative was a *means* for indicating or pointing to its "meanings." In the implicit hierarchy, the relationship between what I. A. Richards has called "vehicle" and "tenor" was one of lower to higher or of servant to master.[25] The directional flow was from the literal, earthly, and temporary to the spiritual, heavenly, and eternal.

This may help us see how different and, from this point of view, eccentric the *Lotus Sūtra* really is. Western readers have overlooked the structure of the text and have thereby missed the critically important fact that the so-called parables or allegories all follow immediately upon, and actually continue, the discussion begun in the *upāya*, or *hōben*, chapter about the relationship of means to ends. If we think in terms of the problem of the relationship of means to ends in language, we can see the chapter as concerned with the relationship of vehicle to tenor. It then becomes immediately apparent that the parables in the *Lotus* function in a far different, and in some ways more sophisticated, fashion than parables do in the allegorical literature of the West. For the surprising feature of those in the *Lotus* is that they are simultaneously the vehicle and the tenor of that vehicle. In a very important sense, the parables of the *Lotus* are about the role and status of parabolic speech itself. They are what I would call self-reflexive allegory; that is, their trajectory of discourse behaves like a boomerang. Much like the *dharmas* described in a crucial section of the *hōben* chapter, they are characterized by "the absolute identity [or equality] of their beginning and end."[26]

Recognizing this makes it possible to see the *sūtra* as much more sophisticated and philosophical than one had been led to think; one can also see why it had such profound implications for subsequent literary and aesthetic expression. By being self-reflexive, the *sūtra* twists the reader's attention into unexpected areas, which seem calculated to help one jettison one's ordinary expectations about reading and interpretation. The

[25] Here I am pursuing further implications of Konishi's discussion of Richards in "Image and Ambiguity."

[26] T. 9.5.c. Translation mine. This insistence upon collapsing the distance between means and ends in the Mahāyāna is closely related to the development of the principle of *hongaku*, or original enlightenment. The best available study in a Western language is Bruno Petzhold, "Hon Gaku Mon und Shi Kaku Mon," in *Studies in Buddhism in Japan* (Tokyo: International Buddhist Society, 1939), pp. 133–178. The Zen master Dōgen (1200–1253), whose origins were in Tendai, pushed the logic of *hongaku* to arrive at the principle of *shushō-ittō*, or "unification of practice and realization." See Nishio Minoru et al., eds., *Shōbōgenzō, Shōbōgenzō-zuimon-ki*, in Nihon koten bungaku taikei 81 (Tokyo: Iwanami Shoten, 1966), p. 83, and Dōgen, "Dōgen's Bendōwa," trans. Norman Waddell and Masao Abe, *The Eastern Buddhist* n.s. 4, 1 (May 1971): 144.

parables (chapters 3 to 7) of the *Lotus* are presented as if they are going to illustrate what is meant by *upāya/hōben*; but it is equally true that the chapter on *hōben* explains, and is a means for understanding, the parabolic narratives. Thus, the illustration is in no way subordinate to what it illustrates. Unlike the Platonic allegory in the medieval Christian West— "a shadow of something else more real or more significant"—the narratives of the *Lotus* are not a means to an end beyond themselves. Their concrete mode of expression is not "chaff" to be dispensed with in order to attain a more abstract, rational, or spiritual truth. The *Lotus* is unequivocal on this point: "One may seek in every one of the ten directions but will find no mode [*hōben*] other than the Buddha's."[27] This accounts for what may seem to be an inordinate amount of praise directed by the *sūtra* toward itself. It also implies that within the *sūtra* there is an unmistakable philosophical move opposite to that in Plato's *Republic*, a move to affirm the complete reality of the world of concrete phenomena in spite of the fact that they are impermanent.

As long as the *Lotus* is misread as merely a sequence of elegant pictures without much real substance[28] or as dealing with religious practice at the expense of philosophical theory,[29] the connection between it and the thought of Chih-i seems either tenuous or forced. In my reading of the *Lotus*, the *sūtra* radically relativizes the customary projection of an implicit hierarchy of value onto the relationship of means to ends. Fujita Kōtatsu has made the point in a different way by stressing the teaching of *śunyatā*, "emptiness," in the *Lotus*,[30] a teaching best understood through the Nāgārjunic interpretation of emptiness as the codependence of all phenomena. Emptiness disallows an ontological hierarchy and makes the abstract just as dependent on the concrete as the concrete is on the abstract.

It was, of course, the Chinese thinker Chih-i who elaborated the implications of these matters.[31] Although he wrote treatises giving a direct ex-

[27] T. 9.15.a. Translation mine.

[28] Winternitz, Danto, and others.

[29] Leon Hurvitz, *Scripture of the Lotus Blossom of the Fine Dharma* (New York: Columbia University Press, 1976), p. xxiii.

[30] Fujita, "Ichijō to sanjō," pp. 393–405. Hurvitz takes issue with this, noting that statistically the number of references to emptiness in the *Lotus* is not impressive. See Leon Hurvitz, "The *Lotus Sutra* in East Asia: A Review of *Hokke Shisō*," *Monumenta Serica* 29 (1970–1971): 723, and Hurvitz, *Scripture of the Lotus Blossom*, p. xxiii. This is not a question that can be answered by statistics; "emptiness" is certainly conceptually very important in the *Lotus*. In addition to Fujita, see also Tamura and Umehara, *Zettai no shinri: Tendai*, pp. 70ff.

[31] The major study of Chih-i in the West is Leon Hurvitz, *Chih-i*, vol. 12 of *Mélanges chinois et bouddhiques* (1962). Research by Sekiguchi Shindai, however, gives reason to suspect that Hurvitz's pioneering work ought to be used with some caution since it reflects

position of the *Lotus*, his major work, the *Mo-ho chih-kuan*, is intrinsically more important and served historically as a direct link between the *Lotus* and the aesthetics of the later Heian poets of Japan. *Chih-kuan*, or what Japanese called *shikan*, is at the center of Chih-i's major treatise, which is devoted expressly to the exposition of that topic. The *Mo-ho chih-kuan* describes it as the quintessence of Buddhism, both in theory and practice. The term *chih-kuan/shikan* is a rendering of two Sanskrit terms, *śamatha* (*shi*) and *vipaśyanā* (*kan*).[32] These are recognized as two distinct phases or modes that are also united into one process. *Śamatha*, the first aspect of *shikan*, could be rendered as "standstill," the philosophical/meditational act through which the random and confused perceptions and cognitions of ordinary experience are brought to a stop and remain in a tranquil state. This stoppage makes possible (and is also made possible by) the second aspect of *shikan*. This is *vipaśyanā*, which could be rendered as "contemplation." This contemplation is directed toward objects of ordinary perception. It does not attempt to locate the "essences" of phenomena. The contemplator, in accord with the fundamental impermanence of all things (himself included), regards them without obstruction (*muge*), that is, without the sort of discriminating mind that would seek to arrange phenomena into hierarchies of relative importance and select out some—primarily himself or some part of himself—as deserving of exemption from the rule of impartial impermanence (*mujō*).

On a number of levels, *shikan* involves a rejection and refutation of ontological dualism. It explores and discloses the fact that there are no exceptions to the change that characterizes all things. There are no "essences" that are impervious to alteration. Likewise, there are no beings that have existence in and of themselves and are therefore independent of all other things. In addition, the very process of recognizing this principle insists that the subject of contemplation is not ultimately separate from its objects. This insistence on "radical nondualism" (*funi*) is very strong

the later ideas of Chan-jan (711–782) rather than those of Chih-i. See David W. Chappell, "Introduction to the 'T'ien t'ai-ssu-chiao-i,' " *The Eastern Buddhist* n.s. 9, 1 (May 1976): 72–86. A partial translation of the *Mo-ho chih-kuan* is N. A. Donner, "The Great Calming and Contemplation of Chih-i: Chapter 1, The Synopsis," Ph.D. dissertation, University of British Columbia, 1976. In an important recent essay, Robert Gimello has explicated the nature of *shikan* (*śamatha vipaśyanā*) in order to demonstrate that facile assumptions that Buddhist meditation is a form of mysticism are unfounded. See Robert M. Gimello, "Mysticism and Meditation" in *Mysticism and Philosophical Analysis*, ed. Steven T. Katz (New York: Oxford University Press, 1978). Although one may question whether *shi* or *śamatha* is "only the necessary prelude to an analytic discernment of the 'truths' of dependent origination" (p. 181), Gimello's essay goes far to correct many wrong but widely held assumptions.

[32] Kusuyama Haruki, "Kango toshite no shikan," in *Shinkan no kenkyū*, ed. Sekiguchi Shindai (Tokyo: Iwanami Shoten, 1975), pp. 181–200.

in Tendai and makes it fundamentally different from the majority of the philosophies and religious practices that have had their origin in the West.

The association in the West between religious philosophies and Platonic or semi-Platonic modes of thought has been long and deep. Perhaps this has led some Western scholars to project it onto the thought and practices of Buddhism; they have assumed that, since Tendai is "religious" thought, it will be roughly comparable to Platonism. This, for instance, seems to be what went wrong in the most important Western study of the Japanese poet Fujiwara Shunzei; Clifton W. Royston seems to assume that, since Shunzei practiced the *shikan* meditation and was immersed in the thought of Tendai, his view of reality was a variety of Platonism. He writes, for instance, of Shunzei's "quasi-platonic, quasi-religious views of poetry,"[33] and in a discussion of the Buddhist component in Shunzei's literary criticism, he maintains:

> There is a sufficient resemblance between Tendai philosophy and Platonism to allow the substitution of the term "noumenon" for the void. In Buddhism as in Plato, phenomena related to the senses are illusory, unsubstantial, subject to decay, and the products of ignorance. Plato conceives of noumenal forms that are eternal, unchanging ideal forms or absolutes.[34]

On the basis of what I have noted previously about the structure and direction of Tendai thought, it should be apparent that this is misconceived. Royston may have realized there were problems with such a comparison, as he appended the following qualification (which, because it misconstrues the meaning of the emptiness of phenomena, only further confuses the situation): "these noumena, perhaps, strictly speaking, do not exist in Buddhism; what is 'real' is the Void, the antithesis of 'reality.' "[35] The problem is that, once Platonism is imported into Buddhist thought as though it were a useful tool for getting a handle on things, it begins to act like a philosophical equivalent of the sorcerer's apprentice, fomenting misconceptions all over the place.

My intention is not to quibble but rather to isolate and expose a conceptual difficulty that is particularly troublesome. It seems to have made both Buddhist thought and the aesthetic of medieval Japan extremely opaque to many Westerners. Since we are here interested in certain poets for whom the thought of Tendai was an *acknowledged* base for their own aesthetic, it would seem important to get as accurate as possible a portrait of Tendai. In this connection we can profitably follow the lead of Manaka

[33] Clifton W. Royston, "The Poetics and Poetry Criticism of Fujiwara Shunzei (1114–1204)," Ph.D. dissertation, University of Michigan, 1974, p. 386. See also Brower and Miner, *Japanese Court Poetry*, pp. 294–295, for a "Platonized" interpretation of *shikan*.

[34] Royston, "The Poetics and Poetry Criticism of Fujiwara Shunzei," p. 384.

[35] Ibid.

Fujiko, a nun immersed in the Tendai tradition and one of Japan's most erudite students of the literature of this period. Manaka notes that what was philosophically important for Shunzei and Teika in the *Mo-ho chih-kuan* was the teaching of *genshō-zoku- jissō*, literally, "the identity of the phenomenon with the real."[36] What is clear, then, is that Tendai thought entertained something like Platonism as a philosophical option but emphatically *rejected* it.

Though this leaves a number of aspects of Tendai to be explored further, we can at least conclude that the new depth in the verse and aesthetic taste of the end of the Heian period did not arise out of a dualist distinction between insubstantial phenomena and substantial, absolute noumena. The parallel with Platonism turns out to have been completely misleading. With it out of the way, we can now more directly ask what constituted the depth that came into the medieval Japanese aesthetic. Before returning to the thought of Chih-i, I would like to consider another key treatise, the *Korai fūteishō*. Completed in 1197, it was Shunzei's only full-length work on poetry. The section that is usually regarded as having crucial importance is one I translate as follows:

> The *Mo-ho chih-kuan* of the Tendai school opens with these words by Kuanting [Chih-i's amanuensis]: "Calm-and-contemplation [*shikan*] has in itself a clarity and tranquility beyond anything known to earlier generations."
>
> Now, if we pay attention to this at the outset, a dimension of infinite depth as well as profound meaning will be discovered. It will be like listening to something sublime and exalted while trying to understand the poetic sensibility—its fine points, weak points, and its depths. This is to say that things that otherwise are incapable of being expressed in words will be understood precisely when they are likened to calm-and-contemplation.
>
> It is worthy of note that in the text of the *Mo-ho chih-kuan* the very first thing related is the process of transmission of the Holy Dharma of the Buddha—that is, the way it was handed down from one man to another. The great enlightened one, Śākyamuni, transmitted it to Kāśyapa, who in turn passed it on to Ānanda; so it went from master to disciple down through twenty-three persons. When we [Japanese] hear about this process of the transmission of the Holy Dharma, we cannot have anything but great reverence for it. But in a similar way we cannot but be impressed by the fact that our own Japanese verse-form, the *uta*, has from antiquity been handed down to us in precisely the same fashion—taking the shape of a series of anthologies, a sequence that began with the *Man'yō-shū* [Myriad leaves anthology] and then continued on through its successors, the *Kokin-shū* [Anthology of songs ancient and modern], the *Gosen wakashū* [Poetic gleanings], the *Shūi wakashū* [Latter-day poetic selections], and so on.

[36] Manaka, *Koku-bungaku ni sesshu sareta Bukkyō*, p. 223.

But someone might charge that, whereas in the case of the *Mo-ho chih-kuan* it is a matter of transmitting the deep truth by holy men known as the "golden-mouthed ones," what I have brought up for consideration is nothing more than those verbal games known as "floating phrases and fictive utterances" [*kyōgen-kigo*]. However, quite to the contrary, it is exactly here that the profundity of things is demonstrated. This is because there exists a reciprocal flow of meaning between such things [as poetry] and the way of Buddhism, a way that maintains the interdependence of all things. This is found in the teaching that: "Enlightenment is nowhere other than in the worldly passions."[37]

Again, it is as in that passage of the *Lotus Sūtra* that says: "The Bodhisattva Mahāsattva interprets even the secular classics . . . to show how they can benefit life and can be reconciled with the perfect Buddhist Dharma." Moreover, the matter is explained as follows in the *Samantabhadra-bodhisattva-sūtra*: "Of one thing it is said 'that is bad' and of another it is said 'that is good.' But there is nothing inherent in things that make them good or bad. For each thing's 'self' is empty [of independent existence]." Thus, for all these reasons I can now for the record state that the Japanese lyric called the *uta* has a dimension of depth, one that has affinity with the three stages of truth in Tendai, namely, the void [*kū*], the provisional [*ke*], and the middle [*chū*].[38]

Though on first reading this passage might appear to be little more than a blatant and facile rationalization, it is actually fairly sophisticated both in what it sets out to do and how it accomplishes it. I propose, first, to make a few observations that may help to clarify Shunzei's argument, and then, by an analysis of specific poems, to show the continuity between Shunzei's theory and his practice.

Shunzei's comparison of the transmission of the Dharma with the handing down of Japanese verse form in a sequence of anthologies is more than a naive claim that parallel processes imply equivalent contents. He is not merely claiming that the Japanese need not feel outdone by historic events on the Asian mainland, where Buddhist teachings were passed from Śākyamuni Buddha down through a long line of Indian and Chinese masters. He is not merely making a naive claim that the Japanese on their archipelago have, in the form of poetry collections, something tantamount to the Dharmic transmission.

Shunzei's argument proceeds quite differently. He is fully aware that some devout Buddhists in China and Japan have given up the practice of poetry in order to give themselves unequivocally to the pursuit of more holy or religious vocations; they have even sometimes dismissed secular

[37] This phrase, although fairly common in the Mahāyāna, is conceptually important in the *Mo-ho chih-kuan*; see, e.g., T. 46.6.a.

[38] The text here translated is from Hayashiya Tatsusaburō, *Kodai chūsei geijutsu-ron*, in Nihon shisō taikei 23 (Tokyo: Iwanami Shoten, 1973), pp. 262–263.

prose and poetry as mere "floating phrases and fictive utterances" (kyō-
gen kigo).[39] The Japanese courtly conventions, according to which it was
necessary to write amorous verse, had been especially troublesome to
these more puritanical members of the Buddhist community. Shunzei's
response to these Buddhists is an adroit citation of the sacred sūtras to
demonstrate that a clear, rigorous distinction between sacred and secular
is itself problematic according to Mahāyāna doctrine. The crux of his
argument is that the composition and collection of secular verse must be
a Buddhist activity because the dialectic of Mahāyāna (eminently, in the
section Shunzei cites of the Samantabhadra-bodhisattva-sūtra) demands
a rejection of any bifurcation of the holy and the profane.[40]

Shunzei then brings in Tendai's three "stages" of truth (santai): the
void, the provisional, and the middle. An aspect of Chih-i's thought, the
three stages are crucial to the linkage Shunzei sees between poetry and
Buddhism. The initial stage of the santai is the doctrine of the fundamen-
tal emptiness or voidness (kū) of all phenomena. Emptiness is a classic
Buddhist teaching and in no way peculiar to the Tendai school. The Bud-
dhist claim of the emptiness of phenomena is not the positing of a nihil
but simply the insistence that nowhere can there be found an entity that
has existence in and of itself. This is to say that the ancient Buddhists
found no evidence of any being or phenomenon having what in Western
philosophy was once called aseity, the status of being unconditioned and
beyond influence or causation by any other thing. The Buddhists insisted
that even things or beings imagined or said to have independent existence
really do not, for their existence depends on the imagination or speech of
the person thinking or speaking of them. For the Buddhist, there are no
beings with aseity, no exceptions to the rule that all phenomena are void
of self-existence (muga). (In fact, to the extent that aseity would be
viewed as an attribute of deity, Buddhists have traditionally had some
difficulty accepting the notion of a "god" in this sense.) The corollary of
the doctrine of the void is that all things are radically related. In the third
chapter of his Mo-ho chih-kuan Chih-i referred to this, the first move in
the santai, as juke-nyūkū, "leaving the provisional and entering into
empty";[41] this means forsaking our ordinary way of perceiving phenom-
ena as having independent being and accepting the correct view of them
as void of such independence.

The establishment of the doctrine of the void is fraught with hazards,

[39] See William R. LaFleur, The Karma of Words: Buddhism and the Literary Arts in Me-
dieval Japan (Berkeley: University of California Press, 1983), pp. 1–25, for a discussion of
kyōgen-kigo and the problem faced by those wanting both literary and religious careers in
this period of Japanese history.
[40] Hara Ichirō, Shi no shukyō (Tokyo: Waseda Daigaku Shuppansha, 1973), p. 153.
[41] T. 46.24.c.

however. Chief among these is the danger of reifying or hypostatizing the void itself. Tamura Yoshirō notes: "It will not do to think of having gone from the provisional to the emptiness of things as if one had somehow now reached some *entity* called 'the void.' "[42] For this reason, it was sometimes maintained in the Mahāyāna that "emptiness itself is emptied" (*kū kū*). Thus, to regard phenomena as empty is itself an activity that needs to be relativized and seen as dependent. In the *Mo-ho chih-kuan* this is accomplished by a reaffirmation of the reality of provisional phenomena (*ke*). This was the second stage of the *santai*. Chih-i called it *jukū-nyūke*, "leaving the empty and entering into the provisional."[43] The term is diametrically opposite to *juke-nyūkū*, but the intention is not to establish two mutually negating propositions; rather, it is to hold that both propositions describe reality, and both are necessary in order to describe reality accurately.

The recognition of the perfectly balanced codependence of the void (*kū*) and the provisional (*ke*) was Tendai's third stage, that of the middle (*chū*). The middle is not a position midway between the other two, but the holding of both in a state of dynamic and equalized tension. Each way of looking at things is valid, but only because the other is also true; each side gives existence and function to the other. The classic Mahāyāna account of the bodhisattva figure makes the same point in more narrative, less philosophical, language. According to it, the bodhisattva recognizes the phenomenal world as empty, without abiding entities, and therefore worthy of being forsaken for Nirvāṇa; nevertheless, in order to rescue others, he returns to the world of *saṃsāra*.[44] Moreover, since "enlightenment is nowhere other than in the worldly passions" (*bonnō soku bodai*), even for the bodhisattva himself there is no other world in which to be, or from which to be saved.

Shunzei's cryptic statement quoted earlier may now be easier to understand: "Thus, for all these reasons I can now for the record state that the Japanese lyric called the *uta* has a dimension of depth, one that has affinity with the three stages of truth in Tendai, namely, the void (*kū*), the provisional (*ke*), and the middle (*chū*)." Shunzei has in mind the entire corpus of Japanese verse, not merely a category of poems said to have *yūgen*. Based on this one can, however, anticipate what he means by *yū-*

[42] Tamura and Umehara, *Zettai no shinri: Tendai*, p. 74. See also William R. LaFleur, "Buddhist Emptiness in the Ethics and Aesthetics of Watsuji Tetsurō," *Religious Studies* 14 (June 1978): 237–250.

[43] *T.* 46.24.b and c.

[44] This is precisely the structure of *shikan*. Fung Yu-lan in his discussion of Chih-i notes that "to achieve Nirvana is the function of cessation; to return then to the ordinary is that of contemplation." Fung Yu-lan, *A History of Chinese Philosophy* (Princeton: Princeton University Press, 1953), 2:377.

gen; by linking the *uta* with the three stages of Tendai, he places the composition, reading, and appreciation of poetry in a context of complete open-endedness.

It is clear that Shunzei's view of poetry included what has recently been called "the indeterminacy of meaning."[45] For him, the "dimension of depth" in poetry had nothing to do with a determinate "meaning" that had been coded into a poem by the poet to then be decoded by the sensitive hearer or listener. According to him, a Japanese poem, or *uta*, though it may be a thing of wonder, cannot really be recondite. The interpretation of depth is not the discovery of hermetic elements, the supposed meaning under the surface of words.

This is in part because the *santai* process in Tendai aims at a kind of ontological egalitarianism. The abstract is no more and no less real than the concrete. Surfaces are never merely superficial. Vehicles cannot be subordinate to tenors. Shin'ichi Hisamatsu, recognizing that ordinary rubrics of understanding tend to attribute more weight and value to what is "inside" and at the "core" and implicitly denigrate the outside as superficial, has astutely observed that Buddhism handles this by saying that "the true inside of the inside is not having inside or outside."[46] In this extremely valuable formulation, Hisamatsu suggests that to dig to the core of the core is to discover the invalidity of such distinctions and also to discover that, seen from inside, the surface is deep. The terms are completely relative. The Zen poet Shinkei (d. 1544) wrote of this in his classic work, *Sasamegoto* (Murmuring to myself): "The beginner enters from the shallow to the deep; and once he has attained the depths, he emerges

[45] The question of "meaning" has been a much vexed one in contemporary philosophy; a good overview of issues involved and positions taken is Ian Hacking, *Why Does Language Matter to Philosophy?* (Cambridge: Cambridge University Press, 1975). I am not suggesting that the interest in language of a poet such as Shunzei was exactly in the same terms as that of modern philosophers, nor do I think he would have insisted on "indeterminancy" as completely as does Willard van Orman Quine in *Word and Object* (Cambridge: Cambridge University Press, 1960). My point is merely that one can infer from their writings and from their practice as poets that Shunzei, Teika, and others—perhaps merely following a more general Japanese usage—rejected the idea that a given poem had a fixed or stable meaning. In fact, one of the most striking things about the *practice* of poetry in medieval Japan was the emphasis upon the creative possibilities in placing an existing poem in a collection (*shū*); without the change of a single syllable, a poem placed in a collection was given a new setting, a new sequence, and a new meaning. See Fujiwara Teika, *Fujiwara Teika's Superior Poems of Our Times*, trans. Robert H. Brower and Earl Miner (Tokyo: Tokyo University Press, 1967). Likewise, it must be said that the development of *renga*, or "linked verse," was made possible by the discovery of the creative possibilities when meaning is regarded as indeterminate. There may be a deep relationship between this and *muga*, or "no [determinate] self," in Buddhism.

[46] Shin'ichi Hisamatsu, *Zen and the Fine Arts* (New York: Kodansha International, 1974), p. 49.

again into the shallow: this is the essential rule of all disciplines. Cause produces effect; effect in turn leads to cause."[47]

The open-endedness of both phenomena and interpretation are very important for understanding Shunzei. In accordance with the movement through three stages of truth in Tendai, in Shunzei's view the depth of poetry is not a place but a process.[48] It is not a determinate point at which the interpreter arrives after doing a certain amount of linguistic homework to solve conundrums built into the poem by its author. It is much closer to what George Steiner calls the "rich undecidability" aimed at by a poet.[49]

In a number of essays, Konishi Jin'ichi has focused on the medieval aesthetic's roots in Tendai, though we often associate it exclusively with Zen; citing the importance of Chih-i, Konishi reminds us that the "content of *shikan* is equivalent to the content of Zen."[50] He pursues the implications of this, using the distinction between vehicle and tenor, signifier and signified: "the Zennist strives for the cessation of understanding arrived at through processes of judgment; this means, therefore, that there is no substantive element that can serve as tenor. This leads to the conclusion that imagery in Zen is tantamount to tenorless symbolism."[51]

Imagery in Tendai seems to have been no different, especially as informed by notions of *shikan* and the three-stage process of truth. The effect was a tendency to reject symbolism rather than affirm it. The following poem by Shunzei is illustrative:

Harusame wa	Spring's fine rain
konomo kanomo no	both in the distance and right here
kusa mo ki mo	both on grasses and trees
wakezu midori ni	is evenly dyeing everything
somuru nariken.	everywhere in its new green.[52]

No literate reader in medieval Japan would fail to recognize that on one level this poem is a thirty-one-syllable encapsulation of the *yakusō-*

[47] Shinkei, *Sasamegoto*, in a version edited by Suzuki Hisashi in Haga Kōjiro, *Geidō shisō-shū*, in Nihon no shisō 7 (Tokyo: Chikuma Shobo, 1971), pp. 193–194. Translation in Shinkei, "*Sasamegoto*, An Instruction Book in Linked Verse," trans. Dennis Hirota, *Chanoyu Quarterly* 19 (1978): 42.

[48] Naka Seitetsu, in his discussion of the *Korai fūteishō*, makes a similar point by seeing this as an emphasis upon "michi," or "way," as a dynamic process. See Naka, *Korai fūteishō*, p. 58.

[49] Steiner, *On Difficulty*, p. 40.

[50] Konishi, "Image and Ambiguity," p. 9.

[51] Ibid., p. 15.

[52] Tōkyō Kokumin Tōsho, ed., *Kokka taikei* (Tokyo: Kakumin Kosho Kabushikigaisha, 1927–1931), 10:495. Translation mine. Another reading for *wakezu* is *wakazu*.

yu, or "plant parable," chapter of the *Lotus Sūtra*,[53] a favorite of the courtiers. Shunzei's poem uses the fairly common ambiguity of the verb *somuru*, which can mean both "to commence" (as in the beginning of spring) and "to dye with color." But the poem's brilliance lies in the way it draws the reader or listener into an extended visualization of the gently falling rain. It does so first on a horizontal plane: *konomo kanomo* is a sequence that refers both to the "far distance" and to the "near at hand." Then it does so vertically: *kusa mo ki mo* refers to the lowliest of grasses and the loftiest of trees. Thus, in very simple but precise language the poet draws attention to the fact that wherever one looks one sees the falling spring rain (*harusame*), a rain always thought of as light, gentle, and nourishing. The poem moves on to depict the rain as evenly and indiscriminately (*wakezu*) serving as the dye (*somuru*) that brings out the color green (*midori*) in everything. Since *somuru*, also means "to commence" or "to begin," it reinforces the idea that at this moment spring has come. Thus, the poem has not only a vivid spatial sense but a temporal one as well; the present moment is itself a perfection.

This poem is almost an open invitation to symbolic or allegorical interpretation.[54] Not only does it recapitulate the imagery of the "plant parable" chapter of the *Lotus*, but, in the strategic location of the word *wakezu* (meaning "without discrimination," or "evenly"), it also captures the motif of that chapter of the *sūtra*, the undiscriminating and undifferentiating beneficence of the Buddhist Dharma. This beneficence, like the rain, falls on all and on all equally. Certainly Shunzei would have expected his contemporaries to recognize the allusions and allegorical possibilities in this poem. Nevertheless, the poem becomes more fascinating when viewed in the context of the preceding discussion. For then it is not a simple restatement of the imagery of a chapter in the *Lotus* but an expression in verse, and through the sophisticated structuring of verse, of something very important concerning the nature of allusion itself. The relationship between the poem and the *sūtra* is not merely a matter of the poem alluding to the scripture and so being dependent in a unidirectional way upon it. On the contrary, because the theme of both the *sūtra* and the poem is the fundamental absence of discrimination (*wakezu*) or hierarchy in the Dharma, any sense of the poem as derivative or subordinate is itself subverted and disallowed. Since it is known that Shunzei was intensely concerned to demonstrate and justify the *uta* as a form of religious discourse, we can now see how he thought through the implications of the act of allusion. For Shunzei, the classic to which a given poem alludes

[53] T. 9.19a–20b. Shunzei's poem is part of a sequence on the chapters of the *Lotus*.

[54] This is the interpretation of Brower and Miner in *Japanese Court Poetry*, pp. 293–294. They write of Shunzei's use of "the vehicle of allegory." This, unless greatly qualified, is a misleading parallel with Western literary modes.

is neither to be enshrined nor to be bested; in that sense it is neither Parnassus nor father. For the relationship of the classics or scriptures to poems currently being written is the same as that of large trees (*ki*) to lowly grasses (*kusa*): it is fundamentally nonhierarchical (*wakezu*). This is articulated both in the *Lotus* scripture and in the poem.

This fits in precisely with what Shunzei says in the *Korai fūteishō* concerning the status of the poem. Shunzei's position was that, although it is a form some of the pious call "floating phrases and fictive utterances," the *uta* is a context in which "the profundity of things is demonstrated." This is because there exists a reciprocal flow of meaning between such things [as poetry] and the way of Buddhism, a way that maintains the interdependence of all things." In Shunzei's view, a poem is Buddhist not because it has hidden within it an allusion to a scripture or an unambiguously sacred source, but because the trajectory back to that source itself produces a rejection of the distinction between sacred and profane literatures.

This rejection results in a strong reaffirmation of the phenomena of the empirical world. In the doctrinal discussions carried out in Chinese and Japanese Tendai, it led to the conclusion that the plants and trees referred to in the *Lotus Sūtra* do not merely symbolize truths beyond themselves but actually have Buddha-nature in their own phenomenal existence (*sōmoku jōbutsu*).[55] In the final analysis, Shunzei's poem is not a literary utterance that uses the rain, grasses, and trees to refer to the *sūtra* and, through the *sūtra*, to the universal and abstract Buddhist Dharma: in its structure and diction it finally disallows a merely symbolic or allegorical interpretation. The orbit of its concern returns inevitably to concrete particulars; it affirms the existence and the beauty of the rain, the grasses, and the trees as they are.

This does much to explain the concrete and vivid qualities prized in the poetry of this era. Thus, for a poet such as Shunzei, there was ultimately not the slightest discord or gap between the requirements of poetry and those of Buddhism; the rejection of allegory and the return to the immediacy of trees and plants as the locus of reality is the aspect of *shikan* called *jukū-nyūke*, "leaving the empty and entering into the provisional." As a literary act, it is tantamount to a collapse of what Auerbach has called "the antagonism between sensory appearance and meaning," because such antagonism, although entertained by the Buddhists as a possibility, is discordant with the motif of the undiscriminating and "even" (*wakezu*). Poetic depth involves more than the use of symbolism; it is not

[55] For a more extended discussion of how, by following the logic of *hongaku*, Chinese and Japanese thinkers in the T'ien-t'ai/Tendai tradition eventually affirmed the "Buddhahood of plants and trees," see part 1 of my "Saigyō and the Buddhist Value of Nature," *History of Religions* 13, 2 (November 1973): 93–128; 3 (February 1974): 227–248.

as much a move away from surfaces to seek inner essences and meanings
as a move away from such inner "meanings" to reaffirm the reality of the
so-called surface.

The poems themselves make the point more clearly and interestingly.
The following is also by Shunzei:

Ima zo kore	Right here and now!
irihi no mite mo	I watch the sun slip away,
omoikoshi	thoughts gone to the west
Mida no mikuni no	paradise of Amida, where
yūgure no sora.	this is the sky of nightfall.[56]

There is an intended strangeness and tension in this verse.[57] The whole
poem is, in fact, a structured oxymoron; *here* and *there* seem to be cate-
gories in total confusion. It begins with an emphatic declaration that ev-
erything that follows depicts something in the immediate present and in
the poet's exact spatial location. It is this insistence that makes what fol-
lows puzzling, since all the succeeding images are of things usually asso-
ciated with the ideal of being distant or removed. Most especially, the
Western Paradise of Amida was popularly conceived to be disjunct from
the present world, the so-called *shaba* world of suffering and darkness.
The world of Amida was referred to as "the other shore," a place of per-
petual light and felicity.

There were, however, Amidist thinkers who insisted that such a dual-
ism was ultimately untenable within Buddhism and that "this shore," our
world, is really identical with the perfect world of Amida. The phrase
shaba soku jakkō (this world is none other than the one of tranquil light)
expresses the point exactly. It is undoubtedly the conceptual background
for Shunzei's composition of this poem. It provides the philosophical
grounding for the oxymoron in the poem, and it also links up directly
with Shunzei's use of the phrase "enlightenment is nowhere other than in
the worldly passions" in the crucial section of the *Korai fūteishō*.

To disregard these points would be to dismiss things that were of ut-
most intellectual, religious, and aesthetic importance to Shunzei. Thus,
they were also important for his verse. Yet they do not necessarily vitiate
even a complex poem such as this: Shunzei's poem is, after all, in concrete
language. The final line vividly portrays the sky in which night is falling,
so the reader is compelled to acknowledge the poet's claim that a nightfall

[56] Poem no. 1968 in Ishida Yoshisada, *Shinkokin waka-shū: zenchūkai* (Tokyo: Yuseido,
1968), p. 842. Translation mine.

[57] Kubota Jun, *Shinkokin kajin no kenkyū* (Tokyo: Tokyo Daigaku Shuppankai, 1973),
p. 304. For a more extended discussion of this poem, see Tsukudo Reikan, *Tsukudo Reikan
chosaku-shū* (Tokyo: Serika Shobo, 1976) 1:9ff.

in this world is really one in Amida's paradise, where, at least according to dualist projections, there was supposedly no place for "negative" things such as night and darkness. The natural implication is the attribution of both beauty and positivity to the fall of night in the empirical world.

This attribution of positivity to the negative is directly related to the depth and the *yūgen* of the best poems of the epoch—as, for instance, in the following superb poem by Fujiwara Teika:

Miwataseba	Gaze out far enough,
hana mo momiji mo	beyond all cherry blossoms
nakarikeri	and scarlet maples,
ura no tomaya no	to those huts by the harbor
aki no yūgure.	fading in the autumn dusk.[58]

For very good reasons, this poem has been highly praised. Many have noted that it deftly moves the eye of the mind over various landscapes—implicit definitions of beauty—to a place where, through the negation of the usual canons of beauty, something beyond them all is discovered in the most mundane, even the most drab, of contexts. For centuries, the literature of China and Japan had depicted the beauties of the various seasons and offered reasons for preferring one or the other; the court poets of Heian Japan had often seen cherry blossoms as the quintessence of spring's beauty and the brilliantly colored maple as that of fall. Teika, however, here envisions a beauty "beyond" all of these.

It would not do, however, to characterize *yūgen* simply as a preference for the faded and colorless. And since this term was first used in Japan by Shunzei as a concept in aesthetic criticism, his view of it deserves consideration. Though Brower and Miner are correct in stating that Shunzei left us "nothing in the way of a detailed poetic of yūgen,"[59] we can infer what he meant by the term from a few of the era's classic poems that he said embodied it. We should keep in mind Konishi Jin'ichi's interpretation of *yūgen* through the theory and practice of *shikan* in Tendai Buddhism. In

[58] Poem no. 363 in Ishida, *Shinkokin waka-shū*, pp. 168–169. Translation mine.

[59] Brower and Miner, *Japanese Court Poetry*, p. 266. It is, of course, true that Shunzei used the word *yūgen*. Yet most Japanese scholars agree that this low statistical use does not invalidate its importance to him nor the fact that his use of it was initially the most important. In addition to the Konishi studies cited in the following pages, *yūgen* has received important consideration in Ōnishi Yoshinori, *Yūgen to aware* (Tokyo: Iwanami Shoten, 1940); Nose Asaji, *Yūgen-ron* (Tokyo: Kawade Shobo, 1944); and Haga Kōjirō, "Nihoteki na bi no seiritsu to tenkai: yūgen, wabi no keifu," in Haga Kōjirō, *Geidō shisō-shū*, pp. 3–42.

addition to the preceding poem, let us consider a few others, such as this one by Shunzei himself:

Yū sareba	Night and fall close in:
nobe no akikaze	winds from the wide heath
mi ni shimite	howl into me
uzura naku nari	along with the muffled moans
fukakusa no sato.	of grass-hidden quail.[60]

These by Saigyō are often cited as examples of *yūgen*:

Kokoro naki	Thought I was free
mi ni mo aware wa	of passions, so this melancholy
shirarekeri	comes as surprise:
shigi tatsu sawa no	a woodcock shoots up from marsh
aki no yūgure.	where autumn's twilight falls.[61]

Tsu no kuni no	Famed for its springtime,
Naniwa no haru wa	Naniwa in Tsu, seen today at last:
yume nare ya	a field of withered weeds
ashi no kareba ni	bent down by harsh winds—my dream
kaze wataruru nari.	to see it come false . . . come true.[62]

Though many other verses could be cited, these four are considered classic examples of the *yūgen* of this period.

I can begin by noting the obvious. Each of these poems focuses on things in nature usually associated with darkness or cold. The reader, in projecting himself or herself into the setting of each poem, has, initially at least, a sense of discomfort, perhaps even displeasure. Peasant huts disappearing in the dusk, winds on a heath at nightfall, the moans of quail, marshes and fields getting progressively colder and darker—such are the poems' settings and materials. It is not a coincidence that the two Chinese characters used to write the term *yūgen* both refer to something that is dark and opaque. Nevertheless, the sense of unpleasantness is quickly, even simultaneously, replaced by a sense of the extraordinary dignity and beauty of the phenomena depicted in the verse.

In view of this, it would be tempting to interpret Shunzei's idea of *yūgen* through sentences written in the *Mumyō-shō* (Nameless essay) by Kamo no Chōmei between the years 1211 and 1216, or some time after Shunzei's death. Chōmei wrote the following concerning *yūgen*:

[60] Tōkyō Kokumin Tōsho, ed., *Kokka taikei*. Translation mine.

[61] Poem no. 515 in *Sanka-shū*; poem no. 362 in Ishida, *Shinkokin waka-shū*; translated in my *Mirror for the Moon*, p. 24.

[62] Poem no. 2157 in *Sanka-shū*; poem no. 625 in Ishida, *Shinkokin waka-shū*; translated in my *Mirror for the Moon*, p. 88.

Since I do not understand it very well myself, I am at a loss as to how to describe it in a satisfactory manner, but according to the views of those who have penetrated into the realm of *yūgen*, the importance lies in *yojō*, which is not stated in words and an atmosphere that is not revealed through the form of the poem. When the content rests on a sound basis and the diction excels in lavish beauty, these other virtues will be supplied naturally. On an autumn evening, for example, there is no color in the sky, nor any sound, and although we cannot give a definite reason for it, we are somehow moved to tears. A person lacking in sensitivity finds nothing particular in such a sight, he just admires the cherry blossoms and scarlet autumn leaves that he can see with his own eyes.[63]

Konishi Jin'ichi has warned, however, against interpreting Shunzei's view through that of Chōmei—especially since, in contrast to those who like white blossoms or scarlet leaves, Chōmei has a decided preference of his own, namely, for the colorless "color." Konishi contrasts Shunzei and Chōmei as follows:

When Shunzei himself expresses the sense of *yūgen*, it is of course something that is supported by the intentions of *shikan*, and it simply will not do to remove this factor. However, there is a difference between this and the specific chromatic which Dr. Nose [Nose Asaji in his *Yūgen-ron*] has demonstrated. The intentionality of *shikan* itself embraces no definite chromatic. *Shikan* expresses the mutual permeation of what is grasped and what is doing the grasping, and as such it can materialize in any one of various colors: sometimes that of splendor, sometimes sadness, sometimes simplicity, sometimes subtlety— each is allowable. This is where there is a difference between Shunzei's own idea of *yūgen* and a view of it such as Chōmei articulated.[64]

The significance of this observation lies not only in the way it helps one differentiate between the views of two medieval Japanese literati but also in its potential for disclosing and articulating more of the basic structure of *yūgen*. Konishi has done this with considerable success. There is a difference between seeing *yūgen* in Chōmei's terms—where it is primarily an ineffable and inexplicable preference for certain emotions evoked by scenes and actions that are faint and thin to the point of being almost without color or definite character—and seeing *yūgen* in Shunzei's terms, where one must draw upon the structure of *shikan* in order to begin to comprehend it.

Konishi's is a good lead to follow. In an early essay on the origins of *yūgen*, he lavishly documented his claim that, before its usage by Shunzei and others as a term in literary aesthetics, it was used in Buddhist texts,

[63] Hilda Katō, "The Mumyōshō of Kamo no Chōmei and Its Significance in Japanese Literature," *Monumenta Nipponica* 23, 3–4 (1968): 408.

[64] Konishi, "Shunzei no yūgen-fū to shikan." Translation mine.

especially those of the Prajñāpāramitā (Hannya) and Mādhyamika (San-ron) literatures. This placed it squarely within literatures concerned to demonstrate that the nature of all phenomena is *śūnya* (*kū*), "empti-ness."[65] The Prajñāpāramitā literature was especially concerned to dem-onstrate that all things were empty of self-existence. Its unyielding dialec-tic at the same time refused to allow emptiness to congeal or reify into an absolute or independent principle; it demanded, as has been seen, that emptiness too be emptied. The operation of this ongoing process of emp-tying implied a vastness and richness in the universe as explored in its interrelatedness. Since nothing anywhere could be found to have indepen-dent existence, there were no stopping places or barriers within reality as investigated by the Prajñāpāramitā. And it is this, according to Konishi, that is directly linked to the depth, density, distance, and wondrous qual-ity that seems to be so much a part of *yūgen*. Reality is boundless in the most precise sense; since there are no hard, absolute, or independent en-tities, there are no boundaries or limits to the deep and mutual interpen-etration of all existent things. *Yūgen* acknowledges and discloses this.

In both the *shikan* of Tendai and the arts of *yūgen* there is a definite quiescence and tranquility. In *shikan* this is undoubtedly related to the practice of seated meditation, basically the seated *zen*, or *zazen*, that was a part of most Buddhist practice but received special emphasis in the Zen Buddhist school. In *zazen* the body (through quiet sitting in the lotus pos-ture), speech (through silence and the quiet chanting of the name of a Buddha), and the mind (through focused concentration rather than ran-dom thoughts) penetrate in a united fashion to the realization that "there is an absolute rejection and dismissal of existence conceived of as a con-frontational relationship between the perceiver and perceived."[66] This is basically consonant with those practices in earliest Buddhism that fo-cused on the cessation of random and disturbed perceptions (*samatha/shi*) and the quiescent observation of the constellations of things (*dhar-mas*) as they come into being and pass away without obstruction (*vipa-śyanā/kan*).

Except for the fact that its expression is in poetry and drama, the *struc-ture* of *yūgen* is not fundamentally different. That is why the poems I have cited, in spite of their initial presentation of uncomfortable phenomena, succeed in conveying a far from ordinary sense of tranquility and dignity. The phenomena presented in these poems are observed in such a way that both their coming into being and their dissolution are observed with equanimity. There is a clear sense that they are characterized by imper-

[65] Konishi Jin'ichi, "Yūgen no gen-igi," *Kokugo to kokubungaku* 20, 6 (June 1943): 499–508. See also Konishi, *Michi: chūsei no rinen*, p. 44 ff.
[66] Konishi, "Shunzei no yūgen-fu to shikan," pp. 111–112.

manence (*mujō*), an impermanence that is greeted and treated not as tragic but as right and ultimately acceptable because it is simply "the way things are" (*tathāgata, nyorai*).

Perhaps what is most important is the collapse of the distance between observer and observed noted by Konishi. This implies that in the *yūgen* aesthetic as conceived by Shunzei there is a crucial move whereby initially the poet or actor, and then also the reader or audience, are drawn into or implicated in this impermanence not on some secondary philosophical level but in and through the mechanics of the poem as a poem.

There is value in looking more closely at the classic example by Teika:

Miwatesaba	Gaze out far enough,
hana mo momiji mo	beyond all cherry blossoms
nakarikeri	and scarlet maples,
ura no tomaya no	to those huts by the harbor
aki no yūgure.	fading in the autumn dusk.

In the poetry of Japan prior to the twelfth century it was a commonplace for verses to be written about the quickly disappearing blossoms of the cherry tree in spring or about the ephemeral beauty of maples in the fall. These were also so associated with the Buddhist teaching of *mujō* that they began to serve as the easily recognized synecdoche for all other things and the impermanence that is necessarily a part of every individual existence; the emotion engendered by such poems was inevitably sadness. By comparison, the poems of the late twelfth century that began to evidence the quality of *yūgen* are considerably more sophisticated. Teika's is no ordinary evocation of *mujō*—though in part the genius of this verse lies in the way it has enfolded within itself a traditional but ordinary statement of impermanence with the accompanying conventional emotion of sadness. The second and third lines of the poem could be independently read as *hana mo momiji mo nakarikere* (the cherry blossoms and maple leaves have disappeared). But by the end of the twelfth century these had become hackneyed lines and trite emotions; and they are transformed into something quite different and much richer by Teika's incorporating them into a complex and dynamic poetic action. He prefaces them with the verb *miwatasu*, referring to the act of looking or gazing out, over, and beyond things lying close at hand toward a place much farther in the distance. This perceptual act drops, discards, and in a sense negates the cherry blossoms and maple leaves; Brower and Miner rightly note that Teika "uses the old symbols of the beauty of spring and autumn, cherry blossoms and colored leaves, as negative comparisons for praising something else."[67]

[67] Brower and Miner, *Japanese Court Poetry*, p. 307.

Teika is not merely expressing an unconventional preference for the detection of beauty in things ordinarily dismissed as drab, however. The voice adopted in the poem is of someone engaged in a perceptual act much more ambitious than usual, an attempt to look over and beyond things that by convention signify the ephemeral and transient—that is, everything expressed in the now hackneyed image of the phrase "cherry blossoms and maple leaves have disappeared." Perhaps the speaker wants to see not only beyond conventional notions of beauty and transience but also beyond all impermanent things. If so, it is ironic that, as he fixes his vision on things far off in the distance—the peasant huts by the harbor (*ura no tomaya*)—they have already begun to disappear from sight in the autumn dusk (*aki no yūgure*). The wonderful irony lies in the fact that what is seen in the distance is quickly and presently disappearing. Although not conventional images of *mujō*, the huts are no less characterized by the radical impermanence of all existent things.

Perhaps the most magnificent aspect of this verse is its sophisticated way of handling the relationship between the perceiver and the perceived. At the very moment when the speaker/perceiver is attempting to carry out his almost Promethean attempt to transcend impermanence, dusk cuts him off from the object of his observation. This means that his observational activity comes to an end; as observer, he is negated with the object of his observation. This is a concrete example of what Konishi claims is essential for *yūgen*, namely, the negation of "existence conceived of as a confrontational [*tairitsuteki*] relationship between the perceiver and the perceived." The poem is an adroit execution of this negation. The act of observation comes to an end at the same moment that it begins—in the unit of time the Buddhists called *kṣaṇa* (*setsuna*);[68] thus, the observer is no more permanent than what he or she observes. Implicit in the perceptual process of the poem is an exact parallel: just as the particular that lies in the distance (huts by the harbor) is not fundamentally different from that lying close at hand (cherry blossoms and scarlet maples), so the general class of things always thought to lie in the distance (the objects of one's perception and observation) is not fundamentally different from the class of things always assumed to lie close at hand (the subject or self that engages in perception and observation). This is the collapse of the distance between object and subject. Ōnishi Yoshinori, in his classic study *Yūgen to aware*, depicts the process that occurs in such a context:

when all of one's "ego" has been transformed into the datum of nature and when one has penetrated into the arena of *shikan*—that is, into the locus of absorption into the vision of pure tranquility—then nature and mind or object and subject will have become one and the same. At this point we should say

[68] See Tamura and Umehara, *Zettai no shinri: Tendai*, p. 277.

that all aspects of existence (German: *Sein*) seem to be directly and simulta-
neously present in a split second of time, and the individual's existence is the
same as the totality's, and the microcosm is amplified in the macrocosm. This
the unique aspect of this aesthetic experience.[69]

Ōnishi also suggests here that, as an aesthetic experience, *yūgen* recapit-
ulates and participates in the structure of *shikan* thought and meditation.

It should be apparent that poems of this sort are much more intellec-
tually sophisticated than any that had preceded them in the history of
Japanese verse. This sophistication led Teika's contemporaries to deni-
grate such poems by referring to them as "Daruma-*uta*," meaning that
they were as abstruse as the Zen of Bodhidharma, the Indian who was
reputed to have brought Zen from India to China.[70] In more recent cen-
turies some Japanese critics have also found them less than completely
palatable, either because they seemed far removed from the pure, direct
feeling communicated in poems of an earlier collection such as the
Man'yō-shū, or because they seemed too contrived for the tastes of critics
such as Saitō Mōkichi (1882–1953), for whom modern "realism" was
the single most important criterion.[71]

Poems such as this will probably continue to bear whatever oppro-
brium attaches to the labels "intellectual" and "Buddhist." Konishi and
other recent scholars have acknowledged this and gone on to research
those very aspects of the ambience within which such poems, and the
aesthetic or *yūgen*, came into being. At the same time, they have insisted
on the value of these poems as literature, that is, as poetry that is probably
unequaled in medieval Japan.

The value of such poetry is reinforced by a brief look at a verse quoted
previously, a justly famous poem by Saigyō:

Kokoro naki	Thought I was free
mi ni mo aware wa	of passions, so this melancholy
shirarekeri	comes as surprise:
shigi tatsu sawa no	a woodcock shoots up from marsh
aki no yūgure.	where autumn's twilight falls.

The poet initially presents himself as courting either pretense or self-de-
ception. Perhaps because he is a monk, he thinks of himself as having
transcended the ordinary person's vulnerability; he portrays himself as
having gone beyond any susceptibility to being moved, swayed, or
thrown into disarray by emotions, beauty, and the like. His attitude is
that of a "body without a heart" (*kokoro naki mi*), or a person free of

[69] Ōnishi, *Yūgen to aware*, p. 100. Translation mine.
[70] Konishi, "Image and Ambiguity," p. 1.
[71] Yasuda, *Uta no fukasa*, p. 64.

passions. But this pretentious posture collapses when a powerful feeling (*aware*), undoubtedly of melancholy, rises within him at the moment when, very unexpectedly, he happens to see a woodcock or a flock of woodcocks take flight (*shigi tatsu*) from the surface of a marsh (*sawa*)— a marsh that was at exactly that time being encompassed by both nightfall and autumn (*aki no yūgure*).

Many critics have pointed out that the linguistic and conceptual break (*kire*) in this poem comes, as it often does in Saigyō's verse,[72] at the end of the third line, breaking the poem into two distinct halves. This sets up a juxtaposition between the first and second parts of the poem. Moreover, this decisive break also makes for an implicit parallelism: just as the woodcock rises suddenly from the midst of the darkening marsh, so the emotion of melancholy seems suddenly to well up within the body and experience (*mi*) of the poet. One assumes that the poet has created an effective and moving parallel between an event outside himself, in nature, and one inside himself as the subject and observer.

Yet the poem is neither so static nor so simply symbolic; if it were so, it would have nothing of the *yūgen* that Saigyō's contemporaries detected in it. A much more useful approach to it is through Konishi's dictum about "tenorless symbolism," which I have suggested is fully harmonious with the mutual reciprocity of tenors and vehicles noted in the hermeneutics of the *Lotus Sūtra*. Taking this approach, the *kire*, or break, between the two halves of the poem becomes a fulcrum upon which the point of view moves in a quite remarkable way. As the poem begins, the observational point is the poet himself:

> Kokoro naki Thought I was free
> mi ni mo aware wa of passions, so this melancholy
> shirarekeri comes as surprise:

Then, at the break, the observational point switches abruptly and completely to the natural scene before the poet's eyes:

> shigi tatsu sawa no a woodcock shoots up from marsh
> aki no yūgure. where autumn's twilight falls.

The vividly depicted scene is of a bird suddenly lifting off the surface of the swamp and just as quickly becoming a mere speck before disappearing entirely into the night.[73]

This scene turns the attention of the listener or reader back again to the first half of the poem; the swamp, bird, and nightfall now become the point of view from which the poet and his experience are seen. What had

[72] Brower and Miner, *Japanese Court Poetry*, p. 295.
[73] Kubota, *Shinkokin kajin no kenkyū*, p. 161.

been the locus of the observed now becomes that of the observer, and the original subject becomes an object. The result is that the irruption of emotion that had initially seemed a disruption of the poet-priest's tranquility now comes to be viewed *sub specie naturae* or, at any rate, from the perspective of nature interpreted in Buddhist terms.[74] This makes the "disruption" like any other phenomenon of existence—it necessarily comes into being and passes away; thus, the "melancholy that comes as surprise" lasts no longer and is really no more significant than the bird that lifts off the surface of the swamp and disappears into the night.

The result is a poem in which there is a complete collapse of what Konishi calls the view of observer and observed as in a "confrontational relationship." This is not because observer and observed have now been fused into one undifferentiated entity but because the poem has disclosed the fundamental interdependence of the two. Through the mechanics and concrete language of a classical Japanese *waka*, Saigyō achieves something fundamentally in accord with Nāgārjuna's dismantlement of epistemological atomism, his demonstration that every act of seeing is one in which the seer and the seen not only depend on one another but also bring each other into being.

The "calm darkness" that Shin'ichi Hisamatsu detects in this type of art[75] is undoubtedly related to its embodiment of an awareness that ultimately even "being" is fully interdependent with what Western languages call nonbeing. The languages of China and Japan have a greater facility for expressing the mutuality and balance between what is and what is not; they are not as intrinsically tilted toward defining being as real and nonbeing as a privation. As languages they do not give the benefit to the being side of things.[76] On this point, though, maybe the language of poetry—even perhaps in translation—can communicate more immediately and directly what is essential. Certainly both the imagery and the emotional range of the poem by Saigyō encompass the two poles of all our usual dichotomies—light and darkness, life and death, being and nonbeing, joy and sadness. One always implies and elicits the other.

This is why it would be a complete misunderstanding to classify Saigyō's poem as a sad poem, even though its final lines depict autumn and twilight and imply a coming death: *Shigi tatsu sawa no / aki no yūgure* (A woodcock shoots up from marsh / where autumn's twilight falls). The tranquility that is so clearly a part of this poem contravenes any attempt to classify the poem according to conventional rubrics; the twilight and

[74] This is developed more in my "Saigyō and the Buddhist Value of Nature."

[75] Hisamatsu, *Zen and the Fine Arts*, p. 33.

[76] The most penetrating discussion of this in a Western publication is Masao Abe, "Non-Being and *Mu*: the Metaphysical Nature of Negativity in the East and West," *Religious Studies* 11 (June 1975): 181–192.

death that are present are a twilight and death that refuse to be bound by
our customary ways of understanding and reacting to them. Thus, even
in the emotions engendered by a poem expressive of *yūgen*, there is an
indeterminacy.

It is no wonder that poets such as Shunzei maintained that in such po-
ems there was a "surplus of emotion" (*yojō*). I think they meant by this
that the poem's world was somehow larger than its words. This was so
because the poems were composed in a manner that rejected any real sat-
isfaction with the conventional linkages between phenomena and emo-
tions. Just as being implies nonbeing, so an image that had conventionally
been associated with sadness must be made to imply its opposite as well.
So, too—beginning with this poetry but extending into Nō drama and at
least as far as the *haiku* of Bashō—certain sounds were evocative of si-
lence and certain motions brought stillness in their wake. The world of
such poetry and such drama was one in which determinate emotions or
ideas were no longer fixed to determinate images or actions. Simple sym-
bols no longer seemed adequate; their portrait was deemed naive because
it had too severely limited the relationship among phenomena. The Bud-
dhists of medieval Japan, nurtured as they were in Tendai, held that the
universe was such that even "in one thought there are three thousand
worlds" (*ichinen sanzen*). This implied the boundlessness of the interpen-
etration of phenomena with one another. To the dimension of depth in
the universe itself these Buddhists reacted with a sense of awe (*myō*). And,
to poets such as Shunzei, a universe of this depth deserved a degree and a
mode of appreciation beyond that given it by the traditional aesthetic;
something new and more adequate was needed. The arts of *yūgen* were
their response.

Two

Nature, Courtly Imagery, and Sacred Meaning in the *Ippen Hijiri-e*

LAURA S. KAUFMAN

DURING the latter part of the Kamakura period (1185–1333), the art of narrative handscroll painting reached a high point in richness and elaboration. One work of great pictorial and thematic complexity that was produced in this era is the *Ippen Hijiri-e*, a biography of Ippen (1239–1289), a Japanese teacher of Pure Land Buddhism. An unusual feature of its paintings is the care that was lavished upon the settings, both architectural and landscape. The varied, panoramic settings, along with the many incidental figures they contain, impart considerable charm and vitality to this pictorial biography.[1]

The *Ippen Hijiri-e* was executed in 1299, only ten years after the death of Ippen. Because it is the oldest extant biography of Ippen, scholars have long recognized it as a key document concerning his career and the early days of the group he founded, the Jishū. The text not only describes Ippen's activities; it also contains explanations of his teachings and practices, and it quotes his Chinese hymns and Japanese poems. The illustrations, too, convey precious information about Ippen's methods of preaching and about the formative stages of the Jishū.[2] Their uniquely detailed, elaborate backgrounds also have an air of authority, and they have been studied as evidence for daily life and material culture in Kamakura times.[3]

No less fundamental, however, is the question of what function was served by incorporating these lengthy portrayals of architecture and land-

[1] Both text and illustrations of the *Ippen Hijiri-e* are reproduced in entirety in Tanaka Ichimatsu, gen. ed., *Nihon emakimono zenshū*, vol. 10: *Ippen Hijiri-e*, ed. Miya Tsugio (Tokyo: Kadokawa Shoten, 1960); also reprinted as *(Shinshū) Nihon emakimono zenshū* 11 (1975). Subsequent references to the Nihon emakimono zenshū series cite the original edition, abbreviating the title as NEZ. For complete full-color reproduction of both text and illustrations, see Komatsu Shigemi, ed., *Ippen Shōnin eden*, Nihon emaki taisei, supplementary volume (Tokyo: Chuo Koronsha, 1978).

[2] Gorai Shigeru, for example, has made good use of the *Ippen Hijiri-e* as a pictorial religious document in his essay, "Ippen to Kōya Kumano oyobi odori nembutsu," NEZ 10, *Ippen Hijiri-e*, pp. 16–37.

[3] See, for example, Shibusawa Keizō, ed., *(Emakimono ni yoru) Nihon jōmin seikatsu ebiki* 2, NEZ supplemental vol. 17 (Tokyo: Kadokawa Shoten, 1965).

scape into a Buddhist biography. Were they provided only to set a convincing stage for action and to enhance pictorial interest? Or were they planned to contribute meaningfully to the process of recording and commemorating Ippen's achievements? In addressing this issue, it is helpful to examine the settings in light of the literary and pictorial traditions on which they are based. Since these traditions prove overwhelmingly to belong to the courtly arts that were practiced by the aristocrats of the Heian period (794–1185), this inquiry will lead into realms far afield from those usually explored by Jishū historians. Yet, as will be seen by clarifying the place of the *Ippen Hijiri-e* in the Japanese cultural tradition, insights emerge concerning its character as a biographical record of Ippen's life and deeds. I shall begin with a consideration of a single scene.

Ippen in His World: The Shaka-dō Scene

The scene of Ippen preaching at the Shaka-dō in Kyoto in 1284 (scroll VII, section 2), one of the most renowned illustrations of the *Ippen Hijiri-e*, demonstrates the dilemma presented by the extraordinary complexity of the settings. The episode portrays a turning point in Ippen's career. Earlier sections describe his years of Buddhist study under followers of Shōkū Shōnin (1177–1247), founder of the Seizan branch of the Jōdo sect, his solitary retreats, and then his first attempts to preach. Modeling himself upon the example of the mendicant Amida *hijiri* (holy men), in 1274 Ippen became a homeless wanderer. His goal was to bring the succor of faith in Amida Buddha to as many people as possible and to encourage recitation of the Nembutsu ("Namu Amida Butsu," the invocation of the name of Amida). At first Ippen often met with indifference, even scorn, but he slowly refined his teaching methods, as he gathered around him a band of fellow mendicants who he called the Jishū, or Ji confraternity. By the time of his arrival in Kyoto in 1284, Ippen's reputation had been established, and he met with an enthusiastic response from the residents of the capital. Of the seven-day service at the Shaka-dō at Shijō Kyōgoku, the text states: "Rich and poor, high and low flocked to see him. The people had no space to turn around and look; their carriages were unable to turn about."[4]

The illustration (fig. 1) opens at the right with the approach to the temple from the east, across the busy Shijō Bridge. It is late spring; water birds are rising in the mist above the distant Kamo River flats. In the foreground, men are washing a horse in the shallows. Beyond the great *torii* of the Gion shrine is the Shaka-dō. The street in front of the temple is full of people; most are ordinary folk who have arrived on foot. Much

[4] For the Japanese text, see NEZ 10, *Ippen Hijiri-e*, pl. 43 and p. 72.

confusion is caused by restless horses left outside the temple gate by samurai, and by the nobility who, unwilling to forgo the privacy of their ox carts, are having their vehicles pulled into the temple compound. The courtyard of the Shaka-dō is densely packed with people and carriages. In a makeshift plank-roofed shelter, the monks and nuns of the Ji confraternity, barely visible in the crowd, are performing the *odori* Nembutsu (dancing Nembutsu), the most sensational of Ippen's proselytizing devices. Ippen is just to the right of the dancing Nembutsu hut, raised up on the shoulders of a husky young monk (fig. 2). Eager hands reach out to receive from Ippen slips of paper inscribed with the Nembutsu invocation. To the left of the Shaka-dō, the painting carries the viewer on past the avenue, Higashi Kyōgoku (today's Teramachi), ending with a lengthy view of mist-enshrouded rooftops.

One can find a justification for every aspect of this painting: the swarming crowd illustrates the triumph of Ippen's public acceptance; the spacious landscape provides a foil for the crowding and excitement at the Shaka-dō. Nonetheless, there is no other extant Buddhist biographical handscroll (*kōsōden emaki*) that contains a preaching scene conceived on a scale comparable to this grand sweep of a city neighborhood. In the original scroll (if not in reproduction), Ippen is clearly recognizable by his distinctive tanned, haggard features and by his strategic placement at the painting's climax. Yet by adopting the scale of an extensive panorama, the artist, of necessity, sacrificed one device that is the stock-in-trade of priests' biographies—a didactic emphasis upon the protagonist. In a painting fifteen inches high and some eighty-six inches long, Ippen occupies approximately one-and-a-half square inches; and he is presented along with 234 other figures. No wonder, then, that some writers have suggested that this painter found buildings, landscapes, and crowds more fascinating than Ippen the holy man.

Although Ippen's presence is not a dominating one, it does have positive qualities, for this is an unusually affectionate characterization of a holy person. In the midst of a sea of people, Ippen is one frail man, his ordinariness underscored by the homely gesture of being carried about on someone's shoulders. In depicting Ippen's features, the artist treads a thin line between idealism and realism: Ippen's buck teeth and oddly shaped head (recorded as well in literary sources) are portrayed, but not so graphically as to render him ugly.

The Creation of the Ippen Scrolls

The humanity of the view of Ippen that is embodied in the Shaka-dō scene and the other paintings of the *Ippen Hijiri-e* seems to have its basis in the circumstances of the work. The twelve-scroll set, which consists in all of

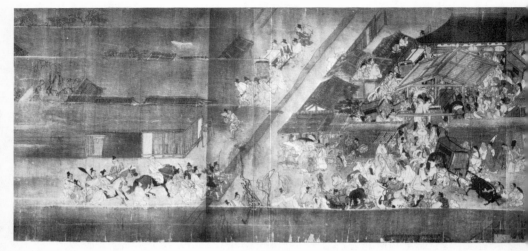

1. Ippen preaches at the Shaka-dō. *Ippen Hijiri-e* scroll VII, section 2.

forty-eight sections of text and illustration, was made for Kankikōji, the temple in Kyoto that owns it today.[5] The date of dedication was the twenty-third day of the eighth month of Shōan 1 (1299), precisely on the tenth anniversary of Ippen's death. Thus, the scrolls were made by Ippen's contemporaries.

We do not know all we would wish about the people who sponsored and produced the *Ippen Hijiri-e*. The patron's name was deliberately omitted from the dedicatory inscription.[6] The inscription names as the calligrapher of the scrolls' titles "Lord Tsunetada of the third rank," who was a member of the noted Sesonji lineage of court calligraphers. It ascribes the paintings to "Hōgen En'i." The only En'i known from contemporaneous records was not a painter, however, but a high-ranking Tendai priest of Onjōji who participated in religious services at court and was a successful *waka* poet. Scholarly opinion is divided today as to whether "Onjōji En'i" is identifiable with the En'i named in the scrolls.[7]

We are on firmer ground, however, with the person who composed the text and who was the likely instigator of the project. He was Shōkai (1261–1323), founder of Kankikōji and Ippen's relative, perhaps his half-

[5] In 1986, half-ownership of the *Ippen Hijiri-e* passed to Shōjōkōji in Fujisawa, Kanagawa Prefecture, which is the headquarters of the main branch of the Ji sect. For safekeeping, the scrolls are deposited in museums, being divided among the Kyoto and Nara National Museums. All four paintings and one text section of scroll seven, which were separated from the set in the midnineteenth century, are owned by the Tokyo National Museum.

[6] For the inscription in Japanese, see NEZ 10, *Ippen Hijiri-e*, pl. 63 and p. 82.

[7] The issue of the identities of the patron and the painter is discussed further below.

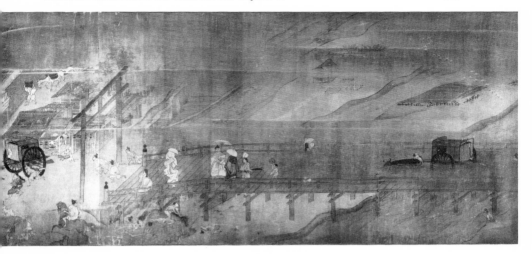

brother. Shōkai knew Ippen intimately. He records his own presence in
three early episodes of the biography and in four episodes during Ippen's
final illness. These accounts of Shōkai with Ippen "first and last" suggest
that one of Shōkai's motives for making the *Ippen Hijiri-e* was to docu-
ment the primacy of his discipleship under Ippen. Shōkai apparently did
not see Ippen frequently after 1274, however, suggesting that he may not
even have been a formal member of the Ji confraternity. Ippen named as
his successor to head the Ji confraternity his student, Taamidabutsu; it
was he, not Shōkai, who began the transformation of Ippen's homeless Ji
confraternity into a stable group that could be perpetuated (and that
would eventually be regarded as a distinct sect of Pure Land Buddhism,
the Ji sect).[8] Thus, Shōkai had little reason to encourage people to see
Ippen as a patriarch. He probably perceived Ippen, much as Ippen per-
ceived himself, as a *hijiri*, a wandering holy man—a great one, perhaps,
but not a sect founder.[9]

[8] Sometime between 1304 and 1307, another illustrated biography of Ippen—actually a
joint biography of Ippen and Taamidabutsu—emerged from within Taamidabutsu's circle.
Usually called the *Ippen Shōnin ekotoba den* or the *Yūgyō Shōnin engi-e*, it was executed in
ten scrolls with its text written by the priest Sōshun. The differences between this work and
the *Ippen Hijiri-e* are significant. The *Ippen Shōnin ekotoba den* forcefully characterizes
Ippen as a first patriarch (and Taa as second). It also places precisely the sort of didactic
emphasis upon Ippen that is absent in the *Ippen Hijiri-e*; some copies even unnaturally
exaggerate Ippen's distinctiveness from other people. Numerous copies were made of Sō-
shun's version (the original of which is now lost), indicating that it served as the canonical
biography for the main branch of the Jishū. See NEZ 23, *Yūgyō Shōnin engi-e*.

[9] For *hijiri* and their role in propagating Amidism among the folk, see Ichiro Hori, "On

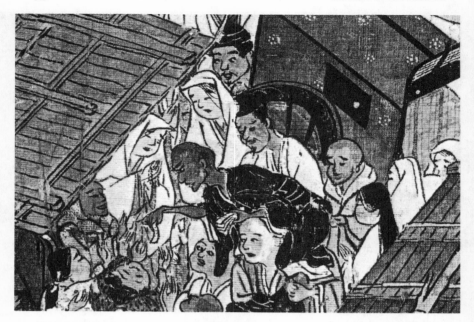

2. Ippen distributing Nembutsu cards at the Shaka-dō. Detail of *Ippen Hijiri-e*, Scroll VII, section 2.

Landscape and Poetry

Shōkai's nostalgia for his youth spent at Ippen's side and his sense of personal loss at Ippen's death are reflected most clearly in the episode of Ippen's departure from his family home in Iyo Province in the spring of 1274 (scroll II, section 2). Having decided to abandon home life, Ippen began at this time his unceasing journey of Nembutsu proselytizing. Here is Shōkai's account of the leavetaking:

On the eighth day of the second month of Bun'ei 11 [1274], Ippen departed from Iyo accompanied by three fellow pilgrims. . . . I escorted him for five or six days, but at Sakurai in Iyo Province I bade him farewell. As we pledged to be reborn in the dawning of the same unfolding lotus [in the Pure Land], I would at least see him again on the eve of death. It was no different long ago, when Ch'en Chung and Lei I [Han officials famed as friends] cemented a bond of close friendship and it held to the end. In our case, we vowed to be teacher and student in this life and in the future—how could this cherished wish be in

the Concept of Hijiri (Holy-man)," *Numen* 5 (1958): 128–160, 199–232. On Ippen as a *hijiri*, see James Harlan Foard, "Ippen Shōnin and Popular Buddhism in Kamakura Japan," Ph.D. dissertation, Stanford University, 1977, pp. 194–212.

vain? Saying that we would surely be reunited at death, he wrote Amida's name for me and granted me the Ten Repetitions. Although we awaited our reunion under the moon of the Western Land, it was hard to endure the sorrow of parting in this world of floating clouds. Checking our tears of grief, we separated to the east and west.[10]

The accompanying illustration depicts each step of the narrative—the departure from home, the ceremony of the Ten Repetitions of Amida's name, and the final parting of ways. Reproduced here is the last segment, showing the events at Sakurai (fig. 3). Ippen and his traveling companions continue on their way, as Shōkai, looking over his shoulder wistfully, turns toward home. The setting is a landscape of verdant spring fields, typical of the gracious natural views of the *Ippen Hijiri-e*. It contains one motif that offers a key to understanding the function of these landscapes—the large cherry tree full of luxuriant blossoms located immediately above Ippen. The flowers have passed the peak of bloom; white mounds of fallen petals lie beneath the tree. Because it remains on the bough so briefly, the cherry flower has long symbolized the fragility of youth and beauty in Japanese poetic tradition. In this painting, the cherry is, first, a visual play on the place name Sakurai (Cherry Tree Well). But it also signifies the passing of the spring of the lives of Ippen and Shōkai and the poignancy of their separation. Thus, it communicates to the viewer, as surely as do the postures of the figures, the emotional significance of the events at Sakurai.

The use of a natural motif to echo the sentiments of the protagonists derives, as does the motif itself, from the native poetic tradition. This tradition compressed mood and emotion into the *waka*, a brief poetic form of thirty-one syllables, by making the imagery of nature, especially seasonal imagery, allude to human feelings and situations. The absorption of this poetic imagery into the visual arts began early in the Heian period. Literary and visual documents of Heian and Kamakura times record the widespread practice of adorning domestic interiors with pictorial cycles whose typical subjects—activities of the twelve months (*tsukinami-e*) or four seasons (*shiki-e*), and views of famous places (*meisho-e*)—mirrored the favored subjects of poetry.[11] Today the poem screens and other forms of poetic illustration have all but vanished, but their heritage is reflected in the prominence of seasonal motifs in many narrative hand-

[10] For the Japanese text, see NEZ 10, *Ippen Hijiri-e*, pl. 27 and p. 68. The passage quoted here is typical of the prose language of the *Ippen Hijiri-e*. The parallel construction of prose and allusions to Chinese legend are enriching devices that also occur widely in thirteenth-century prose literature; they reveal an effort on Shōkai's part to endow his text with an elevated literary tone.

[11] The literary evidence for poem screens is compiled in Ienaga Saburō, *Jōdai Yamato-e nempyō*, rev. ed. (Tokyo, Bokusui Shobo, 1966).

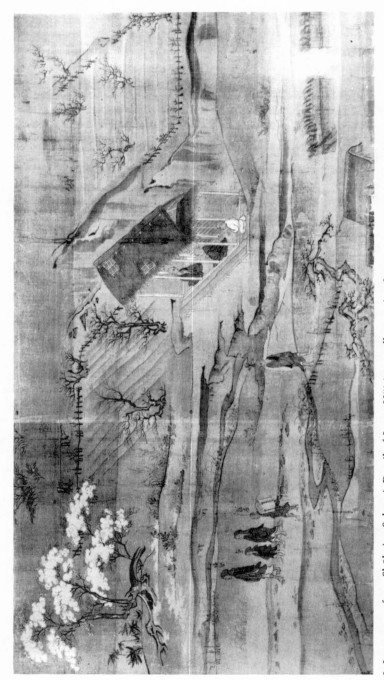

3. Ippen parts from Shōkai at Sakurai. Detail of *Ippen Hijiri-e*, scroll II, section 2.

scroll paintings of the twelfth through fourteenth centuries. In these *emaki* it is not difficult to find instances where, like the cherry tree of Sakurai, seasonal imagery provides emotional overtones that complement the narrative. But the *Ippen Hijiri-e* is outstanding for employing the device with astonishing complexity, even to the point of supporting a remarkably subtle characterization of the protagonist.

The text records, for example, the story of Ippen's preaching in the winter of 1279 at the house of a pious samurai of Shinano Province named Ōi no Tarō (scroll v, section 1). The samurai's sister had a dream of Buddhas circumambulating their house:

> When she saw that the one among them who was tallest was Ippen Shōnin, she was astonished and called in a divination master. "Is what I just saw auspicious or inauspicious?" she asked. The divination master pronounced it auspicious and joyful. At that time, she generated religious aspiration. She invited Ippen and said the Nembutsu with the service that continued for three days and three nights. At the conclusion of the service Ippen departed. Since several hundred people had danced round and round, they had trodden down and broken the floor boards. But when people said, "You had better repair them," the sister replied, "These will be keepsakes of Ippen the holy man. I won't repair them," and she left them as they were. . . . After this, she practiced only the Nembutsu and in the end attained birth in the Pure Land.[12]

The painting opens with Ippen and the Ji confraternity walking from left to right across barren fields (fig. 4). Above their heads is another "flock"—wild geese traveling in the opposite direction. Subsequently, Ōi no Tarō's house appears, set before snowy mountains. Amidst a scattering of broken floor boards, the whole household sees Ippen off.

In poetry the image of migrating geese expressed longing for a loved one who has gone away, even for one who has died. The geese present an ironic contrast, because they will return in the natural course of events, whereas the beloved one will not. So the geese flying toward the house of Ōi no Tarō and his sister suggest their hopeless desire for Ippen's return. Skillful use of compositional devices enhances this meaning. The passage of the birds from right to left is consistent with and reinforces the innate flow of the handscroll. But, as rarely happens in these illustrations, Ippen walks against that current. It tugs against him, as though something were pulling him back to the house. One can imagine many other, more obvious, ways to pictorialize this tale of a divine dream and a well-attended Nembutsu service. But with the help of a natural image, the most personal aspect of the story emerges—the ties of devotion that link Ippen and his followers.

[12] For the Japanese text, see NEZ 10, *Ippen Hijiri-e*, pl. 35 and p. 69.

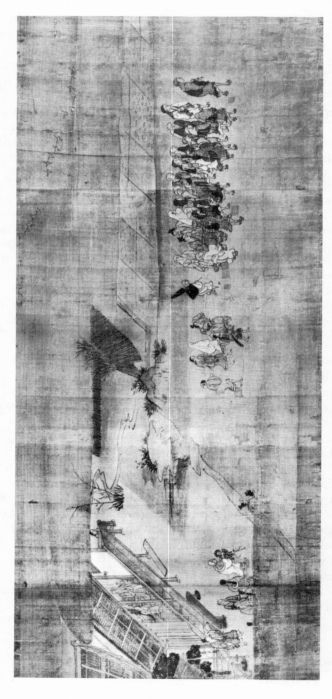

4. Ippen departs from the house of Ōi no Tarō. *Ippen Hijiri-e*, scroll v, section 1.

Ippen as Poet

In the episode of Ōi no Tarō's sister, Shōkai's text itself is hardly poetic. Elsewhere, however, both the content and the tenor of the text directly support the painter's excursions into poetic realms. Numerous sections of the text actually cite poems, including some sixty *waka*. Among these are forty-seven by Ippen himself. Ippen's verses often employ the natural images that so pervade the Japanese poetic tradition, yet few are truly lyrical. They are all strongly Buddhist in content, most often carrying a straightforward religious message. Ippen's *waka* fall into two main categories: those composed as offerings at temples or shrines and those addressed to people he met. Both types reflect the status of poetry in Japan as sacred utterance—a status that made it a potent vehicle for communicating with deity and for expressing one's spiritual realization to others.[13] In some episodes Ippen responds with a *waka* to a request for spiritual assistance that is also couched in verse. These poetic exchanges typically occur with people of high social status, for whom versifying was an integral part of social life.[14]

One illustration that is strongly indebted to the poetic elements in the text shows Ippen at Shirakawa Barrier (scroll v, section 3). Ippen passed through Shirakawa, the gateway between "civilized" Japan and the wild north country, while on his way to visit the grave of his grandfather Kōno Michinobu (1156–1223), the great warrior of Shikoku who died in exile in the north. According to the text:

> When Ippen was approaching Shirakawa Barrier, he fastened this poem to the pillar of the sanctuary of the barrier deity:
>
Yukuhito wo	So that travelers
> | Mida no chikai ni | will not be excluded |
> | morasaji to | from Amida's vow |
> | na wo koso tomure | I affix his name |
> | Shirakawa no seki. | at Shirakawa Barrier.[15] |

[13] On poetry as sacred ritual activity, see Gary L. Ebersole, "The Buddhist Ritual Use of Linked Poetry in Medieval Japan," *Eastern Buddhist*, n.s. 16, 2 (Autumn 1983): 50–71.

[14] One exchange of *waka* that is worthy of special note took place at Karube in Bitchū Province in 1287 at the deathbed of someone named Hananomoto Kyōgan. The name Hananomoto (literally, "under the flowers") refers to the practice of conducting *renga*, or linked verse, sessions under blossoming cherry trees and reveals that Kyōgan was a *renga* poet. This is the only evidence in the *Ippen Hijiri-e* that Ippen had contact with the world of *renga* poetry, although the Jishū contribution to *renga* and to other aspects of popular culture in later generations is well documented. The early history of *renga* is difficult to trace; in the thirteenth century it seems to have been connected with the making of sacred offerings; see ibid., pp. 56–66.

[15] For the Japanese text, see NEZ 10, *Ippen Hijiri-e*, pl. 36 and p. 69.

The illustration (fig. 5) narrates Ippen's deed faithfully. Beyond the rustic barrier house, he kneels respectfully before a tiny shrine to whose facade a slip of paper is attached. But no physical gesture could convey that poetry is Ippen's mode of communication. It is the landscape that evokes the heightened intensity of poetic inspiration. Dancing mountain forms and bright-hued autumn foliage create a bouyant mood suggestive of Ippen's exhilaration at reaching this remote outpost.

The text cites no season. But Shirakawa Barrier was an *utamakura*—a place famous in poetry—and poetic tradition associated it with autumn. One influential Shirakawa Barrier poem was written by Nōin Shōnin (988–1050), a poet-priest who did much to promote the tradition of *utamakura*:

Miyako oba	I set out
kasumi to tomo ni	from the capital
tachi shikado	together with the mist.
Akikaze zo fuku	But now the autumn wind blows
Shirakawa no seki.	through Shirakawa Barrier.[16]

Subsequently, Shirakawa Barrier was celebrated by the great poet Saigyō Hōshi (1118–1190), who recalled Nōin's poem while lodging at Shirakawa on a moonlit night (the moon being conventionally associated with autumn) and inscribed a verse upon a pillar of the barrier house:

Shirakawa no	Shirakawa Barrier house
sekiya wo tsuki no	guarded by the moon—
moru kage wa	its light leaking in
hito no kokoro wo	holds captive
tomuru narikeri.	the human heart.[17]

Ippen's Shirakawa poem reflects familiarity with this verse by Saigyō, for it uses the classical poetic technique of *honkadori*, or allusive variation, to borrow elements of the basic situation and some words (the verbs *moru*, to escape, and *tomuru*, to hold back) from the older poem. But, as is characteristic of allusive variation, Ippen's poem, with its strongly Amidist content, has an entirely new meaning. Saigyō's act of writing the poem upon the barrier house pillar also provided a model for Ippen leaving his verse at the tutelary shrine—again a more overtly pious gesture.

The allusion contained in Ippen's poem was not lost on the painter. Although in all other respects the episode is depicted as occurring in broad daylight, a tiny full moon (inconspicuous in black-and-white illus-

[16] *Goshūishū*, vol. 9; cited in Watanabe Tamotsu, *Saigyō Sanka-shū zenchūkai* (Tokyo: Kazama Shobo, 1971), p. 633.

[17] *Sanka-shū*, poem no. 1213, ibid.

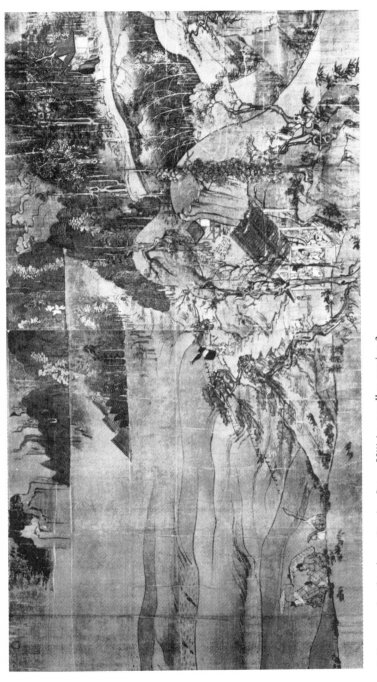

5. Ippen at the Shirakawa Barrier. *Ippen Hijiri-e*, scroll v, section 3.

tration) hangs in the sky beyond the far mountains to the left. But it is Saigyō's poem that mentions the moon, not Ippen's. The painting thus illustrates Ippen's act of dedicating a poem and also contains the major elements of Saigyō's verse from which it derives—the autumn moon and the barrier house.

Saigyō was the greatest *waka* poet to assume the persona of a wandering priest; the romance of his life of "poetic pilgrimage" fired the imagination of generations of literate Japanese.[18] Throughout the centuries, many authors of travel diaries have acknowledged Saigyō as their model, beginning with Lady Nijō. A contemporary of Ippen and Shōkai, Lady Nijō (b. 1258) recorded her life between the years 1271 and 1306 in a work called the *Towazugatari*. (literally, A tale unsought for; although this title may well have been supplied by someone other than the author)[19] The handling of Ippen's journey through the far north strongly suggests that Ippen's biographers were also eager to establish a parallel between Saigyō and their protagonist.

We in later times have been conditioned by the simplifying judgments of history to see Ippen and Saigyō very differently, regarding one as a patriarch of a Buddhist sect and the other as a great court poet. In the late thirteenth century, however, their differences were surely not perceived so sharply. People would have recalled more readily that Saigyō and Ippen alike were *hijiri*—renunciants of both the householder's life and the monastic world, whose activity revolved around the disciplines of travel and pilgrimage, and who, like many other wandering holy men, wrote poems in the course of their journeys.[20] It must be noted, too, that by Ippen's time, Buddhism and poetry had been identified with one another to an extent hardly imaginable to modern minds. Ippen's poetic sensibility would have been seen not merely as a colorful sidelight of his personality, but as a natural concommitant of his spiritual attainment.

[18] For the traditional view of Saigyō as having achieved realization on the "way" of poetry, see William R. LaFleur, "The Death and 'Lives' of the Poet-Monk Saigyō: The Genesis of a Buddhist Sacred Biography," in *The Biographical Process: Studies in the History and Psychology of Religion*, ed. Frank E. Reynolds and Donald Capps (The Hague: Mouton, 1976), pp. 343–361.

[19] Available in English as *The Confessions of Lady Nijō*, trans. Karen Brazell (New York: Doubleday Anchor, 1973); see especially p. 52.

[20] For a discussion of the practice of poetry by mendicant holy men, see Ebersole, "Buddhist Ritual Use of Linked Poetry." Herbert Plutschow offers pertinent comments on the relationship between poetry and travel undertaken as a religious exercise in Herbert Plutschow and Hideichi Fukuda, trans., *Four Japanese Travel Diaries of the Middle Ages*, Cornell University East Asia Papers no. 25 (Ithaca: Cornell China-Japan Program, 1981), pp. 17–21.

Ippen as Religious Traveler

The parallel with Saigyō established in the Shirakawa Barrier episode highlights another facet of Ippen's career that his contemporaries would probably have found attractive in any case—his life of wandering. Throughout their history the Japanese have keenly appreciated travel as an opportunity to experience the profundity and beauty of life. In a Buddhist context, travel offers a natural metaphor for the spiritual path. Travel was often undertaken as a religious exercise; Ippen's forswearing of any home base for fifteen years was an extreme expression of this practice.

Moreover, the travel theme pervades Japanese literature. Since the *Man'yō-shū* was compiled in the eighth century, travel—real or fictive—provided the predominantly city-dwelling court poets with fruitful occasions for versifying. A journey to almost anywhere in Japan could acquire the dimensions of a poetic outing for someone familiar with the names of the many *meisho* (places renowned for beauty or historic associations) and *utamakura* (places celebrated in poetry). The high value ascribed to travel is also reflected in prose. The travel diary (*kikō*) is a distinctive genre of Japanese literature; it attained great prominence in the Kamakura period, when many people journeyed between Kyoto and the military capital at Kamakura in Kantō. The same era saw the emergence, in such works as war tales, of the *michiyuki*, a brief passage of densely textured, lyrical prose that describes a journey. In many texts of this time, it is difficult to separate completely the literary and Buddhist implications of an account of a journey.[21] Travel and the experience of nature that it affords were inextricably entwined in the web of associations that stretched between Buddhism and poetry.

In the thirteenth century, travel was an arduous undertaking, fraught with the hazards of poor roads and uncertain accommodations. Ippen's life on the road must have been especially harsh, for he depended for sustenance and shelter entirely upon the generosity of those he chanced to meet. Occasionally, Shōkai describes situations in which Ippen is exposed to inclement weather or goes without food, warm clothing, or lodging. One painting depicts such a situation; Ippen and the Ji confraternity are shown sitting wearily by the roadside after their expulsion from Kamakura by the military authorities in 1284.[22] But this glimpse of the hard

[21] Plutschow ennumerates some of the religious purposes that motivated writers of medieval travel diaries; see ibid., pp. 12–18.

[22] See scroll v, section 5; NEZ 10, *Ippen Hijiri-e*, pl. 93.

realities is atypical and is overshadowed by the more positive view of Ippen's travels that characterizes the illustrations overall.

Beginning with the first painting, which opens with Ippen departing from his father's house in 1251 to seek Buddhist training, fully a quarter of the cycle's forty-eight paintings contain vignettes depicting Ippen setting out, going along his way, or arriving somewhere. The leavetaking at Sakurai and the departure from Ōi no Tarō's house (figs. 3 and 4) typify these graceful travel scenes, which are often set on country roads, along mountain paths, or near the beach and sea. Over and over, we observe Ippen walking through lovely natural surroundings with his head uplifted. Instinctively we assume that his lifelong journey was one of fresh discoveries and intensely felt inner experience.

The text contains a few passages describing Ippen's travels that may be regarded as the literary correlates of the pictorial travel vignettes. An example is the account of Ippen's journey to Kumano (scroll III, section 1):

> In the summer of Bun'ei 11 [1274], Ippen left Mount Kōya and made a pilgrimage to Kumano. Crossing mountains and seas over the thousandfold cloud-ways, he dipped the sleeves of his robe in the current of the Iwada River. Worshipping at the many Ōji shrines along the route, he opened the fastness of his heart by the water's edge near the Gate of First Aspiration. At the densely overgrown shrines of Fujishiro and Iwashiro, the dew of the manifest traces sparkled like jewels; at the altars of Hongū and Shingū, the moon of subdued brilliance hung like a mirror. Here the waves of the powerful waters of Yin add their sound to the rivers that reflect the shadows of ancient oaks and aged pines, while the clouds of Mount Wu transfer their colors to the mountains ornamented with gem-like summer rain.[23]

With their parallel prose, their poetic use of natural images, and their references to specific famous places, Shōkai's travel passages have all the hallmarks of *michiyuki*. Like the landscapes of the paintings, they express the travel theme in lyrical terms. Interestingly, aside from citing some poems that contain natural images, the text never ascribes to Ippen himself any commentary about nature or suggests that he especially valued the experience of wandering through the Japanese countryside. Instead, the text reveals that Ippen adopted mendicancy in order to reach large numbers of people and to become an egoless instrument of Amida Buddha's intentions. The use of natural imagery in the *Ippen Hijiri-e* as a means to enhance the themes of poetry and travel reflects larger cultural values, rather than an emphasis by Ippen himself upon nature's spiritual or aesthetic qualities.[24]

[23] For the Japanese text, see ibid., pls. 28–29 and p. 66.

[24] This is not to say that Ippen rejected the view, widely held in medieval Japan, that the

Pilgrimage and the Depiction of Sacred Places

In contrast, at numerous points in the text, Ippen is made to express the liveliest interest in another facet of travel: pilgrimage to holy places. Though Ippen sometimes moved virtually at random, often he set out to visit some hallowed pilgrimage site, preaching to people he met along the way. By 1284, his fame was sufficiently widespread that ecclesiastic authorities usually permitted him to hold Nembutsu services on the grounds of these holy places. In this fashion, Ippen managed to visit many of the pilgrimage sites that flourished throughout Japan in the Kamakura period.

As Ippen did not differentiate between the sanctity of the Buddhas and that of Shinto gods, he worshipped at temples and shrines alike. He visited the great centers of popular Amidist faith, including Zenkōji, Shitennōji, Mount Kōya, and the shrines of Kumano, as well as various places associated with such early Nembutsu proselytizers as Kūya Shōnin (whom he emulated above all others), Kyōshin Shami, and Shōkū Shōnin. Shōkai records that Ippen experienced the deepest emotion at these places. At Enkyōji, hallowed to the memory of Shōkū Shōnin, for example, Ippen burst into tears, declaring, "My only goal in traveling through the various provinces has been a pilgrimage to this temple."[25] The notion of Ippen as a fervent pilgrim is further supported in the text by an enthusiastic recounting of the good qualities of the places Ippen visits. Over and over Shōkai digresses from the biographical narrative to report on the history, legends, and miraculous virtues of these sites. These passages are strongly reminiscent of *engi*, tales of the origins of holy places. These *engi*-like passages are surprisingly lengthy; some are documented with quotations from temple records and other sources.[26]

natural world and the truth of the Buddhist teachings were identical. In a letter to Kōgan Sōzu discussing the nonduality of the Nembutsu, Ippen asserted: "Everything that is alive, the mountains and rivers, the grasses and trees, even the sound of the blowing wind and billowing waves—there is nothing that is not the Nembutsu. It is not people alone who share the World-Supreme Vow [of Amida]"; "Ippen Shōnin goroku," in *Hōnen, Ippen,* comp. Ōhashi Shunnō, *Nihon shisō taikei* 10 (Tokyo: Iwanami Shoten, 1971), pp. 305–306. Nonetheless, comments using imagery of this sort are extremely rare among Ippen's recorded words. Seemingly, Ippen stands apart from those Buddhists, Saigyō among them, for whom the relationship between enlightened mind and the forms of nature was an issue of considerable interest. For a discussion of Ippen's understanding of the Nembutsu and for an English translation of the *Ippen Shōnin goroku,* see Dennis Hirota, trans., *No Abode: The Record of Ippen* (Kyoto: Ryukoku University Translation Center, 1986).

[25] Scroll IX, section 4; for the Japanese text, see NEZ 10, *Ippen Hijiri-e,* pl. 52 and p. 77.

[26] See, for example, the accounts of Iwaya (scroll II, section 1) and of Shitennōji (scroll II, section 3); in Japanese, see NEZ 10, *Ippen Hijiri-e,* pls. 25–57 and pp. 65–66; in English translation, see Laura S. Kaufman, "*Ippen Hijiri-e*: Artistic and Literary Sources in a Bud-

In turn, the illustrations portray Ippen visiting many holy places—ten Shinto shrines and sixteen Buddhist temples and pilgrimage places altogether. The paintings may show Ippen engaged in prayer, watching sacred dances, or visiting with local priests; sometimes he performs the duties of a teacher, delivering sermons, distributing Nembutsu cards, or performing the dancing Nembutsu. Whatever the deed portrayed, the theme of pilgrimage is reinforced by careful rendering of the specific appearance of the place. Often the paintings depict not only the distinctive features of the buildings' layout and construction style, but also the topographical relationship between the structures and their surroundings; thus, in many sections, landscapes and architectural delineation are skillfully combined.

Although the sites depicted are widely scattered across Japan, few of these shrine-and-temple views appear to be arbitrary inventions of the painter. In most cases, physical, written, or pictorial evidence can still attest to at least some degree of architectural or topographical accuracy.[27]

It seems that this impressive fidelity was achieved by relying upon various types of information. Undoubtedly some representations were based upon the artist's firsthand knowledge of a place. The Shaka-dō scene (fig. 1) must belong in this category, for it contains a wealth of accurate incidental information—the placement of the Gion Shrine's outer *torii* on the west bank of the Kamo River, for example.

Other sections are quite different in character, incorporating a vastly greater amount of architectural detail. In the view of the Iwashimizu Hachimangū (scroll IX, section 1; fig. 6), a shrine in the Kyoto vicinity, one may count the ridgepoles of more than forty buildings, all densely disposed within a precise layout. Even after studying the shrine at leisure, a painter would find it difficult to organize such an intricate design in a handscroll only fifteen inches high. Virtually the same plan, with the same steep angle of recession, is found, however, in an *Iwashimizu Hachimangū mandara* in hanging-scroll form, probably of the fourteenth century, in the Ōkura Shūkokan in Tokyo.[28] Though it postdates the *Ippen Hijiri-e*, its existence suggests that the latter was probably modeled upon a *mandara* with the same design.

In other instances, where layout and building design are accurate but the composition is simpler, it seems possible that less sophisticated drawings, akin to maps or charts, were consulted. Even travelers' verbal descriptions may have provided information, which would explain why some views are accurate in certain respects but flawed in the overall relationship of parts.

dhist Handscroll Painting of Thirteenth-Century Japan," Ph.D. dissertation, New York University, 1980, pp. 330–336.

[27] For a review of this evidence, see Kaufman, "Ippen Hijiri-e," pp. 23–124.

[28] Illustrated in Haruki Kageyama, *The Arts of Shinto*, trans. Christine Guth, Arts of Japan (New York and Tokyo: Weatherhill/Shibundo, 1973), 4:86.

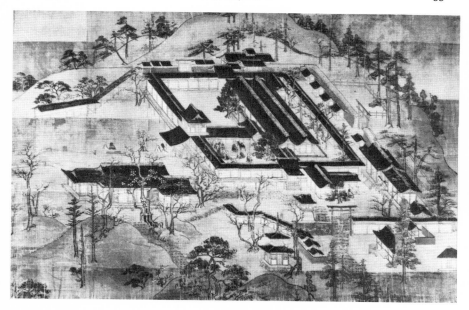

6. Ippen visits the Iwashimizu Hachiman Shrine. *Ippen Hijiri-e*, scroll IX, section 1.

Among these various sources of information, *mandara* are notable for revealing the attitude underlying all the depictions of holy places in the *Ippen Hijiri-e*, however they were derived. The architectural *mandara* is an unusual and uniquely Japanese type of religious painting. Although the word *mandara* (Skt: *maṇḍala*) primarily denotes an abstract diagram of sacred cosmic totality, in Japan it was also applied to views of specific holy places. Buddhist temples were portrayed as well as Shinto shrines, but the religious values expressed in shrine-and-temple *mandara* are essentially Shinto. *Mandara* depict places regarded as intrinsically numinous, communicating that quality pictorially by capturing the look of the place. Accuracy, close detail, and precise draftsmanship all enhance their function of conveying a sense of sacred place. A comparable significance attaches to the scrupulous factual recording in the Ippen scrolls. It evokes the sacredness of ambience that lies at the heart of pilgrimage, justifying Ippen's devotional fervor and suggesting its intensity.

The *Meisho* Theme

The themes of Ippen as a pilgrim and Ippen as a traveler are intimately related. The many holy places reinforce the notion of Ippen's journeying as a spiritual path. Travel vignettes show movement along this path,

while shrine-and-temple views indicate temporary points of stasis. Another link between these themes results from the way all the settings depict specific places. Thus, they share a further common level of meaning that derives from the literary and artistic tradition of *meisho* (famous places).

Just as each temple or shrine view in the *Ippen Hijiri-e* describes a real place, so too each of its landscapes represents a place named in the text. The great pictorial variety of these landscapes suggests that the painter was not satisfied simply to paint generalized views of nature, but wished to endow each scene with as much individual character as possible. The distinctive local topographical features that are portrayed range from the craggy rock outcroppings of Iwaya in Shikoku to the sandy cliffs along the seashore near Hyōgo.[29]

As previously noted, the seasonal motifs contained in these landscapes owe their origin and meaning to the world of courtly poetry and poetic illustration. In *meisho-e* (views of famous places), this same poetic tradition also took the celebration of place as a major theme. With so many illustrations that dwell upon the qualities of place, the *Ippen Hijiri-e* itself takes on some of the characteristics of a *meisho* cycle. Quite possibly, too, several of its landscape compositions were based upon specific *meisho-e* prototypes, although the pictorial evidence that would substantiate this hypothesis has, regrettably, all but vanished. The representation of Shirakawa Barrier (fig. 5), a place long famed in poetry, is an example of an illustration that may have been derived from such a source.[30] Today it is easy to overlook both the intensity of lyrical mood that this *meisho-e* quality would have imparted to contemporary viewers of the *Ippen Hijiri-e* and the literary, historic, and religious resonances implicit in the various illustrations of renowned sites.

The many portrayals of sacred places must also have contributed to this *meisho*-like tone. Indeed, the Shirakawa Barrier's tutelary shrine figures prominently in the episode of Ippen's visit there. And one site of universal renown portrayed in the *Ippen Hijiri-e* is Mount Fuji, which was not merely celebrated for its beauty, but revered as a sacred mountain.[31] At the same time, the *Ippen Hijiri-e* also contains many exacting architectural delineations of shrine and temple compounds. These reflect a ten-

[29] See scroll II, section 1, and scroll XI, section 3; illustrated in NEZ 10, *Ippen Hijiri-e*, pls. 71–72 and 125–126, respectively.

[30] See Laura S. Kaufman, *Ippen Hijiri-e: A Handscroll Painting of Thirteenth-Century Japan* (Ascona: Artibus Asiae, forthcoming), chap. 3.

[31] This is acknowledged in the *Ippen Hijiri-e* by the presence of a tiny *torii* on the mountain's lower slopes. See scroll VI, section 2: illustrated, NEZ 10, *Ippen Hijiri-e* pls. 95–96, and in color (with *torii* visible) in *Ippen Shōnin eden*, pp. 154–157. On *utamakura* as sacred places, see Plutschow and Fukuda, *Four Travel Diaries*, pp. 4–6, 20–21.

dency, increasingly widespread in Kamakura times, to indicate famous places through portrayals of sacred architecture.[32]

By combining these various modes of depicting place, the *Ippen Hijiri-e* mirrors the cultural tradition from which it derives—a tradition in which the beauty of the natural world and sacredness of place coalesce. Thus, the significance of landscape imagery and the significance of architectural imagery cannot be sharply differentiated.

I turn again to the scene of Ippen preaching at the Shaka-dō in Kyoto (fig. 1). It is a tour de force of pictorial complexity, in part because the figures are unusually numerous and animated. The theme of the boisterous urban crowd, seen as well in other *emaki*, is magnificently portrayed here. But at the same time that the painting records Ippen's wholehearted acceptance by the people of Kyoto, it is a hymn of praise to the loveliness and excitement of the capital itself. In effect, the scene is a *meisho* celebrating the most beloved place in Japan—the capital city of Kyoto. Although the palaces, shrines, temples, streets, and gates of Kyoto often appear in Heian and Kamakura narrative handscrolls, this section of the *Ippen Hijiri-e* is the oldest extant view complete enough to evoke Kyoto's special qualities as a city.[33] Its panoramic scope and exhaustive detail capture an exhilarating mix of dwelling places, religious institutions, shops, and appealing natural features. No doubt a resident of Kyoto, where the *Ippen Hijiri-e* was made and kept, would have experienced a special pleasure in unrolling this painting and recognizing in turn all the elements of a familiar corner of the city.

For Shōkai's contemporaries, the element of recognition must have played a prominent role in viewing the Ippen scrolls as a whole. The places represented in many sections would have been familiar, whether from seeing them portrayed in other paintings, from personal experience, or from knowledge of their fame. That such recognition would repeatedly occur while viewing the biography of a holy person seems significant. It suggests that one message conveyed by the emphasis on specificity of place in the paintings is that Ippen the holy man belonged fully to the ordinary world.

In sum, two main points emerge from the present discussion. First, by drawing upon existing modes of landscape and architectural depiction, the elaborate settings of the *Ippen Hijiri-e* enhance themes also present in

[32] For a review of this phenomenon in Kamakura-period handscrolls and a discussion of its significance for the art of *meisho-e*, see Chino Kaori, "Chūsei no meisho-e," in *Nihon byōbu-e shūsei*, vol. 10: *Keibutsuga, meisho keibutsu*, ed. Takeo Tsuneo et al. (Tokyo: Kodansha, 1980).

[33] At a later period, complex panoramic views of Kyoto and environs became a popular subject for folding screens; the oldest extant screens are from the early sixteenth century. See Kyoto National Museum, ed., *Rakuchū rakugai-zu* (Kyoto: Kadokawa Shoten, 1966).

the biographical narrative. But the settings help to characterize Ippen as a poet, traveler, and pilgrim by means of suggestion rather than by overt statement. Evoking mood and feeling, they invite the viewer to appreciate empathetically the depth of Ippen's experiences and responses. In the transformation of physical environments into correlates for a state of heightened emotional intensity, a tone of lyric beauty proves especially effective. Lyricism can help to validate the genuineness of Ippen's spiritual attainment because in Japanese culture profound interrelationships among Buddhism, poetry, travel, natural beauty, and sacredness of place have already been established. Thus, the settings contribute to the characterization of Ippen the holy man by interweaving many layers of meaning and suggestion. This interweaving is more profound than thematic associations alone: the appealing "backgrounds" confound the usual hierarchy of importance in art by sometimes coming to the "fore" of both the viewer's attention and the program of meaning. But rather than conflicting with the figural narrative, they produce a flux, or interaction, among elements that convey significance in different ways.

Second, the settings locate Ippen vividly within the environment in which he and his biographers really lived. Their heightened sense of place is achieved by employing a detailed, realistic style and by borrowing from pictorial traditions that celebrate specific places. It is interesting that while the panoramic scale obviates didactic emphasis upon Ippen's physical person, it also intensifies the sense of his immersion in the world. Thus, Ippen's greatness is not asserted by showing him as above or other than this world. Indeed, as we have seen, the familiar environment is suffused with qualities that can mirror the inner experience of a holy life.

Realism and Evocation

To some extent, these unusual features of the *Ippen Hijiri-e* may be explained by the special conditions under which it was made. The work was dedicated on the tenth anniversary of Ippen's death, within living memory of the events portrayed. The humanity with which Ippen is characterized in these paintings testifies to his close relationship with Shōkai, the editor of the text, and perhaps with others involved in the *emaki* project. The lavish level of patronage is also pertinent: it is attested by the use of a silk ground, which was vastly more expensive than the customary material of paper, and by the length and unprecedented detail of the paintings, which reflect considerable expenditure on paint and painters' wages. These rare circumstances seem to have permitted the creation of a handscroll project that is unusual not in departing from prevailing artistic and

religious values, but rather in giving them fuller expression than was usual.

The vivid and specific portrayal of Ippen and his world, for example, recalls tendencies prevalent in Kamakura Buddhist art generally. Perhaps the most renowned instances occur in the area of Buddhist sculpture, which is characterized in the Kamakura period by an extreme concreteness of physical presence. The sculptors of the thirteenth century were so skilled at conveying sheer physical substance that many of their most satisfying products were not representations of idealized Buddhas, but portrayals of real human beings. This realistic tendency is already present in such early Kamakura works as Unkei's masterful portraits of the Indian patriarchs Muchaku (Asaṅga) and Seshin (Vasubandhu),[34] which were made in 1208 to 1212, almost a century earlier than the *Ippen Hijiri-e*. In a sense, the genre of *kōsōden emaki* (illustrated biographies of illustrious priests) provides a narrative equivalent of the great Kamakura portrait sculptures of Buddhist priests, for both types celebrate the specific qualities of an individual person. The *Ippen Hijiri-e* is a *kōsōden emaki* that manifests that interest through its vivid characterization of Ippen's humanity and extends it to a lively concern for his particular environment.

Those elements in the *Ippen Hijiri-e* that may be termed lyrical—the mood-enhancing landscapes, the poetic images and themes—also have their counterparts. As this essay has shown, they draw upon a broad artistic and literary tradition. That tradition, which constituted a major aspect of the culture of the Heian aristocracy, persisted into Kamakura times partly because the courtiers of Kyoto continued to be influential patrons of culture and arbiters of taste, and partly because their aristocratic civilization served as the foundation upon which a more popular culture began to develop in the Kamakura period. The *kōsōden emaki* typify the way the devices of lyricism could be applied to subjects that achieved new prominence in the realistic Kamakura age. The extant Buddhist biographical handscrolls each contain a few landscape passages that provide the settings for emotionally charged events or for scenes of journey. Although these scenes occur with greater frequency in scrolls executed with aristocratic patronage, they also occur in rougher works of humbler origin.[35] But the *Ippen Hijiri-e* stands out among all of them as

[34] Located in Kōfukuji, Nara, these works are widely reproduced, as in Hisashi Mori, *Sculpture of the Kamakura Period*, trans. Katherine Eickmann, Heibonsha Survey of Japanese Art (New York and Tokyo: Weatherhill/Heibonsha, 1974), 11: figs. 16, 48, 54, 59, 148–149.

[35] An example of the former category is the Chion-in's *Hōnen Shōnin eden*, which was created by the order of the Retired Emperor Gofushimi, with the retired emperor, the emperor, and the other members of the imperial family and court participating in transcription of the text. See scroll XLII, section 7, where Shōshinbō carries Hōnen's ashes through a

employing lyricism more often, more subtly, and with greater cumulative effect.

The handling of poetic themes in the *Ippen Hijiri-e* is, indeed, so consumately sensitive that it can hardly be regarded as an instance of lyricism brought to the level of a common cultural denominator. It must have resulted from planning by people thoroughly immersed in the refined world of court poetry. In fact, it bears many signs of being one of those religious handscrolls of the Kamakura period that originated at the upper levels of Kyoto society.[36] We know that a court calligrapher, Sesonji Tsunetada, performed the honorary task of brushing in the scrolls' titles. It is regrettable that the identities of other people involved in the project are uncertain. In particular, we may never be sure of the name of the unidentified sponsor or his precise relationship to Ippen and the Ji confraternity.

A text claiming to identify the benefactor does exist: it is the *Kaisan Mia Shōnin gyōjō* (Activities of the temple founder, Saint Mia), which states that the donor was Kujō Tadanori, a member of a leading family at the Kyoto court. Tadanori was *kampaku* from 1291 to 1293, shortly before the project of the *Ippen Hijiri-e* must have been conceived. His family had a history of devotion to the Pure Land teachings, beginning when his illustrious great-great grandfather Kanezane was converted by Hōnen Shōnin. The *Kaisan Mia Shōnin gyōjō* is dated by inscription to Genkō 1 (1331); however, it appears in fact to be a work of the Edo period.[37] Because of this late date, its statements cannot be accepted with confidence, although its attribution to Tadanori might be based upon accurate oral tradition or upon an older, now vanished, text. Whether or not Kujō Tadanori was the sponsor, however, one may envision as patron someone similar to him in status and circumstances. This hypothesis is consistent with the evident costliness of the project, and with the scrolls' relative

snowy landscape to burial at the Nison-in (NEZ 13, *Hōnen Shōnin eden*, pp. 188–189). An example of the latter category is the *Zenshin Shōnin-e*, an early fourteenth-century handscroll owned by Nishi-Honganji, Kyoto, that appears to be based on a lost work of 1295 executed by Jōga, a painter of the Jōdo Shin sect from Kōrakuji, Shinano Province. See scroll II, section 4, which depicts the Hakone Shrine and Lake Ashi (NEZ 20, *Zenshin Shōnin-e, Boki-e*, color pl. 2).

[36] Significantly, the only other *emaki* executed on silk is the *Kasuga Gongen reigen ki*, which was made in 1309 by the court painter Takashina Takakane for Saionji Kinhira, minister of the left and head of the powerful Saionji family; NEZ 15, *Kasuga Gongen reigen ki-e*.

[37] Mochizuki Shinzei argued in favor of the attribution to Tadanori in "Ippen Shōnin eden kaisetsu," in *Ippen Hijiri-e: Rokujō engi*, ed. Asayama Enshō (Tokyo: Sankibo Busshorin, 1940), pp. 243–265. Hayashiya Tatsusaburō was the first to refute that view, in "Hōgen En'i ni tsuite: Ippen Hijiri-e hissha no kōshō," in *Chūsei bunka no kichō* (Tokyo: Tokyo Daigaku Shuppankai, 1953), pp. 64–79.

freedom from sectarian bias, for their celebration of Ippen as a great holy man would have been more acceptable in the court environment than an attempt to portray him as founder of a new popular sect.[38]

The Courtly Aesthetic: Heian *Sūtra* Scrolls

Acknowledging the *Ippen Hijiri-e* as a product of the world of the Kyoto courtiers offers a context in which to consider what is surely its most unusual quality—the lack of emphasis upon obvious religious content. This characteristic is intimately related to the strong dependence upon lyricism, which provides ways to convey, instead, subtleties of meaning, and which presupposes a value system that finds lack of obviousness a desirable trait. The secular literary and visual arts of the Heian courtiers abound with instances where suggestion is preferred to direct statement. A well-known example is the *Genji monogatari emaki* of about 1130, in which the figures are still and expressionless, while the colors and shapes of the composition hint at their feelings.[39] The demands of orthodox, hieratic Buddhist art generally preclude such treatment, but in the late Heian period courtiers developed one type of Buddhist art, the decorated *Lotus Sūtra* scrolls, by following a radically untraditional approach to religious illustration. A brief digression to examine one such *Lotus Sūtra* illustration will prove helpful in clarifying the aesthetic principles upon which the *Ippen Hijiri-e* is based.

The *Lotus Sūtra* (Skt: *Saddharmapuṇḍarīka sūtra*, or *Scripture of the Lotus of the Wonderful Law*) was the central text of the Tendai sect and the most often read and copied of all Mahāyāna scriptures in Heian Japan. The twelfth century saw the rise at court of a type of transcription project through which a group of lay people shared the karmic benefits of *sūtra* copying by each taking responsibility for producing a single scroll containing one of the *Lotus Sūtra*'s twenty-eight chapters. The participants, who, it seems, personally supervised the planning and execution of their scrolls, abandoned the traditional Chinese-derived, severely elegant, blue-and-gold format for *sūtra* decoration. They turned instead to the

[38] This point also has bearing on the long-standing controversy over the identity of the painter Hōgen En'i. The poet and highly placed priest of Onjōji, Hōin En'i, has often been rejected as the painter on the grounds that his social status was too elevated to permit him to participate in a Jishū project. The argument is weakened, however, if the patron was a person of high standing. The substantial literature concerning the identity of Hōgen En'i is reviewed and the "Onjōji En'i" theory defended in Kaufman, "*Ippen Hijiri-e*," pp. 283–325.

[39] The expressive function of shape and color in the *Genji monogatari emaki* was first recognized by Alexander C. Soper, "The Illustrative Method of the Tokugawa 'Genji' Pictures," *Art Bulletin* 37 (1955): 1–16.

more familiar modes of courtly narrative painting and to the highly so-
phisticated art of embellishing literary texts. Their colorful, ornate, and
cleverly varied *ippon-kyō* (one-scroll *sūtras*) sometimes contain elaborate
schemes linking the decor to the scripture's content.

It will suffice here to examine one such work, an unusually fine frontis-
piece illustration (fig. 7) that accompanies chapter 23, the *Yakuō-bon*
(Chapter of the Medicine-King Bodhisattva), of the *Heike Nōkyō* (*Sūtras*
dedicated by the Taira family), which was offered to the Itsukushima
Jinja, the Taira tutelary shrine, in 1164, during the brief era when the
Taira clan was ascendant at the Kyoto court.[40]

The design is based on a composition widely used in paintings of *raigō*
(welcoming descent) in which Amida Buddha appears in order to lead a
dying person to the Pure Land. The *Yakuō-bon* frontispiece reverses the
conventional size relationship, however, making the Buddha smaller than
the woman in the lower right corner. She sits beside a lotus pond as mul-

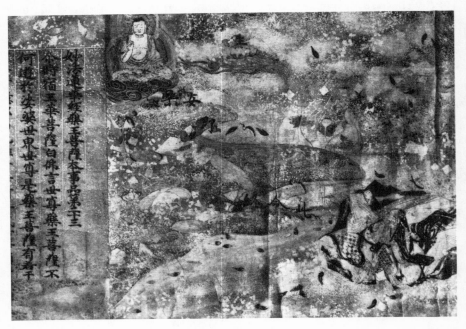

7. *Yakuō-bon* frontispiece. *Heike nōkyō*, chapter 23.

[40] The *Heike Nōkyō* is the only *ippon-kyō* that has survived virtually intact. See Komatsu
Shigemi, *Heike Nōkyō no kenkyū*, 3 vols. (Tokyo: Kodansha, 1976). For a survey of deco-
rated *Lotus Sūtras* of the Heian and Kamakura periods, see Kurata Bunsaku and Tamura
Yoshirō, eds., *Hokke-kyō no bijutsu* (The arts of the *Lotus Sutra*) (Tokyo: Kosei Shuppan-
sha, 1981), pls. 41–84.

ticolored lotus petals flutter down from the Pure Land. Her face and elaborate court robes are executed in the stylized manner of courtly tale illustrations. Upon this scene are superimposed two additional pictorial levels, which do not portray the forms of the world of ordinary appearances.

First, patches, threads, and sprinkles of gold and silver leaf are scattered over everything, even over the woman. These random patterns of cut gold and silver are derived from the vocabulary of calligraphy paper ornament; here, heavily superimposed over a painting, they seem to charge the atmosphere with pulsations and bursts of energy.

Next, some half-dozen *kanji* (Chinese characters) are scattered around the pond, while *kana* (phonetic syllabary) are concealed in the twisting outlines of rocks, leaves, and falling lotus petals.[41] A hint for deciphering the puzzle is contained in the scroll held in the woman's hands, which is open to these words of the *Yakuō-bon*: "The woman who hears and keeps this Chapter of the Previous Life of the Medicine-King Bodhisattva will not be a woman in her next life. After my extinction. . . ."[42] Taken together with the people and objects depicted in the painting (the woman, Amida Buddha, the scripture, and so on), the scattered *kanji* and *kana* continue the text from there, supplying key words and phrases from it: "The woman who hears this *sūtra* and acts according to the teachings of it . . . will [immediately] be able to be reborn, after her life in this world . . . on the jewelled seat in the lotus flower blooming in the World of Happiness where Amitāyus Buddha lives surrounded by great bodhisattvas."[43]

Thus, the frontispiece shows a Heian court lady—one suspects it is the sponsor herself—realizing the promise of salvation for women contained within the *Yakuō-bon*. But it conveys its meaning as the secular puzzle pictures called *uta-e* do, by making the reader combine various types of pictorial and calligraphic clues to reconstruct a poem, in this case not a Japanese verse, but a portion of the *sūtra* itself.

The *Yakuō-bon* frontispiece is a Buddhist illustration based, to an extreme degree, upon elusiveness and evocation. It is also striking for its intensely personal tone, which derives from conceiving of the text's assurances from the perspective of a lay person's emotional experience. The

[41] The following account is based upon Julia Meech-Pekarik, "Disguised Scripts and Hidden Poems in an Illustrated Heian Sutra: Ashide and Uta-e in the Heike Nōgyō," *Archives of Asian Art* 31 (1977–78): 74; and Asano Nagatake and Ishida Mosaku, eds., *Hihō*, vol. 10: *Itsukushima* (Tokyo: Kodansha, 1967), p. 345.

[42] The translation is from *The Sutra of the Lotus Flower of the Wonderful Law*, trans. Murano Senchū (Tokyo: Nichiren Shu Headquarters, 1974), p. 278, as quoted in Meech, "Disguised Scripts," p. 74.

[43] Ibid.

technique upon which these unusual qualities are founded is a radical interweaving of many layers of imagery. The illustration fuses courtly narrative and sacred pictorial traditions. As a poem-picture that contains lines from a *sūtra*, it confounds as well Chinese scripture and Japanese poetry. Realistic depiction, calligraphy, and sprinkled ornament are all employed; indeed, they are presented simultaneously. Their physical superposition results in another level of interweaving by undermining the solidity of conventional figure-ground relationships. One moment the pictorial representation seems foremost; the next moment it serves, like a decorative underpainting, as the ground for written characters. The viewer moves back and forth between overlapped levels, finally piecing together a meaning from elements of every layer.

At first glance, the paintings of the *Ippen Hijiri-e* present a dramatically different aspect from the *Yakuō-bon* frontispiece. As was typical of Kamakura art, they replaced the Heian disregard for realistic depiction with a conscientious representation of ordinary appearances. Their respect for the demands of realism left no place for devices like the daring superposition of pictorial levels on the frontispiece. Yet, as has been seen, in less obvious ways, the *Ippen Hijiri-e* is also a masterpiece of evocation. It too favors human qualities over formal, hieratic presentation; and in its mingling of narrative elements (conveyed by the figures) with the lyrical elements (conveyed by the panoramic settings), it too multiplies levels of meaning through playful inversion of figure-ground relationships. Here, however, this elusive, informal sensibility is adopted into a new stylistic context. Indeed, one of the extraordinary features of the Ippen scrolls is their achievement of consummate expressive subtlety within a style characterized by great specificity and accuracy of rendering.

Conclusion

Justifiably, the *Ippen Hijiri-e* has been studied and revered as a central document of the early Jishū. But its paintings also have a further significance for the understanding of Buddhist art in Japan, a significance that transcends sectarian categories. They show with unusual clarity how the visual arts benefited from the creative interaction between Buddhism and the literary culture, and from the reverence for the sacred natural world, travel, and pilgrimage that enriched and sustained that interaction. The paintings also offer a glimpse of the ways in which specific pictorial approaches enhanced profundity of meaning in a Buddhist work of art. Both their informality and lyricism, derived from the aristocratic Heian culture, and their precision and vividness, which reflect the realistic tendencies of Kamakura art, serve, in the end, the same purpose. They create a

biography with an unwavering allegiance to the humanity of its protagonist, a biography that immerses him fully in the world—at once sacred and familiar—of contemporary Japan. Today in Japan, the Jishū is a small Buddhist sect, yet "Ippen-san" is still fondly remembered by many people for his life of unceasing travel and for his peculiarly Japanese mode of presenting the Buddhist teachings. Remarkably, the makers of the *Ippen Hijiri-e*, working in the decade following Ippen's death, were able to perceive and to celebrate the salient elements of Ippen's enduring contribution to the Buddhist civilization of Japan.

Three

Prefiguration and Narrative in Medieval Hagiography: The *Ippen Hijiri-e*

JAMES H. FOARD

IN HIS COLLECTION of short biographies of Japanese writers, Donald Keene wonders why Japan has not produced much biographical writing.[1] This question parallels that which is often raised about Japanese fiction, namely, why Japan has produced so few "real" novels; and indeed, Keene suggests that the dearth of Japanese biography derives from an indifference in Japan to individual character—the very reason generally given for the supposed lack of novels. Anyone acquainted with the issue of the distinction between *shōsetsu* and "novel" is all too familiar with how quickly such questions can become unproductive terminological quibbles or, worse, arrogant impositions of one culture's critical standards upon another's literature.[2] We would do well, then, to call all Japanese records of individual lives "biographies," for that is what the term means regardless of our critical standards as to what a biography should do; one would then see how a given life story is told and why it is told this way, within its own cultural context.

The most developed Japanese biographical tradition is that of Buddhist hagiography. Japanese Buddhism has been shaped fundamentally, even distinctively, by sacred lives, although (and perhaps hence) not by the individual "character" one expects from biography. By "lives," I do not mean the "historical" careers of great Buddhists, but the records of those careers found in hagiographies, which "both recount the process through which a new religious ideal is established, and at the same time, participate in that process."[3] The history of Japanese Buddhism is to a great degree the history of saints. Even in the general histories of Buddhism by contemporary scholars, the tables of contents reveal the great names: Shōtoku, Kūkai, Saichō, Hōnen, and the rest. The contemporary schol-

[1] Donald Keene, *Some Japanese Portraits* (Tokyo: Kodansha International, 1978), pp. 15–16.

[2] Thomas Rimer, *Modern Japanese Fiction and Its Traditions* (Princeton: Princeton University Press, 1978), pp. 3–4, stresses understanding the Japanese literary tradition in its own terms.

[3] Frank Reynolds and Donald Capps, eds., *The Biographical Process: Studies in the History and Psychology of Religion* (The Hague: Mouton, 1976), p. 3.

ars, of course, seek the "real" Shōtoku and the "real" Kūkai, but for Japanese Buddhism, the real Shōtoku was an incarnation of Kannon, and the real, undying, Kūkai still awaits Maitreya on Mount Kōya. Moreover, the latter Shōtoku and Kūkai have exerted far more influence on Japanese Buddhism than the former, and in this sense they are far more "historic" than the historical personages that bear their names. These lives of hagiography have been at least as crucial as doctrine in effecting change and diversity in Japanese Buddhism—in other words, in generating its history—and have served as bases for much of its ritual, its sense of sacred space and time, and the types, and, above all, the self-images of its communities. The task of studying a given hagiography as hagiography, then, is not to search for the historical person behind it. Instead, we must see what it expresses and how it expresses it, regardless of historicity. Having done that, find the role of the hagiography in establishing the religion of the community that both produced it and was shaped by it.

To identify hagiography in the Japanese tradition throws us into the briar patch of Japanese literary classifications. The principles for distinguishing categories of Japanese literature vary wildly, from analyses of genre to typologies of physical format, and, for the specific purposes of any given historical inquiry, must be handled with care. In the case of hagiography, one turns most naturally to the category of *sōden*, or "biographies of monks," but this category overlaps others, such as *setsuwa* (tales), *ōjōden* (legends of rebirth in the Pure Land), and *emakimono* (narrative picture scrolls), which also overlap each other, and when used technically it does not even include the very influential hagiographies of Prince Shōtoku, who was not a monk. Primarily from my reading of Kikuchi Ryōichi,[4] I have come to rely on a distinction between those *sōden* that stand alone, although they may be collected in *kōsōden* (Biographies of eminent monks), and which are interested primarily in full accounts of the lives of their subjects, and those that generally appear in collections of *setsuwa*, focus on a miracle or *ōjō* (birth in the Pure Land); and ignore or only summarize the rest of the lives of their subjects. This is not an easy distinction to make, for, as Kikuchi demonstrates, the longer biographies often drew on earlier *setsuwa*, and the *setsuwa* in turn drew upon the more extended biographies.[5] There are, furthermore, gradations between the categories. Nevertheless, this remains a useful distinction, for the two kinds of *sōden* served two purposes. The first, the more extended accounts, served to demonstrate the ideals of a particular community for that community, while the second, the *setsuwa* materials, were written for propogation (*shōdō*). It is the former, then, with which I am most concerned, for they served to establish and express the ideals of Buddhist

[4] Kikuchi Ryōichi, *Chūsei setsuwa no kenkyū* (Tokyo: Ofusha, 1972).
[5] Ibid., pp. 142–43, 148.

communities as *they* defined their identity within Buddhism and the Japanese tradition as a whole.

One such hagiography is the *Ippen Hijiri-e* (Illustrated life of the holy man Ippen), composed in 1299 by and for a branch of the Jishū, a Pure Land order, in the capital. This text can serve as an example of Japanese Buddhist hagiography, not because it influenced other hagiographies—although it may have in ways I do not know—but because it is a masterpiece that illuminates the possibilities of the genre, containing within it a wide range of hagiographical techniques integrated into a consistent vision of an emerging community's religious ideals.

The Origin of the *Hijiri-e*

The *Hijiri-e*, an *emakimono*, in which texts and paintings alternate, is made up of twelve scrolls averaging fifteen inches in height and thirty-five feet in length. Together, these scrolls contain forty-eight sections, each section consisting of a text and its illustration, although some scrolls have only three sections and others have five. As the *Hijiri-e* itself tells us (scroll XII, section 3),[6] this number is derived from the forty-eight vows of Amida, but there are no correspondences between particular vows and particular sections.[7] Along with only one other *emakimono* of the period, the *Hijiri-e* is painted on silk, so that its colors remain vibrant and the quality of the text unsurpassed for its age. Still, the text is not immaculate, as moisture has left some damage, but it has been copied enough for scholars to reconstruct these few spots without difficulty. There are no significant textual disputes.[8]

While we are thus spared textual problems, there remains some room for dispute about the sponsor, painter, and author of these scrolls. Near the end of the *Hijiri-e* itself (scroll XII, section 3), we learn that it was composed according to "the encouragement of a certain person," and the final words of the text indicate that it was written by Shōkai and painted

[6] I use the text of the *Hijiri-e* edited by Asayama Enshō, *Ippen Hijiri-e: Rokujō engi* (Tokyo: Sankibo Busshorin, 1940). A complete black-and-white reproduction of the original, together with some color plates, is available in volume 10 of the Nihon emakimono zenshū, 24 vols. (Tokyo: Kadokawa Shoten, 1958–69), hereafter referred to as NEZ. The printed text in this volume merely follows Asayama. The text in volume 69 of the Dai Nihon Bukkyo zensho, 150 vols. (Tokyo: Bukkyo Zensho Hakkojo, 1912–22), follows a 1776 printed version and is not recommended.

[7] The *emakimono* biography of Hōnen by Shunjō has forty-eight scrolls. Such numerology was not uncommon in Jishū materials.

[8] According to notations at the end of the final scroll, the *Hijiri-e* was repaired in 1369 and 1492, and on one of these occasions much of the sixth scroll was misarranged. Most scholars follow Gorai Shigeru's reconstruction of the original arrangement. See Gorai Shigeru, "Ippen to Kōya, Kumano, oyobi odori nembutsu," NEZ, 10:34–35.

by Hōgen En'i in the year 1299, or ten years after Ippen's death. What one makes of this information is largely determined by one's attitude toward another text, the *Kaizan Mia Shōnin gyōjō* (Activities of the temple founder, Saint Mia), which purportedly tells the story of the founding of the Kankikōji, where the *Hijiri-e* has until recently been kept.[9] Claiming to have been written by the third abbot of the temple in 1331, the *Mia* text says that the author of the *Hijiri-e*, Shōkai, whose *ago* (i.e., *amigo*, or name containing "Amidabutsu") was Mia (i.e., Miamidabutsu), founded Kankikōji. It also gives the painter's name as Tosa En'i, thereby placing him in the line of the greatest Yamato-e painters, and states that the *Hijiri-e* was sponsored by one Kujō Tadanori, a high-ranking aristocrat. It would appear, then, that all our problems are solved by this text, and there are those who are enthusiastic about it, particularly its discoverer, Mochizuki Nobunari.[10] Skepticism has been aroused, however, by the fact that its physical characteristics date this text as early Edo (seventeenth century), and the date it claims for itself contains an inexcusable blunder.[11]

[9] The relevant parts of this text are printed in Kanai Kiyomitsu, *Ippen to Jishū kyōdan* (Tokyo: Kadokawa Shoten, 1975), pp. 446–448.

[10] Mochizuki Nobunari, "Ippen Shōnin eden ni tsuite," NEZ, 10:3–15.

[11] The text is dated the second month of the first year of the Genkō era, which was 1331. The era name did not change to Genkō, however, until the eighth month. The attempt to identify the painter En'i, who has no other known surviving works, reveals even further problems. Not even Mochizuki stands by the claim of the *Mia* text that En'i was of the Tosa school of painting. While this was the most prominent line of Yamato-e painters, one that traced its origins to the thirteenth century, the name Tosa was not adopted until the late fourteenth and early fifteenth centuries. The claim by the *Mia* text that the Hōgen En'i of the *Hijiri-e* was called Tosa En'i is clearly an anachronism designed to place En'i in this famous line of painters. The "hōgen" preceding En'i's name in the *Hijiri-e* is a high priestly rank, and Hayashiya Tatsusaburō has offered an impressive array of evidence showing that a ranking cleric named En'i, active at this time, had possible links with both Ippen and the calligrapher of the *Hijiri-e*. Hayashiya's inclusion of several documents, however, involves shaky speculations about the age of En'i mentioned in them, and some of them do not refer to any fact about En'i found in the others. This has led Akamatsu Toshihide to seek modifications in Hayashiya's theory, even while remaining in fundamental agreement. No matter what one's opinion of a particular reference to En'i, Hayashiya points out, with Akamatsu's agreement, that it is difficult to postulate more than one man of similar rank and identical name active in roughly the same period. Mochizuki's response that En'i was a master painter and therefore could not have been a ranking cleric is arbitrary in the extreme. See Hayashiya Tatsusaburō, *Chūsei bunka no kichō* (Tokyo: Tokyo Daigaku Shuppansha, 1953), pp. 64–79; Akamatsu Toshihide, *Kamakura Bukkyō no kenkyū* (Kyoto: Heirakuji Shoten, 1959), pp. 214–218; and Mochizuki, "Eden," p. 9.

The devastating questions that can be raised about the *Mia* text cast doubt upon its assertion that the person who "encouraged" the composition of the *Hijiri-e* was Kujō Tadanori. Nevertheless, this is widely accepted, simply because none of the names in the *Mia* text appear to be fabricated out of whole cloth. The case for Tadanori is strengthened by those who give to the word from the *Hijiri-e* translated above as "a certain person" (*hitori*) a different reading, "the first person" (*ichi no hito*). This latter reading would make the term

From other sources comes firmer knowledge of the author of the *Hijiri-e*, Shōkai. He was Ippen's half-brother, who retreated with Ippen to the caves in Shikoku, took vows with him, and played a prominent role in the last years of his life. While most of what we know about Shōkai comes from the *Hijiri-e* itself, his relationship with Ippen can be confirmed by genealogical records.[12] In all probability, Shōkai was at the center of a Jishū organization in the capital after Ippen's death but was not the "Miamidabutsu" of the *Mia* text.[13] While the main line of the Jishū eventually emerged under Shinkyō Taamidabutsu in the Kantō region, for an analysis of the *Hijiri-e* it is important to remember that there must have been a significant Jishū contingent in the capital as well.[14]

Form Criticism of the Text

The *Hijiri-e* includes narrative prose, expository prose, and poetry, but it is more profitably thought of, not as a set of different styles of writing,

an appellation of the *kampaku*, or counselor to the emperor, a position that Tadanori did in fact hold from 1291 to 1292. Unfortunately, the office was normally filled only for short periods, so that many men held it around the time of the composition of the *Hijiri-e*, but suggestions that some other *kampaku* might be involved seem extravagant. How someone of such high birth was attracted to a group as sloven as Ippen's is partially explained by a history of Pure Land belief at the family level. At any rate, the silk required for the *Hijiri-e* would have commanded an enormous sum, perhaps beyond the reach of Ippen's followers acting on their own. (The only comparable *emakimono* of the period painted on silk, the *Kasuga Gongen kenki*, was sponsored by the Saionji family, one of no small means indeed.) This fact, plus the presence of an aristocrat as calligrapher of titles, forces a conclusion that the *Hijiri-e* had an aristocratic sponsor—a rarity for *emakimono* of this type—who in all probability was Kujō Tadanori. See Ōhashi Shunnō, "Shōkai Jishū kyōdan dōkō," *Bukkyō shigaku* 14, 2 (February 1968): 68–69; Mochizuki, "Eden," pp. 7–8; and Komatsu Shigemi, " 'Hitori no susume ni yorite' seiritsu shita *Ippen Shōnin eden*," in *Ippen Shōnin eden*, pp. 342–452.

[12] The *Ochi keizu*, *Kōno shi keizu*, and *Kōno keizu* available in the Zoku gunsho ruijū (Tokyo, 1927), seventh part, 1:136–169.

[13] The *Mia* text states that Mia Shōnin and Shōkai were the same person, and Mochizuki agrees. In the *Hijiri-e* itself (scroll XI, section 4), however, we find the name Miamidabutsu clearly applied to another person, although *amigo* were limited enough in number for there to be duplications. In another section (scroll XII, section 2), we find that "Midamidabutsu Shōkai" attended a particular religious dance, but in the original text the first name comes at the end of one line and the second at the beginning of a new one, so two people could be indicated. Rather than confirming the identity of the two, this reference was more likely the origin of the mistaken identification in the *Mia* text, which looks more and more like a forgery. See Mochizuki, "Eden," p. 6. This argument follows that of Ōhashi Shunnō, *Jishū no seiritsu to tenka* (Tokyo: Yoshikawa Kobunkan, 1973), pp. 63–64.

[14] Imai Masaharu, *Chūsei shakai to Jishū no kenkyū* (Tokyo: Yoshikawa Kobunkan, 1985), p. 7.

but as a collection of forms, in the manner of Biblical "form criticism."[15] A survey of the forms in the text demonstrates that most of the material had important functions in the early Jishū prior to the writing of the *Hijiri-e*. I identify ten such forms:

1. *Chronologies*. Shōkai begins every section of the *Hijiri-e*, except the first, with a statement of time and place. The chronology is convincing: Ippen neither flies over vast distances nor loiters inordinately. The chronological material is concise and formulaic, and given in its totality before anything else in a section. It may contain, however, scattered details: "In the eighth month of the same year, he left the Inabadō for Zenkōji. The number of days on the road was spontaneously (*shizen ni*) forty-eight" (scroll IV, section 5). This material indicates that Shōkai was probably working from a kind of *nempuryaku* (chronology), although it could have been one that he himself composed in the course of his work on the *Hijiri-e*.

2. *Setsuwa*: There are two types of *setsuwa*: tales that are cited as precedents for the various miracles in Ippen's life, and those that are Jishū products, relating events either in Ippen's life or connected with it. I group them together because they are formally the same, and because Shōkai obviously associates them in his own mind. In scroll VII, section 1, for example, he says that Ippen once announced that the god of the Ise Shrine would reveal itself as a bee, and on that day, the hall where he was staying was full of bees, but no one was stung. At this point, Shōkai launches a fantastic tale, over four times longer than the rest of the passage and ostensibly from the Nara period, about a terrifying killer bee the size of a duck, which was finally felled by a great archer and then, through a child, revealed itself to be the Nikkō Gongen. Shōkai finishes the episode by saying that the manifestations of the gods work in many ways according to time and karmic connection, so one cannot extend examples to all situations, but this story shows that gods can appear as bees.

Sometimes Shōkai cites the sources for his tales, as in scroll VI, section 1, where he gives texts that contain stories of miraculous purple clouds, and elsewhere he gives cryptic hints, such as at the end of the bee story above, where he says that it was told by "one who remembers." At other times, he gives no citation at all. Occasionally, he even finds precedents in stories from the Chinese classics (e.g., scroll V, section 5).

The Jishū tales themselves were apparently discrete units, either oral or written, by the time Shōkai was writing. Not only are they presented as such, as units complete unto themselves, but Shōkai is even vague at some points (e.g., scroll VII, section 1) about when and where certain stories

[15] For a concise explanation of this term, see William G. Doty, *Contemporary New Testament Interpretation* (Englewood Cliffs, N.J.: Prentice Hall, 1972), pp. 58–69.

are supposed to have occurred. The most important and longest tale is that of Ippen's experience at Kumano (scroll III, section 1), for which the tale of Ryōnin, the founder of Yūzū Nembutsu, is given as precedent.

3. *Engi.* Some legends concerning the temples and shrines Ippen visited might be classified as *setsuwa*, but Shōkai uses them differently. Whereas he gives *setsuwa* only after relating the events in Ippen's life for which they are precedents, he gives *engi* either before or after instances in which he mentions Ippen, and he does not find in them specific precedents for occurrences in Ippen's life.

Although they can be found throughout the text, *engi* dominate the early part of the *Hijiri-e*, in which Ippen is still a lone pilgrim. For four places—Zenkōji (scroll I, section 3), Sugō (scroll II, section 1), Shitennōji (scroll II, section 3), and Mount Kōya (scroll II, section 4)—the *engi* is virtually all that Shōkai gives about Ippen's visit. For Mount Kōya, there is a short chronological statement ("From Shitennōji, they went to Mt. Kōya") and absolutely nothing else about Ippen or what he did there. We do, however, get a nice, long *engi* for the place. For Zenkōji and Shitennōji, too, there is no more than a line or two on Ippen himself. The *engi* for Sugō is the finest in the *Hijiri-e*, but we learn only that Ippen there vowed to abandon home and save all beings, with Fudō Myōō as his witness. The sections on Zenkōji and Sugō are particularly striking in their lack of detail since Shōkai accompanied Ippen to these places. In fact, we learn more of his own attendance upon Ippen at Sugō (in a section that appears to be a clumsy insertion) than we do about Ippen's austerities there.

Shōkai undoubtedly relied on sources for these *engi.* Only one can be positively identified—the *Arahakadera goshuin engi* (Handprinted legends of Arahakadera, 1007), which he quotes directly.[16] For the Sugō *engi*, he says that records had been lost, but that he relied on "old people." (I have found a very similar *engi* for Sugō in a Shikoku pilgrim's guide from 1689,[17] but this may have been derived from the *Hijiri-e*.)

4. *Waka.* The *Hijiri-e* contains sixty verses of *waka*, the classical Japanese verse form, more than in any comparable *emakimono*, and nearly all are attributed to Ippen. These verses, while in the *waka* form, are far from the classical, courtly tradition. They make no allusions and do not pretend to lyricism. They do, however, employ *kakekotoba* (pivot words), and *engo* (associations) extensively.[18] Ippen is shown using verse to re-

[16] This text is in the Zoku gunsho ruijū, twenty-seventh part, last volume, pp. 326–333. The section quoted by the *Hijiri-e* is on p. 326. For the discovery of the text, see Hayashi Mikiya, *Taishi shinkō*, in Nihonjin no kōdō to shisō (Tokyo: Hyoronsha, 1972), 13:53.

[17] Miyazaki Ninshō, *Henrō: sono kokoro to rekishi* (Tokyo: Shogakkan, 1974), pp. 270–272.

[18] Kanai Kiyomitsu, *Jishū bungei kenkyū* (Tokyo: Kadokawa Shoten, 1975), p. 82.

spond to inquiries or criticisms (which are also sometimes in verse); to state his teachings; to praise a god, Buddhist divinity, or exemplary person; and to express favor or admonition toward his disciples.

Of all the literary forms in the *Hijiri-e*, the *waka* are the most clearly derived from some earlier compilation. Many are accompanied by quite minimal introductions, and some Shōkai obviously had no idea where to place, such as the ones at the end of scroll IV, section 5, which he introduces by saying "and at other times."

5. *Creeds.* These, too, are generally expressed in verse, although not in *waka*, and all are attributed to Ippen. Included are the long "Betsugan wasan" (Betsugan hymn) (scroll IX, section 4), a hymn in which the impossibility of attaining Buddhahood by one's own efforts is demonstrated for each of the *trikāya* (three bodies of Buddha): the "Seigan gemon" (*Gāthā* of aspiration) (scroll VII, section 5), a *gāthā* vowing incessant practice; the "Jūni dōgu" (Twelve implements) (scroll X, section 1) in which twelve objects are designated as possesions permitted Jishū members; the "Jū ichi funi ge" (*Gāthā* of nonduality of ten and one) (scroll I, section 4), a *gāthā* on the nonduality of Amida's enlightenment and one Nembutsu; and the "Rokujūmannin ge" (*Gāthā* of the six hundred thousand) (scroll III, section 2), which justified *fuda* (talisman) distribution and also explained Ippen's name. These passages are best called "creeds" because they are set, named formulations of fundamental Jishū dogma.

6. *Doctrines.* Aside from the formulaic creeds attributed to Ippen, Shōkai also provides expositions, most likely in his own words, of Jishū doctrine, particularly doctrines about practices that Ippen developed. The two longest of these discuss the two principle Jishū practices, the distribution of *fuda* (scroll III, section 2) and the Nembutsu dance (scroll IV, section 5), but similar commentary can be found elsewhere.

7. *Decorative michiyuki (itineraries).* These "goings out on the road" passages appear when Ippen travels long distances during which few events take place, such as in his Ōshū sojourn (scroll V, section 2) and his trip around Kyushu (scroll IV, section 2), and also at the beginning of his Kumano pilgrimage (scroll III, section 1).

8. *Quotations from documents.* Included in this are the long quotation attributed to Kūya Shōnin (scroll IV, section 5) from "a work which the *hijiri* (Ippen) always carried," and several letters (e.g., scroll VI, section 3).

9. *Shōkai's narrative.* There are several narrative sections that do not seem to be Jishū *setsuwa*, and indeed do not tell a discrete tale. Since these generally concern Ippen's early life in Iyo, his training in Dazaifu where Shōkai also studied (scroll I, sections 1–2), and later incidents which Shōkai probably witnessed (much of the twelfth scroll), these are probably Shōkai's own recollections.

10. *Hōgo.* Ippen's pithy sayings, called *hōgo*, are accompanied, where essential, by an introductory saying or story. There are suprisingly few of these.

The variety of these forms may raise the issue of whether one man was responsible for the text, but I feel certain this is, in fact, the case. The *Hijiri-e* appeared so soon after Ippen's death that it is hard to imagine several distinct biographical traditions arising to be woven into this one. At any rate, Shōkai intrudes into his story far too often for us to deny him. Particularly obvious are his claims of intimacy with Ippen toward the end of Ippen's life, and his statement in scroll vi, section 1 that he learned of one story in Kyoto after Ippen's death.

Nevertheless, Shōkai was more of a redactor than an author, and an analysis of the forms of the text suggest how he worked.[19] He probably began with the chronological material as a framework, into which he fit the various other forms. One can see this process most clearly when he fumbles, unable to place a poem or tale precisely. By far, most of the literary elements of the *Hijiri-e* consist of these discrete units: creeds, poems, tales, *engi*, and miscellaneous documents. To these Shōkai added only a few of his own reminiscences, decorative passages, and, at crucial junctures, doctrinal explanations. The resulting text shows its components quite clearly.

The task of form criticism, though, is not just to identify the components of a text. As Bultmann wrote, "The form of the literary tradition must be used to establish the influences operating in the life of the community, and the life of the community must be used to render the forms themselves intelligible."[20] In other words, the formulaic units were important to the early Jishū for certain reasons, and their collective memory of Ippen interacted with the life and situation of their community to produce these particular forms of tradition. The *Sitz im Leben* of the forms was the religious and social situation of the Jishū, and they therefore help illuminate that situation for us.

Take, for example, the *waka*, so prominent in the *Hijiri-e*. Kanai Kiyomitsu gives a number of examples from medieval literature that show that the oracles of gods and Buddhas were granted in *waka* form.[21] Oracular *waka* came from dreams, from possessions, from the odd *mushi-kui* or "wormhole" characters created by insects eating into the pages, and

[19] There are two passages in the *Hijiri-e* that suggest that Shōkai may have gotten material directly from Ippen himself. In scroll xi, section 4, he records that he wrote down some words of Ippen, and in scroll iii, section 2, Ippen sends him a letter. Neither can be connected with anything specific in the text, however, and the *Hijiri-e* scroll xii, section 3, also records that Ippen burned all of his books shortly before his death to demonstrate that the Nembutsu alone was sufficient.

[20] Quoted in Doty, *New Testament*, p. 62.
[21] Kanai, *Jishū bungei*, pp. 82–126.

from *hitogami* (sacred individuals). The use of *waka* in the *Hijiri-e*, then, reflects two characteristics of the early Jishū. The first is the recognition of Ippen as an absolute authority (*zettaisha*, in Kanai's writing), able to utter divine words. This authority carried over into that of the *yūgyō shōnin*, or "wayfaring saint," the leader of the order who had the power even to deny *ōjō* rebirth in the Pure Land to recalcitrant members.[22] The second feature of the group that the predominance of *waka* suggests is the place of wayfaring *hijiri* among common people, who would receive them as they would *hitogami* or shamans, as mysterious and sacred outsiders.

Of all the forms appearing in the *Hijiri-e*, the best studied is that of *setsuwa*. So familiar is this that I will not dwell on it here except to point out that present scholarship on *setsuwa* literature, perhaps under greatest influence from Nagai Yoshinori,[23] is in general agreement that these tales display an oral (*katarimono*) character and are largely the product of popular preaching both on temple grounds and in villages by itinerants. It is hardly surprising, then, that much of the Jishū's memory of Ippen would be molded into *setsuwa*, and that the Kumano story, which would have been the core of their preaching, would have become the most elaborate. Those *setsuwa* that are given as precedents, of course, were not products of Jishū preaching and were most likely supplied by Shōkai, not as appeals to common people, but as justifications of Ippen's career for other itinerants, who would have known the same tales. This is particularly evident in his citation of the Ryōnin legend as precedent for Ippen's Kumano experience. His use of *engi*, which were also not Jishū products, may have served a similar purpose.

Finally, the "Betsugan wasan," the longest and most elaborate Jishū creedal statement, exhibits another form important for popular propagation. The *wasan*, literally "Japanese hymn," existed since the Nara period but became common only in the late Heian period. Takano Tatsuyuki believes that *wasan* grew naturally from Chinese hymns that were put into Japanese as part of a general nationalization of Chinese culture.[24] Inoue Mitsusada has sought to modify this, claiming that Takano has not taken into account the anti-aristocratic tone of the hymns and their place in devotional Buddhism.[25] In any event, the *wasan* was a fundamental medium of popular Buddhism in the Kamakura period. The hymns are

[22] Jishū death records (*kakochō*) have *fuōjō* or "no rebirth" attached to some names. See Akamatsu, *Kamakura Bukkyō*, p. 262.

[23] Nagai Yoshinori, *Nihon Bukkyō bungaku kenkyū*, 2 vols. (Tokyo: Toyoshima Shobo, 1966). See also D. E. Mills, *A Collection of Tales from Uji* (Cambridge: Cambridge University Press, 1970).

[24] Takano Tatsuyuki, *Nihon kayō shūsei* (Tokyo: Tokyodo, 1960), 4:1–11.

[25] Inoue Mitsusada, *Nihon Jōdokyō seiritsu shi no kenkyū* (Tokyo: Yamakawa Shuppansha, 1956), pp. 168–169.

generally in the 7–5 syllabic meter common in Japanese poetry, and
Ippen's composition is no exception. It is probable that this and other
wasan were sung during the Nembutsu dance, although this remains a
matter of controversy.[26]

The literary forms in the *Hijiri-e*, therefore, appear to be those that
would have been most useful for the kind of group that the Jishū was—a
mendicant order that emerged from, and drew upon, earlier such orders.
As the Jishū expanded, so apparently did the number of biographical
units composed in these forms, as the familiar story of Ippen's meeting
with Hottō Kokushi and the tale appearing in the Nō play *Seiganji* attest.
The *Ippen Shōnin ekotoba den* (Biography in words and pictures of Saint
Ippen), produced by a Fujisawa Jishū group about 1303, shows similar
characteristics and even has different versions of some of the material in
the *Hijiri-e*. The *Hijiri-e* captures the literary forms most important for
the Jishū in an early stage of their development, but these continued to
change as they played their role in the propagation and self-definition of
this mendicant order.

Prefiguration and Biography

Form criticism allows one not only to see the components of a hagiogra-
phy, but also to look beyond it, to the types of literary tradition that were
important for a particular community in a particular social and religious
setting. Form criticism does not, however, let us completely understand
the text itself as it is. The *Hijiri-e*, after all, is a biography: it purports to
relate the life of a man; it begins with his birth and ends with his death.
If we assume it was meant to be an ordered unit, rather than a hodge-
podge conglomeration, we expect this unit to be an ordered human life.
Yet when we sift through the disparate forms, they slip through our fin-
gers with no thread of individual character to bind them together. So
much of the *Hijiri-e* reads as one temple after the other, a miracle here, a
poetry exchange there. Remember, though, that this was written by
Ippen's own kin, who perhaps knew him better than anyone else, so that
this character of the text cannot be blamed on any scarcity of options
available to the author. Instead, he must have had some understanding of
this life as a whole, apart from continuities that would come from indi-
vidual character.

I believe we can approach this understanding through the literary crit-

[26] Ōhashi Shunnō, *Odori Nembutsu*, Daizō Sensho 12 (Tokyo: Daizō Shuppansha,
1974), pp. 93–99. For studies of this *wasan* and those of the later Jishū, see Takeishi Akio,
Bukkyō kayō no kenkyū (Tokyo: Ofusha, 1965); and Taya Yoritoshi, *Wasan shi gaisetsu*
(Kyoto, Hozokan, 1968).

ical notion of "prefiguration," especially as developed by John J. White in his *Mythology in the Modern Novel*.[27] White uses the term "prefiguration" to designate a motif drawn from a myth, legend, or literary classic, which is expected to be familiar to the reader, which is deliberately signaled to him or her, and which is used by the author as an "unraveling commentary" on the story at hand. Prefigurations are extended motifs, not just isolated allusions, but they may be explicitly signaled, depending on the purposes of the author, by nothing more than a title, or perhaps even at the end of a work—or anywhere in-between.

Prefigurations from mythology draw upon identifiable myths, consciously used, and should not be confused with the mythic paradigms that "myth criticism" has managed to find in virtually all literature.[28] Nor are prefigurations allegories, predicting and directing events in the narrative. Prefigurations identify the character of a narrative with one from mythology, not in any absolute sense, but only for the purposes of comparing the two. The divergence of the narrative from the prefiguration and the extension in the narrative of the character and events of the prefiguration often are the most powerful uses of the technique. Also, since prefiguration does not involve absolute and therefore exclusive identification, a character or event in a narrative may be given more than one prefiguration. White calls this technique "condensation."[29]

I have found White's work on mythological prefigurations in modern, and particularly German, novels helpful in understanding the relationship between a given hagiography and its culture's traditions of sacred biography. Too often, historians of religion have subjected virtually any narrative to their own brand of "myth criticism," finding the narrative meaningful only insofar as it repeats a timeless paradigm—either a supposedly universal archetype or the sacred biography of a founder. The problem with searching for meaning in repetition is that hagiography is most often written for extension, change, and recombination of earlier sacred biographies and life ideals, under the impact of new social and cultural conditions, or even in combination with new symbol systems. I have found this particularly true in the case of national saints, in which the hagiography neither repeats the sacred biography of Jesus, Śākyamuni, or Muhammad, nor replaces it. Instead, it uses the old ideal to comment on, and give meaning to, the newer, adaptive hagiography. Hagiography preserves by changing; it fails if it repeats. It is one of many buffers between unchanging transcendence and ever-changing history.

[27] John J. White, *Mythology in the Modern Novel: A Study of Prefigurative Techniques* (Princeton: Princeton University Press, 1971).
[28] Ibid., pp. 7–11.
[29] Ibid., p. 194.

The sacred biographies of religious traditions function as myth. Their hagiographies may also function as myth for some communities. The relationship between the two, however, will have more in common with Thomas Mann than with Mircea Eliade. In his study of the biography of Saigyō, William LaFleur found what I would call a prefiguration in the biography's clear signals of the life of Śākyamuni.[30] Most dramatic is the one given by Saigyō himself in a poem in which he accurately predicts he will die on the same day of the year that Śākyamuni died. LaFleur believes this poem inspired his biographer to elaborate on the parallels between the two lives. This prefiguration, however, is not used to claim that Saigyō's biography repeats that of the Buddha, nor to identify the two in an ontological sense. Buddhism, after all, when it wants to make disparate historical figures identical, has more potent means than death dates. Rather, the prefiguration is used to invite the reader to compare the two lives and, in that comparison, to find a commentary on Saigyō's life that reveals its true meaning. Likewise, in the hagiographical account of the birth of Shōtoku, we find clear evocations of the birth of Śākyamuni, not because Shōtoku is to be identified with Śākyamuni (he was, after all, Kannon), but because Śākyamuni was destined either to rule the world or to become a Buddha, and this prefiguration serves as a commentary on Shōtoku's own rule as a *Dharmarāja* (*hōō*). The hagiography of Shōtoku, in fact, involves several overlapping prefigurations that render impossible the identifying of him with any one of them.

There are two prefigurations in the *Hijiri-e* that Shōkai uses to give coherence to Ippen's life and hence to the diverse literary forms he has assembled. The first prefiguration, as might be expected, is the life of Śākyamuni. This is signaled by Ippen's *shukke*, his leaving the secular world to become a Buddhist mendicant, and emphatically and explicitly by the events of his death. The whole pattern of his life—*shukke*, an enlightenment experience, teaching, death—is normative for Buddhism. Ippen's *shukke*, however, is somewhat messy, since he had two, one as a boy and another as a grown man after he had, for a time, returned to household life. The reasons given in the *Hijiri-e* for his second *shukke* are vague enough for followers and scholars alike to have speculated on the subject.[31] Nevertheless, the prefiguration is clear and explicit. Shōkai uses it to comment on Ippen's life as a *sute hijiri*, or "*hijiri* who has thrown away" all earthly ties and possessions (scroll I, section 2). The most interesting example is in scroll III, section 2, in which he justifies Ippen's return

[30] William LaFleur, "The Death and Lives of the Poet-Monk Saigyō," in *The Biographical Process*, ed. Reynold and Capps, pp. 343–361.

[31] See Ishioka Shin'ichi, "Ippen ni okeru shukke no dōin ni tsuite no kōsatsu," *Tōyōgaku kenkyū* 2 (1967): 87–94. Ishioka believes the story in the *Eshiden* that Ippen was almost killed in a family dispute, and he claims that Shōkai was probably covering up the incident.

to Iyo after Kumano by Śākyamuni's returning to his father's city after becoming the Buddha.

If the first prefiguration is expected and common, the second is surprising and strange, and it challenges us to take seriously the unfamiliar patterns of medieval religious thought. This is the prefiguration of the Name itself. The Jishū doctrine of the "Six-Character Name," derived largely from the Seizan Branch of the Jōdo sect, focused devotion on the Name rather than on the person of Amida Buddha. This was because both Amida's buddhahood and the rebirth of all beings were contained in the Nembutsu phrase "Namu Amida Butsu" itself. In fact, according to the Jishū reading of the Eighteenth Vow, they were the same event, established by and contained in the Name. Since the bodhisattva Hōzō attained perfect enlightenment ten *kalpas* ago to become Amida Buddha, so too must all other beings have attained rebirth. With one Nembutsu, then, the distinctions between this moment and ten *kalpas* ago, and between this world and the Pure Land, are transcended. The critical doctrinal points to bear in mind for understanding the *Hijiri-e* are: rebirth (*ōjō*) for all beings has *already* been established, and it is immanent in the six characters of "Namu Amida Butsu." Ippen's life, from, at the latest, 1274 until his death in 1289, was largely spent distributing *fuda* (paper talismans) with "Namu Amida Butsu" printed on them, regardless of the "belief or unbelief, purity or impurity" of the recipient. This *fuda*, by itself, effected the already established rebirth of those who received it. In short, Ippen's work was that of the Name, and hence the Name served as a prefiguration of his biography.

Just as Saigyō's prefiguration in Śākyamuni was probably first enunciated by Saigyō himself, so too was Ippen's prefiguration in the Name a product of his own self-understanding. Ippen's sense of his own mission is most clearly stated in the "*Gāthā* of 600,000 People" (Rokujūmannin ge), which he composed after being commanded by the Kumano Gongen, a manifestation of Amida, to distribute his *fuda*:

> The six-character Name is the one law.
> The beings and conditions of the ten realms are one body.
> Separating one's thoughts from the myriad practices and embracing the one
> [Nembutsu],
> one rises among people as a beautiful lotus.

The word translated as "one" (aside from the pronoun) in each of the first three lines is *ippen*, from which Ippen took his own name. In addition, the first characters of each line are, respectively, "six," "ten," "ten thousand" (translated here as "myriad"), and "people." Together they form the phrase "600,000 people." On the *fuda*, too, the phrase "The Established Rebirth of 600,000 People" was printed above the Six-Char-

acter Name. This undoubtedly means nothing more than "the myriads of the sixty-odd provinces" —in other words, all Japanese.[32]

Medieval Japanese Buddhism demands that we take such word plays and numerology seriously. Hence, the *gāthā* indicates that Ippen saw himself as the one (*ippen*) Nembutsu, saving all Japanese. All male members of the Jishū were required to take *amigo*, or names containing "Amida Butsu," and I agree with Kanai Kiyomitsu that Ippen's *amigo* was simply "Namu Amida Butsu."[33] Far from arrogance, this *amigo* fit the charisma of Ippen, so amply displayed in the *Hijiri-e* itself. From this perspective, the division of the *Hijiri-e* into forty-eight sections is more than a "nice touch"—one is invited to regard Ippen's life as the working of the Name, fulfilling all forty-eight vows of the bodhisattva Hōzō.

The two prefigurations, that of Śākyamuni and that of the Name, together served as implicit commentary on the diverse materials Shōkai assembled in the *Ippen Hijiri-e*. In so doing, they provided the reader with two things: coherence and meaning. The prefigurations provided coherence because they complemented each other in encompassing the two basic modes of Ippen's life, namely, retreat from the world and the working for its salvation. The former was modeled, as it has been for Buddhists everywhere, on Śākyamuni's Great Renunciation. The latter, although with echoes of Śākyamuni's compassionate teaching, reflected the power of the Name in effecting absolutely universal salvation. In the absence of character or thematic development, or of running metaphor or allegory, these prefigurations brought coherence in an extremely economical fashion: no event in Ippen's life escaped them, because everything could be seen as either enlightening retreat or soteriological advance. By brief but clear signals, the reader was made to reflect on each tale, legend, or whatever, in light of these prefigurations, even though explicit commentary was rarely made. While the text still can be read as one discrete literary form after another, none of these is out of place, because none could be out of place, provided it could be connected by the reader to one of these two prefigurations.

But in the act of reflection on these connections, the reader was provided with more than simple coherence. Once a discrete literary form was placed in relationship to a prefiguration, it was not only made part of a coherent whole but was also given a meaning by the commentary implicit in that relationship. One is entitled to ask, then, through reflection on these prefigurations, what might the reader discover? To answer this, let me first recall William LaFleur's general observation.

[32] Hattori Kiyomochi, "Ippen Shōnin no fusan ni tsuite no mondai," *Nihon rekishi* 95 (May 1956): 5–13.

[33] Kanai, *Ippen*, pp. 59–60, 101.

One of the most fascinating features of Japanese Buddhist culture in the medieval period is that it pursued, on the one hand, the elaboration of an extensive system of Buddhist symbols and, on the other, the subjection of the entire symbolization process to a radical critique that was itself grounded in Mahayana Buddhist thought. The seeming paradox is that the Buddhist symbolic system was forced to undergo analysis on bases that were themselves Buddhist.[34]

In his chapter in this volume, Prof. LaFleur has explored the literary dimensions of this process in the poetry of Fujiwara Shunzei, showing how symbols used to represent a transcendent reality were then critiqued in the very name of that reality. In the *Hijiri-e*, we are confronted with the social dimension of this same process. If we regard modes of life as symbolic expressions and not merely goal-directed choices, we can see that Ippen's life is presented as a retreat from a society of delusion and desire into enlightenment, and at the same time an affirmation that this enlightenment embraced universally everyone in that deluded society. The retreat, of course, is prefigured by Śākyamuni, while the embracing is prefigured by the Name. Another way to look at this is to see Ippen's status as a *sute hijiri* as an extreme form of the dualism between Sangha and laity, fundamental in Buddhism since its inception, and the experience at Kumano as a "radical critique" of this and all other distinctions among human beings, but a critique made possible only by Ippen's initial distinction from society. Nevertheless, it would be a mistake to think of this as simply a chronological movement first away from the world and then back into it. Rather, the retreat occurs together with the embracing of all humanity. In Buddhist terms, one could say they arise together—are "co-dependent." Ippen's life is thus presented as an irregular rhythm of loneliness and crowds, both shown in the illustrations on the stage of the ubiquitous road—the liminal space within medieval society where one could both withdraw from it and encounter it in its totality.[35]

By providing essentially mythic references for Ippen's whole way of life, the two prefigurations served also to give that life authority for the emerging Jishū order, particularly in the context of previous wayfaring groups. These earlier groups, commonly called *bessho hijiri*, were chartered by the great temples to raise funds (*kanjin*) by distributing talismans to contributors, whose names would then be enrolled in registers (*kanjin-chō*) and who would thus establish a salvific connection (*kechien*) with the building or statue their funds supported. Ippen derived virtually all of the features of his religious life from the activities of these *bessho hijiri*:

[34] William R. LaFleur, *The Karma of Words: Buddhism and the Literary Arts in Medieval Japan* (Berkeley: University of California Press, 1983), p. 20.

[35] The notion of liminality is from Victor Turner, *The Ritual Process: Structure and Anti-Structure* (Middlesex: Pelican Books, 1974).

his distribution of *fuda*, his enrolling of names, his propogation techniques, his heroes, indeed his whole way of life. The prefigurations of his biography, however, gave new meaning to these already existing practices. No longer was wayfaring merely a means of propagation; it was itself a retreat from the world. No longer was the distribution of *fuda* for establishing connections with a particular temple; it was itself effecting an absolutely universal salvation. It has already been seen that the *Hijiri-e* was composed of the literary forms common to such wayfaring groups, but it was the prefigurations that defined Ippen's special authority among them. The Jishū was thus able to absorb many previously existing *hijiri* groups and to emerge as the largest wayfaring order in medieval Japan.

In this essay, I have examined only one hagiography, but on this basis it is not unreasonable to suggest how Buddhism influenced Japanese biography. The lack in Japan of biography in the Western sense of a linear exposition of individual character was not, as might be suggested, due to any Buddhist indifference to individual lives. On the contrary, it was due to the very importance of individual "lives" (the lives that are told, rather than lived) in the self-definition of religious and—later and derivatively— other traditional groups. It is no exaggeration to say that, for many groups, it was principally biography that made their special symbols and rites, their peculiar cultural expressions and actions, reflect timeless ideals. For this purpose, the linear development of individual character would have been of little use. Rather, the discrete events in the life of a saint, holy man, or artistic master could become coherent and meaningful—while performing the role biography was asked to perform in Japan—only by relating them to certain mythic prefigurations. In this fashion, biography mediated the tension of history and transcendence.

Four

Coping with Death: Paradigms of Heaven and Hell and the Six Realms in Early Literature and Painting

BARBARA RUCH

THE PHENOMENON of death is an invaluable focal point for comparative humanistic scholarship. As one of the great invariables of human experience, it provides an excellent point of departure for a cross-cultural exploration of culturally determined variations in human perceptions of and responses to what is in fact a traumatic, universal event in human life. Buddhism, a foreign import into Japan that ultimately became the major institution there concerned with mortal questions, likewise provides an excellent framework for the examination of cross-cultural paradigm modification.[1]

This chapter is a brief exposition of some of the varied and complex modes of cultural adaptation practiced by the Japanese in their responses to imported Buddhist concepts of death, the next world, Hell and Heaven (Jigoku and Gokuraku), and cyclical karmic rebirth within the Six Realms of Transmigration (*rokudō*). I use the word Hell for Jigoku rather than hells, largely for convenience, but also because I wish to treat Jigoku as one element in a paradigm rather than in its specific manifestations. The perhaps more accurate word, purgatory (or rather, purgatories), is misleading not only because of the Christian theological nuances with which it is encumbered, but also because clearly both the verbal and visual iconography of Jigoku simply does not emphasize, indeed, hardly even makes reference to, the cleansing effect of being purged; rather, it

[1] The terms paradigm and worldview are not used interchangeably here. Many worldviews can exist within a culture, but when one becomes dominant, it becomes a paradigm. Where everyone accepts a priori an answer to a mystery, and its premises are no longer questioned, it qualifies as a paradigm. During a preparadigm period no one view or answer dominates; candidates compete with each other. When one emerges as a major solution to a concrete mystery and it accords with other beliefs or wishes of those concerned, then it becomes the paradigm for that community or culture. In the pages that follow, I contend that whereas the concepts of Gokuraku and karma came closest to separating out and becoming paradigms in and of themselves in medieval and later Japan, Jigoku and the *rokudō* did not, but were detached by inclination from the larger imported Buddhist paradigm and remained merely one of several coexisting heterogeneous views of what happens at death and beyond.

focuses relentlessly on the hellishness of the punishments. I translate Go-kuraku simply as Heaven or Paradise, although here too, technically speaking, there were plural heavens (Amida's paradise, Miroku's para-dise, etc., also described as "Pure Lands"), but in the popular mind they ultimately merged into one general image. *Rokudō*, literally the "Six Paths," is a Buddhist term that stands for the Six Realms or states of sen-tient existence (*tenjindō*, the realm of the celestials; *ashuradō*, the domain of frenzied warriors; *ningendō*, the human world; *chikushōdō*, the ani-mal state; *gakidō*, the limbo of starving ghosts; and Jigoku, the various hells) through which, according to orthodox Buddhist doctrine, homo sapiens must transmigrate cyclically forever, propelled by the karmic cau-sality inherent in deeds performed by intent or involuntarily, until, by a variety of means, they gain release first perhaps to a Paradise and ulti-mately into Nirvāṇa.

The problem at hand, and the specific thesis presented here, first emerged in the course of my research on medieval Japanese narrative lit-erature that was conveyed by professional performers known as *etoki*, or painting-reciters. These were men and women who used vividly painted hanging or hand scrolls and feather-tipped pointers as props while chant-ing a repertory of religiosecular narratives (fig. 8). They played an impor-tant role not only in the spread of religious concepts and social values but in the evolution of various literary genres, especially during the Kama-kura, Muromachi, and early Edo periods.[2]

Etoki narratives and paintings can be usefully categorized into four general types: first, those that deal with the lives and miracles of famous religious leaders or deified figures, such as Shōtoku Taishi and Rennyo Shōnin; second, accounts of battles or warriors, such as *Soga monogatari* (The tale of the Soga brothers)[3] and *Yoshitomo no saigo* (The death of Yoshitomo); and third, romantic tragedies used in early-modern Sekkyō-bushi[4] and Jōruri, such as *Karukaya dōshin* (The tonsure of Karukaya) and *Oguri Hangan* (The tale of Lord Oguri). The category that stimulated concern with the issues in this chapter, however, was type four, which comprises painting recitations that deal with Hell and Heaven and the Six Realms of Transmigration such as *Yata Jizō engi* (The miracles of Jizō at Yata Temple) and *Kitano Tenjin engi* (The legends of the Kitano Tenjin Shrine), which clearly reflect evolving adaptations of foreign paradigms to match a highly eclectic Japanese taste.

The influence of this type of narrative on late medieval fiction and

[2] For a discussion of *etoki* see Barbara Ruch, "Medieval Jongleurs and the Making of a National Literature," in *Japan in the Muromachi Age*, ed. John Whitney Hall and Toyoda Takeshi (Berkeley: University of California Press, 1977), pp. 294ff.

[3] For an English translation of this work, see Thomas J. Cogan, *The Tale of the Soga Brothers* (Tokyo: University of Tokyo Press, 1987).

[4] For Sekkyō-bushi, see Susan Matisoff's chapter in this volume.

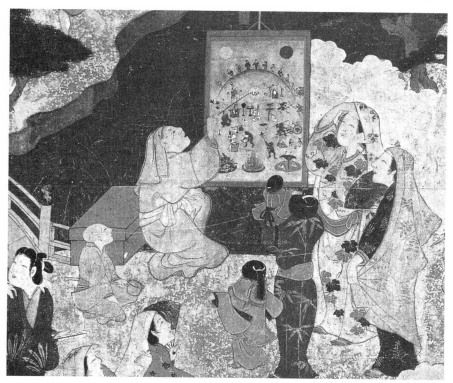

8. A Kumano nun and her young novice assistant with alms cup at the foot of a bridge performing *etoki* (painting-recitation) of the *Kumano kanjin jikkai mandara*. Detail from a pair of two-fold screens, "A Festival at the Sumiyoshi Shrine" (Freer 00.25), seventeenth century.

drama of various forms is demonstrably immense. To understand and appreciate the perceptions of death and religious faith that are fundamental to this latter group of *etoki* narratives and paintings, however, it was necessary to learn more about contemporary Japanese views of imported Buddhist concepts than current published scholarship on Buddhist doctrine and its reception makes clear. I had hardly begun before I ran into anomalies that were deeply puzzling and contradicted current scholarly views.

A New Look at Old Paradigms

The most interesting and challenging problem that manifested itself lay in the fundamental contradictions I perceived between, on the one hand,

scholarly opinion concerning alleged medieval Japanese perceptions of transmigration in the *rokudō* afterlife and, on the other, what I was able to observe to be the perceptions of what happens at death as revealed in the private writings of Heian and Kamakura women and men.

The challenge emerged from two directions. Among Japanese scholars (particularly in the fields of art history, intellectual history, and religious history) could be found the assumption that from about the tenth century on, the imported Buddhist concept of *rokudō* as well as its subsets, Jigoku and Gokuraku, had become thoroughly naturalized and constituted a central part of the Japanese worldview. Watsuji Tetsurō, for one, suggests that such concepts came to be viewed as making wholly natural sense, and that the Japanese as a people therefore adopted the *rokudō* as a paradigm for explaining postmortem life.[5] On the part of Western scholars the most sophisticated proponent and elaborator of this view, indeed the scholar who has taken it beyond the "common-sense" level to a higher arena of hermeneutics, is William R. LaFleur.[6]

My argument is not aimed at countering Watsuji's fascinating interpretation of his own country's past nor LaFleur's elegant examination of the cognitive function's potential in the *rokudō* paradigm in Heian and medieval philosophical thought.[7] It aims, rather, at locating in the personal literature and in paintings familiar to all, not the intellectual explanations of the taxonomy of the next world presented by doctrinal thinkers or

[5] See in particular his essays on the Japanese "seishin" (mind or spirit) in volume 4 of *Watsuji Tetsurō zenshū* (Tokyo: Iwanami Shoten, 1961–63).

[6] William R. LaFleur, *The Karma of Words: Buddhism and the Literary Arts in Medieval Japan* (Berkeley: University of California Press, 1983), pp. 28, 59, quotes Watsuji in support of his view that the *rokudō* was eventually accepted as a priori truth, a "common sense" of the time. This pioneering book, of great importance to the field of medieval Japanese studies, attempts to go beyond a look at Buddhist *elements* in literature to achieve "a real reconstruction of the way the Japanese in the medieval period of their history saw the world and envisioned their destinies in and through Buddhist terms and concepts" (p. ix). One problem with this thesis, however, lies in the a priori acceptance that the Japanese experience *was* essentially a Buddhist experience. Further, the author discovers in medieval Japan "at least two very different, often conflicting, ways of viewing the world," cosmological and dialectic, and "both of these were Buddhist" (pp. ix–x). In his preface he starts out attempting to understand the religious assumptions of "Buddhist poets, dramatists, and writers of prose" (p. ix) and proceeds to deal with Kyōkai, Teika, Zeami, and Bashō. The reader, therefore, is left with the overriding impression that these men are to be understood as essentially "Buddhist writers" (even though their Buddhism in each case differs). One must then ask what happens to the profoundly non-Buddhist conceptions and conduct that these men also manifest. Are these to be rendered secondary or even irrelevant to our understanding of their religious assumptions?

[7] LaFleur's creative and meticulously argued thesis is a fine resurrection of the ninth-century monk Kyōkai as of pivotal importance in introducing through his *setsuwa* collection, *Nihon ryōiki*, the new paradigm of karma and the *rokudō* in a coherent and effective manner for didactic uses.

proselytizers, but the ways in which Japanese at large viewed death—that of themselves and their loved ones—and by extension whether and how they actually incorporated the concept of the *rokudō* into their lives.

Certainly it is true, and texts make it clear, that karmic causality and the Six Realms of Transmigration came to be accepted by every school or sect of Japanese Buddhism, and that there is hardly a literary work to be found that does not show *knowledge* of these concepts. Eventually, every Japanese grew up knowing about them. Scholarly interpretation of these facts, however, both in the West and in Japan, leaves the impression that ultimately such ideas gained a victory over pre-Buddhist attitudes,[8] that Japanese on all levels of society abandoned old views (if only through a synthesis of the old and new), that they came not only to know and understand but to believe in these matters,[9] and that a paradigmatic revolution in their worldview took place.

Without any doubt the incoming paradigms were complex and intellectually elegant, but they were also in many fundamental ways contradictory to native views. In large measure intelligible and reasonable, they represented a powerful system antagonistic to a likewise powerful pre-Buddhist system of belief whose taxonomy of postmortem life had different dimensions. But to interpret the Japanese importation of Buddhism as a culturewide paradigm shift, a replacement of one worldview by adoption of another complex new intellectual or spiritual technology, is, I believe, a misreading of Japanese cultural dynamics. Further, it is extremely important that considerations of gender, age, and class be at the forefront of our awareness. One must keep in mind that when scholars speak of "the Japanese people," what they often really mean is "male intellectuals."

The intent of this chapter, therefore, is to urge that we step back from this general consensus regarding Hell and the *rokudō* in medieval Japa-

[8] For example, LaFleur argues that the *rokudō* cosmology was not merely a "presence" in medieval Japanese life, but that there was a "hegemony" of the Buddhist paradigm (*The Karma of Words*, p. 59) and, specifically, an "intellectual hegemony" (p. 9). Although in later publications he suggests that by "hegemony" he did not imply something "monolithic" (William R. LaFleur, "Paradigm Lost, Paradigm Regained: Groping for the Mind of Medieval Japan," *Eastern Buddhist* 18, 2 [Autumn 1985]: 113), and adds that " 'hegemony' implies a certain struggle to maintain a dominant position because the contenders—those submerged—are real" ("Response by William R. LaFleur," in "A Discussion of William R. LaFleur's *The Karma of Words*," *Supplement* to the May 1988 issue of *The Japanese Religions Bulletin*, p. 42), he nonetheless insists that he prefers "to speak of Japan's medieval period as one of Buddhism's *hegemony* ("Response," p. 40).

[9] Nakamura Hajime postulates, with less than persuasive evidence, that the peasants' belief in Hell was even stronger than that among the ruling class, *Ōjōyōshū* (Tokyo: Iwanami Shoten, 1983), p. 53. LaFleur (*The Karma of Words*, p. 58) states that the Buddhist *rokudō* was the shared episteme, the paradigm that explained death and the beyond and more, not only to "the literati and intellectuals but also to the unlettered peasants."

nese life and to suggest that when Buddhism entered Japan its concept of transmigration and the *rokudō* permeated certain segments of society greatly and other segments hardly at all, and that certain aspects of Buddhist thought, such as karmic causality, had a natural emotional and rational appeal, whereas other elements in the paradigm, such as punitive hells and transmigration through the Six Realms, though of obsessive concern to some and a metaphorically rich ground for the expressive arts, gave rise to much more limited appreciation. In short, I submit that the Buddhist taxonomy of the postmortem universe was not adopted universally. Rather, the process of adoption was extremely complex and the results multileveled and more aptly described as Japanese than as Buddhist.[10]

Images of Death in Literature

The earliest archeological evidence and earliest written literature reveal that in pre-Buddhist times the Japanese dealt with the trauma of death by believing death to mean a departure from this world to "another world"—sometimes thought of as a far distant island or mountain, another country, or a realm beneath the earth or beneath the sea, but a realm where the dead continued to live in another existence. Such a response is not unusual in world history. Archeological and historical evidence shows that almost all cultures from early times on have refused to see death as the end and have shared an almost universal insistence that there be some kind of continuum beyond this world.

In the oldest of Japanese texts—the *Kojiki* (Record of ancient matters) and *Nihon shoki* (Chronicles of Japan), for instance—insofar as we can detect so-called pre-Buddhist thought in these early eighth-century compilations, we find a record of a people who saw death as a permanent end to the present life, as a once-and-for-all event, which was at the same time the start of another existence in a dark and gloomy underworld continuum, a *yomi no kuni*, or if not that, then a place far beyond the sea, a *tokoyo no kuni*, reserved for shaman-like sages. Such realms are vague and the imagery in early literature is unclear or contradictory, but all such realms had a geographical continuity with this world; passing back and forth from here to there was a possibility. Yet none of these realms was a paradise to which all could aspire. The god Izanagi, for instance, goes into the underworld in search of his deceased sister-wife Izanami and finds her

[10] Although Japanese literature reveals the coexistence of heterogeneous conceptions of death and the next world, and such coexistence is, I believe, a conspicuous characteristic of Japanese cultural history, I do not wish here to address the questions of whether or not and to what extent it is particular to the historical and cultural conditions of Japan.

"living" in a body disfigured by the putrefaction of death. She is outraged at him for seeing her in that state. Here we see deeply into recognizable anxieties over both the horrors of what death will do to our own persons and also what it will do to those we love.

At that early stage in Japanese history the death of the body, of oneself and of others, was a terrifying act of nature, but no more. It had no moral or ethical aspect to it; it was no more than a disaster like an earthquake, typhoon, or fire that has mortal but not moral powers. In short, Japanese before Buddhism had no concept of death as a moment of reckoning; there were neither heavens nor hells; there were no punishments, no one to pass a verdict that there should be, no tortures from which to be saved. What really happened after contact with the foreign religion, Buddhism? How did subsequent Japanese men and women perceive death? To what extent, if any, did their perceptions change? What did it mean to them, and how (both as solitary individuals in their private moments and as a society in institutional or at least socially unified ways) did they deal with the trauma of death? Was there indeed a revolutionary paradigm switch, as has been claimed, or not?

Books have now been published that describe in detail the taxonomy of Buddhist hells as introduced to and preached in China and Japan.[11] Historical, literary, philosophical, and theological studies have been made that focus on karma or the Six Realms as taught by early religious leaders such as Genshin, Hōnen, and Shinran. Translations of and commentaries on such sacred texts and treatises as the *Lotus Sūtra* and *Ōjō-yōshū* (Essentials of salvation) and a wide variety of didactic *setsuwa* literature have added much to our knowledge.[12] Yet as one leaves didactic materials behind and reads instead the poetry, diaries, and daily-life fiction (*waka, nikki,* and *monogatari*) of early and medieval Japanese men and women lay writers, it is clear that their views of the postmortem experience are extremely eclectic. They refuse to conform with the so-called early-medieval Japanese Buddhist worldview as represented in modern monographs. Indeed, they seem sometimes even disdainful of paradigms now attributed to them by modern scholars. Unlike the didactic writers, who tend to adopt and then strive for syncretism, the lay poet or story

[11] Daigan and Alicia Matsunaga, *The Buddhist Concept of Hell* (New York: The Philosophical Library, 1972); Anne Swann Goodrich, *Chinese Hells* (St. Augustine: Monumenta Serica, 1981).

[12] For example, Leon Hurvitz, trans., *Scripture of the Lotus Blossom of the Fine Dharma* (New York: Columbia University Press, 1976); A. K. Reischauer, "Genshin's Ojo Yoshu: Collected Essays on Birth into Paradise," *Transactions of the Asiatic Society of Japan,* second series, 7 (December 1930): 16–97; Kyoko Motomochi Nakamura, trans., *Miraculous Stories from the Japanese Buddhist Tradition: The Nihon Ryōiki* (Cambridge: Harvard University Press, 1973); Marian Ury, trans., *Tales of Times Now Past: Sixty-Two Stories from a Medieval Japanese Collection* (Berkeley: University of California Press, 1979).

writer depicts a world peopled by pragmatic eclectics who select from all available traditions and doctrines those aspects that are most emotionally and aesthetically satisfying to the need of the moment. Whatever consistency this eclecticism may have, and it is considerable, it lies in the inner conformity of the specific social, economic, age, or sex group to which the writer belongs.

When we look beyond didactically intended *setsuwa* stories such as the *Nihon ryōiki* (Record of strange occurrences in Japan), and paintings such as the genre of Jūō-zu (Portraits of the ten king-judges of Hell) or depictions of Hell itself, and take as our touchstone how Japanese depicted the experience of death in their most intimate literature, we find that the imagery does not match the orthodox presuppositions.

The facts simply do not support the statement that in "all the great literature of medieval Japan—the *Tale of Genji*, the great military romances, subsequent legendary literature such as the *Konjaku-monogatari*, the poetic anthologies beginning with the *Kokin-shū* . . . and the classical drama of nō, . . . the taxonomy of *rokudō* and the operations of karma are simply presumed to be true, universally applicable, and intelligible,"[13] unless one admits that other taxonomies and operations are also presumed to be true, equally intelligible, and just as applicable.

In almost none of the above-mentioned works is the taxonomy of *rokudō* universally applicable. It coexists with widely divergent views of the world beyond this life. In many of these works the operation of karma, if I may suggest a parallel, is treated much as Freudian psychology is today by some: its tenets are invoked to prove a vested point or to support one's own preferences or inclinations, but dismissed out of hand when emotional demands call up a different response or require a different system of ministration.

In the *Tale of Genji* the *rokudō* is mentioned only once, in this extremely long novel that covers numerous generations of lives. On the opening page of the Suzumushi chapter Onna San no Miya, upon becoming a nun and in fitting out her chapel with the appropriate accouterments, has "scrolls of holy writ copied for each of the Six Realms."[14] Karma is certainly accepted as the explanation of causality for matters in this world. One's deeds from a past, forgotten life are constantly offered as the excuse for everything (shortcomings, talents, setbacks, good fortune, physical attributes, anything sufficiently good or bad to be worthy of note), but in a manner that seems clearly to disengage karma from inexorable future rebirths of a less appealing variety. In the *Tale of Genji*

[13] LaFleur, *The Karma of Words*, pp. 30–31.

[14] Edward G. Seidensticker, trans., *The Tale of Genji* (Rutland, Vt.: Charles E. Tuttle, 1987), 2:668.

Murasaki Shikibu created a world and characters who were totally be-
lievable to her readers, and her characters did not believe that they them-
selves individually, or their loved ones, would really fall into Hell and be
tortured, nor did they anticipate that any of them might be reborn a dog
or cow. The Six Realms they *knew* quite well. Yet when faced with the
reality of death and mourning it was not for them. Their other-world of
death had different dimensions. In the *Tale of Genji*, as Fujii Sadakazu
has insightfully pointed out, "the dead by no means die with finality."[15]
They stand by over the years and watch intently. To cite just one example,
the soul of Yugao, who dies young and unexpectedly without having been
able to assure the future of her daughter Tamakazura, cannot achieve
resolution of her bitterness until she sees to her daughter's maturation
and final happiness. The so-called ten Tamakuzura chapters are required
before the pacification of Yugao's soul is accomplished. Through all those
years in death she is perceived and depicted by Lady Murasaki as wholly
outside the paradigm of the Six Realms; instead, she floats just offstage,
ever guarding her daughter. Genji and Tamakazura seem aware of her
presence on that eery night when they keep the seventh-month watch fires
burning.

From the poetry of the *Man'yō-shū* (Ten-thousand leaves anthology)
through sixteenth-century fiction, one finds again and again coexisting
with the new *rokudō* taxonomy great continuity with that view of the
soul or *tamashii* that predates Buddhism and continues even today—a
belief that people's spirits float bodiless near where they have died or are
buried; that these spirits can somehow inhabit such places and come back
to them from time to time; and that when doing so they can assume their
original form and costumes. Hell and the Six Realms, when they are used
in literature, are most often employed either as metaphor for the varieties
of experience in people's lives in this present human realm or to provide
a flaming, agonizing backdrop to wandering souls. The great majority of
Muromachi-period Nō plays, for instance, are based firmly on concepts
of soul and death that reflect pre-Buddhist demonology (despite the ubiq-
uitous Buddhist priests and their chanting of *sūtras*). This demonology
was extremely important to both Kan'ami and Zeami. Such literature in-
cludes works that utilize superbly the metaphorical implications of Hell
and the *rokudō*, but the constituent pieces of the paradigms have been
disassembled and restrung in philosophical disarray. *Tamashii* move not
in the Six Realms cycle but across time into several *dō* at once, or they

[15] Fujii Sadakazu, "The Relationship between the Romance and Religious Observances:
Genji Monogatari as Myth," *Japanese Journal of Religious Studies* 9, 2–3 (June–September
1982): 127–146.

exist in none, clinging to the place of their greatest love, deepest hate, or greatest pain.[16]

Although Murasaki Shikibu wholly rejected it, some decades later the author of *Sarashina nikki* (Sarashina diary) and her sister were inclined to like the idea of reincarnation. They were convinced, as the result of a dream the sister had, that the charming cat they had found and were taking great delight in spoiling was actually the reincarnation of the daughter of the chamberlain major counsellor.[17] They toyed with the idea of telling the dead girl's father about the cat but never did; it seems half a game of "let's pretend" and half a "maybe." True belief would have elicited a different response.

Clear knowledge of the conventional Chinese Buddhist iconography, but a charmingly playful lack of seriousness, can be found among poets as well. One among many such examples would be a poem by the daughter of Suguwara no Michimasa included in the eleventh-century collection *Shūi waka shū* (Anthology of poetic gleanings). After viewing a sketch for a painting of Hell, she writes:

Mitsusegawa	Hades Three-current River,
wataru misa mo	yet no sign of a ferryman's pole.
nakarikeri.	And after disrobing,
Nani ni koromo o	on what, I wonder,
nugite kakuran?	is one to hang up one's clothes.[18]

In Japanese fiction reincarnation has always retained an aura of foreign exoticism, be it in the tenth-century *Taketori monogatari* (Tale of the bamboo cutter), the eleventh-century *Hamamatsu Chūnagon monogatari* (Tale of Hamamatsu), or the twelfth-century *Matsura no Miya monogatari* (Tale of Matsura no Miya),[19] and the same is apparent even in modern Japanese literature. Mishima Yukio without a doubt felt compelled to

[16] I do not discuss the extremely important Japanese concept of *onryō* (ireful ghosts) in this chapter despite its obvious relevance to the Japanese view of death, not only because it is a large subject that deserves full study in and of itself, but also because it is not directly related to the Buddhist *rokudō* and Jigoku-Gokuraku paradigms on which this study focuses. For a useful overview of this issue see Ichiro Hori, *Japanese Folk Religion* (Chicago: University of Chicago Press, 1968), pp. 44ff.

[17] For an English translation of the *Sarashina nikki* see Ivan Morris, trans., *As I Crossed A Bridge of Dreams* (New York: Dial Press, 1971). The cat episode can be found on pp. 58ff.

[18] *Shūi waka shū, Go Shūi waka shū* (Tokyo: Yuhodo Bunko, 1926), p. 104.

[19] "The Tale of the Bamboo Cutter" is translated by Donald Keene in J. Thomas Rimer, *Modern Japanese Fiction and its Traditions: An Introduction* (Princeton: Princeton University Press, 1978), appendix. For a translation of *Hamamatsu Chūnagon monogatari*, see Thomas H. Rohlich, *A Tale of Eleventh-Century Japan (Hamamatsu Chūnagon monogatari)* (Princeton: Princeton University Press, 1983).

place part of his final tetrology in a foreign (Indian) setting in order to make his reincarnation theme somehow comfortable for his Japanese readers.[20] In *Hamamatsu Chūnagon monogatari*, too, several twists of plot depend on reincarnation back and forth across the seas between China and Japan, which only seems to underline the foreign, not fully domesticated flavor of the imported idea of metempsychosis, and to enhance the story's exoticism.

Pre-Buddhist concepts of death and the next world do not fall into obsolescence but either remain active options or else thread their way through the literature as parallel constructs in the growing complexity of Japanese death imagery. The image of Yamato Takeru's death in the *Kojiki* account is stunning—his soul transformed into a giant white bird soaring away into the skies, his wife and children running distraught with grief through the fields after the bird, cutting their feet on the stumps of bamboo reeds, weeping, then plunging waist-deep into the ocean as the bird wings out over the sea beyond reach. This is neither metaphor nor rebirth into one of the Six Realms; it is metamorphosis of a wholly different nature.[21] In the *Nara-ehon* story, *Tsukihi no honji* (The origin of the moon and sun), two children abandoned to die on an island are saved by their deceased mother, who, in the form of a great white bird, flies from the world of death to the island and feeds her starving children (fig. 9). These intriguing examples of great-white-bird metamorphosis, one departing, the other returning to the world of the living, imply a thousand-year continuum that needs further exploration.

In this limited space it is not possible to cover all of the great wealth of evidence observable in the intimate literature. In summary, most notable in both poetry and fiction is the enduring quality of the pre-Buddhist perception of "the other world" and the continuum of *tama* or *tamashii* spirits that inhabit the sites where they have died or who live in or around their grave mounds. Also remarkable is how little attention is paid to problems that would be inherent in death were Hell or cyclical rebirth in the Six Realms firm articles of common faith. One of the most intriguing aspects of Hell and Six Realms imagery when it does finally appear, particularly in Nō plays and war tales, is its accuracy of canonical detail, on the one hand, yet its disregard for overall paradigm integrity, on the other. To cite an example, in Kan'ami's *Motomezuka* (The sought-for grave), the soul of the maiden of Unai lives a curious composite postmor-

[20] See in particular Yukio Mishima, *The Temple of Dawn*, trans. E. Dale Saunders and Cecelia Segawa Seigle (New York: Alfred A. Knopf, 1973).

[21] Ian Levy discusses this imagery in literary terms in his excellent study *Hitomaro and the Birth of Japanese Lyricism* (Princeton: Princeton University Press, 1984), pp. 19ff.

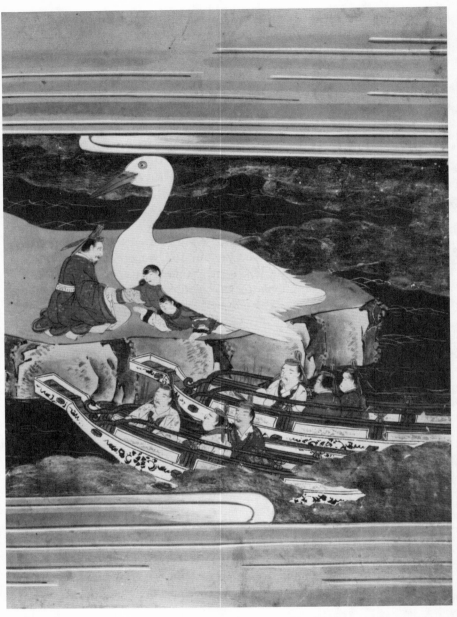

9. A deceased mother returns in the form of a great white bird to save her children's lives. *Tsukihi no honji*, one-volume *Nara-ehon*, early Edo period.

tem existence.[22] She hovers about her grave, sometimes in her original body, sometimes in disguise, and sometimes formless. She is also tortured in various specific hells, and at the same time she moves inside and out of her tomb, which is also seen as a place of refuge.

Among the most favored themes in Japanese literature were the pain of excessive passion, wrongful clinging, anxiety over others, overly fond and lingering memories, and crazed obsessions of jealousy, love, or hate. Such excesses lead to murders, betrayals, adulteries, suicides, and spirit possession of others. Even the pre-Buddhist *tamashii* (spirit) is bent and tortured by such passions of attachment beyond the grave. One of the most striking motifs related to death to be found throughout Japanese literature concerns the emotional pain felt not by the bereaved (though that theme too exists widely) but by the deceased. Even after death, the deceased continues to be emotionally fixated in love or in wrath on someone who remains behind in the mortal world or, as the case may be, even on someone who has also since died but with whom there is no encounter in the world of the dead. This combination of pre-Buddhist *tamashii* plus the Buddhist explanation for the soul's unrest—the passionate attachments felt by the dead that draw them back from the next world time and time again—is exploited brilliantly in poetry, dramatic texts, and fiction.

Buddhism focuses on man's passionate attachment to himself and to his clinging to beloved people and things around him. His ardors and his desires are the source of pain. More than anything else, Buddhism was and is a religion designed to cure or ameliorate the suffering of passions, the fear of the separation caused by death, and the pain of mourning.

Buddhism, of course, has not been alone in isolating attachment and obsession as the chief source of human pain or developing it into a religious structure involving "sin" and the need for "salvation." Philippe Ariès, writing of the Roman Catholic Church, points out the central position of *avaritia* in Catholic theology. Though Christian thought attributes emotional pain to being in a state separated from God, there are nonetheless profound similarities in the teachings: "The Church condemned both the love of human beings and the love of things, for either one separated the self from God." Its condemnation was addressed toward "excessive attachment to *temporalia* or external things, to spouses or worldly friends or material wealth, or to other things that men have loved too much during their lives."[23]

It is not an accident that to counter man's passionate love of life, both Buddhism and Christianity employed images of death, warning that it is

[22] For an English translation see Donald Keene, ed., *20 Plays of the No Theatre* (New York: Columbia University Press, 1970), pp. 35–50.
[23] Philippe Ariès, *The Hour of Our Death* (New York: Alfred A. Knopf, 1981), p. 131.

useless to become too enamored of life and our attachments since all in-
evitably ends in death. Was it then Buddhism per se, or was it that partic-
ular universal truth concerning the inevitability of death, which Bud-
dhism was able to address, that spoke to the Japanese and won their
acceptance?

The Next World in Painting

The visual iconography supplied by Buddhism that appealed to the Jap-
anese, especially in painting, was also focused on specific concerns.[24]
From among the rich variety of imported Chinese Buddhist images, Jap-
anese found most congenial three categories and adapted them to their
taste: (1) the depiction of life's passions—those things that give man his
greatest pain as represented in a great array of detail in the *rokudō* paint-
ings; (2) the semi-anthropomorphic depictions of a pantheon of saviors
and protectors such as Kannon and Jizō addressing themselves to our
earthly troubles or assisting us after death; and (3) depictions of Amida
or others coming down at death to take us to Paradise (the *raigō* paint-
ings), which please, soothe, comfort, allay fears, and give courage and
hope before death. Implicit behind all three was the existence of a
Heaven, a Paradise, as depicted in the Gokuraku paintings, to which ev-
eryone hoped one day to find his or her way, and to which it was believed
loved ones could go. Whereas pre-Buddhist perceptions included life be-
yond this one in another existence, the imported idea of Paradise was a
vastly more comforting improvement on the pre-Buddhist view of *yomi
no kuni* or even *tokoyo no kuni*.

Irrespective of the message that its adherents intended to bring to con-
verts as Buddhism was introduced to Japan, and irrespective of the doc-

[24] In discussing the death paradigm in painting, it should be pointed out that literature
and painting, as source materials, do not supply the same range of perspective. A distinction
must be drawn between commissioned works (most extant premodern Japanese paintings
and religious/didactic writ) and noncommissioned works (poetic diaries, poetry, essays, and
most *monogatari*)—works created, as Murasaki Shikibu said, because one has been "so
moved by things, good and bad . . . one cannot keep it all to oneself." Not satisfied with the
picture I was getting from the didactic literature (*sūtras*, commentaries, *setsuwa* collections
written for proselytizing purposes) as to what the Japanese lay population actually believed
about such things as Jigoku, Gokuraku, and *rokudō*, I went to their intimate literature and
found a different and enlightening picture. Unfortunately, in painting one does not have
that option. There is very little in all of non-*suiboku* Japanese painting, as far as I can tell,
that can be identified as having been painted out of personal experience and as pure self-
expression. Most extant painting was commissioned not only for specific purposes and
functions (though we do not know in every case precisely what those were), but to illustrate
a text or message. The inability to compare commissioned and noncommissioned works in
the visual arts dealing with death, therefore, is a handicap to be kept in mind.

trines stated by its most articulate spokesmen, it was without any question, as one sees at once from the intimate literature and painting, the new idea of a Paradise after death that first captured the Japanese imagination and has held it firmly throughout the centuries. To Japanese this was a new idea, and there is vivid testament, both in text and image, for the start of it all.

The inscription on the silk-embroidered Tenjukoku mandala of the Chūgūji in Nara is believed to date back to the time of Empress Suiko in the seventh century. It relates an incident that suddenly leaps to life by virtue of its universal humanity and its poignant realism. After a long, dry listing of genealogy, names of pairs wedded and subsequent children born, suddenly there is the wife of Shōtoku Taishi bereft at her husband's death:

> Then Tachibana no Ōiratsume was deeply grieved and sobbed with grief. She spoke to the reverend Empress: "I cannot put my sorrow into words. . . . My Ō-kimi always said: 'This world is only vain and passing; the real truth however is Buddha. . . .' As reward my prince is therefore reborn in the Land of the Long Heavenly Life (Tenjukoku). Now I cannot see with my own eyes the actual shape of that land. Therefore I beg you for a representation of it. I long to see the great prince in the way he lives there and is reborn."[25]

This was still at a time before the deification and special worship of Shōtoku Taishi himself. Ōiratsume strains to imagine this new postmortem world, so much more comforting to contemplate than a *yomi no kuni*. It is true that the eighth-century *Nihon shoki* describes Shōtoku Taishi as having gone to the "Pure Land," yet clearly his wife is not describing the Pure Lands of Amida or Miroku. The "Land of the Long Heavenly Life" seems closer to *tokoyo no kuni*—the far-off island to which only the most powerful sages find their way for eternal life.

The visual iconography of the Tenjukoku mandala itself is wholly compatible with this textual evidence and represents a Japanese view of the next world as evolving into a paradise. It is an homage to no recognizable Buddha or bodhisattva nor to Shōtoku Taishi himself. It is precisely what Ōiratsume longed for most: a window, a looking glass through which she is able to see depicted before her the postmortem world in which the husband she has lost now resides and whereby she can envisage his new and happy existence (fig. 10).

As has been seen, Japan was innocent of any idea of a punitive Hell and a rewarding Paradise prior to the introduction of Buddhism. But then, as

[25] The original text, reprinted in Sakaino Kōyō's *Shōtoku Taishi-den* (Tokyo: Bummeido, 1904), is discussed and translated in J. H. Kamstra, *Encounter or Syncretism: The Initial Growth of Japanese Buddhism* (London: E. J. Brill, 1967), pp. 379ff.

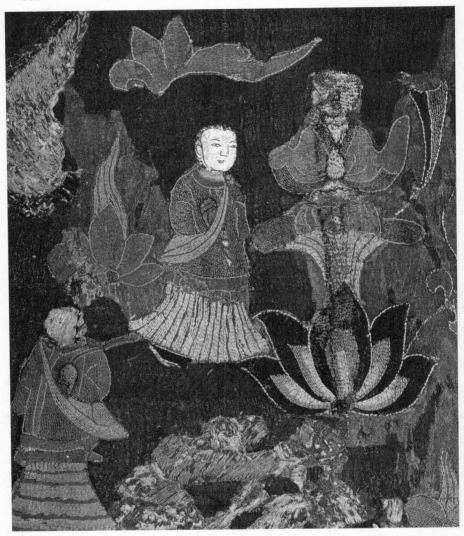

10. Detail from the *Tenjukoku mandara*. Embroidered wall-hanging, seventh century.

one examines these paradigms around the world, it is clear that the diverse cultures of humanity have rarely initiated on their own, spontaneously, the idea of a punitive Hell after death—adding a morality to the fact of mortality. The earliest record of a postmortem judgment is from Egypt, but the idea of a fiery punishment seems to have been born in the Assyrian plateau and spread to the East through India and China to Ja-

pan, and to the West through the Near Eastern Judeo-Christian tradition.[26]

In the West, Heaven and Hell represent a system of moral procedures based on punishment of evil and reward of virtue. But what about Japan? The evidence suggests that despite the heavy Confucian emphasis on rewarding virtue and punishing vice, and despite the native premises that purification and proper ritual will be rewarded by health and prosperity whereas laxness will bring disaster, still the Japanese paradigms of Jigoku and Gokuraku, once evolved, were quite a different matter.

Jigoku, despite appearances, exists not to execute the retribution of an implacable God as we find in the Judeo-Christian tradition or even as one cog in an inexorable system, as with karma, but, by depicting revolting punishments for evil human acts, to help us to despise the human world and all its illusory charm, and thereby to enhance our longing for Amida's Paradise. This is one of the central differences between Jigoku in Japan and Hell in the West, despite the terrifying punishments inherent in both. Textual and visual evidence suggests that by medieval times Gokuraku was rarely seen as a reward for virtue (even when it is explained that way) except for saints and heroes. On the contrary, it was most often in the intimate literature achieved by ordinary people despite lack of virtue, as an indulgence granted by a parent-like divinity out of compassion, love, and, to use Doi Takeo's now famous term, *amae*.[27] (This term derives from the verb *amaeru*, which Doi, a psychiatrist, isolates as behavior stemming from a basic longing to be loved and indulged even when we do not deserve it, and likewise a tendency to indulge loved ones who long to be spoiled.) Paradise became all the more treasured because Amida or Jizō, or Kannon, would be compassionate, would *amaeru* us, indulge us as weak and flawed, and save us anyway. This belief is behind the overwhelmingly popular assumption of "Paradise after death" on all levels of the intimate literature as far back at least as *The Tale of Genji*, and of the popularity of the Amida and Jizō *raigō* paintings.

So different from the deathbed scenes in the West, with Satan and Christ fighting over the departing soul like jealous lovers, early and medieval Japanese literature and paintings that show the moment of death depict no denizen of Hell determined to trick the departing soul into perdition, but only the appearance of or the anticipation of a compassionate savior. The element of the Paradise paradigm that penetrated Japanese society most widely and deeply was the savior coming to welcome one

[26] S. G. F. Brandon, *The Judgement of the Dead: The Idea of Life after Death in the Major Religions* (New York: Scribner, 1967), pp. 19, 47ff.

[27] Takeo Doi, *The Anatomy of Dependence*, trans. John H. Bestor (Tokyo: Kodansha International, 1973).

into Paradise. Amida rises over the nearby hills and descends to one's bedside like a loving parent to retrieve one's sick and dying soul from the painful life of this world. Remnants of colored ribbons that would have stretched from the painting to the dying mortal's hands can be seen attached to the hands of the Amida *raigō* figure painted on the Kamakura-period Konkaikōmyōji screens, for instance (fig. 11). Such ribbons were attached also to Amida statues, thereby giving the dying a tactile link to the savior who was about to lead them to paradise (fig. 12). Awesome, remote Chinese deities such as Amida become humanized under the Japanese brush. Intimacy between parental savior and lay believer became a hallmark of Japanese Buddhism.

One of the most moving depictions of this Japanese partiality for a parental, caring savior can be found in the Amida at Zenrinji known familiarly as the "Mikaeri Mida" or the "Amida who glances back." This unusual Amida statue from the late twelfth century is symbolic of the *kaeri-raigō* (returning to Paradise) paradigm. Instead of Amida depicted as coming to meet us at death, Amida has already come for us and is leading us back home to Paradise. Yet, unlike other *kaeri-raigō* depictions where Amida leads the soul home, eyes forward like the leader of a parade, this Amida lovingly, like a parent, glances back over one shoulder encouragingly, as if to say, "Are you following me all right? Everything's going to be fine" (fig. 13).

There is no way to appreciate how Japanese received the imported concept of Hell without noting the remarkable transformation of Jizō. By the late twelfth century, Jizō, who entered Japan as a formalized abstract Chinese bodhisattva, had been transformed by the Japanese into a thoroughly human-looking savior who belongs to this world. One is stunned by the depiction of Jizō in the fourteenth-century *Yata Jizō engi* scrolls (fig. 14). He has been rendered into a gentle Japanese priest so human, so much a part of the real world, that he would appear perfectly natural walking down the streets of Tokyo even today.

One cannot help but also be struck by the similarity between this figure of Jizō and the image of Jesus in Western art. Both are depicted as familiar human beings in the context of their own society. Both are gentle to children and compassionate with sinners. Both come into the human world to offer their own bodies as substitutes and to suffer for others. Both are capable of going into the fires of Hell to save people. Each has an implacable counterpart: Jesus, the Judaic Yahweh; Jizō, the Judge of the Dead and Lord of Hell, Emma Daiō. In the Japanese case, Jizō helped to neutralize the uncongenial grotesqueries of Jigoku, acted as a go-between with Emma Daiō (who never once has taken off his Chinese garb throughout Japanese history), and sometimes even countervailed death by bringing the sinner back home for an extended life on earth.

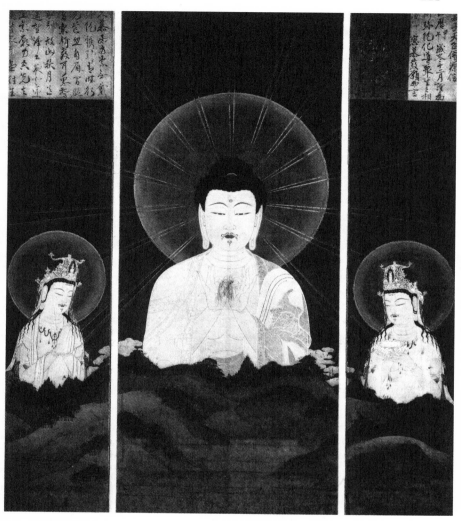

11. Attended by Kannon and Seishi, Amida appears from over the mountains. Remnants of five-colored ribbons are visible between Amida's thumbs and forefingers. Three-panel screen, Kamakura period.

Most astonishing, in the context of art history, an enigma awaiting further study, is the almost identical and simultaneous appearance in Italy and Japan, respectively, of complex iconography depicting, in one composition, Jesus/the Last Judgment/Hell on the one hand, and Jizō/the Ten King-judges/Hell on the other.

The Italian example, the oldest version of this iconography, is the gi-

12. A dying nun sits holding the five-colored ribbons attached to a stature of Amida. Detail from *Hōyake Amida engi*, two-scroll *emaki*, 1355.

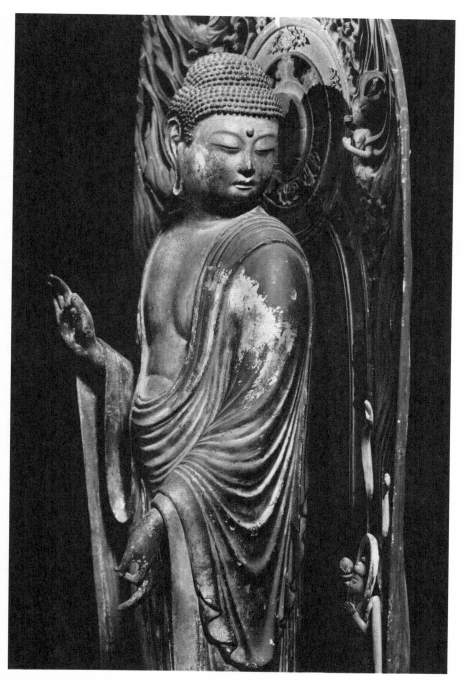

13. Mikaeri Mida, the Amida who glances back. Wooden sculpture, 77 cm high, twelfth century.

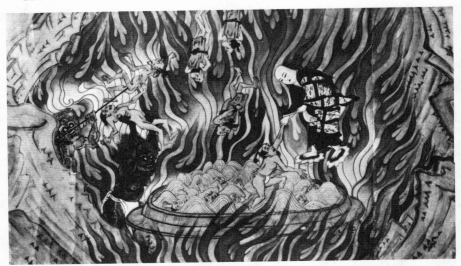

14. Jizō rescuing a man from Hell. Detail from *Yata Jizō engi*, fourteenth-century *emaki*.

gantic early twelfth-century mosaic on the wall of the Cathedral of Tor-
cello outside Venice (fig. 15). In the mosaic Jesus stands as the large cen-
tral figure at the top with archangels Gabriel and Michael at each side
and the twelve apostles, the Last Judgment, and Hell arranged in a com-
plex composition of five tiers beneath him. Like Jizō in *Yata Jizō engi* who
gently lifts an astonished and grateful sinner from the boiling, flaming
cauldron, Jesus too, a demon beneath his foot, reaches down and lifts a
man from the fires of Hell.

Upon seeing the mosaic for the first time one immediately thinks of the
enormously similar complex composition of the thirteenth-century *Jikkai
zu* (Depiction of the ten worlds), a hanging scroll owned by Zenrinji, in
which Jizō is the large upper-central figure and the Ten King-judges and
scenes from Hell are arranged in six tiers top to bottom. Even more star-
tlingly similar is the sixteenth-century hanging-scroll version of the Kon-
gōsanji Jizō composition now in the Nara National Museum (fig. 16)
where Kichijōten and the eleven-headed Kannon have been added on
each side of Jizō, as Gabriel and Michael stand beside Jesus, and where
the details of Hell and Judgment and Amida's salvation are depicted in
even greater and more similar detail.

In both compositions the whole paradigm of punishment in the world
after death and salvation by a compassionate intercessor between the
dead and a fearsome deity is arranged in tiers and separate scenes that are
strikingly similar to each other and yet in content or emphasis unlike the
depictions of death, Hell, and the next world in other cultures.

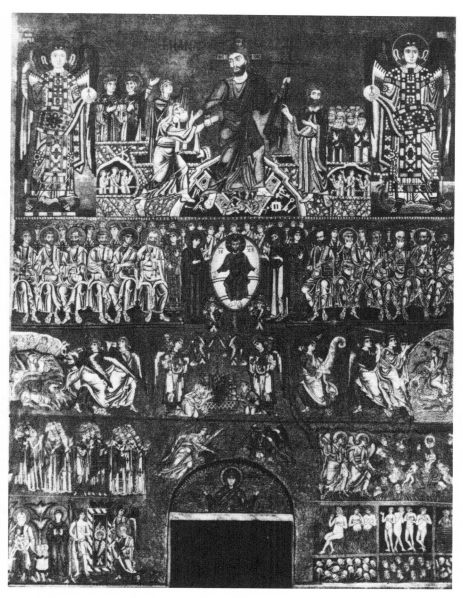

15. Christ, the fires of Hell at his feet and Michael and Gabriel at each side, raises an ancient patriarch from the dead. Below are scenes of the Universal Judgment, including the weighing of souls and the dead in Hell. Early twelfth-century mosaic of the Last Judgment on the west wall of the Cathedral at Torcello, near Venice.

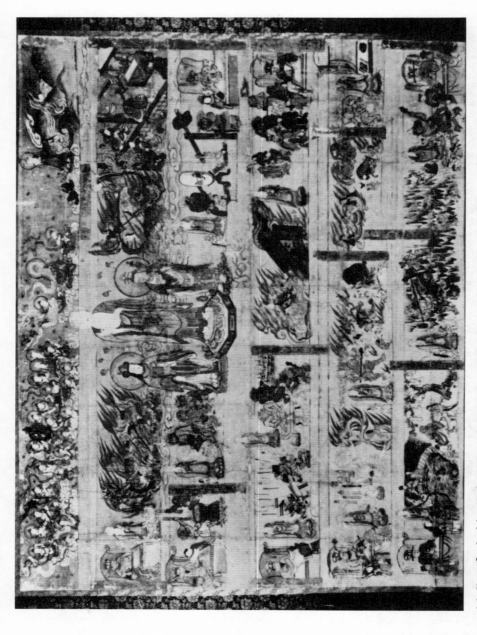

16. Jizō, flanked by Kichijōten and the eleven-headed Kannon, in a complex composition containing the ten King-judges and scenes of Hell similar to the twelfth-century *Jikkai zu* owned by Zenrinji. *Yata Jizō maigetsu nikki*, sixteenth-century hanging scroll owned by Kongōsanji.

"Simultaneous invention" would be an easy answer, but perhaps too easy. In these vastly different cultures, secular painting had almost nothing in common, yet Jigoku painting was similar not only in content but in layout, design, and complex iconography. Thus, a great deal more attention must be given to the possibility that throughout the centuries there was more direct and indirect contact, and more mutual exposure to religious symbols, between the Near and Far East than has heretofore been recognized.

Jigoku Meguri: Tours of Hell

The human race throughout history has been fascinated by the idea of being able to visit the world of the dead. Such visits have been described in profuse numbers from thousands of years B.C.E. to the present day—from the world of Osiris in Egypt to Homer's Odysseus, to Gilgamesh in Mesopotamia, Mu-lien in China, Izanagi and Nichizō in Japan, and on around the world in every major culture right down to today. There are in the bookstores at present accounts written for the general reader by serious medical investigators about people who have "died" and "come back" and who tell us what they saw on the other side. There are explicable psychocultural reasons for wanting to visit the world of the dead or the next world, given that there is belief in such a realm or even merely a hope that it exists. But what is one to make of the wish, the dream, the obsession also found around the world to visit Hell?

One of the most interesting categories of both Jigoku literature and Jigoku painting in Japan is known as *Jigoku meguri* or "Tours of Hell," the first example of which is found in the ninth-century *Nihon ryōiki*. Surely Hell is a peculiar place to want to visit: people are being slashed by knives, torn limb from limb, boiled in molten metal, and beaten with scourges by monsters. Yet the *Jigoku meguri* theme is widespread among cultures whose religious institutions have employed the paradigm of punishing hells as a didactic tool.

In Christian tradition, following the earliest example, the *Apocalypse of Peter* from the first century, "Tours of Hell" or "Visions of Hell" were written in great numbers by people who claimed to have had out-of-body experiences that took them off to view Hell's horrors: Thespesius, Saint Paul, Furseus, Drihthelm, Alberic, Tunsdale, Thurcill, and many more wrote in their own words of their own experiences. During the peak period, between the twelfth and fifteenth centuries, descriptions of Hell become more and more elaborate, and Heaven (which had been part of the itinerary as well) faded more and more into the background. Irrespective of details, however, almost all of these works make use of the same pat-

tern employed by the Japanese monk Kyōkai in the *Nihon ryōiki*. In that pattern a person "dies," finds himself lost in an unknown territory, and is taken by a "guide" to the scenes of Hell's fires, filth, boiling lakes, and demons with torture instruments who manage, in both East and West, to inflict a remarkably similar repertory of punishments for a remarkably similar array of sins. The visitor then "comes back" and recounts the horrors he has seen, usually claiming to have had as a result a religious awakening that manifests itself as a recognition of the expediency of better behavior, and thereafter leads an exemplary life.

One cannot help but realize, however, as one reads about Hell in the literature of both East and West, what a traumatic effect the didactic use of depictions of cruel tortures has had on children. In the early twelfth century Alberic, at the age of eight, fell into a nine-day coma and experienced a vision of Hell. He came back with a full-scale, burning horror story straight out of the *Apocalypse of Peter*, to which he must have already been exposed. The Zen priest Hakuin (1686–1769), though he had no out-of-body experience, was at age "seven or eight" so profoundly traumatized by his first visit to a temple, where he heard a priest's description of Hell's torments, that shortly thereafter in the bathtub with his mother, when the iron tub started to rumble beneath them as the maid added the wood to the flames below, he "let out a cry of terror that resounded throughout the neighborhood" and, determining that there was little hope for him, decided at that moment to "leave home to become a monk," which he did.[28] It seems important for our purposes, however, to separate such childhood experiences of nightmare and fright from that which we are trying to determine as religious faith.

Although the earliest extant examples of *Jigoku meguri* are textual, the genre surely entered Japan from China, where T'ang-period Tun-huang *pien wen* materials make it clear that such stories were performed using illustrative paintings.[29] The most famous of the Tun-huang *Jigoku meguri* stories is that of Mu-lien, "The Great Maudgalyāyana Rescues His Mother from Hell,"[30] a work that became well-known in Japan as well. In China from at least the eleventh century on it was a practice to display paintings illustrating the Maudgalyāyana story during the seventh-month festival of the dead. In any case, the *Jigoku meguri* genre soon found its home in the Japanese *emaki* and later in *Nara-ehon* formats. Classic ex-

[28] From the *kambun* text appended to a letter dated December 26, 1741. Translated by Philip B. Yampolsky, *The Zen Master Hakuin: Selected Writings* (New York: Columbia University Press, 1971), pp. 115ff.

[29] See the numerous books and articles representing the definitive work on this genre by Victor H. Mair.

[30] An English translation of this work can be found in Victor H. Mair, *Tun-huang Popular Narratives* (Cambridge: Cambridge University Press, 1983), pp. 87–121.

amples of the genre are the *Kitano Tenjin engi emaki* and *Yata Jizō engi* mentioned above.

It is not accidental, I think, that following the tradition of the *arhat* Maudgalyāyana, visitors to Hell depicted in Japanese iconography often have extraordinary powers and, by crossing the barrier into the world of Hell, manifest those powers in shaman-like fashion. One of the earliest is the ascetic Nichizō, who at the end of the *Kitano Tenjin engi* scrolls of 1219 is whisked off on a puff of black smoke for a tour of Hell. Further, one must keep in mind the long pre-Buddhist tradition to the effect that the tellers of the past, the *katari-be*, were, among other things, placators of the earth deities and calmers of the spirits of the pre-Buddhist dead. Thus, not only the characters depicted in *Jigoku meguri* accounts but those who narrated these stories fit congenially with the early pre-Buddhist shamanistic tradition.[31] Whatever the case, however, the *Jigoku meguri* tradition was a serious didactically intended genre.

Jigoku Yaburi: The Wrecking of Hell

Japanese seem to have invented another type of visit to Hell. The earliest example I have been able to find is mentioned textually in the *Azuma kagami* (Mirror of the east country; entry for 6/4/1203), where Nitan no Shirō Tadatsune finds a cave at the foot of Mount Fuji (then still an active volcano and under which at least some of the vast number of Buddhist hells were said to be located).[32] Instead of contenting himself with just going down for a look around, he enters with six armed men and does battle with Hell's demons, resulting in casualties on both sides. The age of resisting the disgraceful proceedings in Hell had started, and with it emerged a new theme in Jigoku literature and painting known as *Jigoku yaburi* or "The Wrecking of Hell." By the Muromachi and early Edo periods, Japanese writers were even rather enjoying the burlesque of Hell.

In *Yoshitsune jigoku yaburi* (Yoshitsune's wrecking of Hell), an ascetic is traveling the Azuma road near Mount Fuji when Fuji Daigongen appears as a fearsome *yamabushi* and offers to take him on a tour of Hell. He gives the ascetic a *yamabushi* shawl to put over his shoulders so as to assure his safe travel back and forth. But when they get there an extraordinary event takes place. It happens to be the Bon festival holiday in Hell, and the place is virtually empty of souls, manned only by a few demon-guards. Taking advantage of the opportunity, Yoshitsune storms out of

[31] See Carmen Blacker, *The Catalpa Bow: A Study of Shamanistic Practices in Japan* (London: George Allen and Unwin, 1975).

[32] A partial translation of *Azuma kagami* is appended to Minoru Shinoda, *The Founding of the Kamakura Shogunate, 1180–1185* (New York: Columbia University Press, 1960).

the Realm of the Asura with both the Heike and the Minamoto united behind him; he attacks Emma Daiō's headquarters, secures the crossing over the Sanzu River, and wipes out, with the help of his great war companion, Benkei, all the 136 hells and the Asura, animal, and *gaki* realms as well (fig. 17). In the end, they chant the Nembutsu, ask the Amida trinity to come down for them, and all, including Emma, float off to Paradise.

In *Asaina monogatari* (The tale of Asaina),[33] the hero is a famous strongman who, having defeated the strongest of mortals, cannot rest until he can compare his strength with that of the *oni* (demons) in Hell. After prayers to the gods and a big bottle of *sake* he falls into a drunken sleep, whereupon little *oni* emerge all around him and dance. He chases them across the Sanzu River and to the castle of Emma. In a great show of his famous strength he flattens the gate to Hell and dispatches large numbers of *oni* (fig. 18). Enormously impressed, Emma gives a banquet in his honor and some of the remaining *oni* sing and dance for him. When he awakes, the words of their songs stay in his ears. He realizes the inevitability of death; a changed man, Asaina ends his life by becoming a Buddha and going to Paradise.

This narrative is based on a Kyōgen play of the same name well-known during the late Muromachi period;[34] it actually quotes from the play an anticlerical passage that belittles priests who do Jigoku-Gokuraku sermonizing. The parody of Hell being expressed by both the Yoshitsune and the Asaina stories makes clear the sentiment that without the help of priests and sects, by our own strength, we can defeat the strange, non-Japanese likes of Emma Daiō and his *oni* and get to Paradise on our own after we die.

An Age of Horrific Imagery?

It is regrettable that disciplines other than art history have made so little use of the visual media from the past, and that likewise art history has, except in rare cases, remained relatively untouched by literary and sociological debate. In the vacuum a sort of sociopolitical hermeneutics has

[33] Also read "Asahina." An early Edo-period *emaki* version of this tale is owned by Chester Beatty Library in Dublin. For the text and full photographic reproduction see Barbara Ruch et. al., eds., *Zaigai Nara Ehon* (Tokyo: Kadokawa Shoten, 1981).

[34] Numerous Kyōgen plays make fun of Hell and of Emma. The usual theme is that Hell has fallen on hard times and is virtually deserted; everyone is going to Heaven, and Emma can hardly justify his existence. He tries to figure out ways to sidetrack souls on their way to Heaven, but they always outsmart him. Examples are *Bakuchijūō* (A gambler beats the King of Hell), *Seirai* (Seirai, the bird hunter), and *Yao* (A sinner with references).

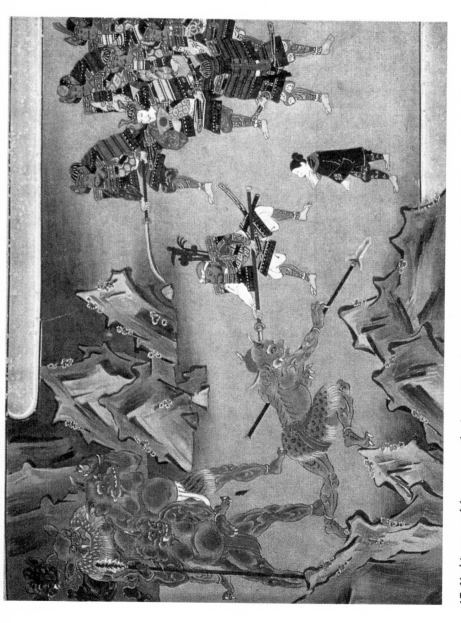

17. Yoshitsune and forces cross the Sanzu River, break down the gates of Hell, and defeat Emma and his demons. *Yoshitsune jigoku yaburi*, two-volume *Nara-ehon*, early Edo period.

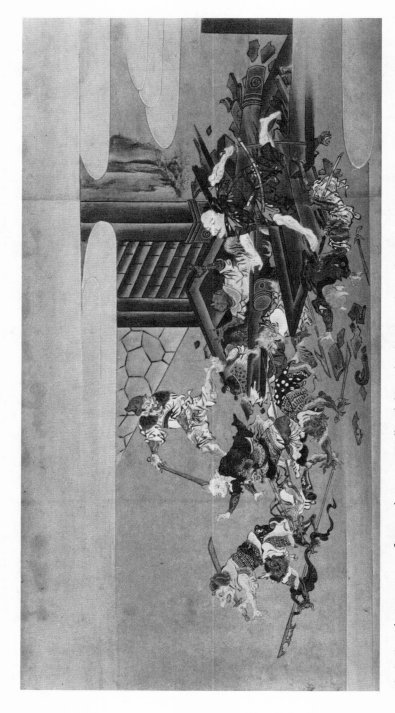

18. Asaina, the strongman, flattens the gate to Hell and dispatches large numbers of demons. Detail from *Asaina monogatari*, one-scroll *emaki*, early Edo period.

often been presented as explanation of fact. Sociopolitical developments in history are invoked to hypothesize on the causes of creativity and on the implicit meaning behind the iconographic depictions of scriptural content. Jigoku and *rokudō* scrolls are a case in point. One finds stated, time and again—it has now become the orthodoxy—that these works were engendered by the social upheaval and uncertainty of the late Heian and early Kamakura periods, which drove men to Pure Land faith, and that it was the social uncertainty of this new age that nurtured the concepts of grisly hells and the *rokudō*. One is told that in an age of nation-wide confusion and social uneasiness, when the aristocracy, which had thrived for centuries, was being replaced in power by the newly risen warrior class, people meditated more and more on the degeneracy of the age, and that the Jigoku, *gaki*, and *rokudō* scrolls are an expression of that disillusionment. In fact, it is almost impossible to run across a reference to Jigoku, *gaki*, or *rokudō* scrolls that is not prefaced in the cultural and art histories by such an apologia.[35]

Granted, there is much to learn about the appeal of these works—who commissioned them, for whom, and especially why. Needless to say, unless we take into account the entire context of Japanese history, religion, and culture out of which these works were born, our understanding of the meaning and function of these scrolls (and the literature connected with them), their production, use, and audience will remain incomplete. Such statements as related above, however, are disturbingly simplistic. They ignore almost everything that was going on in painting during those very same years; they ignore, in fact, the whole inherent character of native forms of Japanese painting, and they seem to be talking about scrolls looked at solely through the aperture of canonic Chinese Buddhist subject matter rather than through the Japanese painter's or beholder's eye.

Since the mid-ninth century, the native Japanese style of painting more than anything else expressed a strong sense of pleasure in the known world. Whether the subject matter was famous scenic spots, local shrines and temples, the parade of seasons, or, in narrative voice, a depiction of people of this world, blowing their noses, barked at by dogs, dancing, and dying, the so-called Yamato-e style had always been a celebration of this world. And if it was the twelfth- to fourteenth-century age that was at fault and brought on a "rush of horrific imagery," then how does one account for that very same twelfth- to fourteenth-century "engendering,"

[35] See, for example, Ienaga Saburō, *Jigoku zōshi, Gaki zōshi, Yamai zōshi*, in *Nihon emakimono zenshū* (Tokyo: Kadokawa Shoten, 1960), vol. 6, English summary; John M. Rosenfield and Elizabeth ten Grotenhuis, *Journey of the Three Jewels: Japanese Buddhist Paintings from Western Collections* (New York: Asia Society in association with John Weatherhill, 1979), pp. 152–153, 157; and Shimbo Tōru, *Jigoku Gokuraku no e* (Tokyo: Mainichi Shimbun-sha, 1984), introduction.

simultaneous to the Jigoku/*rokudō* "gloom," of such an astonishing abundance and variety of other scrolls that lovingly detail not only landscapes and seasons but the manners, customs, festivals, pilgrimages, fictional works, adventures, and glorious miracles of compassionate deities? Clearly, "social unrest," "disillusionment," and "degeneracy" did not throw their ugly shadows on these contemporaneous works.

Gaki: The Starving Ghosts

The *gaki* scrolls (depicting the realm of the *preta* or the starving ghosts-in-limbo) have been particularly ill appreciated, I feel. Of all aspects of *rokudō* painting, the *gaki* world seems to me the most creative. It is in the depiction of *gaki* that one finds a revolutionary plethora of new painting styles whose characteristics need to be explored and understood better than they are—from the surrealistic *gaki* of *Kitano Tenjin engi* to the endearing *gaki* of the Sōgenji version of *Gaki zōshi* (The account of starving ghosts) now in the Kyoto National Museum.

The variety and care apparent in the Japanese adaptations of *gaki* iconography suggest that perhaps more than any other of the Six Realms, with the possible exception of the human realm, the *gakidō* struck the most inherently sympathetic chord in Japanese hearts. From time immemorial, long predating Buddhism, the Japanese worldview had included ancestral souls who needed offerings and care and for whom obligations were felt. There was inherently sympathetic soil in which the imported idea of *gaki* could grow.

The twelfth-century Sōgenji version of *Gaki zōshi* is a testament to Japanese eclectic inclination—a tendency to soften by omission or silence, to seek ways around hard-and-fast dogma, to bring the transcendent down to the real world, and to control the awe-full by humanizing it. The scroll stands in dramatic contrast to the Kōmoto *gaki* scroll in the Tokyo National Museum, which is more rigidly canonical. Despite its opening scene in a Japanese interior, the latter is virtually an illustrated digest of the horrors of *gakidō* as prescribed in the Buddhist scriptures introduced from China. *Gaki* not only suffer intolerable hunger and thirst, but they are driven to eat excretia and carrion and are tortured by demons and vultures (fig. 19). The horrors are relentless; the *gaki* suffer hopelessly. It was this tradition in *gaki* painting that was least congenial to Japanese sentiment.

But the Sōgenji version, in my view, both extricates itself from the rigid Chinese canon and defies the "horrific gloom" pronouncements of modern scholars. I do not believe the Sōgenji scroll was meant to be ugly or shocking. The longer one contemplates this scroll, the less gloom one sees.

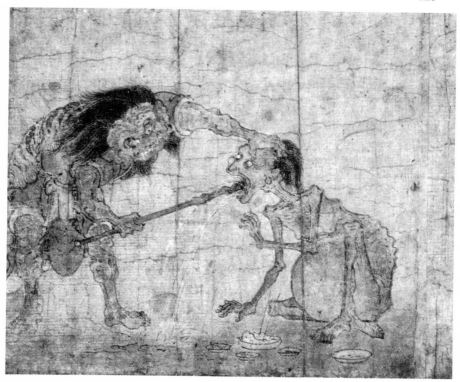

19. The *gaki* not only suffer intolerable hunger and thirst but are tortured by demons. Detail from *Gaki zōshi*, twelfth-century scroll formerly owned by the Kōmoto family.

The poor common folk in the marketplace in the opening scene, though shabbily dressed, seem full of spunk and have a healthy air about them; they have pink cheeks, are plump and well fed, and seem to be going about their business serenely and even with pleasure (fig. 20). The presence of the *gaki* seems just as normal, as starving beggars have always been in a premodern city scene (and starving beggars abound in a wide variety of *emaki* totally unrelated to the *rokudō*). One is certainly not struck by any particularly outstanding technical excellence in the painting style of the Sōgenji version; it in no way approaches the Kōmoto version in this regard. But without a doubt, the painter of these *gaki* has succeeded in communicating in the most uncanny way their loneliness, grief, and suffering, and in wringing pity and compassion from the viewer. In this scroll the *gaki* are depicted as if they were indeed an untouchable caste, ignored benignly in towns as if they were dogs or cats. But the pain is not relentless, and the *gaki* do not suffer hopelessly. The scroll is full of

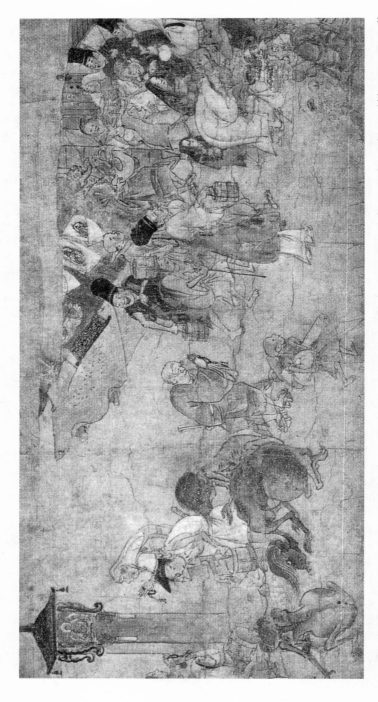

20. The common folk in the market place are cheerful, plump, and full of energy. Detail from *Gaki zōshi*, twelfth-century scroll formerly owned by Sōgenji.

love: gentle, good priests care and give attention (fig. 22); a soft, parental-looking Amida gives refreshment (fig. 21); and the *gaki* themselves are pitifully endearing. In the end as one sees them come running hopefully out of the woods, little arms held out eagerly, one wants to sweep them into one's arms and give them aid (fig. 22). The visual instruction this scroll gives as to useful Buddhist food-offering ritual and prayer suggests that the work was, among other things, a strong reminder to the viewer of the requirements of filial piety even after death; but the genius of this work is found in its passion. It is a painting that stirs deep affection for its subject.[36]

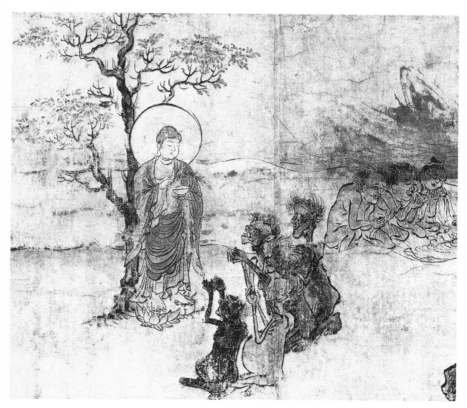

21. A parental-looking Amida gives refreshment to the *gaki*. Detail from *Gaki zōshi* (Sōgenji version).

[36] The Kōmoto version, too, seems underanalyzed. Although it is called *Gaki zōshi* by modern scholars, I feel that the *gaki* are used in this scroll merely as a motif, and that it is really a *rokudō-e*. (*Jigoku zōshi* and *Gaki zōshi*, by the way, do not appear as titles until the Edo period; only the word *rokudō-e* can be traced back to the period in question.) If one

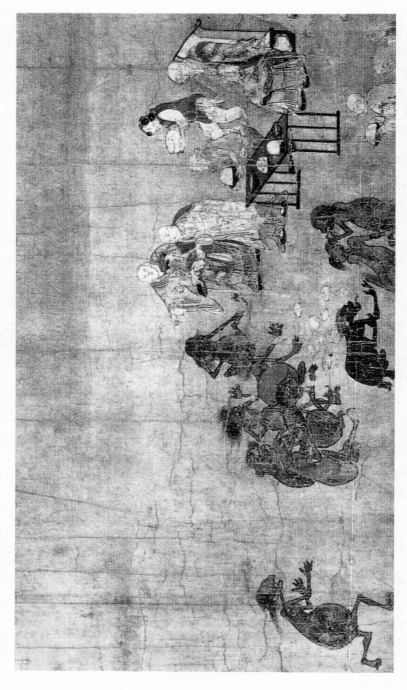

22. Gentle, good priests give food to *gaki*, who run out of the woods eagerly to receive it. Detail from *Gaki zōshi* (Sōgenji version).

In Conclusion

In studying death, we as scholars perhaps become distracted by the theological concerns of eschatology, by the geography and demographics of hells and heavens, and by postmortem juridical prescriptions concerning crimes and punishments as taught by Japanese religious founders and proselytizers. As a result, we have, I feel, often missed the dominant ingredient in the beliefs of the average Japanese person as revealed in early and medieval painting and intimate literature: the longing of the living for the one no longer here. Underlying every Japanese genre is an aesthetics of this incomprehensible sorrow. This suffering, a major motif, is with us both in this world and beyond where beloved and feared ghosts wander. The imported Buddhist paradigm of Hell, Heaven, and the Six Realms, as a totality, did not solve this inherent problem of grief that surrounds mortality. Out of the whole paradigm, only the concepts of merciful saviors and paradise as a destination for the dead did that. A quantum improvement on *yomi no kuni* or *tokoyo no kuni*, they provided a theretofore unknown comfort, a medicine for grief.

Early and consistent cultural bias in favor of concern for this present earthly world and a longing for a postmortem world of joy and reunion engendered in Japan numerous resistances as well as attractions and thus deviations from foreign paradigms. But it is apparent that nonclerical Japanese, in conceptualizing the next world, did more to the imported Buddhism than merely pick out one or two elements to embrace. A superbly illogical eclecticism of major scope resulted.

It may seem too broad a leap to raise here the name of the American poet Emily Dickinson, but Wendy Martin, in her book *An American Triptych*, writes: "In her poetry, Dickinson eschews an epistemological system based on absolutes, preferring confusion, even chaos if necessary, in order to evolve a framework that corresponds to her actual experience."[37] It is clear that the same can be said for the Japanese writers of *waka, nikki, monogatari, yōkyoku,* and *gunki*. Unlike Kyōkai's *Nihon ryōiki*, the women writers of Japan, and many of the men as well, did not depend on traditional Buddhist beliefs of Jigoku and *rokudō* to mediate their experiences and emotions regarding death and the next world.

looks carefully at the *Kōmoto* version one can see that the subject matter depicted in the first scene is perhaps the luxurious life of the *tenjindō*; the next three are not merely *gaki* searching for food, as usually described, but are indicative of birth, then sickness and then death (in short, symbols of the human realm); and finally, there is the torture of Hell, all of it brilliantly woven together by the presence of the *gaki* who move through the scroll touching, experiencing each aspect, and pointing it out, as if they were *etoki hōshi* themselves.

[37] Wendy Martin, *An American Triptych: Anne Bradstreet, Emily Dickinson, Adrianne Rich* (Chapel Hill, University of North Carolina Press, 1984), p. 81.

By the Muromachi age suffering in life, not in a postmortem hell, was widely held as a moral value. If one had suffered sufficiently from the passions of this world, as in the case of the hero of the medieval story *Bontengoku* (The heavenly land of Brahmā), for example, then one might become a bodhisattva outright, or one might even be allowed to reappear on earth as Amida himself to help others, as is found in *Saiki* (The tonsure of Saiki and his two wives). Suffering qualified one for future service and for Paradise itself. In the popular mind, suffering in life came to supersede in importance the suffering in death or Hell's tortures as taught by the Buddhist canon; it was *life's* pain that purged one and set one free.

In the West, Hell has a fundamental relationship to God. God made Hell as an eternal punishment. But who made the hells of Japan? I have not been able to find that the question was ever asked by the Japanese of those early days. The *kami* had made their land. As seen in the case of Fuji Daigongen, even a *kami* could guide one on a tour of a hell, if it happened to be located in his territory. Was Hell to be interpreted, then, as tales from so many steaming, smoking, belching locations around Japan's volcanoes and hot springs assert, a real place just a few miles down the road? Or was it a "next world" continuance just a time lapse away, or even abstract worlds beyond this one? Perhaps it was just a farcical fantasy. Or was it, as Kenreimon'in wearily recounts at the end of the *Tale of the Heike*, a state of body and mind into which each and every one of us will fall one day, and maybe more than once, *before* we die? No doubt over the centuries in Japan, depending upon the age, gender, or class of a person, it was all of these and more. To attribute to Japanese one view of death and the next world, and to call that taxonomy "Buddhist," would be unjust. Clearly, Japanese eclecticism did as much to the imported Buddhist paradigms as the imported ideas did to them.

Five

Seeing and Being Seen: The Mirror of Performance

FRANK HOFF

THE WORDS with which the British actor William Charles Macready (1793–1873) spoke of his own performance as Hamlet came naturally, for he spoke with considerable experience of the audience's part in making what he elsewhere calls "possession" possible: "the inspiration is lost, the perfect *abandon*, under which one goes out of one's self, is impossible unless you enjoy the perfect sympathy of an audience."[1] Macready, so ceaselessly troubled by the failure of the very sympathy he talks about, in time left his profession. A lifelong agony is recorded in his journals and a diary which, as published, fill two volumes with observations on how an actor fails to hold his audience.

Zeami (1363–1443) shared with this nineteenth-century confrere in the theater a curiosity for an interface between audience and performer. But codifying personal experience was more than an attempt to perpetuate a profession, and Zeami's concern was not alone with practical matters. For what he might have called a "Way" (*michi*), the practice and discipline of day-by-day training, was a spiritual matter. And though a concept such as this was hardly on the periphery of Macready's vision of theater, the work of certain of our own contemporaries, Grotowski and others, has made it so for us. A symbiotic relationship between "seeing" and "being seen," which Zeami explored, borders upon a philosophical or religious insight and remains a model of one type of theatrical experience.

It is helpful, at the outset, to note how naturally, once he had begun to conceptualize the otherwise practical matters of theater, Zeami did so through terminology and ideas already at hand in the intellectual climate of the day. The importance of Buddhism at the time, especially of Zen,

A German translation ("Sehen und Gesehen-werden im No") of an earlier version of this chapter was published in 1988 as part of Elisabeth Gössmann and Günter Zobel, eds., *Das Gold im Wachs: Festschrift für Thomas Immoos zum 70* (Geburtstag: Iudicium Verlag, 1988), reprinted with permission. I wish to take this opportunity to thank the translator, Karin Zobel. The present English version has benefited greatly from the need to rethink many passages of the earlier text in response to her queries.

[1] Richard Findlater, *Six Great Actors* (London: Hamish Hamilton, 1957), pp. 125–126.

makes it understandable that its thought and practice would provide him the clue, later in life, for an understanding of the joint experience of actor and audience.

In a short essay on Zeami's treatises entitled "Practice and Theory," Gotō Hajime, a Japanese historian of the performing arts, makes a concise statement of the relation between concepts inherited by Zeami from Buddhist thought of the preceding period.

> The *Fūshikaden* (Teachings on style and the flower) relates essential points of Kan'ami and Zeami's thought.[2] Of special importance are two of its sections that tell how to acquire proficiency in the art. The lifelong training and dedication described in these sections are the foundation of Zeami's Nō. When one thinks of Buddhism in the cultural life of Japan's Middle Ages, of Tendai, Shingon, and varieties of Buddhism in the Kamakura period, one is struck by theoretical and speculative matters. But in many respects, experience has priority over theory. A philosophy of Chinese Buddhism, for example, lies at the base of Dōgen's Zen. But when one reads that enlightenment comes from *zazen*, from "practice," then one realizes that Dōgen places emphasis upon how the "practice" of Zen, its everyday experience, secures enlightenment. The impression one has is that in practical Buddhism of the period personal experience is an important method toward understanding religious teachings and reaching *satori.* . . . Zeami was the recipient of a cultural tradition in the Kamakura period of self-awareness and creativity through personal experience.[3]

Another contemporary Japanese scholar and critic, Gunji Masakatsu, generalizes that, in contrast to the West, an aesthetician in Japan would ask, not how to define the beautiful, but how the artist may attain it.[4] In any case, practice and theory, for Zeami, interrelate and mutually fulfill one another. And day-by-day training flows uninterruptedly into performance and back again. Furthermore, a union of the spectator's activity—seeing—and that of the actor—being seen—could become the essence of theater in a period when religious and secular experience were undifferentiated.

In their own language, practitioners of theater in our own century have reached similar conclusions. Peter Brook notes: "The theater form is a collective experience between actors and audience in which, through various methods, an impression of a parallel reality is brought into being."[5]

[2] English translations of titles of Zeami's works are those given in J. Thomas Rimer and Yamazaki Masakazu, *On the Art of the No Drama: The Major Treatises of Zeami* (Princeton: Princeton University Press, 1984).

[3] Gotō Hajime, *Nō to Nihon bunka* (Tokyo: Mokujisha, 1980), p. 187.

[4] Personal discussion with Gunji Masakatsu in his home in Tokyo, August 1980.

[5] Richard Burgin, "An Interview with Peter Brook," *New York Arts Journal* 19 (1980): 5.

Takechi Tetsuji, a critic and man of the theater closely associated with traditional as well as modern Japanese drama, has this to say about the audience-performer relationship in Kabuki:

> It is an invariable law of stage speech in Kabuki that an actor does not consciously breathe while speaking. By sustaining a sense of tension (though to do so challenges the actor's threshold for physical pain) he wields a physical influence over his audience. Tension draws them along. Tension harmonizes or attunes the physiology of an audience which has become one with the actor. This is an audience's way of participating in creation.[6]

The avant-garde director Suzuki Tadashi notes that performance space in a small theater allows the direct link between spectator and performer that is absent from performance in a larger auditorium.[7] The presence, the very existence in the same room, of an audience is real for the actor as it can never be in a larger hall. For here the "line of sight" joining spectator to actor is an objective reality. So real, in fact, is the presence of the audience that it can be a terrifying experience. The actor senses the audience's presence; he feels it looking at him. Its very regard is a pressure, though a productive one Suzuki adds, for an actor within the small theater space creates not by himself alone. Creation is a joint activity: actor and spectator together create performance.

Zeami's earliest writing includes comment on actors who benefit from their understanding of how an audience relates to performance. The answer to the first of nine questions, contained in the "Mondō jōjō" (Questions and answers) section of the *Fūshikaden*, relays insights of his father in an area that Zeami continued to explore throughout his lifetime: How does a random group of people awaiting the beginning of a performance merge into a single unit? How does the audience become one with the performer at his first appearance?

A sense of timing—the term is used very much as it is in English to praise an actor's skill at choosing the right moment—is at question. But, characteristically of Zeami, the term has a hidden dimension. Day and night, seasons of the year, hours of the clock, the succession of nature, all cycles are regulated through certain temporal laws. Mastery of these, "timing" in that sense as well, contributes to the success of a performance. Zeami discusses practical matters of which any actor will be aware. Yet while making common-sense observations, he has an eye, as well, upon a principle of cosmic harmony.

In the "Questions and Answers" section Zeami describes how a noisy audience gradually settles down. It awaits a performer who will himself

[6] Suzuki Tadashi, *Engekiron: katari no chihei* (Tokyo: Hakusuisha, 1980), pp. 105–106.
[7] Ibid., pp. 100–106.

make use of their increasing tension. And their concentration grows as they anticipate his entrance and the first sound of his voice. The actor chooses the moment of greatest expectation. He adjusts the tone of his voice, at its first utterance, to correspond to a musical pitch proper to the instant, before anticipation, fully ripe, dissipates. The day's success is assured by a perfectly attuned note. The "hearts" of ten thousand merge in the actor's performance.

In a later treatise Zeami uses similar language. Again he describes the use a skilled performer makes of mounting expectation to time his first recitation.

> Coming from the green room, the actor goes down the bridgeway and stops. He looks out to ascertain the mood around him. When everyone is expectantly waiting, thinking, "Ah, he is going to say something," at that very moment he should make the first sound. The instant to begin singing in response to the *kokoro* (hearts) of the multitude, called *jisetsukantō* (the instant [of the first sound], corresponds exactly to the feeling [of the audience]).[8]

Nishio Minoru notes that the dramaturgy of Nō is sometimes said to center upon the principal actor. The technique at play in the passage above is not that of a single person, however. It is shared between performer and audience. With audience and performer as one, this mutual technique becomes a communal one.[9]

A vocal element of performance, as described above, brings about the coalescence of audience and performer. In another essay, *Ongyoku kuden* (Treatise on music and song), Zeami addresses a similar effect: "listener and reciter hear as one." He discusses differences between two types of recitation: *kusemai*, song for a popular dance style whose narrative had an important historical influence on Nō, and *tada-utai*, Nō's standard vocal style of an earlier period. After distinguishing characteristics of *kusemai* in the sixth section of the *Ongyoku kuden*, Zeami turns his attention to *tada-utai*:

> There is no rhythmic decoration in *tada-utai*. Since one sings words just as they would be spoken, word accents are undisturbed. Thus, in *tada-utai* there is apparent the true virtue of theater language. From *sashi-goto* [an unaccented vocal style close to normal speech] and plain words to single phrases and indi-

[8] From the *Jisetsukan ni ataru koto* (Matching the feeling to the moment) section of the *Kakyō* (A mirror held to the flower). Translations from Zeami's works are my own.

The concept of *kokoro* (literally "heart" or "mind"), central to the doctrines of Hossō and Zen, often called the Shinshū (heart/mind) schools of Buddhism, as well as to the question of the mutuality of performer and audience feeling discussed here, is the subject of Richard Pilgrim, "Some Aspects of *kokoro* in Zeami," *Monumenta Nipponica* 24, 4 (1969): 136–148.

[9] Nishio Minoru, *Dōgen to Zeami* (Tokyo: Iwanami Shoten, 1965), p. 226.

vidual stanzas, one listens intently, with the ears, and tranquilly, in one's heart, as singer and listener together respond to a feeling that arises from hearts hearing, as one, the same passage.

How does performance create "communal technique," what Peter Brook calls "a parallel reality"? It requires a performer able both to recognize the waxing and waning of audience attention and to take remedial steps and make adjustments when necessary. The first question in the "Questions and Answers" section outlines specific remedies that allow the performer to adjust his performance to his audience. When Nō's powerful patrons arrive early, it would be impolitic not to begin, even though the rest of the audience has not yet settled down. Remedial measures are needed to attract the latter's full attention. The actor should perform his first play with unusual emphasis, though normal circumstances dictate a technique that is measured and chaste at the outset. In this instance, however, he should move and recite with greater animation, to focus the concentration of both latecomers and members of his audience who have been there from the start. Though the expedient seldom works, adds Zeami regretfully, something must be done. With his long experience in the art, the actor instantaneously recognizes either tension or apathy in an audience's mood.

A similar link between the sensibility (kokoro) of spectator and performer is suggested in the "Hihan" (Judging the Nō) section of the Kakyō (A mirror held to the flower). Here Zeami warns against an overly spectacular production. He says that when too much is going on at one time— a performance where one climax follows hard upon another—the sensibilities of both performer and spectator become jaded. The actor is no longer able to discriminate, nor the audience able to judge the value of what the one is doing and the other seeing.

Later in this chapter I describe the audience as a mirror of the actor's dedication to his training and art. The audience had a practical role as well, for it was the measure of an actor's attainments. Amidst the intense competition of the day, audience approval or disapproval marked out one group for survival, another for failure. An actor of thirty-four or thirty-five should be at the pinnacle of his art, says Zeami. Unaided, however, even skills acquired over a lifetime are not adequate to secure a reputation for true excellence. For this, recognition is indispensable, and it is the audience's role to acknowledge a master.

Audiences came from different social classes, and for Zeami, the more widely based a reputation is, the securer it is. Yet ultimately a connoisseur audience in the capital bestowed "universal recognition" on the actor. And Zeami sought to improve the quality of his work by linking it inextricably with improving tastes in the city.

Zeami uses several expressions for "audience." Among these, Nishio emphasizes *shūjin* (the public at large), wishing to champion the idea that Zeami's audience came from all strata of society.[10] Zeami enumerates a cross section of the society of his day when he identifies places in the capital and in the countryside where his troupe regularly performed: at the imperial court, at the shogunal residences, at the homes of the lesser aristocracy, at large public spectacles, and at temples and shrines in all parts of Japan. At the time, Nō would seem to have been the national art that Nishio claims it to have been.

The latter part of the *Ōgi ni iwaku* (The most profound principles of the art of the Nō) throws additional light on the social aspect of the audience.[11] A troupe's prosperity requires its actors to be loved and respected, and enjoyed by people with a wide range of tastes. But it is ideal when a performer is praised by that audience whose capacity for judgment suits him best. It is to his benefit, then, to be seen by people of superior discernment.

Though the performer wishes to elevate an audience's power of judgment, he is not excused from concern with those whose perceptions are uncultivated. As he continues his discussion in the *Ōgi ni iwaku*, Zeami notes that countryside audiences never ceased to extol his father's acting. It is dangerous for an actor to lose the ability to move an audience that is not refined. He may one day stand in need of its support when his esteem wanes among superior patrons who now transfer their favor to his competitor.

> There are differing circumstances under which an actor can attain recognition. It is difficult for a skillful actor to be looked upon with favor by an audience whose powers of discernment are minimal. And, of course, there is no chance whatsoever that a clumsy performer will be recognized by a superior audience. The reason for the latter is self-evident. When a skilled actor fails to win the approval of an inferior audience, it is of course due to their lack of discernment.

Nonetheless, says Zeami, the knowledgeable as well as capable actor must seek ways of performing that can be enjoyed by those whose powers of appreciation are limited. The following suggests how far Zeami was willing to go in finding ways to interest a less refined audience, an effort whose reward would be their love and respect.

> Do not forget what it was like to perform earlier in your career, when your skill was limited and you were still a novice. For, recalling this, you can perform Nō, as time and place afford the occasion, so that even to the undiscerning eye it will seem "just the way it should be."

[10] Ibid., pp. 243–244.
[11] Chapter 5 of *Fūshikaden*.

The key to the need for continuing excellence is an actor's single-minded training and dedication throughout a lifetime, touching all areas of his art. Zeami calls this discipline (*keiko*).[12] It was Nishio's insight to locate the source of this idea within the cultural background of the Japanese Middle Ages, a period that produced, as a parallel to *keiko*, Dōgen's idea of *gyōji* (assiduous devotional practice).[13] Nishio advanced this hypothesis, one that has since been widely accepted by the scholarly world, even before evidence had been brought to light of the historical circumstances under which Zeami was influenced by Zen ideas and practice.[14]

The *Shikadō* (The true path of the flower), a volume on training, has religious as well as secular overtones. In its conclusion, Zeami discusses the positive effect on the actor's own devotion to training brought by improving the tastes of his audience.

A detailed examination of *keiko* such as the above could not be found in the past. Still, there were some older actors who quite naturally reached the level of skill described here. Criticism by members of the aristocracy and of the upper class was directed at the finer points of an actor's performance at an earlier time. But little critical attention was given to his weaknesses. Today the critical acumen of the aristocracy is higher than ever. They point out even the smallest of our faults. You cannot please them unless your technique is the most refined *yūgen*.

Judging performance is a complex process. To fault the execution of an individual's techniques is only part of it. Zeami summarizes what it means to judge (he calls it "having knowledge of Nō") at the conclusion of the "Hihan" section of the *Kakyō*. Offering a ladder of values, he enumerates steps in forming judgment.[15]

Of course one has to be able to tell whether details of particular performances are successful or not. But one must then set this aside to focus upon the performance itself. And then, putting that aside too, one must recognize the attainments of the individual actor. But then one must set about to forget him too, in order to go on to understand one's own emotions as a spectator looking on. And last of all, one forgets even this, to gaze steadfastly at Nō itself.

[12] The importance of *keiko* to an understanding of Zeami and the relationship of the concept to Zen is a recurrent theme in Nishio's essays, of which one published in 1961 is representative: "Zeami no geijutsuron no tokushitsu to Dōgen no eikyō," *Nihon bungeishi ni okeru chūseiteki no mono to sono tenkai* (Tokyo: Iwanami Shoten, 1961), pp. 351–368.

[13] Nishio, *Dōgen to Zeami*, pp. 102–103.

[14] See note 32 for examples of research into the historical relationship of Zeami to Zen.

[15] My translation incorporates points made in Nishio's paraphrase of the original. (Nishio, *Dōgen to Zeami*, pp. 233–234.) It also borrows, as explained later, from the interpretation found in Tanaka Yutaka, *Zeami geijutsuronshū* (Tokyo: Shinchosha, 1976), p. 151, n. 22.

A chain of dialectic, each statement negating its antecedent, then turning back upon itself, finally to affirm what at first it denied, is a characteristic way of thinking in the period. It has a counterpart in Dōgen's "circle": conversion, practice, *bodhi*, Nirvāṇa.[16] It was Zeami's habit to fluctuate between practical observations and a conceptual scheme that interlinks various steps of judging into a larger pattern. A dialectic of negation encourages one not to become fixated at one pole or the other, but to pay attention alternately to practical matters of stagecraft and to theoretical considerations.

Tanaka Yutaka, whose emphasis is upon another aspect of the passage, comments in this way: Zeami says that it is important to understand the performance, more important to understand the devices and techniques by which an actor makes it a success, but still more important to realize what processes go on within oneself as a spectator looking on. Omote Akira, on the other hand, associates the ambiguous word *kokoro* with the performer and not with the spectator.[17] My interpretation, in light of the theme of this essay, incorporates Tanaka's explanation: Zeami asks of the spectator an understanding of the techniques used by the performer but also of the processes by which the spectator himself experiences the performance. This includes the effects of performance techniques upon an audience member.

Actor and audience, "seeing" and "being seen," is a dialectic. For Nishio, the pair is particularly relevant, as well, to the contemporary search for a selfhood that is subjective yet simultaneously objective.[18] In the re-

[16] Nishio, *Chūseiteki no mono*, pp. 363–364.

[17] Ijichi Tetsuo, Omote Akira, and Kuriyama Riichi, eds., *Rengaronshū, nōgakuronshū, haironshū*, in Nihon koten bungaku zenshū (Tokyo: Shogakkan, 1973), 51:334, contemporary translation at foot of page.

[18] Nishio, trained in German philosophy, is said to have favored dialectic as a thought process. Recent anthropological interest in what is known technically as "reflexivity" offers the possibility of placing my discussion in a larger context. Emiko Ohnuki-Tierney cites Babcock's definition of reflexivity—the capacity of the self "to become an object of itself, that is, to objectify the self," in *The Monkey as Mirror* (Princeton: Princeton University Press, 1987), pp. 128–129, n. 1. Ohnuki-Tierney's definition of the expression "reflexive structure"—that is, "the concept of the collective self as defined in relation to the other"—bears closely upon my discussion of performer and spectator (see references in the index to her book under self, self and other, and reflexive self).

These correspondences are by no means fortuitous. The remote antecedent of the performance out of which Zeami's Nō developed was known as "sangaku"; its more immediate antecedent was known variously as *sarugaku* (see ibid., index headings: sangaku and sarugaku) and *sarugo*. These terms and their derivatives continued to be used of his theater, by others after Zeami, as for example in the countryside. *Saru* is monkey, the putative subject of Ohnuki-Tierney's volume, whose subtitle is *Symbolic Transformation in Japanese History and Ritual*.

The merging of audience and actor, the subject of my essay, could well be associated with Ohnuki-Tierney's view that the dualism of the self and other in the reflexive structure of the

mainder of this chapter I explore two interrelated ideas: the actor perfects his craft by seeing himself as a spectator would, and members of an audience see what happens on stage as though they themselves were performing.

It is well known that Zeami advanced the concept of an actor who acquires the ability to see himself as his audience does.[19] Elsewhere he enunciates a complementary idea: the art of the finest spectator is to enjoy an experience of performance that is the performer's own. In an essay of 1952 Nishio brought together the former idea, that the perfected actor sees himself as his audience does, a theory referred to as *riken no ken* (seeing at a distance), and Zeami's interest in a popular audience.[20] As an educator, Nishio felt the ideas belonged together since the training or education (if one might use these expressions) of an audience leads its members to an identification with the performer.

Because his treatment was a pioneering one, I would like to paraphrase Nishio's discussion of *riken no ken*.[21] Literally "to see with eyes at a distance," the expression *riken no ken* refers to the *shite* (the principal performer of Nō) seeing himself from the standpoint of his audience (the *mite*, or person who looks, as opposed to the *shite*, the person who does or acts). *Riken no ken*, as explained in the *Kakyō*, where it is discussed in detail, is necessary because dance is unrefined unless the dancer, as he moves, is entirely visible to himself. Of course, even with the unaided physical eye, he can see as he dances what lies in front of him, to his left and to his right. But he cannot see what lies behind him. Thus, the dancer has no choice but to look "with his heart." To do this he strives to "place his heart behind him" as he moves. Zeami epitomizes a performer's consciousness operating at two levels simultaneously by another succinct phrase: *mokuzen shingo*, "eyes in front; heart behind."

The question, then, is how to attain the state of *shingo*, "heart behind." The answer is for the *shite* to assume the standpoint of the *mite*. Taking

Japanese is not a static one. "Because the other is a transcendental self, the self must forever reach for the other." The author goes on to associate this striving "at the collective level" with "the desire to reach for the other [that] has propelled the Japanese to emulate and surpass the superior features" of other cultures (p. 136). The central ideas in this chapter could also be examined in light of an emerging discourse about visuality as represented by Jonathan Crary, *Techniques of the Observer: On Vision and Modernity in the Nineteenth Century* (Cambridge: MIT Press, 1990).

[19] Susan Matisoff has translated and introduced a major part of an article by Yamazaki Masakazu in which he discusses the topic "The Aesthetics of Transformation: Zeami's Dramatic Theories," *Journal of Japanese Studies* 7, 2 (Summer 1981): 215–257. See also Michiko Yusa, "*Riken no ken*: Zeami's Theory of Acting and Theatrical Appreciation," *Monumenta Nipponica* 42, 3 (Autumn 1987): 331–345.

[20] Nishio, *Dōgen to Zeami*, pp. 196–211.

[21] Ibid., pp. 198–200.

the *mite*'s place means that the *shite* must discard *gaken no ken* (looking with one's own eyes). By negating a subjective way of looking, "with its grasping emphasis upon myself, myself," as Nishio puts it, the *shite* assumes an objective one. Zeami calls this "looking with the same heart as the audience."

Zeami would like the performer to acquire an ability to see himself by becoming a part of his audience's emotions. This is the way to achieve "heart behind." Zeami refers here not simply to what literally lies behind the performer, for he adds later:

> When one assumes the emotion of the spectator, one sees and understands with the mind's eye whatever part of oneself cannot be seen with the unaided physical eye. . . . If one really understands the principle of *riken no ken*, then one also understands the paradox that "the eye itself cannot see the eye."

The limits of what the subjective eye can see are transcended by the objective eye.

As a performer, Zeami's first wish is to understand his audience. He hopes, in this way, to enhance the pleasure it takes in what is seen, and perhaps even to ensure its enduring patronage. This leads to a desire to improve the sensibility and judgment of even its least promising member. At the conclusion of the section above, Zeami says that through a complete identification with the audience, the performer becomes totally visible to himself. His newly attained total vision makes it clear to others, as well, that this is an actor who has attained the supreme quality of *yūgen* in dance, "bright like a flower or jewel."

An actor judges performance. He wishes to know why one performance is successful, another not. He wants to know what makes one performer accomplished, another not. Perhaps it is useful to have a scale of evaluation. Questions of this sort are part of what is called *hihan* in Zeami's Japanese. At the conclusion of the "Hihan" section of the *Kakyō*, Zeami turns to the spectator as "critic."

The successful performance can move its audience in three ways: through the eye, the ear, or the heart. Zeami discusses each. When a performance is successful through the eye, the performer moves even members of an audience who lack familiarity with Nō, as well as those capable of full appreciation. What they see delights all concurrently.

Performing exclusively in this mode has a drawback, however. It is easy to give too much pleasure to an audience. Distracted by the excitement, spectators are not able to absorb everything; they fail to enjoy particular moments. Their experience becomes diffuse, fragmentary, and formless. The performer redoubling an effort to entertain is himself distracted. Neither *mite* nor *shite* retains the quiet moments needed to discriminate between good and bad. The performance is sickly. The performer needs to

know the cure. He must understand how to underplay, to pull in the reins. He needs to let the spectators' eyes and emotions rest a while. At least let them catch their breath, says Zeami. Maybe when they can once again pause from the endless onrush of emotion and take an unhurried look the performance will improve. The program will get better as it progresses, and there will be opportunity for emotion later. This is the first mode: Nō that appeals to the eye.

A performance effective through its vocal element can move its audience only if the performer is outstanding. Even then for those without a discriminating ear it will hold little interest. It falls on deaf ears, needless to say, when played outside the capital. But at the hands of a first-rate performer, the second sort of Nō improves from moment to moment. The problem is that if a less good actor follows, the remainder of the day's program worsens by comparison. A performer coming later in the day needs to be aware of the problem, startle his audience, and draw out their attention by adding variety to his performance. But be very careful, says Zeami: an actor is mistaken to let an audience in on his secret. They should not be able to guess that he is trying to keep alive the mood of the day. Only the vague sense that somehow or other "it is all getting interesting again" is what is needed. Specific devices are the performer's secret. Let them remain so.

The final mode of performance, that which appeals to the heart, is moving, yet why it is so is never quite clear. One is moved by a play of this sort when it comes after the exhilaration just described. Even the knowledgeable spectator may overlook so refined a performance. Audiences with less experience, like those in the countryside, will miss the point entirely.

The concluding remark contains a crucial reference to the symbiotic nature of experience in the theater:

> In general, you find spectators with a keen discernment of the technical aspect of performance but who do not really understand it. On the other hand, there are those who understand without discerning particulars. The best *mite* combines both: he has a keen eye but intelligence as well. . . . The *shite* who knows how to make the spectator enjoy the performance has the advantage in Nō. The *mite* who is capable of fine discriminations into the *shite*'s emotions and intention, and makes these the basis of his looking, is the *mite* who really understands what he sees.

A spectator who understands both the techniques and devices a performer has used to ensure success understands Nō. His understanding is of the *shite*'s heart, which has become his own. A performer's art is com-

plete when he sees himself as the audience does. The art of the spectator is complete when he sees by means of the performer's emotions.[22]

The process of the spectator's engagement with performance is analyzed in Zeami's treatise, the *Shikadō*, with a single long sentence of great subtlety at the conclusion of the section "Hi-niku-kotsu" (Skin, flesh, and bone). The very borderline between the functions of each is blurred here by the interchangeability of the experience of performer and of spectator. One editor of the passage raises the question whether readers of the text can ever feel certain as to who is the experiencing, recollecting, and judging subject—is it performer (*shite*), viewer (*mite*), or Zeami—as theoretician expounding his argument in the process of teaching the actor's art to his son, Motomasa. In fact, Motomasa himself may be the perceiving subject at certain places in the text. For is it not he who is being educated in a manner that combines in one person the functions both of seeing and being seen?

Zeami opens the section "Hi-niku-kotsu," the latter part of which contains the sentence in question, by noting three artistic qualities in Nō. He identifies these by technical terms borrowed from the aesthetics of calligraphy: skin, flesh, and bone. Only one great master calligrapher simultaneously combined mastery of all three, comments Zeami before raising the question whether the three qualities, or "styles" perhaps, can ever be combined in a single master of Nō.

Zeami locates (*zaisho*, where something is) each style in terms of how a particular quality of the performer is visually perceived by the spectator: the first two—bone and flesh—are "manifest" or "manifestly present" (*kenjo*; *ken ni arawaruru*); the third—skin—is visual by implication (*fū-shi*). At first Zeami's emphasis in the section has been upon furthering, through training, certain capabilities inherent in the performer. Now in the long concluding section, these qualities are discussed as ones that, having been apprehended by the spectator during performance, are recollected afterward as memories of what he had seen. This process—sep-

[22] David Salle, a postmodernist American visual artist, expresses an opinion about how the viewer should look at art that, with certain accommodations for the difference in media, might be thought to parallel the way Zeami encourages the spectator to look at performance through the emotions of the actor.

In an interview Salle describes the way he looks at paintings by another contemporary artist, Stella: "What I see when I look at one of Stella's early paintings is the figure of someone who made the decisions that resulted in something like that. Not really looking at the things so much in the formal sense of, you know, black on red, yellow orange. . . . Looking at his work is the imagining or positing the existence of an individual who made the decision that led to something like that." The interviewer interjects: "*Why would I have done that?*" And Salle responds: "Yes. If you were a painter, what would you have had to do in your personality to make a painting that looked like that? That's the most interesting part of the work for me." *Salle* (New York: Vintage Books, 1987), pp. 49–50.

arated not spatially but temporally (hence *riken*, by one interpretation) from the actual moment of live performance, *sokuza*—leads him toward an evaluative judgment.

The qualities are described in the opening passage:

> *Bone*. The performer who has natural talent improves effortlessly. Bone is what you see of his marvelous powers in performance. *Flesh*. When you see the result of techniques of dance and song brought to perfection through long training and practice, you see flesh. *Skin*. When the first two styles have been further refined through practice until an actor has attained the utmost of security, confidence, and beauty as well in his performance, you see "skin."

Zeami laments the absence of these qualities from the work of his contemporaries. In fact, no one seems even to have heard of them. He counts himself lucky to have at least had the chance to hear his father discuss an aesthetic that is no longer remembered. If one had to characterize today's performer, Zeami says, then one would say that what he does is skin, but skin not in the sense of the genuine style just described; today's actor imitates only the surface of his master's technique. His performance is skin in the pejorative sense, skin deep.

A performer who is master of all three qualities needs to understand a further point. He may possess each separately: the natural ability or bone; the style of dance and song perfected through long training that is flesh; and finally skin, the quality of *yūgen* as he moves on the stage. He may control each separately, argues Zeami. But he is not yet a performer who masters them jointly. This is the point Zeami's argument reaches before the long sentence that so astonishingly mixes the experience of performer and spectator— mixes styles of performance as the performer intends to project them and style as it is perceived in performance by the viewer and later reflected upon as memory that leads to judgment.

> What it means to have simultaneous mastery over all three is this. The actor develops the marvelous style of each as far as possible—to a level, in fact, from which he can go no further, the level of complete security and utter unself-consciousness about all he does on stage. The styles at the moment of performance are "absolutely fascinating," thinks the spectator, who is so enthralled by the marvelous things he sees that he loses the ability to judge.
>
> Afterward, however, the spectator reflects upon this carefully. The feeling that he receives when he does so, that no matter how he may choose to regard the performance there was nothing uncertain about it, is one that arises from the style of bone, brought to perfection after many years of practice; the feeling that the spectator receives, that no matter how he may choose to regard the performance there was an endless supply of interesting points in it, is one that arises from the style of flesh brought to perfection after many years of practice;

and the feeling that the spectator receives, that no matter how he may choose to regard the performance it was graceful (*yūgen*), is one that arises from the style of skin, brought to perfection after many years of practice. Then, drawing his conclusion from what remains of these feelings in his mind's eye after the performance is over (*riken no ken*), the spectator realizes for the first time that the *shite* is a performer who has mastered all three qualities at once: skin, flesh, and bone.

The word "spectator" is the subject of the phrase I translate as "thinks the spectator who is so enthralled by the marvelous things he sees" (*kenjo mo myōken ni bōjite*). The word *kenjo* (spectator) does not appear in the primary manuscript, and one editor notes that without the expression *kenjo mo*, which he supplements from reliable manuscripts, as do other editors, one could make a consistent interpretation of the passage by supposing that it is not the spectator who is referred to but the actor himself seeing the performance of yet another actor.[23]

The editor, Omote Akira, adds a further complication. He notes that it is unclear whether certain statements in what follows are to be understood as the explanation of the theorist, Zeami, or as a depiction of what goes on in the mind of the spectator. In a succinct comment, Omote points to a final ambiguity, one that is implicit in the subject of Zeami's discourse, in the Japanese he uses, and in the circumstances under which he is writing (to transmit experience to his son and student): the *mite* (person who sees) is identical with the person who is being instructed, and this too is a source of ambiguity.[24]

It would seem possible, then, that, in the mind of Zeami, the process of learning cast his son Motomasa, the recipient of the *Shikadō*, into the role

[23] *Rengaronshū*, p. 353, n. 23. *Kenjo* (under certain circumstances read *kensho*) is an expression of significance for a discussion of the role of spectator in performance. Nishio mentions five meanings of the word (whose constituent characters are literally *ken-*, "to see," and *-sho*, "place") as used by Zeami. See Hisamatsu Sen'ichi and Nishio Minoru, eds., *Karonshū, nōgakuronshū*, in Nihon koten bungaku taikei (Tokyo: Iwanami Shoten, 1961), 65:558, additional n. 33. The fifth definition is of special interest because of its Zen associations.

1. Place where audience/spectators sit.
2. People assembled in this place, hence audience, spectator.
3. What is unusual or outstanding about a performance. In this meaning it seems to have been read *midokoro*.
4. The eye, as this is seen from outside (perhaps sometimes read *midokoro* with this meaning).
5. Like the Zen expression *kenjo*, to come to understanding or enlightenment, in that sense to "see through," penetrate.

[24] *Rengaronshū*, p. 353, n. 30.

both of performer and of viewer. The same had also been true of Zeami at one time, for as a boy he learned from the hands of his own father, Kan'ami. It may be that the recurrent image of the mirror in Zeami's treatises, reflecting the key ambiguity examined in this chapter—seeing and being seen—arises naturally from the nature of learning in the tradition of physicality into which Zeami was born: a neophyte begins to learn by watching the body and hearing the voice of his master (the only living form the art can claim, after all) and by then translating these into his own body and voice. By reflecting his master, the pupil takes the first steps in the process of acquiring the art. This figurative way of speaking is my own, of course, and Zeami himself has said that the masterful performer never rests satisfied with the simple imitation of a teacher.[25]

Omote again notes that the subject is unclear in the phrase "Then, drawing his conclusion from what remains of these feelings in the mind's eye after the performance is over, the spectator realizes. . . ."[26] One reason to postulate "spectator" as subject is the verbal form, sometimes noted by Japanese grammarians as conveying something akin to the "amazement at discovery" that follows—*shite narikeru* ("this is a performer distinguished by . . .").[27] The editor notes of this verbal form that it sounds less like what one would expect of the theorist Zeami expounding an argument than like the expression of astonishment uttered when the spectator comes to this realization, having just "added [his own act of ratiocination] to the impression left in his mind after the performance."

The great Nō actor Kanze Hisao rendered this passage into modern Japanese as part of his complete translation of the *Shikadō*, published in 1969. In this, he takes the opposite view. While Omote assumes that the subject of the sentence is the spectator, for Kanze the subject is the actor himself, who "considers, as he is performing, his own image reflected in the eye deep within his heart where he and the spectator are one."[28] Kanze chooses this interpretation because he prefers to take *riken no ken*, "seeing from a distance" in this context, as a phrase that refers to a performer seeing himself from the spectator's standpoint. On the other hand, Omote interprets *riken no ken* here to mean that "the spectator has had a chance to reflect in his mind on the performance after it is over."[29]

Riken no ken is *ken* (sight with a desire to grasp and know the object) that is "separated-sight" (the native Japanese reading of *ri* in *riken* is *hanareru*). The mode of separation can be spatial or temporal. The seeing

[25] "An Art that Remains Eternal," second section of the *Shikadō*.

[26] Ibid., p. 353, n. 29.

[27] Ibid., n. 30.

[28] Kanze Hisao's translation is found in Yamazaki Masakazu, ed., *Zeami*, in Nihon no meicho (Tokyo: Chuokoron, 1969), 10:210.

[29] *Rengaronshū*, p. 353, n. 28, and translation into modern Japanese at foot of page.

(*ken*) can be that of spectator or performer. In the *Kakyō* passage, the subject of the discussion is the dancer who casts off "subjective looking" to identify with the view of the spectator. "To be separated" (*ri*) there refers to spatial separation: by becoming a spectator the dancer places himself and his eye away, in a spatial sense, from his own body's dancing form. At a distance and from the new position, the dancer sees what lies behind him (some interpret "beyond him" in a nonspatial sense as well), whereas *gaken*, normal, subjective, physical sight, only gave him knowledge of what lay concretely in front, to the right and left, of his dancing presence.

The context of *riken no ken* in the *Shikadō* passage delimits the meaning of the phrase less absolutely. There is room for difference of opinion. Omote argues in an extensive note on the phrase *riken no ken* that here Zeami refers to a temporal separation. He states:

> In this context there is no choice but to take *ken* as the seeing of the spectator. And the impression that comes subsequently, with the phrase, "Afterward, however, the spectator reflects upon this carefully," is that of "seeing at a distance." Thus, here the principal meaning of *ri* is that of temporal separation. *Ken* is close in meaning to *kenkan* (the feeling the *mite* has).[30]

Omote analyzes *riken no ken* with similar results in another context, that of a treatise of Zeami called the *Goi* (The five levels). It too refers to the spectator who reflects upon the performance experience after the performance is over. In fact, the justification for this interpretation of the meaning of *riken no ken* seems even stronger in the *Goi* context than it does in that of the *Shikadō* as just argued. *Sokuza*, as in the former, means "the very place and moment of performance." "Removing one's consciousness" in the *Goi* passage is the equivalent of "thinking carefully" in the *Shikadō*. The fact that the compound *kenkan* is used here, where it had been merely *kan* in the *Kakyō* passage, makes the case still stronger, since *kan* (the spectator's "feeling") is added to *ken* (the Chinese character is that for "to see," whose meaning, as used by Zeami, seems to be "the activity of the heart" when apprehending an object). Clearly, an expression as crucial as *riken no ken* needs to be examined, as Omote does in this instance, context-by-context.

To recall a performance after it is over—in fact, many years later—was a personal experience of Zeami on many occasions, no doubt. In a marvelous passage of remembering theater, where memory is used to validate the reputation of Kiami, an actor of an older generation, Zeami does not

[30] Omote Akira and Katō Shūichi, eds., *Zeami: Zenchiku*, in Nihon-shisō taikei (Tokyo: Iwanami Shoten, 1974), 24:471–472, additional n. 91. See also Omote Akira and Takemoto Mikio, *Nōgaku no denshō to geiron*, in *Iwanami kōza, Nō-kyōgen II* (Tokyo: Iwanami Shoten, 1988), p. 99.

make use of theoretical concepts. On the contrary, it is all very simple and personal: a man after his sixtieth year, talking with intimates, recalls what it was like as a boy of twelve to see a great performance by the actor Kiami, who, for the group listening to the conversation, had already become history.

Zeami recalls, in the ninth section of the *Sarugaku dangi* (An account of Zeami's reflections on art), that he once heard Kiami sing the *kuse* role in the play *Atsuta*. "He sang boldly and without trepidation. I still have the feeling of how magnificent his singing was." Earlier, in this collection of his *obiter dicta*, Zeami recalls what it was like at twelve to see and hear Kiami perform. He remembers details of his costume and recollects a phrase from a certain passage: " 'Once upon a time I was as brilliant and lovely as the flower-filled capital,' he recited in a straightforward manner, yet powerfully." Then, adding what is for us a unique glimpse into the art of connoisseurship, a brief insight into the spectator still at work as critic many years after the performance in question is over and when only its memory remains, Zeami says, "I puzzled about it afterward trying as best I could to understand why it had moved me so. As time passed the impression actually got better and better."

The remembrance of Kiami and Zeami's observation on this peculiar trick of memory, that certain impressions of a performance seen long ago improve with time, is a fragment of a conversation among friends and family. On the other hand, the passage examined in the *Shikadō* (completed in the sixth month of 1420 when Zeami was fifty-eight) comes from an integral work, very likely intended for Zeami's oldest son, Motomasa, training at the time in the art of Nō, and is argued consistently from beginning to end. Scholars point out that the appearance of this treatise marked a new stage in Zeami's writing as a theorist. His personal exposure to Zen, now well documented as a historical fact, preceded it by several years.[31] He utilized in the *Shikadō* his recent direct acquaintance with Zen to clarify a lifelong experience as a performer, teacher, and spectator.[32]

One would like to add, in a volume collecting views on Buddhism and the arts, that a subtle analysis of the symbiosis of spectator and performer

[31] For example, Kōsai Tsutomu, "Zeami no shukke to kie," in his *Zeami shinkō* (Tokyo: Wanya Shoten, 1962), pp. 40–68.

[32] The importance of this experience for Zeami as a theorist of performance is mentioned by Omote in an essay where he emphasizes the point that the appearance of the *Shikadō* marks a new phase in his development. "Zeami: Sono nōgeiron tenkai no jikiteki kubun," *Kōza Nihon bungaku 6, Chūseihen II* (Tokyo: Sanseido, 1969), p. 187.

The extent of Zeami's adaptation of words and phrases from Zen thought and practice to a vocabulary for theoretical and practical discussions of a performance aesthetic is clear from several works, including Kōsai, *Zeami shinkō*, pp. 20–39, and Konishi Jin'ichi, *Nōgaku kenkyū* (Tokyo: Hanawa Shobo, 1961), pp. 136–144.

and an unparalleled account of a process of judgment in evaluating the arts—the only way of protracting the otherwise once-and-only experience of performance—would not have been possible without the author's personal experience with Buddhism.

Emotion once experienced in the theater is remembered in the *Sarugaku dangi* passage, where a process of judgment set in motion by reflecting on it is also described. A person's religious experience is worked into Zen conceptual language in the *Shikadō* passage as Zeami explores the nature of perception and understanding in the theater. An actor's style resides, as well, in what the spectator sees, an experience thus jointly shared by both. Judgments may continue to be formed in the spectator's recollection long after the performance is over, judgments that, never perhaps ultimately finalized, become, instead, the knowledge of Nō.

Six

"The Path of My Mountain": Buddhism in Nō

ROYALL TYLER

IT IS COMMON knowledge that both Shinto and Buddhist elements may be found in Nō. Some plays present Japanese deities and some evoke thoughts of shamanistic ritual, while a great many are permeated with obviously Buddhist language. This chapter analyzes the themes of the plays in terms of certain key ideas about the world, in order to describe the Buddhism that is characteristic of Nō.

Earlier Definitions

In the past the Buddhism of Nō has been defined in two ways: as Amidism and as Zen. Arthur Waley distinguished the Buddhism of educated people and artists from that of the common people when he wrote: "It was in a style tinged with Zen that Seami wrote of his own art. But the religion of the Nō plays is predominantly Amidist; it is the common, average Buddhism of medieval Japan."[1] Waley included devotion to the *Lotus Sūtra* in "Amidism." It is hard to know whether Sir George Sansom subscribed to this nonstandard definition in his own summary of the subject:

> There is no trace whatever of direct Zen influence upon the language or the sentiment of the Nō texts, whereas they abound in the ideas and terminology of the popular Amidism of the day. . . . The indirect influence of Zen, however, cannot be exaggerated. The producers and the actors worked primarily for an audience whose aesthetic standards were those of Zen, and whatever may be said of the literary content of the plays, their structure, the method and the atmosphere of their presentation were in full accordance with the canons of Zen taste.[2]

This chapter previously appeared in the *Japanese Journal of Religious Studies* 14, 1 (March 1987): 19–52. Reprinted with permission.

[1] Arthur Waley, *The Nō Plays of Japan* (New York: Grove Press, 1957), p. 59.

[2] G. B. Sansom, *Japan, A Short Cultural History*, rev. ed. (New York: Appleton-Century-Crofts, 1962), p. 388.

Thus, Sansom acknowledged the absence of recognizably Zen doctrine from the plays and concurred with Waley's appraisal of the Buddhism of Nō as Amidism, but at the same time he stressed the importance of Zen for the whole art of Nō. Waley's and especially Sansom's distinction between Zen doctrine and Zen taste, though useful, raises problems that this paper does not address. It would be difficult to define what is necessarily Zen about the aesthetics of Nō, but it would also be difficult to prove that Sansom overstated the case.

In the meantime, however, D. T. Suzuki has left us with an overwhelming impression that the Buddhism of Nō is Zen through and through. He wrote, for example:

> During [the Kamakura and Ashikaga periods], the Zen monks were active in bringing Chinese culture into Japan and in preparing the way for its assimilation later on. Indeed, what we now regard as peculiarly Japanese was in the process of hatching during those periods. In them we may trace the beginnings of *haiku*, *nō-gaku*, theater, landscape gardening, flower arrangement, and the art of tea.[3]

Therefore, Suzuki could write of the play *Yamamba* (The mountain crone): " 'Yama-uba' is one of the Buddhist plays thoroughly saturated with deep thought, especially of Zen. It was probably written by a Buddhist priest to propagate the teaching of Zen." Suzuki must have had in mind the legend that *Yamamba* was written by the Zen master Ikkyū (1394–1481). But even if it was, the didactic writings by Ikkyū, or plausibly attributed to him, still reveal little that is unmistakably Zen doctrine; and the same can be said of *Yamamba*, although the play undoubtedly says nothing with which Zen in a broad sense need disagree.

Both definitions of the Buddhism of Nō, as Amidism and as Zen, refer to schools of Buddhism that are prominently active in modern times. The essential teachings of Zen and of the popular Amidist sects founded by Hōnen (1133–1212) and Shinran (1173–1262) are current, readily available, quite easily learned, and undeniably important. It is no wonder that they should have been invoked to explain aspects of Japanese culture. But while devotion to Amida does appear in Nō, Amidism as a concerted faith has not struck the imagination of the West, and the statements about Amidism by Waley and Sansom seem largely to have been forgotten. Zen, on the other hand, has been wonderfully publicized by Suzuki and many others, and it has drawn fascinated attention. Consequently, most people who know about Nō do not distinguish between doctrine and taste as

[3] D. T. Suzuki, *Zen and Japanese Culture* (Princeton: Princeton University Press, 1970), p. 39. The quotation about *Yamamba* immediately below is from pl. 419.

Sansom did, but take it for granted that the Buddhism of Nō is simply Zen.

Most Buddhist statements and expressions scattered through the texts of Nō support neither Amidism nor Zen. Moreover, there are two particular difficulties with these schools. The first is that while Shinto deities are prominent in Nō, neither Zen nor the Amidist sects are concerned with the Japanese gods. A passage in the play *Yōrō* says, "Gods and Buddhas only differ as do water and waves."[4] This is neither a Zen nor an Amidist position, though it is typical of Nō.

The second difficulty is that while the content of Nō, whether religious or literary, is conservative, Zen and the Amidist sects were relatively recent in the late fourteenth and early fifteenth centuries, when Nō was new. Nō in those days was a widely popular art, not normally a vehicle for religious innovation. Any religious position common in Nō was probably noncontroversial and founded upon centuries of general acceptance. If so, then the Buddhism of Nō is to be sought not in schools that were barely emerging early in the Middle Ages (1185–1568), but in the Buddhism that was completely respectable when the Middle Ages began. This Buddhism is diverse, difficult of access, and withdrawn from the modern world. There are few apologists for it, and none at all for its old understanding with the Shinto gods.

The Importance of Place

All Nō plays are precisely situated. Classical verse is full of the poetry of places and of place names, and strong interest in place may be found in much other writing of the centuries that precede the time of Nō; but it is remarkable that practically every Nō play contains a journey to a specific, named spot.

Most of the principal figures in Nō can be met only where they reside. The glad vision of the God of Sumiyoshi in *Takasago*, the melancholy dream of the girls of Suma in *Matsukaze* (The wind in the pine), and the horrifying recital by the lovers of Sano in *Funabashi* (The boat bridge) are all elaborate evocations of places known in poetry. Other places are distinguished by their association with the death of a warrior. Still others, popular pilgrimage centers whose legends were famous, customarily advertised themselves with these legends. Thus, *Chikubushima* celebrates the pilgrimage center of that name, a sacred islet in Lake Biwa; and *Ama* (The diver) promotes a temple named Shidodera on Shikoku.

The significance of place in Nō is heightened by the journey to the scene

[4] All translations in this chapter are the author's unless otherwise noted.

of the play. The recent arrival of the play's traveler ensures that impressions will be fresh and strong. In *Nishikigi* (The brocade trees), for example, one tastes with the traveler the true flavor of the village of Kefu and of the "narrow cloth" that is woven there. This flavor is conveyed by the man and woman whom the traveler meets there, two lovers who are forever together yet apart. If the traveler did not roam one would never visit Kefu; and one would know these lovers, if at all, only as figures in an old tale.

Often the traveler's wayfaring follows naturally from the story of the play, as in *Ama*, in which the minister Fujiwara no Fusasaki (681–737) goes down to Shikoku in search of his mother. In such cases one sees the key figure of the play through the eyes of a person whose karma has drawn him to the place.

In many plays, however, the traveler has no link with the place or with the person. If such a play presents a Shinto deity the traveler will normally be a Shinto priest, but in other plays of the sort he will typically be a Buddhist monk. The monk has no name, and the scene of the play is not his destination. He is simply passing through. In medieval Japan such religious rovers were normally attached to a home temple and traveled far, and wide, either on personal pilgrimage to other holy sites or to spread the fame and promote the fortune of their own establishment. Many engaged in ascetic practices either on their home mountain or on the mountains they visited; and these practices themselves constituted full acknowledgment of the power of place. One thing such religious wayfarers did was to pray wherever they went for the enlightenment of *muen-botoke*, the spirits of the dead who otherwise have no one in the world to pray for them. The dead absolutely required such prayers, as many Nō plays and medieval stories show, and the wayfarers did *muen-botoke* an essential kindness. Therefore, it is natural that Nō associates these travelers with the appearance of spirits attached to particular spots in the landscape of Japan.

Elements of the Buddhism of Nō

The monks in Nō do not on the whole make an issue of sect, nor do any of the other figures in the plays. A few travelers specify that they belong to the Jishū, for example, a popular Amidist sect that began in the Kamakura period; but their sect affiliation, and their sharp consciousness of it, are atypical.

The two great Buddhist schools of Heian and Kamakura times were Shingon, whose chief center was Mount Kōya, and Tendai, whose chief center was Mount Hiei; and to these should perhaps be added the older

Kegon (Avatāṃsaka) and Hossō (Yogācāra) schools based respectively at Tōdaiji and Kōfukuji in Nara. In principle, these schools, disagreed sharply on one doctrinal issue or another, and political rivalry among them could be fierce. It is not that the identity of a monk's home temple made no difference. The "school" affiliation of a figure in Nō, however, cannot usually be deduced from what one learns of his religious life. This is because a monk from almost anywhere could be doing almost any of the practices then common. Therefore, the following summary is about modes of faith or practice, but not about sects.

The Buddhism of Nō is composed of devotion to Amida (Amitābha), of faith in the *Lotus Sūtra*, and of elements of esoteric Buddhism (Mikkyō). By the Kamakura period Amida had been widely adored for centuries in Japan, both at court and among the common people. Calling Amida's name was a practice anyone might do. There were communities of Amida devotees associated with many great temples, including Kōfukuji and Mount Kōya. Most of their members were of modest rank in the religious life, and one may imagine some of the travelers of Nō as being from among them. There were also great lay gatherings to invoke Amida, like the one that is the setting for the play *Hyakuman*. On Mount Hiei, devotion to Amida was linked in the daily liturgy to chanting the *Lotus Sūtra*: Amida was invoked in the morning, and the *Lotus* chanted in the evening.

Faith in the *Lotus Sūtra*, like devotion to Amida, had been prominent in Japanese Buddhism for centuries. The Tendai school considered that its teaching was founded upon the *Lotus*, but the *Lotus Sūtra* was not at all confined to Tendai. Reciting the *Lotus* was an essential practice for a great many ascetics. En no Gyōja (fl. late seventh century), the half-legendary founder of the mountain ascetic tradition known as Shugendō (the way of cultivation of spiritual power), is invariably depicted sitting under the bird-shaped crag that is Vulture Peak (Gṛdhrakūṭa, near modern Rajgir in northern India), where the Buddha preached the *Lotus Sūtra*. The Bodhisattva Kannon (Avalokiteśvara), who was venerated at a great many sacred mountain sites, is prominent in the *Lotus Sūtra*. So is the bodhisattva Fugen (Samantabhadra), who appears in the play *Eguchi*.

Many of the travelers in Nō seem to have been "upholders of the *Lotus*" (*jikyōsha*). When a spirit begs to hear "the *Sūtra*," or declares its joy upon hearing "the *Sūtra*," it is the *Lotus Sūtra* that is meant. One could comfort a spirit also by invoking Amida, but there was a particularly intimate connection between the *Lotus Sūtra* and the spirits of the dead as they hovered about the places where they were bound to earth. This *sūtra* promised release to the lowliest and most lost of beings, and it affirmed at the same time the sacredness of the place where it was spoken, whether by the Buddha or by one of his followers, and whether upon Vulture Peak

or elsewhere. It was the *Lotus*, more than any other *sūtra*, that was cere-monially copied and buried on sacred mountains, or offered at the shrines of Shinto deities.

Esoteric Buddhism was everywhere in Heian and Kamakura Japan. A monk in a Nō play may say he is from Mount Kōya, but this does not necessarily make him more of an esoteric practitioner than if he came from elsewhere. Esotericism flavors Nō so thoroughly that few specific instances of its presence stand out. One finds a clear intuition that all things, animate or inanimate, are alive;[5] and that the seer and the world are not only of the same stuff, but thoroughly linked by correspondences of body, speech, and mind (*sammitsu*, the "three mysteries"). Shugendō practices were deeply colored by esotericism. The traveler in *Nomori* (The watchman of the plain) is a mountain ascetic (*yamabushi*), hence a Shugendō practitioner, who encounters a magic mirror. The sight of what the mirror shows can be borne only by one with divine power, and the traveler therefore invokes the esoteric deity Fudō (Acala, "The Unmov-ing"). When he gazes into the mirror, his eyes are the eyes of Fudō. This is the Esoteric Buddhist principle of *sammitsu kaji* in action: by invoking the deity with bodily gesture (*mudrā*), speech (*mantra*), and mind (con-templation) the traveler has become one with the deity.[6]

An Esoteric Buddhist motif that stands out in Nō is that of the twin mandalas, the Kongōkai (Vajradhātu, "Diamond Realm") and the Tai-zōkai (Garbhadhātu, "Womb Realm"). Although the iconography of this pair is exceedingly complex, the two describe complementary aspects of the cosmos and thus come to stand quite simply for wholeness: an appar-ent duality that is nondual. Thus, these mandalas may be evoked, as at the end of the play *Fujisan* (Mount Fuji), to describe the perfection of a sacred mountain; or they may even ornament, as in *Kinsatsu* (The golden tablet), the beneficent action of a god.

Shugendō and related matters deserve special note because mountain ascetics are so common among the travelers of Nō. If the traveler de-scribes himself as a *kyakusō* (guest monk) or speaks, for example, of Ha-guro, Kazuraki, or Omine, one knows that he is a *yamabushi* for whom

[5] For example: "In Exoteric Buddhist teachings, the four great elements [earth, water, fire and wind] are considered to be nonsentient beings, but in Esoteric Buddhist teachings they are regarded as the *samaya*-body of the Tathāgata" (Kūkai, *Sokushin jōbutsu-gi*, translated in Yoshito Hakeda, *Kūkai: Major Works* [New York: Columbia University Press, 1972], p. 229).

[6] *Kaji* is the Sanskrit *adhiṣṭhana*. According to Yoshito Hakeda: "The three mysteries inborn in men . . . are united with the Three Mysteries of Mahāvairocana. In other words, it is the basic homogeneity of man with Mahāvairocana which makes faith possible. Because of Kūkai's emphasis on the grace of the Three Mysteries, his religion has also been identified as the religion of "the three mysteries and grace (*sammitsu kaji*)" (*Kūkai: Major Works*, p. 92).

these sacred mountains are especially important. Such a man knows the *Lotus Sūtra*, and various esoteric practices and rites. The abbot of his home temple will probably be a monk of high rank appointed from either Mount Kōya or Mount Hiei, but the temple will be more directly run by a senior Shugendō adept who may be married.

Practitioners of this sort were often healers who worked, through a woman medium, with helping spirits (*gohō*, "protectors") and with ghosts of the living or the dead. Not all of them were permanently identified with Shugendō as an institutionalized tradition; and a successful healer, in particular, could rise high in the formal Shingon or Tendai hierarchy. Zōyo (1032–1116), for example, became abbot of Mount Hiei. Spirits, ghosts, and divine visitations were recognized then as normal, if never as routine, and religious persons of all sorts encountered them. Myōe Shōnin (Kōben, 1173–1232), the traveler in *Kasuga ryūjin* (The Dragon God of Kasuga), was a healer and visionary in touch with supernatural powers. One of these was the Kasuga deity, the Dragon God of the play.

Elements of Landscape

Japan is a mountainous country, and the typical sacred place in the Japanese middle ages was a temple or shrine associated with a mountain. Therefore, a mountain is the central element in the landscape of Nō. The other elements are the full moon, water, the water's edge, and a pine tree. These appear in a great many plays.

The mountain need not be heroic or distinctive. It may be only a hill or a hillock, or a range of hills. *Yama* (mountain) in Japanese refers more to shape than to size, and it does not distinguish between singular and plural. The hills behind the beach at Suma serve in several plays just as well as Mount Fuji in *Fujisan*; and so does the modest altitude of the island in *Chikubushima*.

Mountains in Japan were inhabited first by ancestral spirits who merged into a collective, divine presence, and this presence was worshipped by the living. In time, the concern with the afterlife characteristic of Buddhism led to the recognition of these mountains as the paradises of popular Buddhas and bodhisattvas. In fact, one mountain could easily support more than one Buddhist paradise. The most popular general model of a magic mountain was neither Shinto nor Buddhist, however, but an item of Chinese myth. This was P'eng-lai (Jpn: Hōrai), the mountain island of the immortals. P'eng-lai does not appear often in Nō, but it was prominent in Japanese lore.

The full moon is a well-known emblem of enlightenment in Buddhism,

but it had other associations too. The angel in *Hagoromo* (The feather mantle) is from the moon, and linked in the play with the bodhisattva Seishi (Mahāsthamprāpta); but when she dances in the climatic scene she also

> rains riches:
> prayers fulfilled,
> the realm replete,
> the seven treasures
> overflowing,

and so dispenses not only spiritual illumination but material plenty. Plenty was the object of countless prayers to all the gods, whose presence is here summed up in the moon. Moreover, the capital, the seat of the sovereign, was also associated with the moon. The "Moon-Capital" (*tsuki no miyako*) seems to have been imagined poetically either as the moon itself or as a moon-illumined mountain where the courtiers were "dwellers above the clouds" (*kumo no ue-bito*). The final scenes of most plays are danced under the moon.

The mountain of this landscape is bound to have streams running down it, and mountain streams certainly may occur in Nō. But more is made of the water below the mountain, which is ideally the sea. P'eng-lai rises from the ocean like a stone from an expanse of raked gravel, and even though it is not mentioned in *Chikubushima*, the rocky islet, rising from the broad waters of Lake Biwa, makes an unmistakable image of P'eng-lai. Mount Fuji was called "the P'eng-lai of Japan," and one has the impression that in this guise it somehow summed up all of Japan itself as a magic island in the sea. The water below the mountain, however, did not have to be so vast or encircling. The sea is present in many plays, but a stream in *Yōrō*, a small pond in *Nomori*, a well in *Izutsu* (The well-curb), a bucket of brine in *Matsukaze*, or even a wine cup in *Shōjō* (The wine genie) all serve as well. What matters is that they loom large in the mind's eye, and that they reflect the moon.

Many plays unfold beside this water below the hill. That is because the edge of the water is where human life is lived. The beings on high are not exactly human, nor are those in the deep. Though the reflected moon that shines up from the depths alludes to our inborn enlightenment, we do not usually consider that enlightenment attained, and, being aware of our own weakness, we do not usually consider those who have attained it to be quite like us.

In the world of Nō the typical dwellers both on the heights and in the depths are dragon or serpent beings. A dragon can live in an astonishingly small pool, and conventional language even for the emperor is full of dragon imagery. The drama of *Hagoromo* is that the angel comes down

from the moon to the beach below Mount Fuji and there has her feather mantle (her wings) stolen by a fisherman named White Dragon. To get it back she has to dance. Her experience is a summary of the human condition. A still more schematic account of this condition appears in the medieval *Chikubushima engi* (History of Chikubushima), where a huge catfish (*namazu*) is said to coil seven times around the island at the bottom of the lake. From the summit of the island a white snake descends to the water's edge and lowers its head to drink. At that instant the catfish reaches up to the surface, takes the snake's head in its mouth, and pulls upon it.[7] This is what happens at the margin of the water, where human beings suffer from the simultaneous pull of the heights and of the depths.

The pine tree of the landscape of Nō stands at the water's edge. The angel of *Hagoromo* first hung her mantle on a pine, whence the fisherman took it. Likewise the white snake of Chikubushima coils around a pine before it lowers its head to drink. The pine is well attested in Japan as a link between the heights and the zone where humans live. There are many such pines in Nō, but the most famous one is painted on the wall at the back of the stage. It is called "the pine of the appearance of the god" (*yōgō no matsu*) and is traditionally identified with one at the Kasuga Shrine in Nara. A monk is reported to have seen the Kasuga deity dancing under the pine in the guise of an old man.[8] Pines like this link the planes of the world. The sound of the wind in their branches (*matsukaze*) is a model of poetry and communication, and a pine in Nō may in fact be treated as human. In *Jinen Koji* (Layman Selfsame), for example, a young

[7] Gunsho ruijū shū 2:311.

[8] The earliest occurrence of this story is in *Gōdanshō*, written in the early twelfth century (Gunsho ruijū shū 27:17); it is then picked up by the musician Koma no Chikazane in his *Kyōkunshō*, 1233; Zoku gunsho ruijū shū 2, 1:295, and by later writers. It also occurs in *Kasuga Gongen genki* 10. This text was presented to the Kasuga Shrine in 1309, magnificently illustrated in twenty scrolls. There are various printed editions of it, but I will consistently cite Gunsho ruijū shū 2, where the passage in question here occurs on p. 28.

The monk of the story is Kyōen (979–1047), who started his career at Kōfukuji but went on to become abbot of Mount Hiei. The pine is traditionally identified as a very large, old pine tree still alive on the grounds of the Kasuga Shrine. A sign before this famous tree names it as the *yōgō no matsu*, states that the tree's story is told in *Kasuga Gongen genki*, and tells how Kyōen saw the Kasuga Deity dance there before he went on to attain such distinction on Mount Hiei. Actually, *Kasuga Gongen genki* says clearly that Kyōen was on Mount Hiei when he saw the Kasuga Deity dance, and the earlier accounts can be taken either way. Therefore, despite the fame of the tree at Kasuga, and its traditional identification with the tree at the back of the Nō stage, *yōgō no matsu* is really a common noun, not a name. In fact, there is a "Kasuga *yōgō no matsu*" marked on an Edo-period map of Kaijusenji, the temple where Gedatsu Shōnin died. The tree at Kasuga is more accurately *a* "pine of the appearance of the god," and the pine at the back of the Nō stage is anywhere. For a full study of the *Kasuga Gongen genki* see Royall Tyler, *The Miracles of the Kasuga Deity* (New York: Columbia University Press, 1990).

man dancing to secure release from his wicked captors likens himself to
the pine of Karasaki, which stands on the shore of Lake Biwa.

Happy Affirmations of Nonduality

This dual world and man's correspondingly dual nature, with their
heights and depths, are at once beautiful and painful. It is just because the
problem is so absorbing that affirmations of nonduality are fundamental
in Nō. There are so many of them, made in so many ways, that they are
countless. Some are philosophical, others playful. Some are happy, and
some are marked with suffering.

When the awesome old woman in *Yamamba* reflects that "form is emp-
tiness," the hearer recognizes a phrase from the *Heart Sūtra* and com-
pletes it himself: "and emptiness is form." This perfectly balanced state-
ment sums up Buddhist Prajñāpāramitā (Perfection of Wisdom) thought,
and its philosophical nature is obvious. But mute objects in Nō may con-
vey a similar message, though their import is not obvious at all. What
should one make of a forked staff?

The traveler in *Chikubushima* is a courtier who arrives at the island-
shrine eager to worship there. A shrine attendant then comes forth and
displays to the courtier, with great pride, the island's sacred treasures.
One of these is a length of forked bamboo. The attendant does not com-
ment on it, and the courtier does not ask about it. One might well wonder
what makes it special.

There actually is a length of forked bamboo in a glass case in the pres-
ent Chikubushima museum. It is labeled "The staff of En no Gyōja."
Therefore, it is a kind of *mataburi*: the forked staff carried, fork down-
ward, by mountain ascetics and even by mountain goblins (*tengu*). At
sacred places frequented of old by beings of this sort, and where shrines
and temples still flourish today, one may easily run across *mataburi*-
shaped objects of greater size. These are twin-trunked evergreens that are
visibly honored. A tree of this kind is described in Japanese as *aioi*,
"growing in codependence."

The most famous *aioi* pair in the classical tradition is celebrated in the
play *Takasago*. This pair is a further elaboration on the single forked tree,
for it consists of two distinct trees, widely separated. These are the "pine
of Sumiyoshi" and the "pine of Takasago." Both grow by the sea. A com-
plex of nondual opposites is sustained by the material image of these two
trees. The play shows that the Sumiyoshi pine is male and represents the
present ("His Majesty of Engi, who dwells in the present age"); while the
Takasago pine is female and the past ("the ancient time of the
Man'yō-shū"). Although the trees are "a whole province apart," the com-

munication between them is nonetheless everlasting and complete, so that separation in space is mere appearance, and the gap between past and present likewise. As for their sex, the trees demonstrate the essential meeting of male and female. The Sumiyoshi pine turns out to be the God of Sumiyoshi who represents the idealized sovereign himself; and the Takasago pine, which does not appear in the second half of the play, dissolves into the people and the land. Thus, *Takasago* alludes to the sacred marriage of the sovereign and his realm, who flourish forever in indivisible codependence.

Chikubushima presents for the courtier, and for us, the goddess Benzaiten (originally the Indian Goddess Sarasvatī) who resides high on the rocky island, and the Dragon God of Lake Biwa who lives in the water's depths. (A medieval painting of Benzaiten, also in the Chikubushima museum, shows the goddess beautifully adorned and seated on a coiled white snake.) The play's theme is the conjunction of these two. The courtier himself announces it by singing as he approaches the island:

> Reflections of green trees sink down,
> and fishes climb their branches;
> the moon dives beneath the lake,
> and the rabbit [of the moon] sports upon the waves.

This Chinese-style verse recalls the passage in the play *Kantan* where a young wanderer, miraculously become emperor of Cathay, finds himself between a silver mountain in the east, over which hangs the sun, and a golden mountain in the west, over which hangs the moon. The courtier in *Chikubushima*, too, from the surface of the lake, sees two domains at once, each of which is the other's looking-glass world.

Moreover, once the shrine attendant has displayed the forked staff, he next offers to show the courtier the "mystery of the island." This "mystery" turns out to consist of the attendant jumping off a high rock into the lake, whence he emerges sneezing. It is a puzzling moment. But when the Dragon God has risen from the lake and Benzaiten has come down from the summit, and both have danced, Benzaiten flies off again skyward, and the Dragon God leaps back from the same rock into the deep. Thus the "mystery of the island" is not someone jumping inexplicably off a rock; it is the best demonstration one man can make that above and below are nondual.

Using an analogous play of reflections, *Nomori* demonstrates the nonduality of subject and object with marvelous ingenuity. The traveler, a *yamabushi*, meets an old man beside a pond known as *nomori no kagami*, the "mirror of the watchman of the plain." The pond is located on Kasuga Plain, below the mountain of the Kasuga deity, and the old man is the watchman.

The watchman tells the *yamabushi* a story. Long ago, the emperor was out hunting nearby when he lost his hawk. He then wandered until he came across the old man himself, then young. "Have you seen my hawk?" the emperor asked. "Certainly," the watchman replied, "just look in the pond." The emperor was perplexed but he looked in, and there the hawk was, deep in the water, perched on the high branch of a tree. As he recalls the moment the old man weeps, for then he was vigorous and, although humble, could exchange words man-to-man with the exalted sovereign himself.

But the old man has meanwhile let it slip that the pond is not actually the "real" mirror of the watchman of the plain. The real mirror, it appears, belongs to a certain demon. The *yamabushi* immediately burns to get at that mirror and to look into it for himself. By-and-by the old man reveals himself, inevitably, as the demon in question, and holds the mirror forth. The *yamabushi*, lately so eager, recoils and averts his eyes, for he sees in the mirror more than he can face. He gathers himself, however, calls on Fudō, and looks again. He now sees the universe before him, Heaven and Hell, in all six directions and to its outermost confines. His face is all the worlds.

At Murōji, a lovely temple whose history is deeply linked with Shingon Buddhism and with Shugendō, there is a twin-trunked evergreen with a sign in front of it that reads, "Two yet not two." What can one do but smile? Such a tree is like the worshipper's handclap at a Shinto shrine. It says nothing but creates open space. A forked tree, two as one, shows the world whole; and in an undivided world the space is boundless.

Bafflement

A forked tree would open no space, and evoke no smile, if the difference between good and bad, and so on, were not so obvious. No one would stress that form is emptiness if form and emptiness were visibly the same. One whom duality baffles is Sakagami, in the play *Semimaru*. Sakagami is mad, and although she is an imperial princess, she roams the world restlessly, as a profoundly philosophical outcaste. In the play she visits her brother, Semimaru, who plays the *biwa* (lute) in a hut at the top of a mountain pass. Semimaru cannot travel at all because he is blind.

Sakagami's name means at once "Upside-Down Hair" and "God of the Slope." Both are perfectly suitable. Instead of falling normally her hair grows straight up; and her life is a procession of quite material ups and downs. She says:

How extraordinary it is that so much before our eyes is upside down. Flower seeds buried in the ground rise up to grace the branches of a thousand trees. The moon hangs high in the heavens, but its light sinks to the bottom of the countless waters. I wonder which of these should be said to go in the proper direction, and which is upside down?

> I am a princess, yet I have fallen,
> and mingle with the mass of common men;
> my hair, rising upward from my body,
> turns white with the touch of stars and frost;
> the natural order or upside down?
> How amazing that both should be within me![9]

Sakagami's flowers "which rise up to grace the branches of a thousand trees" are described in other plays as manifesting the "upward aspiration to enlightenment" (*jōgu bodai*). Thus, their upward aspiration is a counterpart to the descent of moonlight deep into the waters. Moreover, since the flowers are conventionally of spring, and the moon of fall, the pair also alludes to the seasons and to time. Pretty as all this is, however, Sakagami is still very confused.

There is a passage in an esoteric *yamabushi* text that also starts from a question about duality. Like Sakagami's answers to her own question, the answer the passage gives is unlikely to produce much beside further bemusement. It puts the whole problem in terms of *yin* and *yang*, but otherwise the structure of its thought is strikingly like Sakagami's own.

The passage is from *Buchū kanjō honki* (Treatise on initiations in the Omine mountains), written in 1254. The rhetorical questioner asks, "Regarding the truth that the potential and the produced [for example, seed and fruit] are nondual, does one bring them into nonduality, or are they nondual already?" To this the writer replies:

Regarding cold and heat, what we call "cold" is cold endowed with maleness. "Heat" is heat endowed with femaleness. By means of female heat, male cold rises, and thus the two produce a child. The nature of fire is to rise, the nature of water is to fall. What is called the male thought-power (*nenriki*) is *yin* and water. It is cold. . . .

When heaven and earth parted, the male water was heaven, cold, and *yin*; the female fire was earth, heat, and *yang*. . . . The male cold congeals and becomes bone. The female heat, the *yang* breath, conjoins with this and thus becomes flesh. . . . Therefore, the white bones are concealed (*yin*) within; and the red flesh stands forth (*yang*) without, and its color appears. . . . Furthermore,

[9] Translated by Susan Matisoff in Donald Keene, ed., *Twenty Plays of the Nō Theatre* (New York: Columbia University Press, 1970), p. 107.

there is the deep mystery of male *yang* and female *yin*. It is the profound question of the reversed distinction between *yin* and *yang*. . . . According to the secret oral transmission, the female organ enters, in a counterpart manner, into the male organ. When man and woman conjoin they insert the male organ into the female organ. At this time there is likewise something that enters the male from the female organ. When the male enters the female, the female organ is *yin* and the male is *yang*. Hence, this [moment] is the beginning of the reversal of *yin* and *yang*. Those who do not know this profound truth cannot achieve the contemplation that is the identity of subject and object (*nyūga ga'nyū kan*).[10]

The identity of subject and object—of the seer and the seen—is just what the *yamabushi* grasps in *Nomori*, and although he does not do so by any method to be avoided in polite conversation, he would recognize the theme of this text very well. The play of opposites is dizzying. Cold and heat, male and female, red and white, heaven and earth seem to reflect each other into infinity, and with a startling physicality. Since canonical Buddhist texts, Chinese rhetoric, and classical Japanese discourse all play with polarities in various ways, it is impossible to tell whether the tradition of this text in particular might have had any direct influence on Nō. However, the passage is not much more uncouth, though it is less grand, than the mountain crone of *Yamamba*.

The Thirst to Rise and the Descent of Grace

The mountain crone,

> . . . whose hair
> sprouts as snowy weeds,
> whose pupils
> shine like stars,

is incomprehensibly diverse, and easily terrifying. She lives deep in the mountain wilderness. According to one theory explained in the play, she

[10] This passage is translated from the longer extract quoted by Moriyama Shōshin, *Tachikawa jakyō to sono shakaiteki haikei no kenkyū* (Tokyo: Rokuya-en, 1965), pp. 134–135. *Buchū kanjō honki* was written by Kyokuren, the head of a Shingon-affiliated Shugendō temple in the Omine mountains. The sexual imagery of its discourse marks it as linked to the so-called Tachikawa-ryū, a "left-handed tantric" Shingon heresy that seems to have originated at the aristocratic Shingon temple and Shugendō center of Daigoji near Kyoto. The Tachikawa-ryū teaching was carried to the provinces in 1113 by Ninkan, a younger brother of Shōkaku, the founder of the famous Sambō-in at Daigoji. The father of both was Minamoto no Toshifusa (1035–1121), a minister of the left. (See Moriyama, pp. 14–66.)

is made of acorns, walnuts, toadstools, vines, balls of pine resin, inde-
scribable trash, and a temple gong. Her existence recalls that of Saka-
gami, for she roams endlessly from peak to peak, riding the "clouds and
waters."

The traveler of the play is a dancer from the capital whose sobriquet is
also "the mountain crone." She is on a pilgrimage, and her ways over
these mountains are "High Road," "Low Road," and "the Upward
Trail." "The Upward Trail," she is particularly informed, "was made by
the Buddha himself, and traveling it puts one in touch with the Buddha's
own inner illumination." Therefore, despite the difficulty of this path, the
dancer decides to take it. On the way she meets the mountain crone, who
in a magnificent sermon on her own nature answers Sakagami, and no
doubt the dancer, far better than *Buchū kanjō honki*. She says:

> Lift of Dharma-nature peaks
> shows the upward urge
> to perfect knowledge;
> plunge of gorges without light
> shows downward saving grace
> that touches the golden disk,
> the ground of all.

Thus, she affirms that nothing is permanently potential or produced, right
side up or upside down. Instead, the abyss reaches upward while heaven
graciously descends. The play of these two is the world, and it is there for
anyone to see in the mountains that are the form of the world. The moun-
tain crone continues:

> Yes, see me once
> as other than human,
> and I who am cloud
> screening here from yonder
> shift my form:
> the true nature of things
> changes a while,
> and as one thought
> transmutes existence,
> I turn demon,
> come to fill your gaze.
> Yet when you see
> that true and false are one,
> then "Form is emptiness"
> is obvious.
> For once there is

a Buddha's Law,
There is a world's law;
once suffering,
supreme knowledge;
once Buddha,
then all beings;
and once all beings,
the mountain crone.
Willows are green,
flowers red, you know. . . .

So things are simply as they are, however one may puzzle about them, and the mountain crone herself follows from the Buddha's eternal enlightenment. But however true this may be, it does not necessarily ease the mind. Sakagami is still confused, the dancer's pilgrimage is still a hard road, and the mountain crone still sings,

Well then an ill way,
the mountain crone
rounds of the mountains,
made in pain!

The Nonduality of Suffering

The moon in Nō is often comforting, reminding the viewer as it does of a loftiness and profundity far beyond his commonplace preoccupations. In its nightly course westward, to sink behind the mountains' rim, it may recall the Buddha Amida whose paradise is in the west, and whose saving grace is infinite.

Ki no Tsurayuki (868?–945?) may have had Amida in mind when he wrote this verse on "seeing the moon reflected in a pond":

One without a second
I had thought it,
yet in the watery deep—
no mountain rim—
rises now the moon.[11]

The motif, so common in Nō, is developed elaborately in the play *Ama* (The diver).

Ama first intimates that the moon is the traveler himself, who has come down to a remote shore from the exalted capital; then it likens the moon's

[11] No. 881 in the *Kokinshū*, 905.

reflection to the priceless pearl that the Dragon Girl of the cosmic ocean offers to the Buddha in the "Devadatta" chapter of the *Lotus Sūtra*. The play leaves no doubt that the woman diver who brought up the play's magic jewel sacrificed her life to do so. For the diver, as for Sakagami and the mountain ascetic, these matters may require physical as well as spiritual abandonment of self.

In *Ama* Fujiwara no Fusasaki goes in search of his *ama* mother. When he gets to the shore where he has heard she lives, he meets an *ama* to whom he immediately addresses a peculiar request: he asks her to dive down and remove the seaweed that offends his gaze by obscuring the reflected image of the moon. She does not protest. On the contrary, she answers that long ago a woman like herself did indeed dive to the bottom of the sea to rescue a magic jewel. This jewel had been a gift to Japan from the emperor of Cathay. It was clear and round, and no matter how one turned it, one saw in it the Buddha's face. This jewel had fallen into the sea dragon's clutches. To rescue it the woman had to dive into the deep, cut open her breast, and hide the jewel in her heart as she fled upward from the dragon. No wonder the Dragon Girl of the *Lotus Sūtra* died as soon as her offering was made, to pass instantly through a male rebirth into enlightenment. Her gift was her life. Moreover, the diver's jewel and the Dragon Girl's pearl are to the Great Stūpa of the *Lotus Sūtra* as the moon's reflection is to the moon.

So dramatic a story has great power, but one might still hope for a more expansive thoughtfulness in the telling. The images are strong, and the diver's suffering heroic. But could they not be more amply set forth? Nowhere does a suffering being caught between height and abyss speak more beautifully or more wisely than the harlot in the play *Eguchi*.

This harlot keeps a brothel in the port town of Eguchi. She appears to the traveler with her fellow singing girls, making music in a boat that rides on the moonlit waters of an estuary. In her song she laments their estate:

Oh, it hurts to ponder
this our reward for lives gone by!

Yet she delivers from her boat a sermon on the human condition that she knows so well, and notes that despite our best efforts at philosophy, we still go astray:

Yes, plants and trees
that have no heart,
human beings
gifted with feeling:
which of these

shall evade sorrow?
So we reflect,
yet are at times,
stained with love's hue. . . .
The heart's fond pangs,
the mouth's own words,
turn to links
with wrongful clinging
for all things seen,
all things heard,
turn to the heart's confusion.

Yet the harlot continues as one who sees all this whole:

Wonderful!
On the great sea
of truth perfectly contained,
winds of the five dusts
and the six desires
never blow;
yet waves of the real,
linked in sequence,
rise each and every day.

The "great sea of truth perfectly contained" (*jissō muro no taikai*) may
be imagined as a shining ocean of indeterminate expanse. One would ex-
pect it to be quite smooth, but on the contrary it is furrowed with waves.
These waves have to do with the chain of causation that creates the sen-
sible world, the world of the passions. It is remarkable that the great sea
is tossing and heaving because it cannot be touched by any turbulence
associated with the impure senses. If it were so touched, it would not be
"perfectly contained." Since it is "perfectly contained," the waves do not
rise because of any impurity. Hence they are waves of *shinnyo*, of the real.
The moon in Nō is often "the moon of the real" (*shinnyo no tsuki*), and
these waves, as the harlot speaks, are of the moon, or moon-illumined.
They rise in consequence of their *en*, or cause, which cannot be impure
either, because the great sea is "perfectly contained." Therefore, the
waves are wholly enlightenment.

 The harlot goes on to say, however:

And the waves rise
for what reason, pray?
We set our heart
on passing shelter:
if we did not,

there would be no sad world,
no lovers to yearn. . . .

Thus, the waves are caused by desire after all: desire for the things of the world and of the flesh, which are summed up in *Eguchi* by the image of "passing shelter." The "passing shelter" particularly in question is the harlot's own brothel. Such a woman riding the water under the "moon of the real" is herself a "wave of the real." The play makes clear that as she inspires desire, so she suffers thereby in equal measure; yet her sermon shows that all the waves on the sea are enlightenment, even the most distraught and the most blind. At the very end of *Eguchi* the harlot rises into the heavens, revealed as the all-wise bodhisattva, Fugen.[12]

Alas, not all suffering beings have present to mind the truth that the harlot speaks. Among them is the old gardener in *Aya no tsuzumi* (The damask drum). It was this gardener's misfortune to fall in love with a young and high-born lady. In answer to his entreaties, the lady told him to beat a drum that she had hung in the tree by the garden pond; and she promised that when she heard that drum she would come down to him. The drum was damask, however, and refused to sound; and the maddened gardener drowned himself in the pond. Then his phantom rose up to possess the lady:

On the face of the evening pool
a wave stirred.
And out of the wave
a voice spoke.[13]

The voice spoke of rage and malediction. Yet gardener and harlot are equally waves, and no different in nature. The water of the pond is the water on which the harlot rides. There is no doubt of this because the tree by the pond, with the round, white, treacherous drum in its branches, is a *katsura* (cinnamon) tree: the tree that grows in the moon.

[12] Regarding the enlightenment of Fugen, the *Bodhicitta śāstra* (Jpn: *Bodaishinron*) says: "Because of this meditation, he (the practitioner) sees his true state of mind [*bodhicitta*], which is tranquil and pure like the light of a full moon covering space without discrimination. [This state of mind] is called complete enlightenment [i.e., the perfection of the cognizer]; it is also called pure *dharmadhātu* [i.e., the perfection of the cognized]; and it is also called the sea of the perfection of wisdom [i.e., the perfection of the identity of the cognizer and the cognized]. Its ability in *samādhi* to contain a variety of immeasurable precious jewels is like the moon's [ability to contain] its pureness and brilliance. Why [is this so]? Because all beings are endowed with the mind of Samantabhadra: one sees one's own mind like the disc of the moon." Minoru Kiyota, *Tantric Concept of Bodhicitta: A Buddhist Experiential Philosophy* (Madison: South East Asia Center, University of Wisconsin-Madison, 1982), p. 87.

[13] Translated by Arthur Waley in *The Nō Plays of Japan* (New York, Grove Press, 1957), p. 176.

Salvation

However nondual the moon may show suffering and enlightenment to be, and however convincingly this nonduality be demonstrated, beings who are subject to the passions (*bonnō*) still suffer. Therefore, they long for a realm free from pain, where all delusion is dispelled; and they thirst for release from the agonies that evoke visions of Hell. Many of the phantoms who appear in Nō are in Hell and convey terrible anguish. The yearning for rebirth (*ōjō* or *jōshō*) in paradise was essential to the religious life of most people, cleric or lay. Hope for salvation, so often expressed in Nō, is probably the main reason why the Buddhism of Nō has been defined as Amidism; for in more recent times "salvation" has been almost synonymous with *ōjō* in the Western Paradise of Amida, as defined by the followers of the Pure Land sects.

Buddhist texts describe the multiple realms of Hell in variously complicated ways, and some of these realms were common topics in stories and in art. The hells were located in principle under Mount Sumeru, the central mountain of the Buddhist universe. There were hells of searing cold as well as of heat, but on the whole they were fiery. The cries of sinners and the yells of hell-fiends are often mentioned in Nō, as are the rods with which the sinners are shattered.

Hell in Nō is a realm of fearful confinement where communication is only barely imaginable, and almost impossible to achieve. Just as the gardener in *Aya no tsuzumi* is imprisoned into lonely rage by his passion for a lady who could hardly be expected to respond, so the bizarre monster in *Nue* (The nightbird) is stuck in the dark and cannot move. When alive, this monster had immobilized the emperor by tormenting him mercilessly; indeed, the monster's ghost boasts as he reenacts his crime, "I fill all space about the sovereign's stronghold!" When the monster was killed, his corpse was sealed into a hollow log and thrown into the river. Thus, his ghost received fitting retribution. In Hell there is no space at all.

The damask drum is typical of Hell because nothing gives back sound. In *Kinuta* (The block), a wife who believes herself abandoned is cut off by her own despair and dies insane. Then she is in Hell, where she is given the same fulling block that her madness drove her to beat in life. She beats the block in Hell, too, but it makes no sound, and her shrieks are silent. Her tears as they touch the block turn to flame.

If there were forked staffs in Hell, their meaning would be impenetrable. Subject and object have no contact at all there, and duality appears final. One horrifying demonstration of duality occurs in *Motomezuka* (The maiden's grave). The play is about a young woman who was courted by two fine youths, and who liked both so well that she could not choose

between them. In the trials her father proposed, the suitors always came out perfectly even, till at last the maiden drowned herself in despair. In Hell she is made to embrace the red-hot central pillar of her own grave-mound, while the two suitors, in the form of iron birds, dive at her from either side and rend her flesh with their beaks.

Paradise, on the other hand, is perfectly open, light, and free. A forked tree in paradise has no special meaning because there is no duality to reconcile. Buddhist paradises are associated with different Buddhas and bodhisattvas, and these too, like the hells, are often shown in painting. Each has canonically described features of its own, but all are lovely, and in all the timeless Teaching is eternally and directly heard. Beings in such a paradise are forever in the presence of the divinity they adore, and whose love has made this perfect realm. The Buddhist ideas in Nō are there to analyze, but faith in them precedes reason, and much of this faith is love.

Phantoms in Nō do not speak from Paradise as they do from Hell, since one in Paradise needs nothing from the living. Nor are any plays set in a Buddhist paradise, although *Obasute* (The abandoned crone) presents an old woman, abandoned on a mountaintop, singing of Amida's Pure Land under a full moon. Instead, Nō presents places on the earth as paradisal.

This is done in plays like *Takasago* and *Chikubushima*. Suffering men and women long for salvation, but Nō allows for those moments when everything is perfect, just as it is, and when earth can hardly be distinguished from Heaven. Such plays present a visit to a sacred place, made under ideal conditions, and at the traveler's own unconstrained wish. The season is spring, the air is mild, and the breeze just enough to stir the leaves. The traveler is perfectly happy and at ease, whether or not a god appears. But then a god does appear, also unconstrained, and confirms impressively what was already clear: that there is nothing wrong anywhere. All things are in boundless harmony, in an idealized version of the temporal order that theoretically prevailed in Japan. Thus, the dance of the gods in *Chikubushima* is a happy tribute to the sovereign whose representative witnesses it; and *Takasago* lauds the sovereign thus:

So wise His rule
that plants and trees,
land that this is
of our great Lord,
aspire under his sovereign reign
to live on and on. . . .

The sovereign is the one who presides over this perfected harmony. No wonder the courtier in *Chikubushima* did not ask about the forked staff. He already knew.

Where to Find the Buddhism of Nō: "The Path of My Mountain"

It is one thing to abstract patterns from Nō plays, or to make general statements about the Buddhism of Nō; but it is another to convey the fancy of the plays or of their religion. The plays are not exactly untidy, but they are so constructed and ornamented that they do not yield their patterns easily. That is because they are not religious rites or treatises, but art; and their goal is not primarily to set forth ideas. Though they can at least be read or seen, their religion is spread through all sorts of texts and artifacts, and is indeed untidy as soon as one descends past a certain level of generalization. An accurate account of Nō should convey its lack of rigor.

The Buddhism of Nō is a Buddhism that admits stones, plants, trees, humans, spirits, gods, and Buddhas into an open brotherhood of the numinous. The philosophical problems posed by this brotherhood are probably insurmountable, and in fact related doctrinal questions were continuously raised and debated in the Buddhist schools. It is this Buddhism, however, that is Waley's "common, average Buddhism of medieval Japan."

There is no better way to convey its flavor than to describe the religion of a particular sacred place. Many sacred sites resembled each other in general, but each had its idiosyncrasies; and each, in its way, gave chance its due. Such an account can only be a little difficult to follow since it must mention names and matters that, in that configuration, are important only at that site. It can probably be said that the religion of a place makes no sense without the site itself, and the mountain. An outstanding example of such a sacred site is provided by the medieval cult of Kasuga.

Abe no Nakamaro (701–770) lived in China for many years but still missed Japan. This verse of his is cited by the old man in *Nomori*:

> Now I lift my gaze
> to the high plains of heaven.
> I see the moon
> that rose at Kasuga
> over Mount Mikasa!

The same moon can be seen over Mount Mikasa in the devotional paintings of the medieval Kasuga cult (Kasuga *mandara*). Upon its disk may float images of Buddhas and bodhisattvas.[14]

Mount Mikasa is 283 meters high. When seen from the west, the direction of Nara, its regular, conical form stands free against a dark back-

[14] The Kasuga *mandara* that I cite below are all published in Nara Kokuritsu Hakubutsukan (Nara National Museum), ed., *Suijaku bijutsu* (Tokyo: Kadokawa Shoten, 1964).

ground of higher hills. Even today Mount Mikasa may not be trodden except by priests of the Kasuga Shrine, which is immediately below the mountain. There is a small sanctuary at the top, and the traces of a much older, open ritual site. The Kasuga Shrine is the ancestral shrine of the Fujiwara clan; and Kōfukuji, which in premodern times was intimately linked with Kasuga, is the major Fujiwara ancestral temple. Both played vital roles in the early history of Nō.

All extant accounts relate that the god Takemikazuchi reached the top of Mount Mikasa, from Kashima in the Kantō, early in 768, and that the Kasuga Shrine was first erected later that same year. With Takemikazuchi, or shortly after him, came the three other deities of the main shrine: Futsunushi from Katori in the Kantō; Amenokoyane, the Fujiwara clan deity, from Hiraoka, south of modern Osaka; and Hime-gami (Lady Deity). Hime-gami too probably came from Hiraoka, but in medieval writing about Kasuga she is a manifestation of Ise, and continuous with the Sun Goddess, Amaterasu. The fifth principal Kasuga deity is the Wakamiya (Young Prince), who is understood to be the son of Hime-gami and Amenokoyane. The Wakamiya's origins are obscure, but he acquired an independent sanctuary building about 1135.

These deities were singly or collectively known as Kasuga Daimyōjin (Great Resplendent Kasuga Deity), of whom it is impossible to say whether he was singular or plural. In 937 Kasuga Daimyōjin announced, in an oracle, that he wished to assume the name "Bodhisattva Complete in Mercy's Works" (Jihi Mangyō Bosatsu). Thus, the divine presence of Kasuga claimed, as other gods had already done, the standing of a bodhisattva.[15]

It is unclear when the Kasuga deities were first identified with canonical Buddhas and bodhisattvas; and the identifications, once made, wavered through the centuries. In Kasuga art (late Heian through Muromachi) they vary particularly widely, but the main written sources are a little steadier.

The single most prominent *honji* (original ground) Buddha at Kasuga is Fukūkenjaku Kannon (Amoghapāśa), whose *suijaku* (trace shown below) is Takemikazuchi. Fukūkenjaku Kannon is identified as the *honji* of Takemikazuchi in an influential record of Kasuga *honji*, with their *suijaku* forms, made from dreams attributed to the Regent Fujiwara no Mo-

[15] The first deity to do so was Hachiman, who claimed the title of Daibosatsu (Great Bodhisattva) in 761. Kasuga Daimyōjin's oracle of 937 is recorded in *Kasuga go-sha go-honji narabini go-takusenki*, an unpublished text of 1175. A transcript of this text, and of the other manuscripts cited in the notes that follow, was kindly provided me by Ōhigashi Nobukazu of the Kasuga Shrine. The oracle of 937 is also described in *Kasuga Gongen genki*, vol. 1, Gunsho ruijū shū 2: 4.

tomichi (1160–1233).[16] The other *honji* revealed in Motomichi's dreams are Yakushi (Bhaiṣajyaguru) for Futsunushi, Jizō (Kṣitigarbha) for Amenokoyane, Jūichimen Kannon (Ekādaśamukha) for Hime-gami, and Monju (Mañjuśrī) for the Wakamiya.

Motomichi's list agrees in all but one respect with another made by the great Kōfukuji monk Gedatsu Shōnin (Jōkei, 1155–1213). Gedatsu Shōnin identified Takemikazuchi with Śākyamuni.[17] Thus, a Kamakura-period Kasuga *mandara* in the Tokyo National Museum shows all six of the *honji*, including the two for Takemikazuchi, painted against a great moon-disk that floats over Mikasa-yama. It was from such a height that the Buddhist divinities showed their familiar, localized forms in their *suijaku*, which are the Kasuga gods. This pattern was typical for a sacred mountain.

Mount Mikasa is clearly an ancient *kamunabi*, a mountain where the spirits of the ancestors were contained and enshrined. The date of 768 for the founding of the shrine, which has been official at Kasuga since at least the tenth century, is nonetheless suspect.[18] As a sacred hill, Mount Mikasa must be much older. Like Mount Sumeru, such mountains may be associated with Hell. Hell was below a spot just south of the main shrine and was the home of the demon in *Nomori*. In about 1420 a Kōfukuji monk described from this hell, through a medium, how Kasuga Daimyōjin descended thither every day in the form of Jizō (Amenokoyane's *honji*), and blessed the sinners there with holy water and with the Buddhist Dharma, until they gradually "rise and pass out of Hell."[19]

The summit of Mount Mikasa was assimilated to Paradise, though apparently not to the paradise of Amida. Amida appears at Kasuga, if at all, only in one region of a complex paradise shown over Mount Mikasa in a

[16] The list is identified as *"Fugenji-dono no on-yume go-ki"* in *Shun'ya shinki*, an unpublished, undated text of which the earliest extant copy is dated 1437. The title of the text means "Divine Record of Spring Night" and is a play on the name "Kasuga," which is written with the characters "spring" and "day."

Kasuga-sha shika, an unpublished text of 1295, does not mention Motomichi's name. It specifies, however, that the same list was "certified at the order of the retired emperor [Go-Shirakawa] by the priest Ōnakatomi Tokimori [1097–1180], the Shō-no-Azukari [Overseer] Nakatomi Nobutō, and others, in Jōan 5 [1175]."

[17] *Kasuga-sha shiki* specifies that it was Gedatsu Shōnin who made this identification on the basis of the verse quoted below, which Gedatsu heard "in a dream." The identification of Takemikazuchi with Śākyamuni was adopted by the compilers of *Kasuga Gongen genki*.

[18] The standard story appears already in *Koshaki*, an unpublished composite of the Heian text. However, the author of *Kasuga-sha shiki* noted in 1295, with frank puzzlement, written evidence that the four principal Kasuga deities were enshrined in the Imperial Palace already in 755. Moreover, the famous Tōdaiji map of 756, in the Shōsō-in, shows a "god-place" (*shinchi*) at the present location of the Kasuga Shrine.

[19] *Kasuga Gongen genki*, in Gunsho ruijū shū 16:417.

Kamakura-period Kasuga *mandara* owned by the Nōman-in of Hasedera.

Kōfukuji favored instead rebirth in the Tosotsu (Tuṣita) Heaven of Miroku (Maitreya). It was not uncommon for a mountaintop to be understood as the Tosotsu Heaven, and since the Hossō teaching had originally been given to the Hossō founder Mujaku (Asaṇga) directly by Miroku, the tie between Kōfukuji and Miroku was particularly close. No paintings seem to show the Tosotsu Heaven over Mount Mikasa, but written records suggest that thoughts of this paradise must often have been associated with Kasuga Daimyōjin's mountain. Miroku was an alternative *honji* for Futsunushi and for the Wakamiya.

Gedatsu Shōnin is reported to have declared, when possessed by Kasuga Daimyōjin: "Shaka and Miroku (Śāyamuni and Maitreya) are one in substance. . . . Vulture Peak and Chisoku [the Tosotsu Heaven] are one."[20] And once Gedatsu Shōnin heard Kasuga Daimyōjin say:

Know me as I am!
The Buddha Śākamuni
came into this life,
and lo! the bright moon
now illumines the world!

This moon, which would be painted rising over Mount Mikasa, may allude especially to the Buddha preaching the *Lotus Sūtra* on Vulture Peak.

The play *Kasuga ryūjin* dramatically presents Mount Mikasa as Vulture Peak. The play's traveler, Myōe Shōnin, has been planning a pilgrimage to India. Kasuga Daimyōjin, however, does not want him to go, and when Myōe visits Kasuga to say good-bye, the deity detains him with an oracle that explains his concern, and which promises to "make visible upon Mount Mikasa the five regions of India, the Buddha's birth from Māyā, his enlightenment at Bodhgaya, his preaching upon Vulture Peak, and his passing in the Śāla Grove." Suddenly,

the divine oracle,
mightily voiced,
yields to a burst of light:
Kasuga, plain and mountain,
turns to a realm of gold.
The plants, the trees,
are the body of enlightenment,
a wonder to behold!

[20] Ibid., p. 415. The poem quoted immediately below occurs just before this passage, on pp. 414–415. According to this account, Gedatsu heard it spoken by "a voice from the sky."

The Eight Great Dragon Kings of the *Lotus Sūtra* then arrive,

> attended by their entourage,
> an entourage of millions,
> like waves on the plain

to hear the Buddha preach the *Lotus Sūtra*. When all are in place the Buddha no doubt begins his great discourse, but that is not directly mentioned. Instead, the Dragon Girl of the *Lotus* rises and begins to dance.

Mount Mikasa is nowhere near the sea, or indeed near any substantial body of water at all. But since the water of the landscape of Nō need not be large, Sarusawa Pond at the south gate of Kōfukuji, and the brook called Saho-gawa that runs down from behind Mount Mikasa, do quite well for the cosmic ocean:

> The Dragon Girl is up to dance,
> her billowing sleeves
> gleam a pristine white
> across the boundless main
> they sweep: a spray
> of shining drops
> rises from the blue
> color of the sky
> cast on the ocean abyss!
> Hither she treads the deep:
> the ship of the moon
> rises on the waters
> of the Saho River. . . .

Until at last,

> The Dragon Girl
> mounts the gale-driven clouds
> and vanishes air-borne
> toward the south;
> the Dragon God
> with lusty tread
> churns Sarusawa Pond
> and its cerulean waves
> till He towers a thousand fathoms,
> a mighty Serpent,
> swarming in the mid-heaven,
> writhing upon the earth,
> He tosses the pond waters high
> and is lost to view.

The point of all this is to persuade Myōe that he has no need to go any-
where at all, and Myōe is convinced. He gives up his journey. The play is
an extensively revised version of actual events, for whereas Myōe Shōnin
really did plan to go to India, Kasuga Daimyōjin dissuaded him from
doing so in a series of oracles and dreams delivered in the first months of
1202. In some of the dreams Myōe went to Vulture Peak, as Kasuga Dai-
myōjin himself did whenever he wished.[21]

Such delightful grandiloquence is in tune with the fortunate character
of Myōe's vision, but the principle of it should not be dismissed as mere
theater. Once in the early thirteenth century a monk of nearby Tōdaiji
dreamed he saw many "precious ships" in the absolutely minuscule
stream that runs under the main avenue toward the Kasuga Shrine, at a
spot called Rokudō, or "Six Realms [of Reincarnation]." These boats
then flew off toward the summit of Mount Mikasa, full of people. The
dreamer was told that the lead boat carried Myōe Shōnin, and that the
other passengers were those who had entrusted themselves to Myōe's
guidance. Myōe was leading them over the Six Realms, the ocean of suf-
fering, directly to paradise.[22]

A mid-fourteenth-century history of Kōfukuji contains the following
entry: "Chōhō 3 [1001], eighth month, second day. Gatō Shōnin boarded
a boat and sailed to Mount Fudaraku."[23] Fudaraku (Potalaka), the para-
dise of Kannon, is reputed to be a mountain that rises from the southern
ocean and looks like P'eng-lai. Gatō Shōnin actually sailed from Cape
Muroto in Shikoku, and it is remarkable that his departure should have
been reported in a history of Kōfukuji. The reason is probably that
Mount Mikasa too was Fudaraku. Like Chikubushima, Fudaraku can
only be reached by boat, but as the Tōdaiji monk's dream shows, the
absence of sea around Mount Mikasa was not a problem. A beautiful
Kamakura-period Kasuga *mandara* in the Nezu Museum shows Mount
Mikasa with a detailed vision of Fudaraku floating above it. The holy

[21] According to *Kasuga Gongen genki* 16:416, Kasuga Daimyōjin told Gedatsu: "I often
go to the Tosotsu Heaven and worship there the Lord of Compassion [Miroku]. Even my
eyes cannot encompass the sixteen *yojanas* of his marvelous form."

The story of the oracles of 1202, in which Kasuga Daimyōjin dissuaded Myōe from going
to India, was written down by Myōe's disciple Kikai in 1232 or 1233. This remarkable
document is published under the title *Myōe Shōnin jingon denki* in *Kōzanji shiryō sōsho*,
vol. 1 (Tokyo: Tokyo Daigaku Shuppan Kai, 1971); and under the title *Kasuga Daimyōjin
go-takusenki* in Gunsho ruijū shū, and in Dainihon Bukkyō zensho, vol. 123. The account
of the same series of oracles in *Kasuga Gongen genki* 17 and 18 appears to be based mostly
on Kikai's record.

Kasuga ryūjin has been translated by Robert E. Morrell in "Passage to India Denied:
Zeami's *Kasuga Ryūjin*," *Monumenta Nipponica* 37, 2 (Summer 1982).

[22] *Kasuga Daimyōjin go-takusenki*, in Gunsho ruijū shū 2:180.

[23] *Kōfukuji ryakunendaiki*, ca. 1332, in Zoku Gunsho ruijū shū 29, 2:135.

mountain is surrounded by tossing waves, over which boats are sailing from the near shore; and at its summit the Blessed bodhisattva shines like a welcoming star.

Faith like this is essential to the Buddhism of Nō. The mountain crone and the harlot of *Eguchi* said all that inspired reason can say, but the quiet of the following story is eloquent. Fujiwara no Toshimori (1120–?) never neglected his monthly pilgrimage to the Kasuga Shrine.

> Once when he had come to the Shrine the night rain was falling softly, and dripped pleasingly from the pines. He felt unusually at peace. Soon he began to reflect on the vanity of making his pilgrimages in quest of worldly gain. Then he heard an awe-inspiring voice speaking from toward the [Four] Sanctuaries and saying, "The path of enlightenment, too, is the path of my Mountain." Toshimori shed tears of joy, and would wet his sleeves again long afterward, remembering.[24]

The Red Leaves of Fall

Westward across the Yamato Plain from Mount Mikasa is a hill explicitly known in classical poetry as a *kamunabi*. This is Mount Tatsuta, a place celebrated for the beauty of its autumn leaves. The Tatsuta-gawa flows past Mount Tatsuta, and below the mountain stands the Tatsuta Shrine.

The traveler in the play *Tatsuta* is a monk who first meets Tatsuta-hime (the Lady of Tatsuta) by the river, where she takes on the guise of a shrine maiden. As the season and poetry demand, the river is covered with a leafy, red brocade. The Tatsuta deity is presented in the play as the guardian of the "August Spear, Protector of the Realm." This spear alludes to centrality, eminence, and power. A spring welling up at the seat of such power would cascade on down the mountain and nourish the regions below. In *Tatsuta*, the river is evoked as flowing down from such a spring.

The traveler has arrived just in time to see music and dance (*kagura*) offered splendidly that night, by the light of torches, to the presence on the mountain. This is the *taki-matsuri* (waterfall festival) of Tatsuta, which the play links intimately to Ise. The poetry of the scene suggests the following vision. As the music begins, the light of the full moon touches the crest of the hill, and from the lip of the moon, as it were, tumbles the

[24] *Kasuga Gongen genki* 5:14–15. Most transcriptions of the original text read *kokoro* (heart) instead of *yama* (mountain), so that the Deity's utterance reads, "The path of enlightenment is the path of one's own (or my) heart." This reading, however, appears to be an error. Precisely the same story occurs, with *yama* instead of *kokoro*, in *Ima kagami* (ca. 1180); and *kan* 20 of *Kasuga Gongen genki* contains this sentence: "Surely that is why Myōe Shōnin revered the Mountain [Mount Mikasa] as Vulture Peak, and why our Daimyōjin taught the Lord Toshimori that it is the path to enlightenment."

pure water of the stream. The fall at first is white, and whiter in the moonlight. Lower down it leaves the zone of rock and evergreen and passes beneath the autumn trees. Thus, it takes on the color of the leaves and flows away to the sea clothed in the red of the world of time and desire. This red is the Lady of Tatsuta herself, who is the red leaves of fall.

It is a commonplace in poetry that tears shed high in the sky by geese as they depart in autumn are red when they fall to earth, and that autumn leaves turn color when touched by the season's cold rains. *Tatsuta* amplifies both thoughts in perfect consonance with the fully stated Buddhist significance of the play, which is first given in the words of the Chinese T'ien-t'ai (Tendai) patriarch Chih-i (538–597): "The tempering of the light and the merging with the dust initiate the link to enlightenment; the achieving the Way through all eight phases finishes accomplishing all creatures' weal."[25]

According to Chih-i, the Buddha tempers his light and merges with the dust so as not to blind and confuse ordinary beings with the full radiance of enlightenment. Thus, the Buddha dims his light and enters completely into the ordinary world. In this way he manifests enlightenment in various familiar forms, and so makes the thought of enlightenment accessible to anyone. Chih-i cannot have intended this passage to be used as in *Tatsuta*, for the play makes it a complete summary of Buddhist-Shinto syncretic (*honji-suijaku*) thought, and of the Buddhism of Nō.

The familiar forms that make enlightenment accessible are those of the mountains, rivers, trees, gods, and holy persons of Japan. The "merging with the dust initiates the link to enlightenment" because the presence of these forms makes enlightenment available to all. *Kechien*, the "link to enlightenment," was the goal of pilgrimage, and it was to be found in such sacred presence. Thus, *Tatsuta* develops this first part of Chih-i's statement in verse:

> The red leaves low on the trees
> are the divine intention [*kami-gokoro*]
> mingling with the dust
> as the tempered light
> deepens in hue. . . .

In poetry the cold rains color the top leaves first, but by-and-by the red descends to the lowest branches, thus showing in the present context that no place is too humble to speak of enlightenment, and no person too lost to be touched by grace.

The second part of Chih-i's statement, about "achieving the Way

[25] *Mo-ho chih-kuan* (Jpn: *Makashikan*) 6. The full text in the Japanized version cited in *Tatsuta* is given in the glossary under *wakō dōjin*.

through all eight phases," alludes to the traditional eight phases of the Buddha's career, from his descent into his mother's womb to his enlightenment, teaching, and final extinction. During this career the Buddha rose from ignorance to the knowledge that "finishes accomplishing all creatures' weal." In other words, the Buddha's enlightenment accomplished the enlightenment of the world. This thought is expressed in a verse that occurs several times in Nō:

> As the One Buddha achieves the Way,
> he looks down upon the world,
> and plants, trees, soil, and land
> all grow to Buddhahood.[26]

A painting of the scene would show mountains under the moon, with perhaps a dark pine wood along a stretch of shore.

Final Remarks

This beautiful view of the world had deep roots in the past of Nō, and its motifs remained alive into modern times in literature and art. Its Buddhist content, however, gradually ceased to be understood, or passed into the twilight of "folk religion." Buddhist sects were strictly codified and organized as a matter of government policy in the Edo period (1600–1868), while the newer ones (Zen, Pure Land Amidist, and Nichiren) gained increasing prominence and acquired, in their turn, the general reputation of being "Japanese Buddhism." Moreover, Buddhism as a whole came under attack in the Edo period from thinkers who pointed out its pernicious influence. At last in the first years of Meiji (1868–1912), Shinto and Buddhism were separated by edict, and the activities of *yamabushi*, mediums, and other relics of the past were declared illegal.

Suzuki Shōsan (1579–1655) was an early seventeenth-century Zen teacher and moralist who illustrates quite well the beginning of a new way of seeing. Shōsan loved Nō. He had studied Nō singing himself, and like other writers of his time he took from Nō many ornaments to his style. He seems, however, not to have seen in Nō what this study has sought to show.

Shōsan was particularly interested in the famous and highly paradoxical play *Sotoba Komachi* (Komachi on the gravepost), in which the poetess Komachi passes from broken, old beggar outcast to triumphant win-

[26] The verse occurs, for example, in *Nue*. The full text is given in the glossary under *ichibutsu jōdō*. . . . It has been studied by Miyamoto Shōson in " '*Sōmoku kokudo shikkai jōbutsu' no Busshoronteki igi to sono sakusha*," *Indogaku Bukkyōgaku kenkyū* 4, 2 (March 1961): 262–291.

ner of a doctrinal debate, to mad crone possessed by a long-dead suitor, to humble aspirant to enlightenment. The play is as baffling as Sakagami's musings or as the discourse of *Buchū kanjō honki*, and precisely that aspect of it made no sense, or bad sense, to Shōsan. Shōsan had no head for ambiguities, and he did not believe that, as so many medieval texts affirm, "the passions are enlightenment." Therefore, he rewrote *Sotoba Komachi* into *Omokage Komachi* (Komachi in dignity).[27] Shōsan's own Komachi is unwaveringly positive, and as right-thinking as a tough old nun whose youth is no more than the shadow of a memory. She is an unexceptionable moral lesson. It is clear from Shōsan's other writings that that is exactly what he intended, but his Komachi for a new age has lost a great deal. Alas, she is not art.

[27] Suzuki Tesshin, ed., *Suzuki Shōsan dōnin zenshū* (Tokyo: Sankibo, 1962), pp. 217–220. A full summary is given in Royall Tyler, trans., *Selected Writings of Suzuki Shōsan*, East Asian Papers 13 (Ithaca: Cornell China-Japan Program, 1977): 137–138.

Seven

Chūjōhime: The Weaving of Her Legend

ELIZABETH ten GROTENHUIS

THIS IS the story of a legend—of how a specific legend developed and changed according to the responses and needs of its audiences. The heroine is an eighth-century Japanese nobleman's daughter named Chūjō-hime who, it was believed, inspired the Buddha Amida to descend to earth and oversee the weaving of a tapestry depicting the Western Pure Land. After briefly discussing the eighth-century tapestry, I will examine selected thirteenth- and fourteenth-century pictorial and literary works that develop the basic legend of Chūjōhime, then proceed to examine a dramatic twist in the legend, elaborated by the Nō playwright Zeami (1363–1443), which was to influence all further iterations of the story. After Zeami, the legend about Chūjōhime became increasingly independent of its religious orientation, but at the same time her place as a deity within the broader world of Japanese folk culture was assured. The simultaneous humanization and deification of Chūjōhime may be understood as an expression of an inclination to view reality in nondualistic, nondichotomized terms.

The Taima Mandala

In the middle of the eighth century, a large tapestry almost four meters square, depicting the Western Pure Land of the transhistorical Buddha Amida (Skt: Amitābha), was woven in China of silk threads. It was probably brought to Japan soon after and donated to Taimadera, the *uji dera* or family temple of the Taima clan. This temple, located in the countryside south of the Heijō capital (near present-day Nara City), was to give its name to the tapestry.[1]

Although only about 40 percent of the tapestry survives, scholars have been able to reconstruct its original appearance, aided by painted restoration work that began in the thirteenth century. This tapestry shows the

[1] For further discussion, see Elizabeth ten Grotenhuis, "Rebirth of an Icon: The Taima Mandala in Medieval Japan," *Archives of Asian Art* 36 (1983): 59–87.

Western Paradise presided over by Amida and his two chief attendants Kannon (Skt: Avalokiteśvara) and Dai-seishi (Skt: Mahāsthāmaprāpta) (fig. 23). The paradise is also inhabited by many other deities, musicians, and dancers, as well as devotees being born in the lotus pond in front of the central terrace where a large figure of Amida sits enthroned. Three narrow rows of pictures framing the central vision present incidents from the holy text on which the work is based, the *Kanmuryōju-kyō* (The *Sūtra*

23. Diagrammatic representation of the Taima mandala. Courtesy of Taimadera, Nara Prefecture, Japan.

of contemplation on the Buddha of Immeasurable Life):[2] in the left vertical court, the story of the Indian prince Ajātaśatru, who imprisoned and attempted to murder his father and mother; in the right vertical court, thirteen of the sixteen contemplations taught by the historical Buddha Śākyamuni to Ajātaśatru's mother Queen Vaidehī in order to help her achieve birth in the Western Pure Land; in the lower horizontal court, the last three contemplations subdivided into the nine possible degrees of birth in Paradise and represented by *raigō* (welcoming descent) scenes of the Buddha and his attendants.

No mention of this tapestry has been found in Heian-period (794–1185) documents. But from the last decade of the twelfth century onward, it appears with regularity in the literature of the Japanese Pure Land (Jōdo) tradition. The first copies of the tapestry seem to have been made in the Kenpō era (1213–1218). Hundreds of painted and woodblock-printed copies have been created through the centuries, often on a greatly reduced scale. The tapestry itself was first extensively repaired in the Ninji era (1240–1242), and again in the Enpō era (1637–1680).[3]

This tapestry should theoretically be called a *hensō zu* in Japanese. *Hensō zu*—literally, "transformed visions" or "changed aspect depictions"—are visual presentations of doctrinal or literary themes.[4] After the early eleventh century, however, the influence of Esoteric Buddhist nomenclature caused many depictions of sacred realms to be called *mandara* in Japanese (Skt: *maṇḍala*). In Esoteric Buddhism the mandala represents the realm of enlightenment, the locus for the identification of practitioner and Buddha. Since Pure Land believers experience enlightenment in the Western Paradise thanks to the teachings of Amida, there is broad justification for calling this Pure Land a realm of enlightenment. In any case, the Taima *hensō zu* is popularly called the Taima *mandara*. To distinguish

[2] Translated by F. Max Müller, ed., *Buddhist Mahāyāna Texts*, in Sacred Books of the East (1894; reprinted Delhi: Motilal Banarsidass, 1968), 49:161–201. In this volume the *Kanmuryōju-kyō* is given a literally translated Sanskrit name, the *Amitāyur-dhyāna-sūtra*, although no Sanskrit or Tibetan version of the *sūtra* is extant, and some scholars doubt that a Sanskrit original ever existed. A more recent translation is Ryukoku Translation Center, *The Sūtra of Contemplation on the Buddha of Immeasurable Life as Expounded by Śākyamuni Buddha* (Kyoto: Ryukoku University, 1984).The original Chinese text is found in Daizōkyō Kankōkai, ed. Taishō shinshu Daizōkyō, 85 vols. (Tokyo: Taisho Issaikyo Kankokai, 1924–1932) 12 (text 365) (hereafter cited as T). The composition of the Taima mandala, seen in such details as the division of the sixteen meditations into two groups of thirteen and three, is indebted to the Chinese Pure Land master Shan-tao (ᴄ.ᴇ. 613–681) and his commentary on the *Kanmuryōju-kyō*, which is found in T. 37 (text 1753).

[3] Yanagisawa Taka et al., *Taimadera*, in Yamato no koji (Tokyo: Iwanami Shoten, 1982), 2:2–18.

[4] For further discussion, see Victor H. Mair, *Tun-huang Popular Narratives* (Cambridge: Cambridge University Press, 1983). See also Hamashima Masaji et al., *Jōdokyō*, in Zusetsu *Nihon no Bukkyō* (Tokyo: Shinchōsha, 1989), 3:113–120.

the eighth-century tapestry from the many later versions, the early weaving is commonly termed the Kompon (original) Taima Mandara.

In the center of the lower horizontal court of the thirteenth- and post–thirteenth-century versions of the Taima mandala is an inscription recalling the legendary origin of the mandala in Japan. The basic information presented is that in the year Tempyō-hōji 7 (C.E. 763), the mandala was miraculously woven out of lotus threads. Some, more detailed inscriptions describe how Amida and Kannon descended to earth in human form in response to the prayers of a devout young noblewoman named Chū-jōhime, and that after Kannon wove the tapestry, Amida explained its meaning. Unfortunately, we can never know what originally appeared in the center of the lower horizontal court of the Kompon Mandala, since by the early Kamakura period, when the work was first described in written sources, that part of the tapestry had disintegrated.[5] How the person of Chūjōhime first became connected with the Taima mandala, therefore, is a question that cannot be definitively answered. One can only trace her legend from the thirteenth century onward when she was already firmly associated with the mandala.

Thirteenth- and Fourteenth-Century Versions of the Legend

The earliest reference to the origin of the Kompon Taima Mandala appears in the 1191 *Kenkyū gojunrei ki* (Record of an imperial pilgrimage of the Kenkyū era). Two theories are proferred concerning the *Gokuraku hensō zu* (Transformed vision of Paradise) in the Saidō (Western Hall, also called the Mandara dō or Mandala Hall). The first is that thanks to a vow of the wife of Prince Maroko, in Tempyō-hōji 7 (763) on the evening of the twenty-third day of the sixth month, a "transformed person" appeared and wove the mandala out of lotus threads. In another chapter, the same work records that at an earlier time, when the lower horizontal court had not yet been lost to abrasion, the date Tempyō-hōji 7 (763) was woven in, as was the name of the donor—identified as the daughter of Yokohagi (no) Otodo. This passage goes on to relate that a "transformed being" appeared and wove the mandala.[6] The basic information recorded in the *Record of an Imperial Pilgrimage of the Kenkyū Era* was repeated and embellished in the next hundred years, appearing in a number of literary works.[7]

[5] Bunkazai Hogo Iin-kai, ed., *Kokuhō tsuzure ori Taima mandara* (Tokyo: Bunkazai Hogo Iin-kai, 1963).

[6] Saeki Eriko, " 'Taima mandara engi emaki' no seisaku haikei ni kansuru ichishiron," *Bijutsushi* 106 (February 1979): 130.

[7] For a listing of these texts, see Kawahara Yoshio, "Seizan ryū ji in no jihō chōsa ni yoru

The earliest and the archetypal pictorial version of the legendary history of Taimadera and of Chūjōhime is the *Taima mandara engi emaki*, a narrative handscroll painting telling of the legendary origin of the Taima Mandala. This handscroll painting, noteworthy for its heightened vertical scale and generous use of gold, belongs to Kōmyōji in Kanagawa Prefecture. The work, consisting of six pictorial and six textual portions, is dated to the second half of the thirteenth century.[8]

The text of the Kōmyōji painting is extremely close to the *Yamato-kuni Taimadera engi*, also called *Ninnajibon* (Ninnaji variant) of 1253. In both the picture scroll and the Ninnaji Variant, the story of the founding of Taimadera and the miraculous creation of the mandala is fully developed. The fact that it seems to be at least one important source for the Kōmyōji painting is significant because the Ninnaji Variant was the registration book for solicitation of funds (*kanjin chō*) for the repair of the Mandara dō at Taimadera in 1242. Since the text of the Kōmyōji scroll painting is so close to the Ninnaji Variant, it has been suggested that the painting might have been commissioned at about the same time by individuals (perhaps high-born women) connected with the great repair project.[9]

The *Taima mandara engi emaki* opens with a section of text telling of

yobiteki hōkoku sho," *Nara kokuritsu hakubutsukan shiryō shitsu chō* (Nara: Nara National Museum, 1979), pp. 17–18. See also Gorai Shigeru, *Taimadera engi to mukae kō, Kōen no nōto* (Summer 1977), in connection with the Taimadera exhibition at the Nara National Museum. The first specific mention of the name Chūjōhime is found in the *Shishu hyaku in enshū*, edited by the monk Jūshin in 1257.

Several suggestions have been made to solve the question of Chūjōhime's true historical identity. All these theories have in common the notion of a connection, through the maternal line, with the old aristocratic Taima clan. In most of the early *engi*, including the Kōmyōji handscroll painting, Chūjōhime is called the daughter of Yokohagi no Otodo, that is, of Minister Yokohagi. Yokohagi Daijin was another name for Fujiwara Toyonari (704–765), who served as minister of the right beginning in 757. Fujiwara Toyonari may thus have been Chūjōhime's father. In other sources, however, Chūjōhime is identified as the mother-in-law or the wife of Toyonari. For further details see Kawahara, "Seizan-ryū ji-in no jihō chōsa ni yoru yobiteki hōkoku sho," pp. 4–5; Kawahara Yoshio, *Taimadera*, in Yamato koji taikan (Tokyo: Iwanami Shoten, 1978), 2:7–8; Tanaka Hisao, "Chūjōhime densetsu o horu," *Geijutsu shinchō* 3, 249 (September 1970): 123–124. (Speculations about Chūjōhime's historicity are also summarized in E. ten Grotenhuis, *The Revival of the Taima Mandala* [New York: Garland 1985], pp. 174–177.)

I am grateful to Karen L. Brock for reading this manuscript and making helpful suggestions, including pointing out that it would be better not to call Chūjōhime a "princess," since she was not the daughter of an emperor or a prince (*miya* or *naishinnō*).

[8] Kawahara Yoshio, *Taima mandara engi, Chigo Kannon engi*, in Nihon emaki taisei 24 (Tokyo: Chuo Koronsha, 1979); Shirahata Yoshi, *Saigyō monogatari emaki, Taima mandara engi*, in Nihon emakimono zenshū, rev. ed., 12 (Tokyo: Kadokawa Shoten, 1977).

[9] Saeki, " 'Taima mandara engi emaki' "; Kawahara, *Taima mandara engi*, pp. 115–20, 127–131.

the origin of Taimadera: founded by Prince Maroko, the third son of Emperor Yōmei (r. 585–587), the temple was transferred to a new site after an oracle appeared to Maroko in a dream.[10] The text then discusses the religious aspirations of the daughter of Yokohagi no Otodo. Uninterested in worldly affairs, she copied a thousand scrolls of the Pure Land–praising *sūtras*, mounted them on jeweled rollers, tied them with gorgeous strings, and dedicated them to Taimadera.

The second section of text tells how on the fifteenth day of the sixth month of the seventh year of Tempyō-hōji (763), Yokohagi no Otodo's daughter became a nun and set herself a limit of seven days to realize her vow of seeing the Buddha Amida in living form. On the twentieth day of the month a nun mysteriously appeared and told the girl that she must gather one hundred horseloads of lotus stems. The girl reported the request to the emperor, who ordered a subordinate to commandeer a party of conscripted laborers and gather the stems. This having been done, the nun extracted a miraculously large amount of thread from the lotus stems.

The third section of text relates how a well was dug, in which the nun miraculously dyed the thread five colors. Spectators wondered whether there was any connection to miraculous events that had occurred at this site a hundred years earlier. They recalled how the Emperor Tenji (r. 668–671) had sent a messenger to inspect a stone that nightly emitted rays of light. Hearing that the stone was shaped like a Buddha image, the emperor had it sculpted into a triad representing the future Buddha Miroku (Skt: Maitreya) and two attendants and, further, had a hall dedicated to Miroku built on the spot. The semilegendary seventh-century ascetic En no Gyōja also planted a sacred cherry tree there.

The second scroll of the *Taima mandara engi emaki* begins with a section of text that relates that on the evening of the twenty-third day of that

[10] The entire text of this scroll painting is translated in ten Grotenhuis, *The Revival of the Taima Mandala*, pp. 156–164.

The establishment of Taimadera, located in present-day Taima-cho, Kitakatsuragi-gun, Nara Prefecture, is not recorded in the official Nara-period histories; histories (often legendary, such as the present one) from the Kamakura period and later record that the Taima clan first vowed to build their clan temple in the early seventh century. In C.E. 681, the temple was moved to its present location. At first it was called Manhōzō-in, then Zenrinji, but now it is known only as Taimadera. In the eighth century Taimadera belonged to the Sanron sect, but today it owes allegiance to both the Shingon and the Jōdo sects, a sectarian arrangement that probably dates from the Muromachi period. Three of its five subtemples belong to the Jōdo sect; the other two are Shingon subtemples, affiliated with Mount Kōya. The main halls—the Mandara-dō (Hondō), the Kōdō, and the Kondō—are the common property and responsibility of the priests of both sects. Fukuyama Toshio, "Taimadera no rekishi," *Bukkyō geijutsu* 45 (December, 1960): 1–11.

month, an "apparitional woman" appeared.[11] She set up a loom in the temple hall and wove furiously through the night. Having completed her task, she then hung before the first nun and the girl a brilliant tapestry about four meters square depicting the Western Paradise. After dedicating it, the weaver mounted clouds of five colors and departed to the West.

The corresponding pictorial section shows the apparition as an elegant woman depicted in succession from right to left: once sitting with the nun and the nobleman's daughter, then in the next chamber moving toward a room farther to the left where she sits and weaves a magnificent tapestry. In the final room to the left, the nun and the girl worship the now completed mandala hung on the wall (fig. 24) while the apparitional woman is cloud-borne, ascending to the upper left. The lower half of the completed mandala is visible—showing a resplendent golden lake of Paradise. These interior scenes are clearly visible because roofs are not painted, so that activities taking place indoors can be seen.

The fifth section of the text describes how the nun explained in some detail the parts of the mandala and their significance to the nobleman's

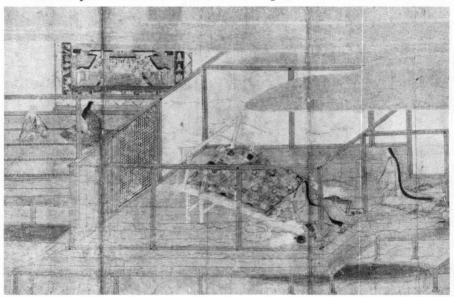

24. *Taima mandara engi emaki.* Second half of the thirteenth century. Ink, colors, and gold pigment on paper. Two handscrolls; H. (each) 49.4 cm. Kōmyōji, Kanagawa Prefecture. National Treasure.

[11] Both the nun (Amida) and the weaver (Kannon) are described in this text as *ke*, which can be translated as "transformed" or "apparitional." *Ke* connotes a superhuman manifestation, a temporary manifestation in human form by a deity.

daughter. The girl, overcome with emotion, wept profusely. After the nun recited a verse about the Western Paradise, the girl swooned. Upon regaining consciousness, the girl asked the nun who she was, and the nun revealed herself as Amida and the weaver as Kannon. Pointing to the West, Amida then departed.

The last textual section tells how on the fourteenth day of the third month of Hōki 6 (775), the nobleman's daughter attained birth in the Western Paradise. Otherworldly fragrances wafted through a blue sky. Music emanated from the West, and birds chirped as a welcoming descent came to greet her, floating down on a bank of purple clouds. Thus, Amida's promise to receive all devotees into his Western Paradise was fulfilled.

The next major artistic work to mention the donor of the mandala (and here she is called "Chūjōhime) is the *Ippen Hijiri-e*. The *Ippen Hijiri-e* (Pictorial [history] of the holy man Ippen), an ambitious pictorial and calligraphic work on silk dated 1299, chronicles the life and travels of Ippen (1239–1289), the founder of the last of the major Amidist sects, the Ji (Time) sect.[12] Taimadera figures specifically in the fifth section of the eighth scroll of this twelve-scroll narrative painting. The text records how in 1286, after he visited the mausoleum of Shōtoku Taishi at Mount Shinaga, Ippen traveled to Taimadera in the nearby province of Yamato. The accompanying pictorial section shows Ippen and members of his fraternity seated in a temple hall eating a meal, while parishioners approach the hall with more offerings of food.[13]

The *Ippen Hijiri-e* is important for this essay because—presumably reporting an established tradition—it identifies Chūjōhime as an incarnation of a Buddhist deity. The textual portion describing Ippen's visit to Taimadera includes the following comments:

> During Ippen's confinment for prayer, the temple monks bestowed on him a priceless temple treasure, a scroll of the *Sūtra in Praise of the Pure Land*. This *sūtra* is among a thousand scrolls copied by the hand of the donor, Princess Chūjō. Since they say that this person was a manifestation of Seishi Bosatsu, Ippen regarded it as an extremely precious thing and treasured it.[14]

A scant hundred years after her first mention in a literary document, then, Chūjōhime had been elevated to bodhisattva rank. Although her story

[12] Miya Tsugio, *Ippen Hijiri-e*, in Nihon emakimono zenshū, rev. ed., 11. See also the chapters by James Foard and Laura Kaufman in this volume.
[13] Laura Kaufman has argued convincingly that, although this scene is identified as Taimadera in the *Ippen Hijiri-e* text, it is really a protrayal of the Jimokuji in Owari Province, which Ippen visited in 1283. Laura S. Kaufman, *Ippen Hijiri-e: Artistic and Literary Sources in a Buddhist Handscroll Painting of Thirteenth Century Japan* (Ann Arbor: University Microfilms International, 1980), pp. 78–80, 94–97.
[14] Ibid., p. 365.

was to take on new dimensions, she would never lose this status as a purified being who was akin to a deity.

Another pictorial work, the *Taima mandara engi* (Legendary history of the Taima Mandala), presented in two hanging scrolls and clearly based on the *Ninnaji-bon*, is found at Taimadera.[15] This pair of paintings is dated on the basis of style to the middle of the fourteenth century. The first hanging scroll contains seven sections, read from top to bottom, which visually retell the story of the founding of the temple. The second scroll, which is read from bottom to top, contains twelve major sections skillfully linked to recount the legendary history of the mandala and the welcoming descent of Amida. This *Taima mandara engi* is the last extant major pictorial work that presents the legend of Chūjōhime in its traditional form.

Zeami and the Nō Theater

During the late fourteenth and fifteenth centuries, a dramatic new twist was added to the legend of Chūjōhime. She now came to be seen as an ill-treated child, whose thoughts and aspirations were directed toward the Western Paradise after she had been cruelly abandoned in the mountains. Later, when the episode of Chūjōhime's abandonment in the mountains was tied to rejection by a wicked stepmother, it fired the popular imagination and became an integral part of the legend.

The earliest extant literary works that record the addition of the legend are two plays of the late fourteenth or early fifteenth century traditionally attributed to Zeami and included in the standard repertory of the Nō theater. One is *Hibariyama* (Skylark Mountain); the other, *Taema* (a variant reading for Taima). Current research suggests that *Hibariyama* was not actually written by Zeami himself, but was a contemporary or earlier play by another author.[16] Literary scholarship accepts *Taema* as an authentic work by Zeami even though the play is not mentioned in any of Zeami's writings, and there is no manuscript of it in Zeami's own hand.[17]

In the first act of *Hibariyama*, a retainer of the Minister Toyonari tells how he was ordered to take Chūjōhime, Toyonari's daughter, to the mountains and kill her, presumably because Toyonari had believed some slander about the girl. The retainer took her to Mount Hibari, at some distance from the capital city of Heijō, but could not bring himself to kill her; instead, he built a simple hut for her and her faithful nurse. The name

[15] Kawahara, *Taimadera*, in Yamato koji taikan 2:113.

[16] Nishino Haruo, " 'Hibariyama' Zōkō," *Kanze* (Spring–Summer 1976): 3.

[17] Hattori Yukio, " 'Taima' sono honsetsu ni tsuite," *Kanze* (Spring–Summer 1977): 32.

Hibariyama is significant because skylark connotes the weak, fluttering condition of the abandoned child.

In the second act, Toyonari meets the nurse when he is out hunting near Mount Hibari. Having discovered that his daughter was innocent, he laments over his past severity and rejoices to verify the rumor that Chūjōhime is alive and living on the mountain. When the nurse is convinced that his repentance is genuine, she leads him to his daughter; father and child are movingly reunited and joyfully return together to the capital.[18]

What is especially significant about *Hibariyama* is the absence of any reference to Taimadera and Chūjōhime's religious experiences there. This drama exists as a separate entity, an independent folktale relating a not uncommon theme—that of a child wronged, abandoned, and eventually happily restored to her former indulged position.[19]

Taema, on the other hand, draws on the legend connecting Chūjōhime with Taimadera. In the first act, a Pure Land priest and his companions decide to visit Taimadera, where they meet an old nun and a young girl who praise Amida's teachings. The priest inquires about the history and importance of Taimadera, and the nun tells the traditional story of Chūjōhime and the weaving of the mandala. The nun and the girl then reveal themselves to the priest as Amida and Kannon, returned to the temple to perform a memorial service.

In between the first and second acts, the Kyōgen player, "a person from the vicinity" who is visiting the temple, talks with the priest and tells him the story of Chūjōhime's abandonment by her wicked stepmother on Mount Hibari, as a consequence of which she decided to renounce the world and enter Taimadera:

> First of all the lady called Princess Chūjō was the daughter of the Minister of the Right from Yokohagi, Lord Toyonari, who lived in the reign of Emperor Junnin. For certain reasons she was sent away and abandoned on Mount Hibari. Most people would find it hard to live in the mountains like that, but as she was a Buddha on Earth, she never complained and instead passed her days in the invocation of the Buddha's name and in meditation. On one occasion her father Toyonari went out hunting and made his way to the Hibari mountains.

[18] Sanari Kentarō, *Yōkyoku taikan* (Tokyo: Meiji Shoin, 1931), 4:2637–2650.

[19] This is not an uncommon theme in Nō. There is, for example, the play *Yoroboshi* attributed to Juro Motomasa (1395–1432). This one-act play deals with a boy who has been banished from home by his father on account of a false accusation. The boy's grief causes him to go blind, and he becomes a beggar near the famous old temple, Shitennōji, in present-day Osaka. His father, having realized his mistake and become deeply repentant, eventually finds his son and brings him home. (Japan Society for the Promotion of Scientific Research, ed., *The Noh Drama: Ten Plays from the Japanese*, trans. Japan Classics Translation Committee [Rutland, Vt.: Tuttle, 1967], pp. 97–112.) For a parallel Sekkyo-bushi version see the chapter by Susan Matisoff in this volume.

He discovered there a beautiful lady, living in a brushwood hut she had built in a ravine. Lord Toyonari was quite surprised, for he supposed that no one could live in such a rough place. When he asked who she was, the lady replied, "I am the daughter of Lord Toyonari, but I was abandoned here, through the designs of my stepmother, in these deep mountains."

When Lord Toyonari heard this, he was astonished; not even in his dreams had he imagined that such an outrage had happened. "But I am your father! Please forgive me for everything." He took her back to the capital at Nara, and he was already planning to have her installed as Empress.

But the Princess had no taste for such affairs and thought only about enlightenment in the future world. She crept away from the capital and came to this temple. Here, she cut off her hair to become a nun. She prayed that she might worship Amida in his living form, and once she did, indeed, see him. She prayed to him, "Bestow some miracle for mankind in this degenerate age, which will lead them to enlightenment."[20]

After the Kyōgen interlude, the second act of *Taema* dramatizes the miraculous appearance of the spirit of Chūjōhime. In a lengthy and moving passage of dance and song, she urges the visiting priest to read and worship the Pure Land *sūtras*.

In *Taema* Zeami probably grafted a current tale, such as the one that is dramatized in *Hibariyama*, to the older legend dealing with the origin of the Kompon Taima Mandala. The clue to this possibility lies in the fact that it is in the Kyōgen's speech that the *Hibariyama* story appears in the play *Taema*. The Kyōgen player, who appears between acts 1 and 2 of a Nō play and is generally a villager, has the function of explaining the dramatic situation in easier language and in psychological terms everyone in the audience can understand. He adds background or incidental information, often related to the lives of the characters, but not necessarily essential to the development of the play.[21] Zeami must have added the Kyōgen's speech to flesh out the story of Chūjōhime, to answer the implicit question as to why a young, beautiful girl should want to renounce the world. Perhaps by borrowing a current story unrelated to the events that occurred at Taimadera, and by inserting Chūjōhime as the protagonist, he gave the Taimadera story new life and created a new, synthetic legend. Zeami was, in Susan Matisoff's words, a "practical man, a suc-

[20] Thomas Rimer, "Taema—A Noh Play Attributed to Zeami," *Monumenta Nipponica* 25, 3–4 (1970): 441–442; (entire play pp. 431–445).

[21] One problem that should be mentioned is that the pure *katari* (narration) of an Aikyōgen, such as appears in *Taema*, was not usually written down until the Edo period (1603–1868). A playwright like Zeami would presumably have told the Aikyōgen player what he wished him to say, in general terms; the specifics of the speech were the responsibility of the Kyōgen. We can assume that the Hibariyama legend was incorporated into Zeami's original conception of the play, although its exact formulation is unverifiable.

cessful playwright, and an adept manager. He fully approved of the idea of revising old plays to make new, more appealing versions."[22]

The Chūjōhime legend thus expanded and changed dramatically within the Nō theater. The world of the Nō bridged the aristocratic culture of the Heian period and the popular culture that was to become prominent in the Edo period. Drawing on stories and themes from traditional Japanese literature, such as the *Man'yō-shū, Kokin-shū,* and the *Ise, Genji,* and *Heike* tales, Nō playwrights often reworked and reinterpreted these old pieces, especially elaborating the internal lives and dilemmas of the characters. The actors and playwrights also bridged the social worlds of the aristocratic elite and the commoners. Zeami, ostensibly belonging to a low socioeconomic class and performing in the country at local shrines and temples, was also favored by the shogun Yoshimitsu and was acutely aware of the need to please an aristocratic audience well-versed in classical culture. The deft weaving of poems and literary allusions into the texts of the Nō plays marks this drama as the final expression of a long development of traditional literature.

A dramatic vehicle that could express delicate nuances of emotion, the Nō contained elements that would influence Jōruri ballad-dramas and Kabuki plays. The Nō also provided a major source of material for the playwrights of the seventeenth century and later. Kabuki plays, for instance, often derive their inspiration not directly from the earlier prose literature but from the Nō repertory; this process may be seen at work in the Kabuki adaptations of the Chūjōhime legend. The cultural exchange between the aristocratic and popular spheres that began in the Kamakura period (1185–1336) was finally complete by the mid-Edo period. The fourteenth and fifteenth centuries proved to be the pivotal time in this cultural shift.[23] Certainly, in the Nō play *Taema,* an essentially aristo-

[22] Susan Matisoff, *The Legend of Semimaru, Blind Musician of Japan* (New York: Columbia University Press, 1978), p. 109.

Among other instances in the Nō theater in which various tales are combined, a notable example is the play *Miwa. Miwa* is actually a collage of three separate stories whose only common denominator is their setting, Mount Miwa. The first tale concerns the monk Gempin, who leaves the capital to live at the foot of Mount Miwa and there lends his warm cloak to a village woman who turns out to be a manifestation of the deity of Miwa. When she reveals herself, she tells Gempin two further legends: one, a Cupid-Psyche-like story concerning relations she had as a human girl with a "husband" who always visited her in disguise; eventually she discovered that he was the god of Miwa. This second tale leads into the third, which is a rendition of the famous story of the sun goddess Amaterasu hiding herself in a cave on Mount Miwa and causing the earth to fall into darkness. Finally Amaterasu emerges, the world becomes light once again, and the sun goddess and the deity of Miwa are revealed as having originally been the same deity. Monica Bethe, trans., "Miwa: Three Circles," in *Twelve Plays of the Noh and Kyogen Theaters,* ed. Karen Brazell (Ithaca: Cornell University East Asia Papers, 1988), 50:23–38.

[23] I am indebted to Monica Bethe for access to her unpublished manuscript on the Nō

cratic story takes on popular overtones; while at the same time the pop-
ular story *Hibariyama* becomes elevated by being conjoined to the leg-
endary history of a revered icon.

Selected Pictorial Versions of the Chūjōhime Legend after Zeami

One handscroll painting that reflects the new dimensions of the Chūjō-
hime legend is the three-scroll *Taimadera engi emaki* in the possession of
Taimadera, which is dated Kyōroku 4 (1531). This work, often called the
Kyōroku-bon, contains twenty-three sections of text with corresponding
pictorial sections.[24] The first scroll of the set records and pictorializes the
history of the founding of Taimadera. It is essentially the same story that
is found in the *Taima mandara engi emaki* from Kōmyōji, although with
somewhat embellished details.

The second scroll includes the Mount Hibari story in a more elaborate
version than the one that appears in the Nō plays. The legend of Chūjō-
hime, which was continually developing and expanding, now includes a
younger brother and the story of abandonment on not one but two moun-
tains. The textual and pictorial sections in this second scroll may be sum-
marized as follows:

1. Yokohagi Saidaijin Toyonari's noble wife makes a pilgrimage to Hase-
dera, where she has an auspicious dream.

2. As a gift from the Kannon enshrined at Hasedera, a daughter is born to
Toyonari's wife. When the girl is three years old, a brother is born.

3. When the girl is seven, her mother dies.

4. Toyonari remarries and his wife, the children's wicked stepmother, aban-
dons them in Jigokutani (Hell Valley) on Katsuragi Mountain.

5. Rumors reach the emperor concerning this situation, and he sends an im-
perial messenger to escort the children back to the capital.

6. The young girl experiences a religious awakening and starts to study *sū-
tras* praising the Pure Land.

7. The wicked stepmother gives instructions to a retainer to coax away the
girl.

8. The girl is abandoned once again, this time on Mount Hibari. The retainer
is about to kill her.

9. Moved by her pleas, the retainer decides instead to rear the little girl with
the help of his wife. The girl copies out Pure Land *sūtras* on paper obtained by
the wife of the retainer.

theater in which this summary of the importance of Nō as a cultural bridge appears (Kyoto,
1984).

[24] Kawahara, *Taimadera*, in Yamato koji taikan 2:113–114.

In the third scroll Toyonari finds Chūjōhime on Mount Hibari and brings her back to the capital. After the death of her younger brother, the girl enters Taimadera, and the subsequent familiar events take place.

Illustrated legendary histories of Chūjōhime continued to be produced in the Edo period. One three-scroll set with twenty-three scenes and corresponding sections of text, based on the *Kyōroku-bon*, was created in 1633 for the Nembutsu-in subtemple at Taimadera. It is now in a private collection.[25]

Another Edo-period work, a one-scroll narrative painting entitled *Hibariyama engi emaki*, is found at Shōrenji in Uda, Nara Prefecture. This picture scroll focuses on the Mount Hibari story; only three of the twelve sections deal with Taimadera. This narrative painting also provides a legendary origin for Shōrenji, said to be located on that now-hallowed site of Mount Hibari made sacred through the suffering of Chūjōhime. The eleventh section of text and its accompanying illustration describe how Chūjōhime left Taimadera after the miraculous weaving of the mandala, climbed up Mount Hibari, and founded Shōrenji. She also patronized the carving of statues of herself and the kind wife of the retainer, which were enshrined in the temple. The text ends with a statement that everyone who makes a pilgrimage to Shōrenji will be joined in a Dharma relationship with Chūjōhime, something that will destroy all bad karma.[26]

The Harvard University Art Museums in Cambridge, Massachusetts, own a handscroll dated ca. 1600 called the *Chūjōhime no honji* (The prototype of Chūjōhime). Originally this work seems to have been a book, and, judging from the disjointed quality of the narrative, it seems likely that some sections have disappeared. The losses probably occurred when the pages of the book were cut apart and attached together in the handscroll format.

The Harvard *Chūjōhime no honji* is a fine example of a genre of work called *Nara-ehon*, a term of modern vintage that suggests hand-illustrated manuscripts in either book or scroll form created from the fifteenth through the eighteenth centuries. These undated narratives, often rendered by anonymous painters in an amateurish or folkish style, were almost exclusively illustrated works of medieval Japanese prose literature. *Honji-mono*, a subgroup of *Nara-ehon*, deal with the miserable, previous human existences of deities. These tales, full of suffering and woe, end with a revelation of the identities of the deities who had experienced such earthly misery.[27] The suffering of stepchildren was a popular theme

[25] Nara National Museum, ed., *Chūjōhime eden* (Nara: Nara National Museum, 1979, exhibition catalogue), p. 8, pl. 20.

[26] Ibid., p. 5, pl. 11-1.

[27] Further references to other "Chūjōhime no honji" may be found in Keiō Gijuku Daigaku Shido Bunko, ed., *Shido bunko ronshū* (Tokyo: Keio Daigaku, 1962), 1:234. The term

within *Nara-ehon* and *honji-mono*.[28] The story of Chūjōhime appears with some regularity in this genre.[29]

The Harvard handscroll opens with a scene of the household women weeping with the nobleman's daughter. Next one sees the stepmother directing the retainer to take the girl away. The retainer escorts Chūjōhime out of the house while her ladies continue to wail. In the mountains the retainer is about to kill the girl; her gold robe lies on the ground (fig. 25). This scene, with its oversize blossoms and almost clumsy drawing, conveys well the amateurish flavor characteristic of many *Nara-ehon*. In the next episode the retainer receives Toyonari, who is riding on a horse, while the girl and the retainer's wife wait inside the hut. Then a tearful meeting between Toyonari and Chūjōhime ensues; the bearers wait outside the hut. Next one sees the retainer and his wife being received by Toyonari and Chūjōhime in their noble residence in Nara. In the next section the girl is seen alone, contemplating her further course of action. Chūjōhime then appears taking instruction, and finally the tonsure, at Taimadera. In the ensuing scene lotus threads are hung to dry on En no Gyōja's cherry tree; then the thread is spun. Finally a welcoming descent comes to escort Chūjōhime to the Western Paradise.

Selected Jōruri and Kabuki Dramas

During the late Muromachi period (1392–1568) and especially in the Edo period, Chūjōhime became the subject for *otogizoshi* short stories, as well as Jōruri ballad-dramas and Kabuki plays. The aspect of her story most emphasized in these sources had nothing to do with the miraculous creation of the mandala, but with the abuse she had suffered as a stepchild. This chapter will mention only some of the late plays dealing with Chūjōhime, plays that merit further study and interpretation.

honji is derived from the simplest meaning of the phrase *honji suijaku*, the thesis that Shinto deities are *suijaku* or "flowing traces," manifestations or *avatars* of Buddhas and bodhisattvas, who are their *honji* or "original ground."

[28] Zaigai Nara Ehon Committee (Barbara Ruch et al.), *Zaigai Nara Ehon* (Tokyo: Kadokawa Shoten, 1981), pp. i–iii. On the general theme of suffering stepchildren see also Susan Matisoff's chapter in this volume.

[29] A scroll deposited in the Tokyo University Library detailing the Chūjōhime story and dated 1651 (a few decades later than the Harvard piece) describes how Chūjōhime's stepmother slandered the girl and caused her banishment. I am grateful to John Buchanan for allowing me to study his unpublished translation of this story.

According to this scroll, the stepmother had a male in her employ impersonate three different men. She ordered the man to parade in and out of Chūjōhime's apartments sometimes dressed in state robes, sometimes in informal dress, and sometimes in shabby, priestlike clothing. Calling Toyonari to observe, the stepmother persuaded him that his daughter, the young princess, was "utterly fickle, giving herself to . . . a veritable throng of lovers" (p. 4).

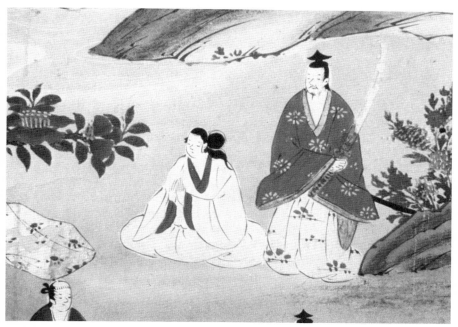

25. *Chūjōhime no honji.* Ca. 1600. Ink, colors, and gold pigment on paper. Handscroll, H. 30.9 cm.

The Jōruri performers added a new feature to the Chūjōhime legend, a romantic entanglement that had been lacking from the narrative up until this point. Now they posited the existence of a sister, rather than a brother, for Chūjōhime. The man in charge of cleaning the garden at the mansion of Toyonari one day chances upon the sleeping figure of Chūjō-hime's sister and is so stirred by passion that he becomes ill. When the wicked stepmother discovers this, she chases the sister out of the house. The sister subsequently goes to live with the garden cleaner. The step-mother then contrives to abandon Chūjōhime on Mount Hibari, ostensi-bly to punish her for her sister's lewdness. This legend introduced the theme of an illicit love affair that did not directly compromise Chūjōhime. It also helped satisfy a romantic dream that a common person, in this case a lowly gardener, could hope to win a beautiful aristocrat as his own.[30]

The Kabuki repertory, too, contained a number of plays dealing with

[30] For further detail on the spread of the Chūjōhime legend in popular narrative literature, see Gorai Shigeru, "Taimadera engi to Chūjōhime setsuwa," *Bungaku* (September 1977): 46–59, and Gorai Shigeru, "Ji sha engi kara otogibanashi e," *Bungaku* (September 1976): 29–41.

the Chūjōhime legend.[31] In 1628 a play *Chūjōhime miyako no hina* (Chū-
jōhime, the young lady from the capital) was first performed in Edo; the
following year another play, *Chūjōhime Hibariyama*, opened in Edo. In
the Genroku era (1688–1703) a play entitled *Taima Chūjō mandara no
yurai* (The origin of the Taima Chūjō Mandala) was first performed. This
play extolled Chūjōhime's beauty and implied for the first time an illicit
love affair in which Chūjōhime herself was directly involved. Part of the
purpose of this drama was to determine her virtue in the face of tempta-
tion. New dimensions of Chūjōhime were being explored.

In 1740 the first public performance of a Kabuki play dealing with
Chūjōhime was given in Osaka. Called *Hibariyama hime sute no matsu*
(The young princess abandoned on Mount Hibari), this play, which is
performed even today, focuses on the jealousy and sadism of Chūjōhime's
stepmother. Chūjōhime is seen as a paradigm of the abused child, a Jap-
anese Cinderella.

The Meiji period saw the first performance of two other Kabuki plays
dealing with Chūjōhime's life. In 1884 the *Chūjōhime Taima engi*, based
largely on the temple legend, was presented in Tokyo; and in 1887 a play
entitled *Hibariyama koma tsunagi matsu* (The pine tree to which a colt is
tied on Mount Hibari) opened there. This second play explores a new and
melodramatic turn in the legend: Toyonari's second wife falsely accuses
Chūjōhime of having a love affair with a man of low rank. She then con-
spires to steal her husband's secret statue of Kannon but is observed per-
forming this deed by Chūjōhime, whom she now has even more cause to
hate. She tries to murder the girl, leaving her lying in the snow, beaten
almost to death. Fortunately, however, two servants rescue Chūjōhime,
who then escapes to Mount Hibari through the compassionate interven-
tion of Toyonari. There Chūjōhime builds a hermitage and devoutly prac-
tices Nembutsu *zammai*—concentration on uttering the holy name of
Amida. The girl prays for and experiences the welcoming descent of
Amida, which places her forever beyond the reach of those who wish to
hurt her.

The Humanization and Deification of Chūjōhime

After the fifteenth century, then, the legend of Chūjōhime had become
increasingly humanized. The focus of interest had shifted from the man-
dala for whose existence she was largely responsible to an ever-expanding
story about the secular activities of the noblewoman herself. Focusing so

[31] Iizuka Tomoichirō, *Kabuki saiken* (Tokyo: Daiichi Shobo, 1926), pp. 468–470; Nara
National Museum, ed., *Chūjōhime eden*, p. 1.

strongly on the donor or inspirer of a mandala, or other work of art, seems to have had no precedent in China. The names of Chinese donors were often inscribed on paintings and sculptures, and portraits of Chinese donors were sometimes included, for example, in the foreground of paintings representing the Western Paradise.[32] But I know of no example in China where a donor steps out of a work of art, as it were, and becomes almost as important as, if not more important than, the original work itself.

At first the Chūjōhime legend enhanced the mandala itself, providing a means by which to make the work more comprehensible to the devotee. The concrete biography of Chūjōhime thus became an entrance to the more abstract and theoretical mandala. Later, the legend and particularly the part of the story that occurred before the young girl entered Taimadera came to exist as an independent entity. Chūjōhime's life story became as important as the Taima mandala itself, perhaps more so, because she had become a popular figure, a folk deity, while the mandala and its subtleties were well known only to those steeped in the doctrines of the Pure Land tradition.

But at the same time that Chūjōhime was becoming increasingly personalized and humanized, she continued to be admired, revered, and virtually deified. From the perspective of the Judeo-Christian tradition, which makes a rigid distinction between the sacred and the profane, the Creator and the created, this development may seem peculiar. In fact, however, it exemplifies a Japanese tendency to view such apparent opposites as "sacred" and "profane," in nondichotomized terms.

Various places in Japan were commemorated to the memory of the nobleman's daughter. Mention has already been made of Shōrenji, the temple erected at Uda in Nara Prefecture on the mountain where Chūjōhime was thought to have been abandoned. Shōrenji, however, was built at only one of the sites identified as Mount Hibari.[33] As itinerant preachers spread the story of Chūjōhime, they often identified the settings for her biography with the specific localities they were visiting. This narrative device made the characters in the stories seem more real to the often uneducated folk who gathered to listen.[34]

[32] ten Grotenhuis, "Rebirth of an Icon," fig. 3. For further discussions of female patrons and sponsors of painting in East Asia, see Marsha Weidner, ed., *Flowering in the Shadows: Women in the History of Chinese and Japanese Painting* (Honolulu: University of Hawaii Press, 1990). For general discussion of feminine images in Buddhism, see Diana Y. Paul, *Women in Buddhism: Images of the Feminine in the Mahāyāna Tradition* (Berkeley: University of California Press, 1985).

[33] See Gorai Shigeru, "Chūjōhime to Hibariyama," *Emakimono zenshū no geppo*, in Saigyō monogatari emaki, Taima mandara engi 12:277–280.

[34] See Matisoff, *The Legend of Semimaru*, p. 4. Matisoff's extensive comments on Sekkyō-bushi, which developed into a vehicle for popular entertainment and foreshadowed

There are also temples said to be erected at Chūjōhime's birthplace and over her gravesite. The most famous of the several memorials of her birthplace is in the city of Nara, where the Jōdo sect's Tanjōdera (Birth Temple), a small nunnery with a pretty garden, is located almost across the street from the Tokuyūji of the Yūzū Nembutsu Amidist sect, which boasts her gravesite. Both temples are located in Narigawacho, which in the nineteenth century and the first half of the twentieth century was the pleasure district of Nara. Prostitutes as well as respectable women looked to Chūjōhime as an example of a female in distress who had transcended difficult circumstances and as a virtual deity who could sympathize with their problems and cure their bodily ills. Even today, a common herbal medicine for the alleviation of a whole range of "female complaints" from irregular and painful menstrual periods, headaches, joint pains, and hysteria to fever, chills, dizziness, and poor circulation of the blood is marketed as Chūjōtō (Chūjō medicine).[35]

It seemed that a salvific bodhisattva had been transformed into human form, into the person of Chūjōhime. The bodhisattva Kannon and the noblewoman Chūjōhime can, in fact, be identified as virtually coequal agents in the creation of the original Taima Mandala. Chūjōhime's great faith summoned forth Amida, who then instructed Kannon to weave the tapestry. It is not surprising, then, that from the late thirteenth century onward, Chūjōhime was identified as Seishi, the third member of the triad of Amida, Kannon, and Seishi, the deities who preside over the Western Paradise. But Chūjōhime, though initially depicted as a devout girl, with lofty aspirations, soon became (or perhaps always was) far more earthly and human in nature than either Kannon or Seishi.

One last example illustrates the tendency to both humanize and deify the nobleman's daughter. These interacting factors seem to be present in a ceremony called the *nerikuyō eshiki*, that takes place every May 14 at Taimadera. This is a festival reenacting the descent of Amida's celestial company to welcome the devotee to Paradise, in which (at least at Taimadera) Chūjōhime plays a central role. Although reenactments of the descent of Amida date from the Heian period, originally none of these ceremonies had anything to do with the legend of Chūjōhime. There

Jōruri, are relevant to an understanding of how the Chūjōhime legend might have developed and spread. See especially *Legend*, pp. 46–52, 113–123, and her study of Sekkyō-bushi herein.

[35] Chūjōtō has been produced since the early Meiji period by Tsumura Juntendō from a formula ascribed to Chūjōhime. Meiji-period pharmacy signs for Chūjōtō are reproduced in Dana Levy et al., *Kanban, Shop Signs of Japan* (New York: Japan Society, 1982), pl. 70–72, pp. 150–152. The young lady pictured on contemporary boxes of Chūjō medicine wears a Heian-style headdress similar to those of the ladies in the Meiji pharmacy signs. The Tsumura family has also patronized the building of halls at temples associated with the memory of Chūjōhime. See ten Grotenhuis, *The Revival of the Taima Mandala*, p. 191.

seems to have been a revival of this kind of dramatic reenactment in the Muromachi period, when Chūjōhime was becoming an increasingly popular figure.[36]

The ceremony at Taimadera is basically a formal procession, with some dance movements, to a background of Gagaku music. It begins at the Mandara-dō (Mandala hall) and proceeds eastward along a ramp some 200 meters long to a small hut symbolic of the mundane world. At the head of the procession is a palanquin bearing a statue of Chūjōhime; on every other day of the year, this statue, showing Chūjōhime in the robes of a nun, is venerated in the Mandara-dō to the right of the main object of devotion, an early sixteenth-century painted Taima mandala. The descent follows the palanquin; forty-eight celestial children (*chigo*), representing the forty-eight vows made by Amida prior to his becoming a Buddha, are followed by priests of the temple, and finally by the twenty-five bodhisattva attendants of Amida wearing gilt lacquer masks and silk and brocade Chinese-style robes, and carrying various objects, usually instruments. Kannon, carrying a small gilt lacquer lotus throne, brings up the rear of the procession, with Seishi and the bodhisattva Fugen.

Next occurs a private five-minute ceremony in the hut; spectators understand that Kannon is taking a small statue of the bodhisattva Seishi from the hollow interior of the wooden statue of Chūjōhime and affixing it to the lotus throne. This image represents the enlightened heart of Chūjōhime. The procession then returns to the Mandara-dō in reverse order. Kannon, Seishi, and Fugen "dance" slowly up the ramp, with the little bodhisattva figure on the lotus throne, clearly visible and held on high (fig. 26). Then follow the twenty-five bodhisattvas, the priests, and the *chigo*. Finally, at the very end, is the palanquin bearing the statue of Chūjōhime.

In this festival Chūjōhime assumes a role that is at the same time partly divine and very human. She is identified with the bodhisattva Seishi, but she also represents the common person, who is promised a welcoming descent and subsequent cherished spot in the Pure Land of Amida. This ceremony deepens both the faith of believers and their longing for the Western Paradise, helping make them feel that they, like Chūjōhime, can indeed rise to Paradise.

[36] Okazaki Jōji, *Pure Land Buddhist Painting*, trans. and adapted by Elizabeth ten Grotenhuis (Tokyo: Kodansha International and Shibundo, 1977), p. 102. The ceremony is mentioned and pictorialized in the last section of the third scroll of the *Taima mandara engi emaki* of 1531 (the *Kyōroku-bon*) and also in the 1633 version of the legendary history. Other Pure Land temples that still reenact the descent include Sennyūji in Kyoto (an autumn celebration). For more discussion of the *nerikuyō eshiki* at Taimadera, see ten Grotenhuis, *The Revival of the Taima Mandala*, pp. 197–202. See also Hamashima, *Jōdokyō*, in *Zusetsu Nihon no Bukkyō*, 3:135–144.

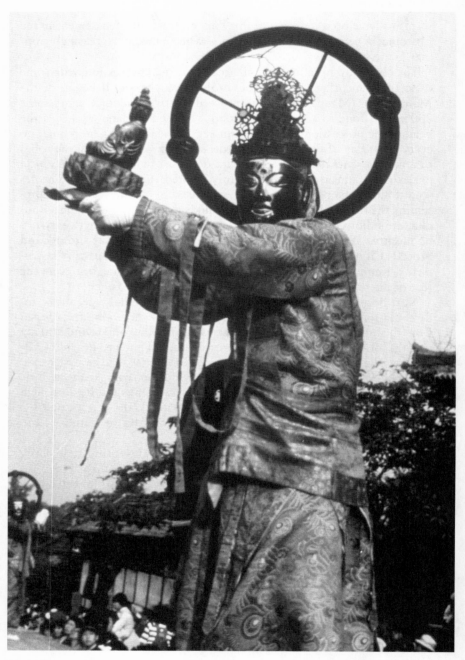

26. Kannon carrying Chūjōhime in the form of the Bodhisattva Seishi to the Western Paradise. The *Nerikuyō eshiki* ceremony held at Taimadera, May 14, 1978.

Eight

Multiple Commemorations: *The Vegetable Nehan* of Itō Jakuchū

YOSHIAKI SHIMIZU

AN UNUSUAL PAINTING by Itō Jakuchū (1716–1800) entitled *Yasai Nehan* (Vegetable Nirvāṇa) is in the collection of the Kyoto National Museum (fig. 27). This scroll formerly was among the treasures of the Seiganji temple in Kyoto, a branch temple belonging to the Nishi Honganji school of the Jōdo Shin sect. Measuring 181.7 centimeters in height and 96.1 centimeters in width, the *Yasai Nehan* is a very large work, especially in comparison with other works by Jakuchū executed in ink on paper.

This painting depicts an assemblage of vegetables in an open field, at the center of which a large radish or *daikon* reclines on a bed formed by a farmer's straw satchel. The radish head (where the stalks and leaves begin) is placed on the left-hand side, while the narrow, tapering root, in two branches, like a pair of feet, faces to the right. Grouped around the reclining radish are over sixty vegetables. Closest to the radish are turnips, one on the left-hand side of the radish and another on the right, close to the tip of the root. These two vegetables are laid flat with their leaves and stalks hugging the ground. Another turnip can be seen in the upper group of vegetables, near the right-hand group of corn stalks in the background. All vegetables, above, below, right, and left of the radish, are distributed so as to surround it. Many of them, like the two turnips, are prostrate. Pumpkins, gourds, mushrooms, lotus leaf, bamboo shoots, chestnuts, pears, *gobō* (burdock), melon, and eggplants can be identified even by viewers unfamiliar with the who's who of the Japanese vegetable kingdom.

The composition alludes to the scene of Parinirvāṇa (Japanese, *Nehan*), the Buddha's death: the reclining radish at the center, eight vertical corn stalks, the vegetable assembly itself, and a fruit peeking down from upper-left of the composition amidst the corn leaves all correspond to the motifs of Śākyamuni, Śāla trees, mourners, and Lady Māyā descending from Heaven.

While *Yasai Nehan* is an obvious allusion to the long-established *Parinirvāṇa* composition, what is not obvious is why this painting was

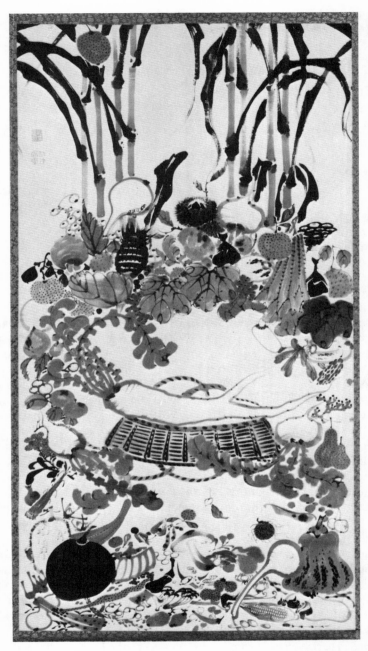

27. Itō Jakuchū (1716–1800), *Yasai Nehan* (Vegetable Nirvāṇa), ca. 1792.

painted. Several questions arise regarding its content: Is there some deeper meaning that makes this painting Buddhist? Is this composition the product of a genius spontaneously inventing his theme *ex nihilo* or does one find for the painting some historical rationale explaining how it has come about? If so, what is that rationale?

These questions inevitably involve the history of Japanese Buddhism, especially as regards the understanding of the relationship between the nature of the historical Nirvāna (that of Śākyamuni) and the universal Nirvāna of all beings.[1] A link must be established between the theme of Jakuchū's picture and ideas contained within the Buddhist view of beings and their Nirvāna as interpreted by the Japanese. The investigation must also deal with elements other than purely Buddhist ones. We must confront various strains of the cultural makeup of historical Japan, some of which are intricately interrelated, but can also be examined in their own right. To put it simply, we must deal with two basic questions: What makes Jakuchū's painting Buddhist; and what are the cultural traditions that lead to this particular work?

Underlying this strategy of investigation are four assumptions: that there is more than one level of meaning in *Yasai Nehan*, that the formal structure of Jakuchū's scroll is continuous with earlier Nirvāna paintings, that other levels of continuity are also to be found, and that all of these features are absorbed into a single process of creation.

The Nirvāna Painting Genre and Its Literary Sources

Along with the humorous treatment of the subject that the viewer can readily perceive in Jakuchū's painting, one is also struck by the deliberateness with which the composition was created. At every point, from the correspondence of the corn stalks to the eight Śala trees and the posture and position of the radish that simulates those of the Tathāgata, to the number of the attending vegetable species that closely corresponds to the number of mourners depicted in traditional Nirvāna compositions, *Yasai Nehan* parallels a canonical iconography. Jakuchū's meticulous composition does not appear to be simply a parody of the traditional theme. While the painting was done in ink, each form is clearly and descriptively

[1] The Japanese term "Nehan," transliterating, via Chinese, the Indian term "Nirvāna" should be here accepted as not strictly making the distinction between death and liberation of beings in the Buddhological sense. The Japanese term is deliberately seen, as creative ambivalence, to mean both the final event in Śākyamuni's life—the termination of life in corporeal and spiritual sense, that is, *jakumetsu*—and the parallel event in other beings. In the traditional Buddhological parlance "Parinirvāna" is the term to designate death of the Buddha.

rendered. It does not belong to the genre of *haiga*,[2] for example. The fact that the composition immediately alludes to the tradition of Nirvāṇa painting surely tells us that this work was not created *ex nihilo*. The first task, then, is to discover the precise relationship between traditional Nirvāṇa painting and Jakuchū's scroll.

The Freer Gallery owns a large Buddhist painting, presumed to be of the fourteenth century, that depicts the scene of Mahāparinirvāṇa, the final event in the Buddha's life (fig. 28).[3] Acquired in 1970, the Freer painting is a relatively recent addition to the collection. According to the dedicatory document found on the back of the painting at the time it was remounted, the scroll was at one time a treasure of the Emmeiji temple in Ise. In 1671 the temple's abbot Nyūyo found the painting damaged so extensively that he ordered restoration as well as a new mounting. Prior to the purchase by the Freer Gallery the painting was remounted again and underwent an extensive repainting in a restorer's studio in Kyoto. In spite of these two restorations, once in the seventeenth century, and for the second time as recently as 1965, the painting preserves much of the typical Nirvāṇa composition. It consists of the basic narrative of Śākyamuni's Parinirvāṇa as described in the Mahāyāna text, *Daihatsu-nehan-gyō* (*Nehan-gyō* or Nirvāṇa *sūtra* for short).[4] But the detail of Lady Māyā's descent from Tōri-ten (the Trāstrimśa Heaven) to witness her son's departure from this world is from a different text, the *Maka-Maya-gyō* (*Sūtra* of Lady Māyā).[5] Among the more than forty Japanese Parinirvāṇa paintings extant, many of them designated as *jūyō bunkazai* (important cultural properties), almost all have syncretic elements derived from more than one textual source.

What the earliest Japanese Nirvāṇa paintings were like is difficult to say, but it is certain that when the Japanese liturgical text, *Nehankō-shiki* (Rules of ceremony commemorating the Parinirvāṇa), was written by Genshin (942–1017)[6] in the mid-Heian period, the syncretic tendency of the Nirvāṇa narrative was already present. Lady Māyā's presence at the Nehan is mentioned in Genshin's treatise, and the earliest extant Japanese

[2] Caricaturish drawing or painting often accompanied by light verse or *haiku*, containing comical, humorous, or satirical content.

[3] Accession number 70.30; ink and color on silk, h: 196.2 cm. × w: 190.0 cm.

[4] Daizōkyō Kankōkai, ed., *Taishō shinshu Daizōkyō*, 85 vols. (Tokyo: Taisho Issaikyo Kankokai, 1924–1932), 12:365–603 (text 374) (hereafter cited as T).

[5] T. 12:1012c–1013a (text 383).

[6] Genshin was an eminent priest of the Tendai school. A disciple of Ryōgen (see note 21 below), Genshin was a scholar of the *Lotus Sūtra* and the author of *Ōjōyōshū*, an important work on the Pure Land belief, which was influential not only in Japan but also in China. For his *Rules of Ceremony Commemorating the Parinirvāṇa*, see Dainihon Bukkyō zenshō 33:183a–185b (hereafter BKZ).

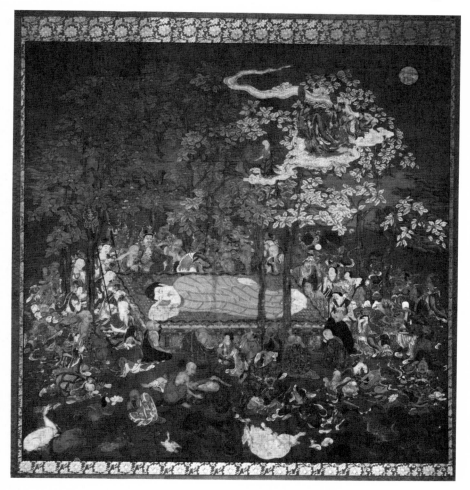

28. Anonymous, fourteenth century, *Parinirvāṇa*, Freer Gallery of Art (accession no. 70.30).

Nehan painting of 1086 at Kōyasan predictably includes her among the mourners.[7]

The Nirvāṇa episode was an earth-shaking event in the annals of Buddhism, and as such, its representation in painting was central to the religious life of the faithful both as an allegory of what Śākyamuni had taught and as a commemoration of Nirvāṇa as a symbol of the beliefs

[7] See, for example, Takada Osamu, Yanagisawa Taka, and Anja Tetsuo, *Genshoku Nihon no bijutsu* 7 (Tokyo: Shogakkan, 1969), pls. 1–5.

held by all Buddhists. Nirvāṇa paintings, like the one in the Freer Collection, were, and still are, hung in the main hall of a Buddhist temple, in commemoration of the passing of Śākyamuni, on the fifteenth day of the second month, the day set by the Buddhist calendar to observe the *Nehankō* or Nirvāṇa ceremony. Inasmuch as a ritual commemoration is the function of Nirvāṇa paintings, let me specify my usage of "commemoration" by quoting an apposite definition of the term by Eugene Vance:

> By "commemoration" is meant any gesture, ritualized or not, whose end is to recover, in the name of a collectivity, some being or event either anterior in time or outside of time in order to fecundate, animate, or make meaningful a moment in the present. Commemoration is the conquest of whatever in society or in the self is perceived as habitual, factual, static, mechanical, corporeal, inert, worldly, vacant, and so forth.[8]

Such an extended definition of the term is required for the Japanese tradition's use of Nirvāṇa paintings as commemoration; their function, too, was to recover an event that took place both outside Japan's space and as a distant—or even atemporal—event. With the Nirvāṇa painting as a signifier in the commemorative act and the event and concept of the Parinirvāṇa as the signified, the tradition of Nirvāṇa painting enjoyed a particularly privileged role in the historical tradition of Japan. Privileged—on the one hand because the paintings were shown once a year as liturgical images, and, on the other hand, because they were major allegorical images that not only represented the last moments of Śākyamuni's life but also were believed to embrace the essential doctrine of the great teacher.

The *locus classicus* of the Nirvāṇa narrative is the *Nehan-gyō*, a formidable forty-chapter document compiled by the Chinese monk Chang-an (late sixth to early seventh century), and comprehensible, if at all, only to the most learned of clerics. But for most Japanese who lived in the medieval period, a simplified version such as Genshin's *Nehankō-shiki* must have been more familiar. The continuous production of Japanese Nirvāṇa paintings presumes the existence of the Nirvāṇa narrative as an accessible genre of Buddhist literature—as seen in such genre pieces as the "Nehan monogatari" (Stories of the Parinirvāṇa) in the *Konjaku monogatari* (Tales old and new, ca. 1274), which was basically a summary of the Nirvāṇa account narrated in *Nehankō-shiki*. The Nirvāṇa story as transmitted in Japan had the potential to spur a new genre of literary forms and, as will be seen, pictorial forms as well.

Nirvāṇa paintings allow narrative reading of the composition with variant forms of interpretation, and because of that complexity, they are

[8] Eugene Vance, "Roland and the Poetics of Memory," in *Textual Strategies*, ed. Josué V. Harari (Ithaca: Cornell University Press, 1979), pp. 374–375.

fundamentally different from such iconic images as individual paintings of the members of the Mahāyāna pantheon or those images systematically represented in mandalas. A Buddhist image that enjoys sacred status by virtue of its symbolic attributes (*mudrās*, etc.) or whose form is imbued with a specific meaning in lineal relationship to a specific text expounding some doctrine is a "closed form." Such images can be contrasted with the format taken by Nirvāṇa paintings, which may be called an "open form." The allegorical character of Nirvāṇa paintings opens up avenues of interpretation and encourages the accretion of motifs, and it is possible to bring to these an analysis similar to that applied to narrative forms of literature. Nirvāṇa paintings are built around the "core story" of the death of Śākyamuni, who was mourned by his followers. Any other motifs modifying the core story are means to embellish this narrative.

The Freer painting contains the structural core—the expiring Buddha under the Śāla trees surrounded by mourners. As in the Freer version, Nirvāṇa paintings sometimes emphasize a special motif, such as the Śāla tree leaves turning white (according to the original text, "whiter than the white cranes"), or increase the number of animal and bird species, but they always have, at their center, an allegorical structure—the dying teacher surrounded by his disciples. This structure is allegorical because it can be extended and finds its continuity in the pictorial narratives of some eminent historical personages of Japan, for example, those of Ippen Shōnin (1239–1289) (fig. 29).[9] The final scene of those long narrative scrolls is an allusion to the Nirvāṇa scene, but with a difference in the reversed position of the monk's head, a convention also seen in the pictorial biography of Hōnen Shōnin (1133–1212).[10] It comes, then, as no surprise that in the early nineteenth century a scroll entitled *Bashō Nehan* or the *Nirvāṇa of the Poet Bashō* was painted.[11] In such cases the struc-

[9] Ippen was the founder of the Jishū, or Ji school, a populist movement within Pure Land Buddhism. By wandering about the country Ippen taught his belief in Nembutsu (chanting of the name of the Buddha Amida). In 1299, ten years after his death, his pictorial biography in twelve handscrolls was produced by his disciple En'i accompanied by text by Shōkai, also Ippen's disciple. This set is in the Kankikōji collection in Kyoto. See also the chapters by Kaufman and Foard in this volume.

[10] Hōnen was the founder of the Jōdo sect in Japan, which was based on his belief in Pure Land faith and the power of Nembutsu. He acquired numerous followers, including members of the court, but orthodox Buddhists saw his teaching as a heresy. Banishment followed in 1207, then pardon four years later. Long after his death an elaborate set of handscrolls, forty-eight in all, pictorially narrating Hōnen's life, was produced between 1307 and 1317, known as *Hōnen Shōnin gyōjō ezu*. The set is now in the Chion-in collection in Kyoto. For complete reproduction of the scrolls see Nihon emakimono zenshū 13 (Tokyo: Kadokawa Shoten, 1961).

[11] The painting is by Matsumura Goshun (1752–1811). Ink and color on silk, h: 115.84 cm. × w: 67.62 cm. It was signed and dated by the artist in 1803. The present whereabouts

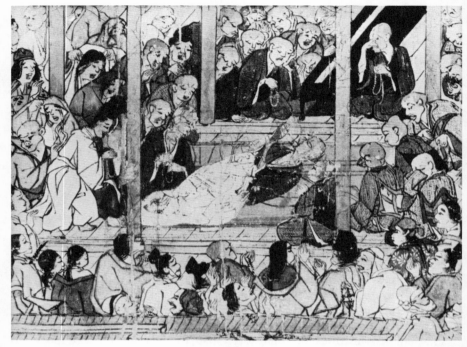

29. En'i, late thirteenth century, *Death of Ippen*, detail of section 3 of twelfth scroll of *Ippen Shōnin eden* (Pictorial narrative of Monk Ippen), 1299.

ture of the allegory of Nehan creates a new work without destroying its collective meaning. Such new works may be said to have a double allegory: one to the new subjects themselves, and one to the structure of the historical Buddhist Nirvāṇa painting. Whether the central subject is a poet or mendicant monk, such figures are structurally privileged to be linked to the symbolic meaning of Śākyamuni's death. The possibility of interchanging of subject without destroying the collective meaning of Parinirvāṇa implies that all scenes of expiration in the Buddhist world are ontologically privileged to commemorate and participate in the death of the ultimate teacher Śākyamuni.

Japanese Nirvāṇa paintings of the Kamakura period, the period from which more Nirvāṇa scrolls survive than any other, must have been painted without drawing solely on the long *Nehan-gyō*. Certain freedom is given in emphasizing either particular motifs or their expressions. The Nehan liturgy itself must have been performed with special emphasis on

of the painting are unknown. It is illustrated in *Nakayama-ke zōhin nyūsatsu* (November 1928), fig. 67.

particular features of the narrative. Acts of offering, for instance, became specifically connected with a particular numerology that developed out of the Nirvāṇa textual tradition. For example, the *Nehan-gyō* refers to fifty-two kinds of beings as mourners. The numerological reference alone spurred a new aspect of the Nirvāṇa liturgy and its associated concepts in Japan. *Gojūni-shu kuyō* (offerings of fifty-two kinds) was the term describing the act of offering at the Nirvāṇa ceremony held, like a religious play, at Nison-in in Saga, according to *Kokon chomonshū* (Famous events ancient and modern, ca. 1254).[12] Those who attended the service "made fifty-two kinds of offering." In time fifty-two began to be associated with the concept of Nirvāṇa itself, as was the case in the fifteenth-century Nō libretto *Nue* of Zeami.[13] In the sixteenth century a huge Nirvāṇa painting done for Daitokuji by Kano Shōei (1519–1592) included exactly fifty-two figures around the recumbent Śākyamuni.[14]

The Nirvāṇa paintings produced from the Kamakura period onward increasingly emphasize the dramatic aspects of the narrative. This shift may be explained by a new *Nehankō-shiki* written by Myōe (1173–1232) at the onset of the thirteenth century, at the Kegon sanctuary of Kōzanji.[15] Myōe's *Nehankō-shiki* is one of the four Rules of Liturgy (*Shizako-shiki*), setting forth the rules of liturgical proceedings and urging the partakers in the ceremony to remember fully the original meaning of the passing of the great teacher Śākyamuni. Like Genshin's version preceding it, this text places the Nehan ceremony before sunrise on the fifteenth day of the second month, but unlike Genshin's, the Nehan rite of Myōe is followed by three other ceremonies—one for *arhats*, another for Commemoration of the Traces of Śākyamuni, and still another for Honoring the Relic, from the early part of the evening until late at night.[16] Myōe's *Rules* set a highly emotional tone in the description of the Nirvāṇa:

Fifty classes of beings assembled, from myriad bodhisattvas to infinite numbers of bees and insects. . . . Śākya lay down on his right side, his head placed in the north and his feet south. His face facing west and his back east, he immediately

[12] Iwanami Shoten, ed., *Nihon koten bungaku taikei* (hereafter NKBT) (Tokyo, 1978), 84:105.

[13] NKBT 40:309. Here it is *gojūni rui* (fifty-two kinds of being).

[14] See full-color reproduction in Tayama Hōnan, ed., *Daitokuji*, in Hihō 11 (Tokyo: Kodansha, 1968), pl. 38.

[15] Also known as Kōben, Myōe was a priest of the Kegon sect in Japan. A strong follower of the teaching of the historical Buddha Śākyamuni, Myōe tried in vain to go to India in 1205. The attempt was abandoned due to illness. In 1206 he founded the Kōzanji temple on Mount Toganoo in Kyoto. For Myōe's life and arts related to Kōzanji, see Kyoto National Museum, ed., *Kōzanji ten* (Kyoto: Kyoto National Museum, 1981).

[16] For *Shizakō-shiki* see T. 84:898–899 (text 2731). The ceremony honoring *arhats* is called the *Rakankō*; that to contemplate on the Traces of Śākyamuni is called the *Nyorai isekikō*; and that honoring the Relic is called the *Sharikō*.

entered four stages of meditation, and attained Parinirvāṇa. . . . Thereupon, the *arhats*, who were in the state of complete freedom from worldly attachment, forgot their rule of asceticism; bodhisattvas, who were making efforts to reach a higher state of bodhisattvahood, let go their wisdom of knowing the birth-lessness of myriad beings. Guhyapada threw away his *vajra*-staff and howled into the sky. Great Brahmā threw away his net and collapsed on the ground. The king of myriad lions threw himself on the ground and wailed. The water birds, wild geese, and ducks felt deep sorrow. Lion, tiger, boar, and deer all stood hoof-to-hoof, forgetting to attack one another. Gibbons and dogs sad-dened by grief dropped their heads; . . . the great earth shook and quaked; the great mountains collapsed; plants and trees, groves and forest, all cried out their grief.

Now, Myōe's *Kōshiki* includes his own commentary on the Śāla Grove at Kuśinagara, a site he had never visited:

> To the northwest of Kuśinagara, on the western shore of the River Hiraṇya-vatī, is the Śāla Grove. The trees are like oak (*yadorigi* or *kashi*), their bark is blue and leaves white, among which four are especially tall. This is the place where the Tathāgata passed away. The *sūtra* says, "In the Śāla Grove, pairs of trees, those on east and west, joined and became one tree. The pair on the north and south joined and became another. They hung low over the bed and covered the Tathāgata with their shade. These trees were saddened and turned their colors whiter than the white cranes. . . ." One account says that the trees are five *jō* [about 30 feet] tall, and that their roots are all linked, as the heart of a linked lotus plant. The branches are evenly shaped on all trees, well-balanced, like husband and wife. Their leaves are deep green, their flowers are shaped like wheels, their fruits as large as jugs, and they taste as sweet as honey, for this is the place where Lady Māyā descended from Heaven and mourned the passing of the Tathāgata.

Then Myōe turns to a painting of Nirvāṇa, apparently to be used for the ceremony:

> As I look at this painting of Nehan at the Twin Śāla Grove, the Tathāgata's head is placed in the north and he reclines, facing west. Myriad beings surround him in front and back, left and right. Lion, tiger, and wolf restrain their fero-cious postures. The faces of bodhisattvas and *śrāvakas* show restrained sorrow of mourning.

Myōe further notes, in a highly personal way:

> As we open the pages of the holy text of the Nehan Section of the Chinese Tripitaka, there are many characters that have water and mouth radicals. These [characters] are meant to convey the scenes of bodhisattvas and *śrāvakas* mourning and crying; goblins, animals, and *asuras* shedding tears.

Myōe's *Nehankō-shiki* commemorates and explains in highly emotional tenor both the *Nehan-gyō* text itself and a contemporary painting of the Nirvāṇa which, in turn, anticipated a large body of Kamakura-period Nehan paintings. The noticeable increase in the number of animals and birds in these compositions may be interpreted as an influence from Myōe's *Rules*, as well as being an allegory on the potentiality of Buddhahood in all beings as taught by Śākyamuni. Before going further into the ontological question of the meaning of Nirvāṇa paintings, let me sum up what those compositions meant to medieval Japanese, especially in the light of Myōe's *Rules*. Two points must be kept in mind: (1) Nirvāṇa paintings were meaningful to the monastic community as commemorative symbols of the origin of Buddhism—the Buddha and his death, and (2) the paintings allegorized doctrinal positions of Buddhism concerning Nirvāṇa as taught by the Buddha, which affirmed universal Buddhahood.

It is the second of these two points that became culturally responsible for the further development of the Nirvāṇa painting as allegory, a process in which two basic notions of Nirvāṇa were popularized. These two notions were (1) that all beings, sentient and insentient, have Buddha-nature (*busshō*), and that, regarding the attainment of Buddhahood (*jōbutsu*) as the activity of universal Buddhahood, all beings, including plants and trees, attain Buddhahood. The cultural implications of these notions are complex, but one may say that in developing allegorical recensions of Nirvāṇa paintings it was the notion of the universal potential for attaining Buddhahood by all beings that allowed the interchangeability between the original subject (Śākyamuni) and other subjects, be they poets or mendicant monks. These notions indeed blurred the distinction between the teaching of the historical Buddha that was transmitted to his disciples and that which was believed in by later Buddhists and presented through both texts and pictures. The latter belief elaborated the credo that all beings possessed Buddha-nature, a point on which not all Buddhist theologians agreed. In this expanding tradition of allegories we see an ever-increasing blurring of distinctions between the human world, animal world, bird world, and plant world as regards Nirvāṇa.

This phenomenon was especially prominent in the development of a popular Buddhist-inspired literary genre, *irui-mono* (nonhuman fables),[17] a specialty of the late Muromachi and early Edo periods. This was the category of narratives in which animals, birds, and plants were given the human capacity to speak, act, and feel, in order to test human morality and values among themselves and, sometimes, against human beings as

[17] For a brief discussion of *iruimono* see Barbara Ruch, "Medieval Jongleurs," in *Japan in the Muromachi Age*, ed. John W. Hall and Toyoda Takeshi (Berkeley: University of California Press, 1977), pp. 283–284.

well. In the history of art, too, this category allowed the space of a narrative reserved for humans to be invaded by what we might think of as anthropomorphized birds and animals, and these are a frequent occurrence in popular narrative illustrations. It is only predictable that, in Buddhist paintings, the category would allow the allegorical structure of a Nirvāṇa scene to be taken over entirely by the members of the nonhuman world, such as vegetables, as was the case in Jakuchū's *Yasai Nehan*. This takes us back to *Yasai Nehan* and to the two questions posed at the outset. What makes Jakuchū's painting Buddhist, and what are the cultural meanings behind this work?

Vegetable Buddhahood: The Doctrines of Busshō and Sōmoku Jōbutsu

The first question brings out a general notion that Japanese Buddhism has developed about the vegetable world and its Buddha-nature (*busshō*), and about its capacity to attain Buddhahood (*jōbutsu*). Since the introduction of the Tendai creeds into Japan, the vegetable kingdom had been recognized as being capable of attaining Buddhahood, a point that became a major issue of religious disputation among the leading Buddhist clerics and scholars. The germ of this idea is contained in the *Lotus Sūtra*'s chapter of the "Metaphor of Medicinal Herbs." In Leon Hurvitz's translation:

> Kaśyāpa, consider the grasses, trees, shrubs, and forests, as well as the medical herbs, in their several varieties, and their different names and colors. . . . A thick cloud spreads out, covering the whole thousand-millionfold world and raining down on every part of it equally at the same time, its infusions reaching everywhere. The grass and trees, the shrubs and forests, and the medicinal herbs—whether of small roots, stalks, branches and leaves, or of middle-sized roots, stalks, branches, and leaves, or of large roots, stalks, branches, and leaves—and also all trees, great and small, whether high, intermediate, or low, all receive some of it. Everything rained on by the same cloud in keeping with its nature gains in size, and its blossoms and fruit spread out and bloom. Though produced by the same earth, and moistened by the same rain, yet the grasses and trees all have their differences.[18]

The metaphor explaining how the Buddha's teaching of Dharma penetrates all beings, like one rain moistening every part of all plants, is reiterated in a short *gāthā* that follows the prose section:

[18] Leon Hurvitz, trans., *Scripture of the Lotus Blossom of the Fine Dharma* (New York: Columbia University Press, 1966), pp. 101–102.

Dry earth is everywhere moistened,
Herbs and trees flourish together,
From the product of that cloud,
Water of a single flavor,
The grass, the trees, the shrubs, and the forests,
Each in due portion receive infusions.
All trees,
High, intermediate, and low,
In accordance with their size
Are each enabled to grow,
Their roots, their stalks, their branches, and their leaves,
Their blossoms and their fruits having luster and color.
What the one rain reaches
All gain a fresh gloss. . . .[19]

The universal possession of Buddha-nature, that "all sentient beings possess Buddha-nature" (*issai shujō shikkai yū busshō*), is also reiterated explicitly in the most relevant text to the Nirvāna event, the *Daihatsu-nehan-gyō* itself. Such an idea, interpreted by Buddhists to mean that all beings, whether of the animal or vegetable kingdom, possess *busshō* and are capable of *jōbutsu*, was formulated quite early in the history of the Tendai school of thought, first in China in the eighth century and then in Japan in the ninth century.[20] Japanese Tendai literature yields numerous commentaries on this subject. By the tenth century the notion of the vegetable world—every species in the plant and tree kingdom—having Buddha-nature was asserted to demonstrate the superiority of the Tendai creed over others. The *mondō* (dialogue) text, *Sōmoku hōsshin shugyō jōbutsu-ki* (Notes on grass and trees' entry into priesthood, religious practices, and attainment of Buddhahood), which formulated the Tendai view on this issue as narrated by the priest Ryōgen (912–985), sets forth the notion in clear terms.[21] A famous debate held at Seiryō-den of the imperial palace between the Hossō school and the Tendai school—the former championed by the monk Chūzan (active 963–976) of Kōfukuji, and the latter by Ryōgen—is described in the *Taiheiki* (Taihei chronicle, fourteenth century). The inclusion of this debate, which is presumed to have actually taken place in 963, indicates that the issue was a cardinal

[19] Ibid., p. 105.

[20] For a study in the English language on the theme of *busshō* and *jōbutsu*, see the lucid piece by William R. LaFleur, "Saigyō and the Buddhist Value of Nature, Part I," *History of Religions* 13 (1973): 93–126. For the issues relevant to Nō libretto in the Muromachi period, see Donald H. Shively, "Buddhahood for the Nonsentient: A Theme in Nō Plays," *Harvard Journal of Asiatic Studies* 20 (1957): 135–161.

[21] BKZ 24:309–310. For Ryōgen's view see LaFleur, "Saigyō," pp. 100–104.

theological problem for the Buddhists of the tenth century. The *Taiheiki* does not report the winner of the debate, but it is a fact that Japanese Buddhism, which received various degrees of influence from the Tendai doctrines, was deeply concerned with the universality of Buddha-nature. The affirmation of the universal Buddha-nature was considered by Taira no Yasuyori (active 1157–1195), a lay believer of the *Lotus Sūtra*, to be the key to an understanding of the Tendai school. This is related in Ya-suyori's *Hōbutsu-shū* (Precious treasures), an important collection of Buddhist narrative tales of the twelfth century, which helped propagate widely the creeds of the *Lotus* and other canonical texts among the laity.

In the meantime, the newly arrived Zen school showed its concern with the debate on Buddha-nature. Dōgen (1200–1253), whose original religious training began at the Tendai center Enryakuji atop Hiei-zan before his trip to China and his subsequent introduction of Sōtō Zen to Japan, was a leading exponent of that view. Dōgen's commentaries on the T'ang patriarchs' sermons on Buddha-nature, in *Shōbō genzō* (The eye storehouse of the true law), put forth an all-embracing notion of *busshō*: "Since the plants and trees exist in [our] consciousness as reality, they are all a part of the universal Buddha-nature."[22]

The prevailing notion that plants have Buddha-nature and thus can attain Buddhahood (*jōbutsu*) was not transmitted simply out of the corpus of canonical Buddhist texts, texts that were probably comprehensible only to learned scholars and Buddhist monks. For the laity, short and simple verses in various literary genres were sufficient reminders. In the fifteenth century, for example, the Nō libretto, *Nue* by Zeami (d. 1443), contains the following exchange of verses that took place between the ghost of a monster and an itinerant monk. The passage reads like a proverb synthesized from various Buddhist texts. The *waki* (the itinerant monk) declaims:

When one Buddha who perfected the Way beholds the Dharma-world,
all those in the plant-and-tree realms,
without exception,
attain Buddhahood.

and the *shite* (the monster bird) responds:

All, both sentient and insentient,
without exception, attain Buddhahood.[23]

[22] T. 82:97c–98a (text 2582).
[23] NKBT 40:309. Waki: "Ichibutsu jōdō kanken hōkai, sōmokkokudo shikkai jōbutsu." Shite: "Ujō hijō kaigu jōbutsudō."

The credo of universal Buddhahood was transmitted, as Zeami's lines demonstrate on the level of Nō, to the laymen of the late medieval and Edo periods through popular literature often cast in the vernacular and written in *kana*. An example of this genre is *Getsurin-sō*, a fictive narrative about a competition for excellence between the plum and the bamboo, by an anonymous author of the late Muromachi.[24] The text starts with a long preamble in which the same idea just quoted from Zeami is paraphrased in the language of the populace:

> Plants and trees have no [human] feelings. Flowers do not speak. [But] though unresponsive to human feelings, like trees and rocks, their original nature (*honshō*), like that of human beings, is the Buddha-mind (*busshin*). . . . In winter, fields and hills wither away under the frost; the tree tops become sparse. It seems that plants and trees, as if entering Nirvāṇa, hide underneath the fallen white snow. The Law of this world—birth, aging, sickness and death—is manifest. They [plants and trees] are not inferior to humans.

The *Getsurin-sō* then gives a quotation, erroneously claiming it is from the *Chūin-kyō* (*Sūtra* on the intermediate state) of the famous *gāthā*, which was also quoted by Zeami:

> When one Buddha who perfected the Way
> beholds the Dharma-world,
> all those in the plant-and-tree realms,
> without exception,
> attain Buddhahood.

It continues:

> An average person does not abandon evil thoughts and thus loses his Buddha-mind. Plants and trees, while they have heart, do not speak; though devoid of speech, they respond to seasons and are subject to the change of time; so they have [their own] feelings (*kokoro*). One must not, even by mistake, cut down plants and trees without reason.

Through such channels of discourse the notion of *sōmoku jōbutsu*, "Vegetable Buddhahood," was shaped into a common belief as well. By the Edo period, it had become an integral part of Japanese cultural perception. The *Otogi zōshi* (Fables), for example, includes a story, "Neko no sōshi" (Tale of the cat), said to have been written shortly after 1602, that tells a story of mice and cats in which this same *gāthā* appears as a proverb. It should be pointed out that in the world of *Getsurin-sō*, plants

[24] Yokoyama Shigeru and Matsumoto Takanobu, eds., *Muromachi jidai monogatari taisei* (Tokyo: Kadokawa Shoten, 1978), 4:323–353. The passage translated in the text appears on p. 323.

partake in human institutions, and that in "Neko no sōshi" the story develops as a mouse and a cat appear and converse in the dreams of a Buddhist monk. The blurring of the human, animal, and plant worlds was occurring freely in Japanese verbal and pictorial arts well before the seventeenth century.

The Symbology of Radishes

In Jakuchū's *Yasai Nehan* the radish is placed on a farmer's harvesting satchel made of straw. The radish is uprooted from the earth, ready to be served. So the Nehan scene is to be seen as *kuyō*, or the radish's sending-off ceremony. The radish is a major item in the culinary traditions of Japan and China, and not infrequently made a symbol of the frugal life both of monastic communities and the secular world. While it is not known exactly what the early maigre feast held in Buddhist temples consisted of, a vegetable diet indeed symbolized the frugality and rigor of monastic life. One can infer this from a passage in Dōgen's *Shōbō genzō*, in which food is reduced to the basics:

> The brown rice harvested from the rugged field;
> the yellowed pickles of vegetables.
> It is up to you to eat them.
> If you don't, I don't give a damn![25]

In the fourteenth-century Kyoto monastic communities, the Zen-master Gidō Shūshin (1325–1388) laid out five monastic rules to be observed by the monks, starting with "frugal living to be observed by simple meals at designated times. Each meal consisting of rice, soup, vegetables, not to exceed five or six kinds."[26] Zuikei Shūhō (1392–1473), Gidō's later follower, left a short poem about his vegetable garden.[27] Presumably the poem was written at some time during Zuikei's retirement, before his death in 1473, a period that preceded the devastating Ōnin War in Kyoto:

> The chilling bite of the frost froze rice and millet,
> only one kind of winter vegetable always survives.
> This year the starved have pale faces.
> with [this vegetable] Heaven has blessed this monk of a humble hut.

[25] T. 82:142a (text 2582).
[26] Tsuji Zennosuke, ed., *Kūge nichiyokufu ryakushū* (Tokyo: Taiyosha, 1939), p. 192, entry of 4:8:24 of the Eitoku era (1383). This menu is referred to as one of the Five Rules (*Gokisoku*) by Ōsen Keisan (1429–1493) in his "Monastic Rules." See his collected works, *Hoan keika zenshū* in *Gozan bungaku shinshū*, ed., Tamamura Takeji (Tokyo: Tokyo Daigaku Shuppan Kaisha, 1967), 1:278–280.
[27] Zuikei Shūhō, *Gaun kō*, in *Gozan*, ed. Tamamura, 5:572.

Zuikei is not specific about what was planted in his vegetable garden, but the line "only one kind of winter vegetable" must refer to either turnips or radishes, the sturdy root-vegetables that can grow all year-round. The combined imagery of the radish (or turnip) and a humble dwelling of a monk—the radish as a gustatory symbol of the monk's life—grew in time to be a new aesthetic theme for the Japanese of the fifteenth century. This was through the establishment of a genre of ink painting inspired by Chinese paintings on the theme of the radish. This genre was manifested in two areas: first, in its application in Japanese art appreciation, particularly in the space of a picture-viewing alcove at temples and in tearooms; and second, in the tradition of Japanese ink paintings of radishes.

The Radish as an Aesthetic Motif

For pre–ink-painting artists, the radish probably was little more than a decorative motif. An early instance of a radish motif within a Japanese context is its use on a courtier's robe, in *Nenchūgyōji chakuza zō* (Picture of the seating order for annual events at court), a work attributed to Fujiwara Nobuzane of the late twelfth and early thirteenth centuries, now in the Kyoto National Museum.[28] The radish motif does not appear to be charged with any specific meaning here. However, a new meaning of the radish image entered Japanese artistic tradition around the mid-fifteenth century, notably with the appearance of a pair of ink paintings purported to be by the famous Chinese Ch'an monk Mu-ch'i Fa-ch'ang[29] of the Southern Sung. The diary of a monk of the Onryō-ken apartment of Shōkokuji, Kikei Shinzui (1401–1469), in the entry of 2/29 of the first year of Bunshō (corresponding to 1466) records a pair of paintings brought to the Shogun's household by the Shoshidai (deputy-chief officer) of Bungo: one painting was *The Radish* (*Daikon*) with an inscription that read, "Savoring all day long in a hut," and the other, *The Vegetable* (*Yasai*) on which was inscribed, "Guest arrives; sharing one taste."[30] The two paintings survive to this day in the Imperial Household collection (figs. 30 and 31). On the following day in 1466 the diarist records a chat that took place in front of *The Vegetable* with a certain retired monk Taiya, who said that when he was in China as an official envoy, the morning and evening meals always had a vegetable with white stalks, and that the

[28] A handscroll in ink and slight color on paper, reproduced in *Kokka* 608 (July 1941).

[29] The most up-to-date study on Mu-ch'i is by Toda Teisuke, *Mokkei, Gyokkan* (Mu-ch'i, Yü-chien), in Suiboku bijutsu taikei 3 (Tokyo: Kodansha, 1973).

[30] Tamamura Takeji, ed., *Onryōken nichiroku*, 2:631a, entry of 1:2:29 of the Bunshō era (1466). Inscription for *The Radish* is "Sokuan nichiyo"; that for *The Vegetable*, "Kyakurai ichimi."

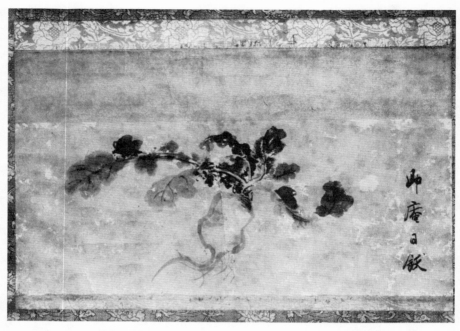

30. Attributed to Mu-ch'i Fa-ch'ang (active ca. 1260s–1280s), *The Radish*.

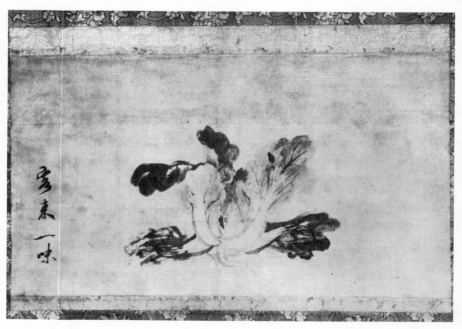

31. Attributed to Mu-ch'i Fa-ch'ang (active ca. 1260s–1280s), *The Vegetable*.

painting (hanging in the room) looked just like that.[31] This comment indicates again that the meals for monks in China as well as in Japan were primarily vegetarian.

Whether these paintings are really by Mu-ch'i is beside the point. What is important is that in time they became two of the well-known Chinese paintings that were jealously collected by some of the noted tea aesthetes of Sakai in the sixteenth and seventeenth centuries.

The tea chronicles, not to mention tea-utensil inventories taken in the mid-sixteenth through mid-seventeenth centuries, mention the various owners of each of these paintings.[32] The latest among the inventories to record *The Radish* was a seventeenth-century *Chūkō meibutsu-ki* (Inventory of famous objects reassembled) in reference to the famous paired paintings, *Persimmons* and *Chestnuts*, in Daitokuji's Ryōko-an collection.[33] A note in the *Meibutsu-ki* says that these two are known as members of the six kinds of plants: chestnut (*kuri*), persimmon (*kaki*), melon (*uri*), eggplant (*nasu*), radish (*daikon*), and turnip (*kabura*). ("*Kabura*" became a misnomer for *The Vegetable* in the seventeenth century.) Of these, *The Vegetable* enjoyed less popularity among the tea aesthetes than did its mate *The Radish*. A post-Rikyū tea record entitled *Senrin* (Return to the forest) mentions in its commentary that *The Vegetable* looks too detailed to be favored by tea practitioners: the idea of leaves decaying is too explicit, one aesthete charged, too heavy for an ink painting, and it looks too much like a painting with colors.[34] Others, so the commentary continues, took a dislike to *The Vegetable* because it reminded them of a warrior's helmet. However each of the pair was interpreted by different tea aesthetes of the sixteenth and seventeenth centuries, the fact remains that they were famous works, and what was significant about them was that in the Japanese recensions, radishes are attributed a "Buddhist" flavor.

Soon after these two Chinese paintings were first seen in the Ashikaga shogunal household in the late fifteenth century, they began to inspire Japanese copies. A group of Japanese *Radish* paintings in ink from the fifteenth through the late sixteenth centuries survives, some bearing inscriptions by contemporary Zen monks. The earliest of these paintings is in the Jōfukuji collection and is inscribed by Daitokuji's fortieth abbot, Shumpo Sōki (1409–1496) (fig. 32). The inscription reads:

[31] Tamamura, *Onryōken*, 2:63a, entry of 1:3:1 of 1466.

[32] *Yamanoue no Sōji ki*, in *Sadō koten zenshū*, 7:127, 207 (hereafter SKZ); *Matsuya Hisamasa kai ki*, SKZ 9:17; *Senrin*, SKZ 11:384–385; *Matsuya meibutsu shu*, SKZ 12:25, 30, 33, 34, 36; *Enshu mikura moto cho*, SKZ 12:314; and *Chūkō meibutsu ki*, SKZ 12:333–334.

[33] Toda, *Mokkei*, pls. 67 and 68.

[34] See note 32 above.

The gardener knows that for a well-flavored soup;
the turnip [*sic*] must be pulled up
 fresh, still full of the aroma of wind and dew.
Its leaves are big as those of the banana trees;
 its root is large and stout.
And in a single stalk there are two sorts of name.[35]

In the second line *rafuku* (Chinese: *lo-po*) is not turnip but radish. The last line may simply mean that it has two names: one Chinese *lo-po* and one Japanese *daikon* (read *ō-ne* in the Heian period). Shown in Boston in 1970 at the Zen painting and calligraphy exhibition, the catalogue entry for this painting states: "one cannot escape the impression that the Zen priests who painted, inscribed, or admired paintings of this type were inclined to associate the turnip (radish) with gustatory pleasure rather than meditation." I shall have more to say about this later.

The second painting (fig. 33) is by Jonan Etetsu (1444–1507).[36] Jonan was a monk of Tōfukuji and a friend of the painter Sesshū. There is no inscription on the scroll, but its connection with the Chinese painting, in

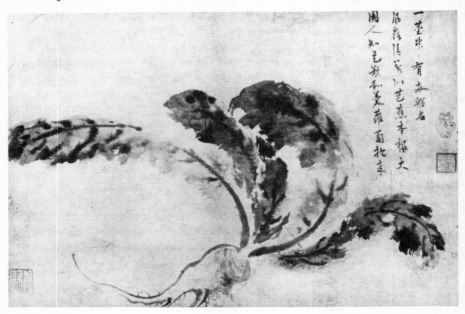

32. Anonymous, *Radish*, inscription by Shumpo Sōki (1416–1496).

[35] Translated by Jan Fontein and Money Hickman, *Zen Painting and Calligraphy* (Boston: Boston Museum of Fine Arts, 1970), entry 60.

[36] In the Sansō collection, Claremont, California. Yoshiaki Shimizu and Carolyn Wheelwright, eds., *Japanese Ink Paintings* (Princeton: Princeton University Art Museum, 1976), entry 36.

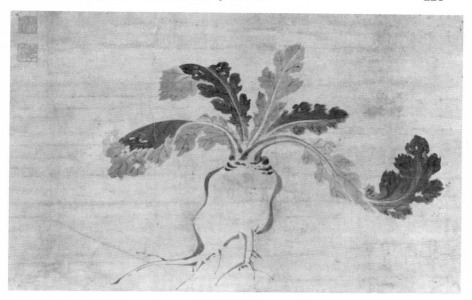

33. Jonan Etetsu (1444–1507), *Radish*.

spite of stylistic differences, is unmistakable. A recent exhibition cata-
logue remarked: "The radish theme, with the humble character of the
plant and the worm-eaten areas of the leaves, is very much in keeping
with the Zen Buddhist regard for the importance of everyday experience
and the awareness of the transiency of all living things."[37]

These two paintings, one with an inscription and one without, do not,
in themselves, allude to anything especially Buddhist. But sometimes the
radish image is given a specific Buddhist allusion by a terse inscription
that quotes a single line from a Buddhist *gāthā* as a signifier. A third paint-
ing of a radish, from the brush of Sesson Shūkei (ca. 1504–1589; fig. 34),
is a case in point.[38] The inscription is by the Zen monk Keisho Shūzui
(active around 1555), the 152d abbot of Engakuji in Kamakura:

> One must always cultivate these in the garden;
> texts and books transmit their names, saying good rains bring them.
> One rainfall readily fattens Chu-ko Liang's vegetable.[39]
> How great the uses of their roots, stalks, branches, and leaves?

[37] John M. Rosenfield, ed., *Song of the Brush* (Seattle: Seattle Art Museum, 1979), entry
13.

[38] In the collection of the Institute of Zen Studies, Hanazono College. See Tanaka Ichi-
matsu and Nakamura Tanio, eds., *Sesshū Sesson*, in Suiboku bijutsu taikei 7 (Tokyo: Ko-
dansha, 1978), pl. 117, and commentary on p. 188.

[39] The Japanese reading: *Shokatsu no sai* (Chi: *Chu-ko ts'ai*). See note 40 below.

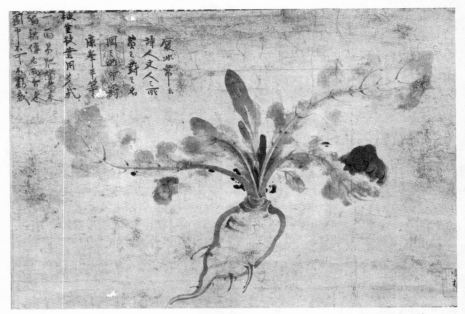

34. Sesson Shūkei (ca. 1504–ca. 1589), *Radish/Turnip*, inscription by Keisho Shunzui (active ca. 1555).

The last two lines about one rainfall fattening the turnip and the wording of the vegetable's features allude to the passage in the "Medicine Herb" chapter of the *Lotus Sūtra* already discussed:

> Their roots, their stalks, their branches, and their leaves,
> Their blossoms and their fruits having luster and color.
> What the one rain reaches
> All gain a fresh gloss. . . .
> In this way, the Buddha also appears in this world. . . .

Through such a brief allusion to the Buddhist *gāthā* in the inscription, *The Radish* by Sesson becomes an allegorical painting, linked to the *sō-moku jōbutsu* concept. It was not simply a gastronomic interest or an artistic inspiration from everyday objects in the monks' environment that gave these painted radishes commemorative status. Also, in these two cases, the inscriptions contain more than one level of allusion. Sesson's *Daikon* (probably from the confusion with *kabura* or turnip) is called here Chu-ko Liang's vegetable, that is, a turnip.[40] A note that follows

[40] See Li Fang, *T'ai-p'ing kuang-chi* (Hsin-hsing shu-chü ed.), 411:1581a. Here, under the entry *Ts'ai* (edible greens), is given a description of *man-ching* (a kind of turnip). Chu-ko Liang (181–234), the famous military general, is reported to have ordered his garrison to

Shūzui's inscription says, "Hō [Chi: *feng*; turnips] are what poets and literati gave high regards of an extraordinary kind. . . ." These points of reference and the allusions behind such images as these vegetable roots are by nature syncretic. On one level the radish (or turnip, as the case may be) is reaffirmed as a being in the plant kingdom having the Buddha-nature, and thus capable of attaining Nirvāṇa. On another level, there is an allusion to the poetics of Chinese literature, which abounds in references to humble vegetables in association with blandness and poverty, which the Chinese literati (*wen-jen* or *bunjin*) faced. For example, Huang T'ing-chien (1045–1105) of the Northern Sung period is reported to have moralized about *lo-po*, or, *daikon*:

> Let no gentlemen of the court be ignorant of this taste;
> Let no common people under heaven have starving faces as pale as
> vegetables.[41]

The Radish as a Social Motif

If Huang T'ing-chien's remark was a moral precept, it was a precept unobserved after all by the Chinese literati, to whom the imagery of vegetables or plants often had "the smell of Buddhists" (here tacitly pejorative, especially in light of the traditional literati's art criticism), and such Chinese traditional perceptions may, in part, account for the lack of high recognition of the artistic genius of the painter-monk, Mu-ch'i Fa-ch'ang.[42]

plant the turnip as useful food for the following six reasons: (1) within a short period of time after planting the seed, the sprouts can be eaten raw; (2) when the leaves come out, they can be eaten by boiling; (3) if the troops are to remain long, they can cultivate it; (4) when the troops move on, the turnip can easily be abandoned; (5) when the troops return, the turnip can easily be found again; and (6) in winter the root can be dug out and eaten. For these reasons the turnip was called "Chu-ko *ts'ai*." *Man-ching* described here is not radish, but the turnip, green in color both on the inside and outside. The modern name for *man-ching* is *wu-ching* (L. *Brassica campetris*). See *Chung-wen ta tz'u-tien* 8:106:12588b–c. The Japanese Muromachi monks' knowledge of this can be seen in a poem by Ōsen Keisan in his *Shōho shū*, Tamamura, *Gozan* 1:6.

[41] Quoted as Huang T'ing-chien's poetic inscription on a painting of *The Radish* in Kaibara Ekken, *Yamato honzo*, in *Ekken zenshū*, 6.110a.

[42] This is not to say that the Chinese painters, including scholar-painters, did not paint vegetables. Vegetables and fruits as a category of painting subject matter appeared as early as the Northern Sung period (i.e., eleventh century). These subjects were painted extensively by painters through the Yüan and Ming periods (i.e., fourteenth and fifteenth centuries). See, for example, *Hsüan-ho hua-p'u* (1120, *Shih-chiai shu-chü* ed.), 20:581–587, and Ch'en Pang-yen, *Li-tai t'i-hua shih-lei* (1708) 91:1a–12a. A typical unappreciative criticism of Mu-ch'i by the Chinese is that of T'ang Hou, *Ku-chin hua-chien* (*Shih-chiai shu-chü* ed.),

For Japanese, however, the idea of vegetable symbolism having layers of meaning, and the influence this idea had on their perception and sentiment, persisted. The *Radish* and *Vegetable* traditions, as seen through these Muromachi examples, continued to inspire talented painters of the Sengoku period (ca. 1467–1568), such as the Kano school painters as represented by the fan paintings, close copies of either the original Mu-ch'i or their Muromachi recensions, which exist today in Nanzenji.

In the culinary tradition, too, the radish and other vegetables were savored as the tea-*kaiseki*, which usually follows the tea ceremony (a sort of secular liturgy), undoubtedly as a symbolic gesture of humility and frugality inspired by the traditional monastic meals. An eighteenth-century aristocrat, Konoe Iehiro (1667–1736, better known as Yoraku-in), an artistic personality, left his tea chronicle *Kaiki* (The locust tree chronicle), which was transcribed during the period 1724–1735 by his loyal vassal and medical doctor in attendance, Yamashina Dōan (1677–1746).[43] Dōan gives two examples of the *kaiseki* menu, which today usually consists of a set of one kind of soup and three kinds of vegetables. On the eighteenth day of the fifth month of the year corresponding to 1727, the sixteenth abbot of Higashi Honganji, Shintei-in, invited Konoe Iehiro for tea, which was followed by a meal consisting of "soup, shredded radish, Korean goose, *yuzu* (citrus) served with its leaves, pickles of radish, and melon." The meal was served in front of a painting, *The Heron* by the fourteenth-century painter-monk Mokuan.

Again, on the twenty-seventh day of the tenth month of the year corresponding to 1728, a tea session was held at Konoe Iehiro's home. The meal, served in front of a Chinese painting of plums by Wang Mien, consisted of the following:

> *Daikon furofuki* [radish cut in thick round slices, boiled in hot water and served with *miso* paste]; green moss with *yamaimo* dressing [root of yam plant, usually served mashed into slimy form]; pickles (*narazuke*); and radish pickled overnight served on maple leaf.

The *daikon furofuki*, thick round slices of radish, boiled and served with *miso* paste, was a rustic delicacy for an aristocrat like Konoe Iehiro, who was noted as an urban aesthete. But the same *furofuki* was also eaten by the frail Confucian scholar, Seida Tansō (1719–1785). A Fukui clan-appointed scholar, Tansō was slightly younger than Iehiro, but contemporary with Jakuchū, who saw in the radish a moral allegory of the hardship of the peasant.

"The recent [painter] Mu-ch'i, the Buddhist monk Fa-ch'ang, did ink plays; they are coarse and ugly, without the manner of the ancients."

[43] SKZ 5.

Around 1742, Seida Tansō was suffering from an ailment in his legs and, in the twelfth month of that year, made an excursion to the hot spring of Tajima (Hyogo-ken, Shirosaki). On his return Tansō took a boat on the Shirosaki River and arrived at Toyooka, where he changed to a palanquin for transport back to Kyoto. Only a few *ri* from the town darkness fell. The transporter knew a farmer near Izushi, at whose house Tansō spent the night. An intimate account of the night with the farmer's family and the *daikon* he ate there is included in Tansō's *Kujaku-rō hikki* (Peacock pavilion essays).[44] The context in which the radish was served deserves a full quotation:

> In the house there were no *tatami*, only straw rugs with cloth borders were placed in the room. The host, the farmer, who was in his fifties, and his wife together entertained us in the most sincere manner. When I gave sweets (*kashi*) to their two children—one seven or eight years old, the other four or five—they behaved as if they had been given precious treasures. They seemed to want more, so I told them to come to my room to get some. They followed me, but as soon as they saw my pair of swords they became frightened and ran away. So I gave the sweets to the mother, who happily gave them to the youngsters. There was no *kotatsu* [warming pit] in the house. Across from the threshold was a sunken hearth (*irori*), which burnt wood all night long. What the smoke from the fire did to my bedding I do not have to tell, much less how well I slept that night. What little light the oil lamp emitted left the room dark, and the glow from the burning wood in the hearth was faint. As I looked about six feet away into the darkness there was something black. With some staring I discerned that it was a huge black ox. To spend a night with an ox is a novel experience indeed.
>
> The meal that night and the following morning was the creation of the host, who put all his heart into preparing it. Minced horseradish was cooked in soup, and *furofuki* was served by cutting the radish in thick round slices and boiling them in hot water. The thin slices of *daikon* were cooked with tiny dried sardines (*tatsukuri*) seasoned with soy sauce. For breakfast I was served dried radish and turnip. One should say the sardines served the night before were, for the farmer, as much of a delicacy as the lumps of a camel or the lips of an orangutan. My older brother, who came with me to look after my ailment, also witnessed the man's hardship with his own eyes.

The radish meals referred to above are both an aesthete's symbol and a daily necessity. While an aristocrat like Iehiro might eat radishes in symbolic cultivation of rusticity and frugality in his urban tea setting, Tansō, a Confucian scholar-traveler in the remote countryside, ate humble radishes in an actual farmer's house. The different meanings and cultural

[44] NKBT 96:324–325.

attributes given to the radish as a culinary item are not in these instances Buddhist. Yet, just as the ink images of the radish in the Muromachi period were charged with different layers of meaning, so was the radish as a culinary item in the eighteenth century imbued with different meanings in different contexts. In Japanese culture the radish was never a neutral object.

By the time of Jakuchū, images of the radish and other vegetables were fraught with myriad cultural attitudes. In the artistic world of Jakuchū, however, such images must be seen in other contexts as well. These were basically two. One was the growing quasi-scientific interest in the natural world shared by scholars who were undoubtedly stimulated both by Chinese Ch'ing dynasty scholarly positivism and, to a lesser degree, by Western science. The other was the world of Itō Jakuchū himself—a biographical context that is laden with events that are Buddhist.

The Scientific Radish in Eighteenth-Century Art

The eighteenth century in Japan saw a flood of publications, encyclopedic in character, that were descriptive of the natural world. Two contemporary publications on plants and food are worthy of special note. The first, *Yamato honzō* (The flora of Japan), by Kaibara Ekken (1630–1714) in sixteen chapters, is a *summa* of descriptive botanical information culled from various traditional sources, including the Chinese *Pen-ts'ao kang-mu* (Outline of flora) by Li Shih-ch'en (1518–1593), a copy of which Hayashi Razan had obtained in Nagasaki in 1607. The second, *Honchō shoku-kagami* (or *shokkan*) (Mirror of the culinary items of Japan), was published in 1697 by Hirano Hitsudai and gives detailed descriptions of the history and facts of vegetable species, including their antitoxic and curative uses. Kaibara Ekken begins the *Yamato honzō* by saying that *daikon* (written *lo-po* or *rafuku*) "should be considered first among the vegetable species." In 1754, an illustrated book on famous products of various provinces, *Nihon sankai meibutsu zue* (An illustrated guide to the celebrated products of Japan from the mountains to the sea), was published in Osaka, in which the turnip of Ōmi and the radish of Owari are illustrated with commentaries (fig. 35). The radish of Owari is said to be the first among the radishes of Japan, followed in order by the Nerima radish of Edo, the Ibuki radish of Omi, and those of Kurahashi, Eguchi, and Kizu.

What all these published sources on radishes show is that at the time Jakuchū painted the *Yasai Nehan* there was considerable interest in recording, reporting on, and illustrating specific items in the plant, vegetable, and animal worlds at the specialized, quasi-scientific, and popular

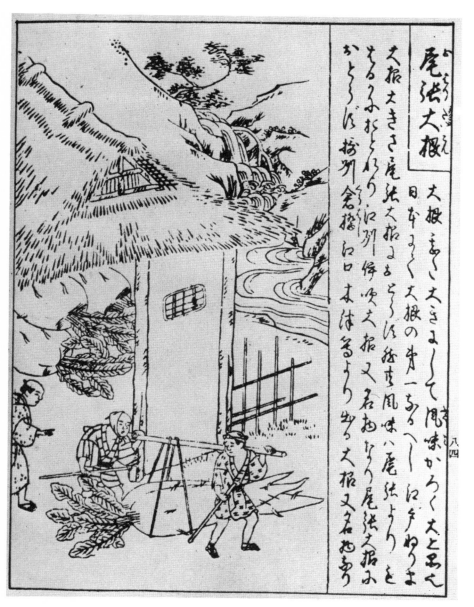

尾張大根

大根まことく大きまして
風味かろくたと玉へ
日本まく大根の中一ちの
もるうふおとうより江別
をとうふお

八四

35. Hirase Tessai, comp., *Nihon sankai meibutsu zue* (An illustrated guide to the celebrated products of Japan from the mountains to the sea), 1754.

levels. A parallel phenomenon in art history proper was a growing inter-
est in descriptive forms in Japanese painting, partly inspired by European
artistic idioms and the emergence of sketchers-from-life, who rendered
specific items in their sketchbooks. Maruyama Ōkyo (1733–1795) and
his school are typical of the artists working in this genre during the eigh-
teenth century.

The radish, "first among the Japanese vegetable species" in eighteenth-
century Japan, was as familiar to the people in Kyoto as tea leaves. It was
the most common species of farmers' produce, found as easily at a green-
grocer's as in a farming village. *Yamato kōsaku* (Agriculture of Japan),
attributed to an eighteenth-century *ukiyo-e* artist (fig. 36), represents the
tenth month of the year by the scene of a farmer's family cutting *daikon*
to dry in preparation for the coming winter as food for themselves and as
produce to be sold in a big town. A greengrocer of the Meiwa era (1764–
1772) illustrated in a woodcut entitled *Edo shomin fūzoku zue* (Illus-
trated customs of the Edo townsmen) displays *daikon* on the front rack
of the store (fig. 37).

An apparent paradox of form-content relationship between the radish

36. Ishikawa Ryūsen (late seventeenth-early eighteenth century), *Yamato kōsaku* (Ag-
riculture of Japan).

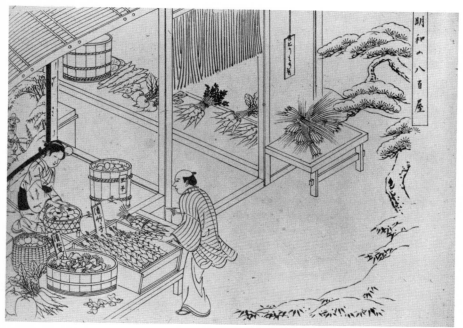

37. Anonymous, "Meiwa no yaoya" (Greengrocer of the Meiwa era, i.e., 1764–1772), reprinted in *Edo shomin fūzoku zue* (Illustrated customs of the Edo townsmen).

and other vegetables as a subject in Jakuchū's *Yasai Nehan* and those in circulation in the secular world is that, in form, Jakuchū's figures are closest in morphology to non-Buddhist images, but the context they create in his painting, in spite of the encyclopedic character, hardly reflects the typical interpretation of *daikon* by other contemporary artists.

Vegetables, the Nirvāṇa Painting, and Jakuchū's Life

Itō Jakuchū was born, significantly enough, into a greengrocer's family on Nishiki Street in Kyoto in 1716.[45] He was the oldest of three sons. At the age of twenty-three, when his father died, Jakuchū succeeded to the family business as the fourth-generation head, suggesting that the family business had a considerable history. In 1751, at age thirty-six, Jakuchū erected tombstones at Hōzōji, a temple of the Jōdo-Shin school of Buddhism in Kyoto, for his parents, although his mother was still alive. Ja-

[45] For life and art of Jakuchū, see Tsuji Nobuo, *Jakuchū* (Tokyo: Bijutsu shuppansha, 1974).

kuchū's connection to Hōzōji as his family mortuary temple is significant. But in terms of his own social and artistic life, the Rinzai Zen temple of Shōkokuji played a greater role, for it was through the writings of that temple's Daiten Kenjō (1719–1801), a learned scholar monk, that Jakuchū's biographical accounts are known. By 1752 Jakuchū was signing his paintings and documents Jakuchū Koji, "the Lay Buddhist Jakuchū," and in 1755 he handed the family business management over to a younger brother, Hakusai, so that he could devote himself to painting full-time.

In 1765 another younger brother, Sōjaku, died, which prompted Jakuchū to present a set of twenty-four major paintings of birds, flowers, plants, insects, and fish, accompanied by the Śākyamuni, Fugen (Samantabhadra), and Monju (Mañjuśrī) triptych, to Shōkokuji in order to commemorate his brother's death. At the same time, Jakuchū erected another tombstone for his deceased brother at Hōzōji. Here one sees a curious division of Buddhist protocol: on the one hand, Jakuchū kept his ties with the Jōdo-Shin temple Hōzōji as his family temple; on the other hand, he showed active patronage of Shōkokuji, which he reinforced by signing a contract of perpetual offering (eidai kuyō keiyaku), stating he would make donations both in cash and kind to the temple even after he died. A Buddhist context was created around the set of paintings Jakuchū donated to Shōkokuji when, in 1769, a Sembō ceremony (Ceremony of repentance) was held in the hōjō (abbot's living quarters) of Shōkokuji surrounded by these works as pictures of shōgon (embellishment of liturgical space). In the following year, 1770, commemorating the thirty-third anniversary of his father's death, Jakuchū added six more paintings.

In the meantime Jakuchū had already made contacts with the Ōbaku Zen school in Uji, notably at Mampukuji; and for Sekihōji in Fukakusa, a temple allied to Mampukuji, he was creating a stone sculpture diorama that is commonly called "The Five-Hundred Arhats," representing the eight phases of Śākyamuni's life, including Parinirvāṇa. In 1779 his mother died, at the age of eighty. In the meantime, his younger brother, Hakusai, the head of the family business, erected his own tombstone at Hōzōji. This fact confirms that the Itō family traditionally belonged to the Jōdo-Shin school of Buddhism. In 1788, when Jakuchū was seventy-three years of age, a major fire consumed most of Kyoto, including his family house on Nishiki as well as Shōkokuji. Miraculously, Jakuchū's paintings were saved. Stripped of his family business connection, Jakuchū was poverty-stricken. He became ill, and Shōkokuji nullified the "contract of eternal offering," on account of his misfortunes. From around this time Jakuchū seems to have made Sekihōji his retirement residence. In 1792 Hakusai died, and that event appears to have brought an end to the family firm, which had lasted for five generations. Eight years later Jakuchū, too, died at Sekihōji, where he was buried without being cremated.

The biographical accounts of Jakuchū, as well as his major paintings and other artistic productions, tell much about his concern with Buddhist piety. The offering of his magnum opus in 1765 to commemorate his brother's death was an act of piety traditional in spirit. The set, when displayed in its entirety, would simulate the setting of Śākyamuni's final sermon listened to by the multitude of plants, birds, insects, and fish. The stone diorama at Sekihōji shows an extraordinary diversion from Jakuchū's style of painting as well as medium. This highly original work echoes the primitivistic sculptures of Jakuchū's contemporary, Mokujiki (1718–1810), and the still earlier Enkū (1632–1695), and yet links in a remarkable way with the earliest extant sculptural diorama of the Parinirvāṇa created in the late seventh century at Hōryūji as well.[46]

Jakuchū's *Yasai Nehan* now has to be placed within this context of the artist's vita. First to be considered is its provenance. The painting came from Seiganji, a temple that belonged to the Jōdo-Shin school of the Nishi Honganji branch. Not surprisingly, Seiganji had direct connection with Hōzōji, Jakuchū's family mortuary temple—the latter being a satellite temple of the former. It is, thus, more than likely that Jakuchū painted *Yasai Nehan* for Hōzōji, his family temple, which, in turn, must have donated it to Seiganji at some later date. The question that remains is when and why did Jakuchū paint this *Yasai Nehan*?

The key is in the style of this painting. Although Tsuji Nobuo dates this work, on the basis of style and the features of its seals, to the artist's mid-career, that is, ca. 1765–1779,[47] it can be argued that a subject such as this must have been prompted by an urgent need to commemorate a major event that was at once significant in Jakuchū's personal life and crucial to him as an artist. I tend to place this painting after 1792, the year of his brother's death. The urgency that prompted Jakuchū to produce this painting must have come from the fact that the head of the Itō family had died, threatening to terminate the family's traditional business. Furthermore, the family business, which had for so long depended for its livelihood on vegetables, was to be commemorated by honoring those vegetables, represented by *daikon*, first among all Japanese vegetables.

Thus, two deaths beyond that of Śāyamuni were commemorated, the death of Jakuchū's brother and that of the family occupational tradition. Since Jakuchū's becoming a professional artist could be seen as an abdi-

[46] Mokujiki was in Kyoto during the third month of the year corresponding to 1787. He stayed at Mampukuji in Uji on the thirteenth day of that month. For Mokujiki see Yanagi Sōetsu, *Mokujiki Shōnin* (Tokyo: Shunjusha, 1972). For Enkū see Donald F. McCallum, "The Sculpture of Enkū," parts 1–2, *Oriental Art* 20 (1974): 174–191, 400–413. For Hōryūji's pagoda diorama see *Hōryūji*, 2 in *Hihō*, series 2, pl. 51.

[47] Tsuji speculates that the *Yasai Nehan* was done "during the second half of the artist's fifties or the first half of the sixties," that is, between ca. 1766 and 1776.

cation of family responsibilities and a prefiguration of the occupational failure, it is not surprising that he would have been motivated, possibly only unconsciously, to recast that loss in a Buddhist sense—transforming the humble radish of the social and greengrocer world into a symbol of Buddhist withdrawal from the world. His own withdrawal from society into the realm of art and religion was, therefore, given transworldly substance by equating it with two major events in the Buddha's life—his initial withdrawal from society to become an ascetic, and his final withdrawal from the world into Nirvāṇa. Finally, the artistic strategy of choosing a Nirvāṇa composition made out of nonanthropomorphic motifs allowed Jakuchū to avoid infringing on the Jōdo-Shin tradition of *not* commemorating the traditional Nirvāṇa.[48]

Conclusion

Without representing a single anthropomorphic image, without a single explicit Buddhist figure, *Yasai Nehan* shows a continuity with the traditional Nirvāṇa painting through its allegorical structure, which now accommodates biographical motifs. It has been seen how vegetables in the Japanese Buddhist world were charged with attributes given by Buddhist ideas and perception. The emergence in the Muromachi period of radishes as a special category of ink painting has also been noted. Jakuchū, in the eighteenth century, integrates all these cultural strains in a single biographical statement. The implication of the content of the *Yasai Nehan* is that the issue of life and death for all beings, sentient or insentient, always returns to the essential teaching of the Buddha. Blurring the conventional distinction of things, this message applies as much to vegetables as to humans.

It might be appropriate to add to these observations a passage from a work of the poet Kobayashi Issa (1763–1827), which offers an apt example of the extent to which the latent Japanese perception toward life and death of one category of beings is superimposed over that of another, creating a synecdoche or multilayered allegory that quite literally lets "other[s] speak,"[49] blending the imageries of both categories. The passage

[48] Sakawa Senkei, "Butsu nehan zu ni tsuite," *Bukkyō girei: sono rinen to jissen* (1978): 50–56.

[49] Both "synecdoche" and "allegory" are terms derived from Greek. As a literary technique, "synecdoche" provides help in "understanding one thing with another." "Allegory," consisting of "*allos* (other)" and "*agoreuein* (to speak)," is a technique of narrating an event that "refers to another simultaneous structure of events . . . or natural phenomena." For both terms see Alex Preminger, ed., *Princeton Encyclopedia of Poetry and Poetics*, enlarged ed. (Princeton: Princeton University Press, 1965), pp. 12–15, 840.

is from Issa's *Oraga haru* (The spring that is mine), about a child priest of his home village, who was picking plants in the field and drowned in a river:

> The child's body was found about one *ri* from the place where he had fallen. When the exercised villagers pulled the body from the water, three or four sedge plants fell out of the child's *kimono* sleeve—the child must have picked them to take home for his parents. When the body was returned to the temple that night, the parents, having waited so anxiously for the child's return, dashed toward the body, and, after one look, screamed their cries in spite of the on-lookers. It is the Law of this world, even for one who daily preaches on the impermanency of things, that, when reality hits him who loves another dearly, his enlightenment is lost. In the morning was the laughter of the child leaving the temple gate; in the evening a corpse returns. It speaks no word.[50]

Issa attended the funeral of the child a week later and composed a poem:

> Did a thought ever cross their mind
> that they might see the young green bud of early spring
> turn into the smoke of the field?

The poem is followed by Issa's comment:

> To the *fuki* plant, dandelions, and their kind that lie for long patiently under the fallen snow, comes the season of breezy spring. No sooner do they see the light of the world, stretching their longing heads out from the cracks in the snow, than they are instantly nipped off. For these plants isn't the sorrow as deep as that of the child's parents? They say everything in the plant and tree kingdom attains Buddahood. Then they, too, must have Buddha-nature.

In these synecdochic metaphors is reflected the Japanese Buddhist per-ception toward the sorrow of parting of one species of being expressed in terms of the same condition of another, different species. It is in the inter-blending of sets of metaphors around the meaning of the Buddhahood of myriad kinds of being that the ultimate reconciliation with the idea of the inevitability of parting occurs.

It is in the poetics of things that Buddhist thought is embodied, not by and in itself, but in its embracing capacity to include all. In the absence of a similar model of development in other cultures, this pattern of creation, commemoration, and allegorizing can be thought to be indigenously Jap-anese.

[50] NKBT 58:436–437.

Nine

Holy Horrors: The Sermon-Ballads of Medieval and Early Modern Japan

SUSAN MATISOFF

AMONG THE MOST thriving popular entertainments that flourished in the major urban centers of Japan from around the turn of the seventeenth century was a form of puppet theater known as Sekkyō-bushi, or "sermon-ballads."[1] Preserved in print by enterprising booksellers riding the crest of a great new wave of mass literacy, the sermon-ballads afford us a fascinating glimpse at popular religious beliefs reflected in a form of mass entertainment. The term *sekkyō*, literally "*sūtra*-explanation,"[2] has a long history, but the sermon-ballads of early modern times make scarcely any reference to the *sūtras* and are, to say the least, far removed from their presumed ultimate origins in the didactic sermons of Nara and Heian priests. Although one might naturally call texts staged with the use of puppets "plays," the translation of the name of the genre as "sermon-ballad" reflects the religious origins and aura of the texts, their earlier development as narratives chanted with musical accompaniment before they were transformed into a stage art, and their essentially popular nature.

While instances of divine, miraculous assistance, joyous rebirth, or reward in this lifetime provide some relief to their predominantly gloomy tone, sermon-ballad plots typically concern suffering, especially the suffering of young people separated from their parental families and cast into dire straits ranging from loneliness to desperate illness, disfiguration,

[1] *Sekkyō* is written with characters meaning either "explain *sūtras*" or "explain-teach." Some, but not all, contemporary scholars make a differentiation, using the former to indicate the performance genre and the latter to indicate the performers themselves. *Fushi*, or in combined form -*bushi*, the second element in the name of the genre, is a term with a broad range of meanings. In its original sense it denoted a segment or joint, as of a stem of bamboo. Its meaning extends to the realm of music, where *fushi* is used to translate "melody." The central idea of "segment" remains, however. *Fushi* are set patterns of singing or chanting a passage of text. While not necessarily melodic, a *fushi* passage is intoned rather than simply declaimed. Several different narrative musical styles with shamisen accompaniment in the Kabuki theater, for example, are known as different types of *bushi* (*gidayū-bushi, kato-bushi*, etc.).

[2] I.e., *sekkyō* as "explain-*sūtra*."

starvation, torture, slavery, and death. These are their characteristic "holy horrors."

In the following pages I present brief summaries and analyses of three of the most popular and best-documented sermon-ballad texts. In this instance my primary aim is to demonstrate the folk religious beliefs apparent in these pieces, particularly the fusion of belief in native deities and various Buddhas and bodhisattvas. One critic has spoken, most aptly, of the "opaque simplicity" of Sekkyō-bushi. The plots unfold with certain refractive shifts of time and place, characteristic of story-telling techniques the world over (there are set scene-shifting openers, for instance, that are reminiscent of the "meanwhile back at the ranch" of Western melodrama).³ But the simplicity of sermon-ballads involves relatively little interweaving of the subplots that so often characterize later puppet theater and Kabuki plays.

The vocabulary of the sermon-ballads is relatively limited and the style comparatively simple. When specifically Buddhist technical terminology does, occasionally, occur in the texts, it stands out in high contrast. Though substantial parts of the texts are metered, following the ubiquitous Japanese 7–5 syllable alternation pattern, the effect is generally prosy compared with, for example, *Heike monogatari* (The tale of the Heike). Recurrent formulaic expressions and set motifs are evidence that the origins of the sermon-ballad texts lie, at least in part, in oral composition. Though questions of compositional technique are not my focus here, it is worth noting that such repetitive elements added to the intensity of the emotional appeal of sermon-ballads in performance, though their effect on a modern reader of a text may be the opposite.

The Historical Development of Sekkyō-bushi

The earliest record of the term *sekkyō* dates from 753, in a passage in *Zoku Nihongi* (Chronicles of Japan, continued).⁴ In its earliest reference the word appears, as its characters imply, to pertain to a public elucidation of the meaning of certain *sūtras*, particularly the *Lotus Sūtra*, and "sermon" might be an entirely appropriate translation for the term at that time. As best one can judge from available evidence, the original intent of Sekkyō was didactic, and the preacher of Sekkyō was, in effect, a missionary, serving with institutional support to promulgate Buddhism to mixed

³ For example, in *Karukaya* the following formula is repeated several times: *Kore wa XX no monogatari, sate okimoshi. . . .* "This is the story of XX, leaving it for now. . . ." See Muroki Yatarō, *Sekkyō-shū*, in *Shinchō Nihon koten shūsei* (Tokyo: Shinchosha, 1977), pp. 30, 65.

⁴ Quoted in Iwasaki Takeo, *Sanshō Dayū kō* (Tokyo: Heibonsha Sensho, 1973), p. 21.

audiences of both aristocrats and commoners at temple services in the Nara and Heian capitals. The earliest Sekkyō may have been so elevated and technical as to be difficult for many in the audience to understand. Nevertheless, as Sei Shōnagon's typically bold comment in *Makura no sōshi* (The pillow book) reminds us, holding an audience was a crucial concern for any preacher who wished to be effective. For this particular aristocratic woman, it was essential that "a preacher ought to be good-looking"[5] lest her attention wander. There are indications that Heian Sekkyō preachers enlivened their sermons by incorporating entertaining parables and anecdotes. Some tales in *Ōkagami* (The great mirror) and *Konjaku monogatari* (Tales of times now past) give evidence of contemporary humorous Sekkyō.

While the full picture of the institutional affiliations, social origins, and priestly condition of early *sekkyōshi*, "Sekkyō reciters," is not entirely clear, as early as the Heian period some were seen as "half-priest, half-layman," and some led "lax lives," supporting wives and children.[6] Sekkyō performers moved out into the community and the varieties of Sekkyō proliferated. Musical elements from Buddhist *shōmyō* chanting[7] were incorporated into Sekkyō; brisk competition developed among the practitioners (many perhaps no longer quite what one might think of as "preachers"), and some *sekkyōshi* were clearly well on the way to becoming popular entertainers.

Some Sekkyō were performed by priests directly affiliated with the activities of Hōnen,[8] and some textual variations of *Heike monogatari* show evidence of their use as Sekkyō.[9] Others spread the teachings of such major figures as Shinran (1173–1262) and Rennyo (1415–1499).[10] These were, in effect, the more formally affiliated, more purely Buddhist types

[5] Ivan Morris, trans., *The Pillow Book of Sei Shōnagon* (New York: Columbia University Press, 1969), 1:33. The original can be found in Ikeda Kikan et al., eds., *Makura no sōshi, Murasaki Shikibu nikki*, in Nihon koten bungaku taikei (Tokyo: Iwanami Shoten, 1965), 19:37.

[6] Sekiyama Kazuo, *Sekkyō no rekishiteki kenkyū* (Tokyo: Hozokan, 1973), p. 28, quotes a passage from a courtier's diary, dated 1120, to this effect.

[7] The traditional style of chanting Buddhist *sūtras*. This was one important element of Buddhist practice studied extensively by Japanese student monks sent to China in the eighth and ninth centuries.

[8] Hōnen (1133–1212) was founder of the Jōdo sect. Sekiyama, *Sekkyō no rekishiteki kenkyū*, pp. 65–77, discusses Hōnen's place in the history of Sekkyō, calling him *Sekkyō no hito*, "a man of Sekkyō."

[9] Kenneth Dean Butler, "The Textual Evolution of the *Heike Monogatari*," *Harvard Journal of Asiatic Studies* 26 (1966): 34–35.

[10] For the line of relationship as "founders," "disciples," and "revivers" linking these three thinkers, see Stanley Weinstein, "Rennyo and the Shinshū Revival," in *Japan in the Muromachi Age*, ed. Whitney Hall and Toyoda Takeshi (Berkeley: University of California Press, 1977), pp. 331–358.

SERMON-BALLADS OF MEDIEVAL JAPAN

of Sekkyō. Sekiyama Kazuo, author of the authoritative history of institutional Sekkyō, makes the important point that *fushidan* Sekkyō, a style of dramatic preaching performed primarily by priests at Jōdo and Shinshū temples, remained highly popular into the early modern period. (A few elderly practitioners are still active in rural temples.) Despite its dramatic aspects, Sekiyama points out that it is of crucial importance that the distinction be kept clear between this tradition and the Sekkyō-bushi tradition on which, no doubt, it had some influence.[11] The texts discussed in this chapter are not in the temple *fushidan* Sekkyō repertoire.

But medieval Sekkyō also encompassed a less clearly documented and less institutionally "pure" form. Here one finds *sekkyōshi* who very likely had no formal institutional affiliations. Their self-"ordination" might simply mean that they dressed in a style somewhat reminiscent of Buddhist priests or, at least, shaved their heads in the manner of priests. These *sekkyōshi* were but one group among a great variety of semipriestly or pseudo-priestly medieval entertainers who gathered their audiences at crossroads on market days or among the throngs who flocked to shrines and temples on festival days. The temple or shrine provided a context for the performance, a place where a potential audience existed, but the temple priesthood was unlikely to have thought of these performers as colleagues.

Often they were little better than beggars who found asylum at certain temples. These pseudo-priestly entertainers were, for the most part, itinerants who plied their trade along pilgrimage and general travel routes. From a present-day perspective, given the ephemeral nature of their performances, it is difficult to determine just how the activities of some of these various groups differed. Medieval *sekkyōshi* of this sort were in the company of other pseudo-priestly entertainers known as, among other terms, *ommyōji* (*yin-yang* adepts), Nembutsu *hijiri* (Nembutsu ascetics), *dengaku hōshi* (field-music priests), *biwa hōshi* (lute priests), *etoki hōshi* or *etoki bikuni* (picture-telling priests or nuns), *monogatari sō* (tale-monks), *shōmyōshi* (*shōmyō* chanters), *kugutsushi* (puppeteers), *aruki miko* (itinerant mediums), or *kuchiyose miko* (voice-summoning mediums).[12] The apparent common denominator in the religious beliefs of such entertainers was extreme eclecticism, and the reflection of similarly eclectic beliefs in the sermon-ballad texts of the early modern period is particularly interesting.

The major literary source affording one a glimpse of medieval Sekkyō

[11] Sekiyama, *Sekkyō no rekishiteki kenkyū*, p. 260.

[12] The activities of such types of entertainers and their part in the development of medieval Japanese literature are discussed in Barbara Ruch, "Medieval Jongleurs and the Making of a National Literature," in *Japan in the Muromachi Age*, ed. Hall and Toyoda, pp. 279–309.

is the *Shintō-shū* (The Shinto collection). This collection of fifty tales was edited in Kyoto by some person or persons associated with a Jōdo-affiliated Sekkyō tradition known as Agui Shōdō.[13] Collected and edited in the mid-fourteenth century, the stories range from those concerning the origins of Shinto, or the significance of the *torii*, to temple origin legends and *honji-suijaku* tales explaining some Shinto deities as *suijaku* manifestations of primary (*honji*) Buddhas or bodhisattvas.[14] The extreme syncretism of this collection marks it as a departure from the more purely Buddhist Sekkyō tradition, and a few of its narratives bear some resemblance to sermon-ballads performed in urban theaters after the turn of the seventeenth century.

Another major source for our image of medieval *sekkyōshi* is found in the depiction of the title character in the Nō play *Jinen Koji*. While Jinen Koji is described in the play as an invited lecturer preaching within a temple, the Ungōji in Kyoto, he is clearly an entertainer. He sings, dances, and engages in verbal battles of wit with slave traders from whom he rescues a veritable damsel in distress. He plays the *sasara*, an extremely humble bamboo percussion instrument that was the characteristic accompaniment of medieval Sekkyō. It is nothing more than a rasping scraper consisting of two parts. One piece, fashioned from a length of bamboo cut at the end to form a whisk, was rubbed with the second piece, a jointed strip of bamboo. The resultant noise provided rhythmic emphasis, though clearly not melodic accompaniment, for popular Sekkyō performances.

In all probability, Jinen Koji was not the name of a single individual but a general name for entertainers of this type.[15] The Nō, thought to be a composition by Kan'ami later revised by Zeami, presents a rather prettified image of a humorous fellow beloved by his audiences. Still, other thirteenth- and fourteenth-century documents hint that entertainers known as *jinen koji* were itinerant performers, some with shaved heads, some not, who were noted especially for their ability to move their audiences to tears. They were described as *kojiki* (beggars) who wandered

[13] See Susan Matisoff, *The Legend of Semimaru, Blind Musician of Japan* (New York: Columbia University Press, 1978), pp. 48–52.

[14] The *honji-suijaku* theory was, of course, a powerful tool in the process of Shinto-Buddhist amalgamation and was used to explain Shinto deities as Japanese incarnations of Buddhas and bodhisattvas. From as early as the Nara period, development of Tendai- and Shingon-related Shugendō (also referred to as *yamabushi*)—an ascetic movement encompassing both Buddhist and native folk beliefs—helped the *honji-suijaku* philosophy to gain widespread acceptance. Alicia Matsunaga, *The Buddhist Philosophy of Assimilation* (Tokyo: Sophia University, 1969), is a monographic study of the historical development of *honji-suijaku* theory. See especially pp. 259–270 regarding artistic and literary expressions of the theory in Japan.

[15] Kanai Kiyomitsu, *Nō no kenkyū* (Tokyo: Ofusha, 1969), pp. 546–554.

about, their origins unknown. We can infer that these strangers were sometimes more than a little frightening to their audiences.

The earliest extant printed text identified specifically as a sermon-ballad text, *Sekkyō Karukaya*, printed in Kyoto in 1631, dates from long after the *Shintō-shū* and the Nō *Jinen Koji*. It comes from a time when at least some, if not all, sermon-ballads had acquired a new context as stage entertainment, performed in fixed theaters by chanters who were accompanied by musicians playing the shamisen. Soon performances were enlivened by the use of a few simple puppets that acted out the stories the narrators chanted. Within the urban milieu, Sekkyō-bushi was in direct and vigorous competition with Jōruri puppet drama. Jōruri, too, developed originally from a narrative tradition without puppets, and theater historians differ in their opinions as to which genre was the first to incorporate the use of puppets. Though Sekkyō-bushi is also called Sekkyō-jōruri by some writers, I prefer the former designation as more reflective of the originally independent development of the two genres. Some *ko-jōruri*, "old Jōruri," texts predate the earliest Sekkyō-bushi texts. Clearly the two styles were originally distinct, and they remained distinguishable for a time even after some chanters began to perform in both styles.

There is a certain fuzziness about the definition of a particular work as Sekkyō-bushi. The most definitive characteristic, musical and intonational style, is lost because of the absence of musical notation in the texts. Typical sermon-ballad phrases crop up occasionally in texts of other genres, but any sermon-ballad text is generally replete with such phrases as *ryūtei kogarete onaki ari*, "weeping with flowing, burning tears"; *itawashi ya* or its seven-syllable alternative *ara itawashi ya*, "how pitiful!"; or *aware tomo nakanaka nani ni tatoen kata mo nashi*, "so very sad it is beyond compare."

The common linguistic features of core Sekkyō-bushi texts are striking, especially when one compares texts of performance attributed to various *tayū* "chanters" active in different cities. Some provisional attempts have been made to identify a particular regional dialect as the basis for certain grammatical idiosyncrasies in the texts, but whatever the origins of their linguistic peculiarities, it seems likely that the language of Sekkyō-bushi had become fixed before its performers moved into the cities.[16] The printed booklets of sermon-ballads were called *shōhon* (true texts) and reflected the fact that the booksellers attempted to record the actual performance of a specific chanter with all possible fidelity. Chanters and book dealers responsible for particular texts can be identified, but no specific author can be determined for any given sermon-ballad.

The formats of the three texts discussed in this chapter are all similar:

[16] Muroki Yatarō, *Katarimono no kenkyū* (Tokyo: Kazama Shobo, 1970), pp. 246–248.

small, inexpensive woodblock-print booklets containing from eight to fifteen illustrations. In many of these illustrations the scene is horizontally divided into an upper and lower half, each depicting a different incident in the text. To uninitiated eyes the effect is strange. Perhaps squeezing two pictures into one was an economy measure. Though *shōhon* booklets were mass-produced, the number of copies in a typical edition is not known. The popularity of some texts is, however, demonstrated by the existence of *atozuri*, inferior copies made by using old blocks.

In content, the sermon-ballads have much in common with various medieval prose texts called *honji-mono*, including such well-known medieval tales of suffering and redemption as, for example, *Kumano no honji* (The original form [of the Deity] of Kumano) or *Bishamon no honji* (The original form of Bishamon).[17] In several cases, including two discussed below, sermon-ballad texts are related to earlier Nō plays. Conversely, some plots that are well known as *otogizōshi*, a loosely defined category of late medieval and early modern short stories, were apparently adapted for Sekkyō-bushi-style stage performance and appeared in *shōhon* versions.[18] Some sermon-ballads appeared in undated *Nara-ehon* "Nara picture books,"[19] illustrated manuscript books that were an important vehicle for the dissemination of popular literature in the early seventeenth century. Like the *shōhon* printed booklets, the *Nara-ehon* show us that the audience for sermon-ballads was expanding to include readers as well as the earlier street crowds and temple-goers or urban theater-goers.

Early in the Tokugawa period *sekkyōshi*, like many other formerly itinerant groups, were forced to settle in distinct *buraku* enclaves and were evidently kept apart from general society. A few of the most talented enjoyed great success for a time, performing in Kyoto, Osaka, Nagoya, and Edo. The Tokugawa government attempted to obtain a measure of con-

[17] Plots categorized as *honji-mono* are generally cast in the form of stories of the lives of human beings who endure remarkable suffering, leading to some sort of dramatic death, after which their true nature as deities becomes apparent. Though the pattern may be taken as a reflection of native Japanese belief in the direct transformation of humans into *kami* deities after death, literature of this type was clearly also influenced by Buddhist *honji-suijaku* theory. A series of articles by Matsumoto Ryūshin, "Chūsei ni okeru honjimono no kenkyū," parts 1–7, *Shidōbunkō ronshū* 9 (1971), 11 (1974), 13 (1976), 14 (1977), 16 (1979), 18 (1981), 19 (1982), is a detailed study of textual variants of plots of this type.

[18] Yokoyama Shigeru, *Sekkyō shōhon shū*, 3 vols. (Tokyo: Kadokawa Shoten, 1968), includes numerous examples, notably *Fushimi Tokiwa, Chūjōhime no gohonji, Ko Atsumori, Bishamon no honji, Yuriwaka daijin,* and *Kumagae senjin mondō.*

[19] For example, *Oguri*, printed in ibid., 2:351–383. There is also an opulently illustrated scroll manuscript version of *Oguri* now held by the Imperial Library. Small black-and-white photographs of the illustrations are to be found in Araki Shigeru and Yamamoto Kichizō, eds., *Sekkyō-bushi*, in Tōyō bunko 243 (Tokyo: Heibonsha, 1973). This particular scroll was obviously expensive to produce and can be taken as evidence that interest in sermon-ballad texts was not limited to the indigent and illiterate.

trol over them by requiring their licensing through the Semimaru shrine, located between Kyoto and Ōtsu.[20] As they became "stars," some chanters may have escaped to a degree from the very low status of their rural counterparts, moving into the cities and ceasing regular attendance at ceremonies at the licensing shrine.

The heyday of urban sermon-ballad performance apparently spanned the middle fifty years of the seventeenth century. It was during this period that the instrumental accompaniment used for Sekkyō-bushi, as for Jōruri, became the exciting new import from Okinawa, the shamisen. With puppetry adding another element of novel appeal, the chanters' performances of traditional narratives were greeted with enthusiasm. The repertoire of highly successful urban performances was evidently quite limited. The phrase "five Sekkyō" occurs in several seventeenth-century documents, though two old lists of "the" five have only two titles in common: *Karukaya* and *Sanshō Dayū*.[21] Perhaps one cannot fix a precise repertoire of clearly defined sermon-ballads, but obviously their total number was relatively small and their audience appeal lay primarily in their familiarity, not in new or surprising elements.

In the Kyoto-Osaka area sermon-ballad performances peaked in popularity around 1660, then rapidly declined. In Edo (modern Tokyo), the beginning of their popularity as a stage art and the turning point toward decline each came about thirty years later. Why was Sekkyō-bushi not more lastingly successful? On the one hand, Jōruri, with which sermon-ballad performances were in constant competition, was continually changing and innovating. By comparison, sermon-ballads came to seem conservative, morose, even dull. Though the Confucian scholar Dazai Shundai (1680–1747) in his essay *Dokugo* (Solitary words) nostalgically recalled Sekkyō-bushi as morally proper, in contrast to the "lasciviousness" of the Jōruri of his day, his taste was clearly not shared by the majority of his contemporaries.[22] As time passed, sermon-ballads became more secularized; most texts dropped their *honji* frameworks, and the

[20] Muroki, *Katarimono no kenkyū*, pp. 195–204.

[21] Ibid., p. 255. A particularly important source of contemporary information concerning Sekkyō-bushi is the *Matsudaira Yamato no kami nikki*, cited by Muroki. In an entry dated the thirteenth day of the second month, 1661, the diarist comments as follows: "Among many things that have changed since days gone by is the fact that numerous Jōruri texts have been appearing. Making a rough count of them, they include Sekkyō texts as well. There are quite a few good books. I list here as many as I can call to mind." He then lists eleven titles that he identifies as Sekkyō, including all three titles discussed in this chapter. By contrast, the increasing popularity of Jōruri is easy to judge. Matsudaira's list extends to over 150 titles. See *Matsudaira Yamato no kami nikki*, in Wakatsuki Yasuji, *Kinsei shoki kokugeki no kenkyū* (Tokyo: Seijisha, 1944), pp. 29–33.

[22] Quoted in Iwasaki, *Sanshō Dayū kō*, p. 17.

emphasis shifted more toward the accomplishment of this-worldly revenge.

Sekkyō-bushi exerted some influence on both the content and style of later Jōruri. The sermon-ballad tradition seems to have been a source for the legacy of powerful female characters and the interest in domestic plots in the later dramas. Sekkyō-bushi performance style could be used to provide variety in a Jōruri performance. In effect, Jōruri triumphed by simply absorbing some elements of sermon-ballad style within its own exciting, varied, innovative repertoire.

Ritual language, formulaic expressions of grief, and familiar stories of suffering, faith, and salvation came to seem stereotyped and boring. The audience became, with the passage of time, increasingly sophisticated and skeptical. For the listener who offered alms to a beggar-performer in a temple courtyard, Sekkyō-bushi was to some degree a religious experience. For the urban theatergoer buying a ticket rather than giving alms, sermon-ballads soon ceased to be worth the price of admission.

Like the orphaned characters of their texts, sermon-ballads themselves have been, until recently, something of an outcast genre. The principal study of Sekkyō history, written by Sekiyama Kazuo,[23] devotes a mere twenty pages or so, in a volume of some four hundred pages, to Sekkyō-bushi as an early modern theatrical art. In contrast to early Sekkyō proper, as performed in temple services, sermon-ballads seem to strike Sekiyama as distastefully degenerate. In like fashion, in major studies of Japanese theater history, Sekkyō-bushi has been accorded but pale significance as drama when compared to the lyricism and refinement of Nō or the rich dramatic and linguistic complexity of later puppet theater.

Yet looked at for what they are, rather than scorned for what they are not, sermon-ballads are a fascinating body of texts. Appreciation of Sekkyō-bushi requires judgment by different standards than are appropriate either for institutional Buddhist didactic sermons or for highly literary dramatic forms, and in the last three decades or so such new standards have begun to be created and applied by a widening circle of Japanese scholars, leading, perhaps inevitably, to what some now call a "Sekkyō research boom." And though one performance scarcely constitutes a "boom," a 1976 stage revival of one sermon-ballad, *Sanshō Dayū*, was surely the first such performance in well over a century. Whether one's interest is in the history of dramatic literature or the history of religion in Japan, the sermon-ballad texts present a rich source of information, for these two histories were inseparably intertwined in the medieval period. Though sermon-ballad texts date largely from the seventeenth century,

[23] I.e., *Sekkyō no rekishiteki kenkyū*.

the scholarly consensus holds that Sekkyō-bushi is a medieval genre, first captured in writing at just about the point that its stories began to be transformed, or forgotten, as outmoded. As Muroki Yatarō succinctly states, in terms of the plots of these ballads, "the tail end of the Muromachi period lasted a good long time."[24] Acting in their own commercial interests, the booksellers who faithfully recorded the sermon-ballad performances of their day have left for modern readers and researchers a rich source of information concerning medieval popular religion. In the remainder of this chapter, I introduce three classics of the genre and offer a preliminary analysis of some of their most characteristic features.

Three Exemplary Pieces

Karukaya

The oldest known sermon-ballad *shōhon* booklet is the text of *Karukaya*, published in Kyoto in 1631.[25] Its opening and closing passages provide a frame that sets the story in a specifically Buddhist context. The piece begins:

> Now, concerning the original deity (*honji*) whose tale I am about to tell, if you ask of the province, this concerns Shinano. I will tell you of the original form of the deity celebrated as the Parent-Child Bodhisattva Jizō, by the left side of the Zenkōji Nyorai Hall. Now as I tell you all about him, if you inquire in detail about his history, he was Lord Shigeuji of the Matsura Estate in the Province of Chikuzen on Tsukushi.

Karukaya ends with the simultaneous deaths of Shigeuji and his son Ishidōmaru, who are then transported together to Amida's Pure Land.

> A sweet fragrance wafted about as blossoms were scattering. As the Buddhas of the three worlds looked on, this fortunate pair were transformed into Buddhas, and that they might be worshipped by the masses in this final age, they were celebrated as the Parent-Child Jizō by the Interior Hall at Zenkōji in Shinano. I have told you the story of the Parent-Child Jizō. The province prospers, the place thrives; grand was their rebirth through singlemindedness.[26]

[24] Muroki, *Katarimono no kenkyū*, p. 50.

[25] The *shōhon* was entitled *Sekkyō Karukaya*. The inclusion of the term Sekkyō in the title evidently served to distinguish this *shōhon* from Jōruri texts, which were also beginning to be published in great numbers around this time. This is the primary base text of *Karukaya* used in both modern annotated scholarly Sekkyō-bushi collections. See Muroki, *Sekkyō-shū*, p. 417, and Araki and Yamamoto, *Sekkyō-bushi*, pp. 326–327.

[26] *Ichinen gojo wa daiji nari* in Muroki, *Sekkyō-shū*, p. 77.

This frame, with its positive tone, counterbalances the pathos of the inner story, a tale of desertion and death. Despite the joyous mood of the frame, the overwhelming tone of the inner narrative is dismal.

Suddenly awakened to religious consciousness by the scattering of cherry blossoms, Shigeuji leaves his pregnant wife and young daughter to become a monk. Though he assures his wife of his eternal love, he deserts his family and proceeds to Kiyomizu temple in the capital. There his prayers to the bodhisattva Kannon[27] lead him to an encounter with a mendicant monk[28] who, after reciting a virtual catalogue of the sacred places of the capital, leads Shigeuji to the Pure Land thinker Hōnen at his headquarters at Shinkurodani.

Shigeuji's request that Hōnen perform the tonsure for him meets with initial refusal. Hōnen relents when Shigeuji threatens to fast to death on the spot, explaining his initial reluctance to accept Shigeuji as a disciple by saying that they both would fall into Hell should Shigeuji change his mind and wish to revoke his vows if later contacted by his family.

Shigeuji convinces Hōnen to perform the tonsure by claiming that he has no family. He recites a long *seimon* vow, a catalogue of the names of numerous deities, to persuade Hōnen of the truth of his claim. (This was probably a semi-independent virtuoso theatrical set piece that served to display the chanters' vocal talents at least as much as the character's piety. A nearly identical *seimon* occurs in the sermon-ballad *Sanshō Dayū*.)[29]

[27] Kannon (Skt: Avalokiteśvara; Chi: Kuan-yin) has enjoyed persistent popularity in Japan as an object of devotion, and worship of this deity appears to have been an element of the earliest strains of Japanese Buddhism. The textual authority for Kannon beliefs was primarily the twenty-fifth chapter of the *Lotus Sūtra*. Representations of Kannon take a variety of iconographic forms, such as Shō Kannon, represented as a seated figure wearing a crown that bears an image of Amida; Jūichimen Kannon, an eleven-faced figure; Senju Kannon, a figure with multiple (theoretically a thousand) arms; and so on.

[28] A *kanjin hijiri* or "subscription monk." This figure in *Karukaya* may be interpreted as a reflection within the text of one of the types of semirelijious itinerant performers mentioned previously. Muroki, *Katarimono no kenkyū*, pp. 270–294, discusses connections between *Karukaya*, the *kōwakamai* text *Atsumori*, and several other related texts. He considers Kōya *hijiri*, mendicants based on Mount Kōya, to have had a hand in the development of *Karukaya* and suggests that the catalogue recited here, which closely resembles a passage in *Atsumori*, may reflect a Kōya *hijiri* chant that predates both *kōwakamai* and Sekkyō-bushi. For a history of the activities of Kōya *hijiri*, see Gorai Shigeru, *Kōya hijiri* (Tokyo: Kadokawa Shoten, 1975).

[29] See Iwasaki, *Sanshō Dayū kō*, pp. 75, 198–205. Iwasaki traces the origins of these set pieces to a kind of incantational magic, now generally called *yamabushi saimon*, which was performed by medieval religious wandering ascetics known as *shugenja* or *yamabushi*. Such recitations, embellished with shamisen accompaniment, became essentially pure entertainment in the early modern period and came to include topical subjects as well as the traditional incantational content. Iwasaki suggests that the passages included in *Karukaya* and *Sanshō Dayū*, in fact, closely reflect the earlier use of such chants as a way of magically affecting the outcome of events.

Curiously, when Hōnen gives Shigeuji a new name in religion, he asks him to identify his place of origin. Because Shigeuji says that he comes from the Karukaya estate in Chikuzen, Hōnen gives him the epithet Karukaya Dōshin.[30]

Thirteen years pass without event until Shigeuji, in his first dream of the new year, foresees that his family will come seeking him. He asks Hōnen's leave to go to Mount Kōya, hoping thereby to escape encountering his wife. Hōnen suspects Karukaya of scheming to return home and asks for his confession, whereupon Karukaya confesses that, in fact, he does have a family, tells of his dream, and insists on his desire to avoid contact with them. Hōnen agrees and sends Karukaya to Kōya.

Here the narrative folds back on itself and returns to a time thirteen years earlier, just before the birth of Ishidōmaru. In despair, the deserted wife is considering suicide before her baby's birth, but, dissuaded by one of her ladies, she remains alive and gives birth to the boy. The narrator comments, "How mortifying! Though he has a father he is called an orphan!"

The narrative shifts forward again. Ishidōmaru is thirteen. Seeing a family of swallows at play in the garden, Ishidōmaru realizes that he, too, like the baby birds, must have had a father. His mother reveals that she has heard that his father is at Shinkurodani, and the son immediately decides to search for his father. Leaving behind her elder child, Ishidōmaru's sixteen-year-old sister Chiyozuru, the mother joins her son in his quest.

On arriving at Shinkurodani, Ishidōmaru learns from Hōnen that Shigeuji (Karukaya) has left for Mount Kōya. Mother and son continue their journey until they reach an inn at the foot of the sacred mountain where the innkeeper explains that there is a proscription against females on the mountain. Here the 1631 text includes a long, intriguing section known as "Kōya no maki" (the Kōya chapter), which is not found in other early versions, and which surely existed as an independent narrative. This very curious section includes a fanciful account of the early life of Kūkai, the founder of the Kōya temple complex.[31]

In this section Kūkai's mother is described as the daughter of a Chinese emperor, a girl set adrift in a small boat by her father because she was the

[30] Muroki, *Katarimono no kenkyū*, pp. 276–281, discusses the complicated implications of Shigeuji/Karukaya being labeled a *dōshin*. He indicates that *dōshin* was, in fact, a derogatory term designating laymen who performed menial services in exchange for sustenance from a temple. In *Karukaya* the social level and activities of the *dōshin* are elevated and prettified, but Karukaya's managing the cremation of his dead wife's body may be taken as a reflection of the kind of activities actually carried out by such persons.

[31] Kūkai (774–835), who introduced the Shingon sect into Japan following his return from studies in China in 806, first established a temple on Mount Kōya in 816.

"most evil woman in the Three Kingdoms."[32] After floating to Japan, she decides to ask the sun to bless her with a child. Climbing up on a rooftop with a large tub of water on her head, she awaits the full moon. Thereupon a golden fish from the western sea seems, as in a dream, to fly into her womb. After a pregnancy of thirty-three months she gives birth to a boy she calls Kingyomaru, "Goldfish Boy."[33]

Filled as it is with bizarre legends about the founder of Japanese Shingon Buddhism, the Kōya Chapter deserves separate treatment at greater length. The final episode of this section serves to explain the taboo against women on the mountain. It says that when Kūkai's eighty-three-year-old mother ascended the mountain to find her son, the earth shook in a great cataclysm. Kūkai demanded that his mother leave, and as she hesitated he spread his *kesa* monk's robe on a rock and told her to walk across it. When she did, her menstrual flow, which had ceased when she was forty-one, began again. The *kesa* burst into flame and carried her "off to heaven."[34]

This remarkable account of the supposed pollution of the holy precinct is used by the innkeeper to explain why all women, even Kūkai's mother, are forbidden on the mountain. This in turn becomes the reason compelling Ishidōmaru to part from his mother. He will seek his father while she waits behind. The narrator tells us, "What seemed but temporary later proved to be their final parting in this life."

Ishidōmaru does in fact find his father, but he never recognizes him as such. The father acts as if he had died, showing his son a grave that he falsely identifies as that of Ishidōmaru's father. The boy descends the mountain carrying the grave marker, only to discover that his mother has died in his absence. Karukaya and Ishidōmaru cremate the body, but Karukaya never reveals his connection to the woman and boy. Ishidōmaru returns with keepsakes of their mother to tell his sister of her death, only to arrive home in time for his sister's funeral. The last tie is cut.

Bringing with him his sister's cremated remains, Ishidōmaru returns to Mount Kōya to pray for his family and becomes a fellow *dōshin* with his father, never knowing the connection between them. When others begin to comment on the closeness and resemblance between Karukaya and the

[32] *Sangoku ichi no akujo. Akujo* can be taken to mean either "evil" or "ugly."

[33] Kūkai's father was Saeki no Takimi, and his mother, whose given name is not known, was a member of the Ato clan. According to Muroki, Kūkai's childhood name was Mao, written with the characters for "true" and "fish." Word association probably helps account for the nickname invented here, Kingyomaru, which may reflect the popularity of goldfish, a novelty in Japan after their first importation in 1502. Muroki, *Sekkyō-shū*, pp. 44–45.

[34] Miyata Noboru, *Kami no minzokushi* (Tokyo: Iwanami Shoten, 1979), pp. 58–66, discusses the general phenomenon of exclusion of women from sacred peaks in Japan and mentions briefly the legend concerning Kūkai's elderly mother.

young newcomer, Karukaya decides they must separate. Telling Ishidō-maru (now called Dōnembō)[35] that a purple cloud rising in the west will signal his death, Karukaya proceeds, by way of Shinkurodani, to Zenkōji. Fifty years later father and son die on the same day, the one at Zenkōji, the other on Kōya. "In this lifetime," the narrator tells us, "they could not call each other by name," but in the Pure Land, joyously, they could.

Sanshō Dayū

Like *Karukaya*, *Sanshō Dayū* begins with an opening *honji* passage:[36]

> Now let me tell you a tale from the province of Tango all about the original form of the Branded Jizō,[37] for it was once a person too. If you would like to know about its original human form (*honji*) and where this all took place, well here's the story.

In this case, however, the *honji* framework does not fit the story quite as neatly as in *Karukaya*. The closing passage tells of the prosperity ultimately enjoyed in this lifetime by Zushiōmaru, the teenage boy who is the central figure of the narrative. The Kanayaki Jizō, or "Branded Jizō," is explained toward the end of the text as having been an amulet that miraculously protected Zushiōmaru. It does not seem logically true, as the narrative unfolds, that the Kanayaki Jizō was once a person.

As in *Karukaya*, the opening situation concerns a fatherless family.

[35] The symbolism of this name draws on the term *dōshin*. The characters with which it is written would mean "acolyte who thinks of the Way." The epithet *dōnen* was sometimes used of the secret, unacknowledged wife of a monk, and here it may also suggest the closeness between the unacknowledged father and son, in which case the meaning of a homophone, *dōnen* (same thought, singleminded), is relevant.

[36] The oldest extant *shōhon* of *Sanshō Dayū* dates from roughly 1639. The title was written in *hiragana* phonetic script. A number of different character compounds have been used at various times to write the name, and the folklorist Yanagita Kunio saw in this name an association with *sanjo*, a term used to designate menial laborers who performed various tasks at great estates or temples. *Sanjo* grounds were, in effect, asylum areas for the down-and-out of society and were sometimes the temporary stopping-place for low-class, itinerant entertainers who were themselves referred to by this term. Taking Yanagita's thesis one step further, the historian Hayashiya Tatsusaburō suggests that the term *sanshō dayū* might refer to the overseer of such groups of menials, rather than being, as Yanagita suggested, an instance of assigning to a character in a performance text the name used to refer to the chanters of the text. See Araki and Yamamoto, *Sekkyō-bushi*, pp. 323–325.

[37] *Kanayaki Jizō*. The fourteenth-century tale collection *Shaseki-shū* contains a story about an image (in this case Amida) that miraculously removes burn marks from the face of a servant whose master had pressed a red-hot coin into her cheeks. The Buddha image in the personal chapel of the master, a resident of Kamakura, itself takes on the marks of the injury. Watanabe Tsunaya, ed., *Shaseki-shū*, in Nihon koten bungaku taikei (Tokyo: Iwanami Shoten, 1966), 85:94–96.

Iwaki no Hangan Masauji, a man of great wealth and status, is absent, having been sent into exile on Tsukushi. His wife, daughter, and son have fallen on hard times. Like Ishidōmaru in *Karukaya*, Zushiō first thinks about the fact that he must have had a father when he observes a family of birds. His desire to find his father inspires him to set off toward Tsukushi. His mother, sister, and a servant, Uwataki, head southward with him.

Captured by slave traders when they are unable to find a night's lodgings, the group is split up. The mother and servant are taken in one boat, the two children in another. As the boats are about to proceed in opposite directions, the mother manages to tell her children that the amulet around the neck of Anju, the sister, will protect them in times of trouble. She tells Zushiō that his amulet contains a document confirming his lineage and his hereditary right to his father's lands.

After being wrested from their mother, the children are sold repeatedly by slavers until they fall into the hands of Sanshō Dayū at Yura no Hama in Tango Province. When he asks their names, the sister claims that they are such country peasants that they have no particular names, just "big sister" and "little brother."

Sanshō Dayū then names her Shinobu and her brother Wasuregusa, meaning, roughly, "longing" and "forgetting." The two are set to heavy tasks, she as a salt-dipper and he as a woodcutter. In despair they consider suicide but are dissuaded by a helpful fellow slave, a woman called Kohagi. Thereafter Anju and Zushiō make vows of brotherhood and sisterhood with Kohagi.

The reason behind Sanshō Dayū's extreme ill will toward the children is not specified, though he seems bothered by their constant weeping. He orders one of his sons, Wicked Saburō, to isolate them in a rough hut, a *bechiya*,[38] where they are left without food. The two begin to plot escape, each urging the other to flee while the one who remains behind will provide distraction and delay any search. Anju insists that her brother must be the one to go on since only he can perpetuate the family line.

The children's plans have been overheard. Sanshō Dayū then orders them branded, and as each begs to be branded twice to spare the other,

[38] A *bechiya* or *betsuya* was an isolation hut used to separate from the community those whose physical state, generally contagious illness or menstruation, was deemed a possible cause of pollution. In fact, Anju defines it as such in the text of *Sanshō Dayū* itself, then wonders if it is the custom in Tango Province, where she and her brother have been sold, to isolate even those who are not sources of pollution. Remnants of the custom, including a few villages where communal isolation houses for menstruating women still stand, have been reported by ethnographers working just before the Second World War. See Segawa Kiyoko, "Menstrual Taboos Imposed upon Women," in *Studies in Japanese Folklore*, ed. Richard M. Dorson (Bloomington Indiana: Indiana University Press, 1963), pp. 239–250.

Wicked Saburō applies the hot metal to both, branding them on their foreheads. Sanshō Dayū then orders them left on the beach under a huge overturned boat carved from the trunk of a single great tree. They are left to starve and are saved only by the compassion of Sanshō Dayū's second son, who secretly brings them food.

Startled by their survival, Sanshō Dayū sets them to work again, this time allowing them to cut wood in the mountains together. There Anju prays before her Jizō amulet and begs for aid. Suddenly their brand marks are gone; Jizō has miraculously removed them. Two brands mark the forehead of the amulet, and the faces of the children are healed. Anju now persuades her brother to escape. She tells him to seek a temple should he encounter difficulty and gives him the Jizō amulet.

When Sanshō Dayū realizes that Zushiō has made his escape, he orders Anju tortured. Tied to a ladder, she is tormented with boiling water, ice water, then an auger driven into her kneecaps. Finally she is tortured with hot coals. Never breaking her silence to reveal where her brother has fled, on the sixteenth day of the New Year, her sixteenth year, she dies. Her brother, now wandering alone, has, with the coming of the year, just reached the age of thirteen.

Anju's death brings the narrative to a turning point. It is worthwhile at this juncture to pause and consider the apparent illogicality of the *honji* opening of this piece, with its statement that the Branded Jizō was once a human being. It may well be that in earlier versions of *Sanshō Dayū* the closing passage, following logically from the opening, identified Anju herself, not the amulet, as the human original form of Jizō. We might then say that in handing her amulet to Zushiō, Anju has transmitted her own life-force to her brother. Anju fits the medieval *honji* paradigm: a life of terrible suffering that marks the sufferer as sacred and brings incarnation as a deity.

Zushiō finds asylum in the provincial temple, or Kokubunji. The temple priest hides him in a dark leather basket suspended from the rafters. When Sanshō Dayū's men arrive at the temple in intense pursuit, the priest holds them off. This section of the sermon-ballad text mixes humor—the priest feigns deafness, creating some delightful misunderstandings—and the impressive language of the *seimon* oath, nearly identical to that in *Karukaya*, following which the priest vows that there is no youth in hiding there. Wicked Saburō, however, spots the basket, brings it down, and cuts open the binding ropes. But Zushiō is safe. The brilliant glow of light emanating from the Jizō amulet dazzles the eyes of the pursuers, rendering Zushiō, in effect, temporarily invisible.

Once Sanshō Dayū's men have departed, Zushiō emerges from the basket and for the first time reveals his identity to the priest, requesting that the priest take him to the capital so that he may sue for reinstatement of

his father's status. The priest again hides Zushiō in the leather basket, which he carries to the capital, claiming at checkpoints along the way that he is bringing the Kanayaki Jizō from Kokubunji to the capital for refurbishing. The priest takes Zushiō as far as the Shushaka Gongen-dō. There the two part, after Zushiō has called the priest *inochi no oya*, "father for life."

Zushiō is crippled from being enclosed in the basket, unable to stand. A group of children from the area of the Gonden-dō load him onto a flat wooden cart or *tsuchiguruma*, a cripple's dolly, and pull him to Tennōji where, grasping the great stone *torii* outside the temple, he pulls himself upright. Zushiō remains at Tennōji and is taken on as a servant by one of the priests.

Here the story shifts to concern a new character. A wealthy man of thirty-six, Umezu no In, regretting his childlessness, has made a pilgrimage to Kiyomizu to pray to Kannon for a child. The appearance of such a child, a *mōshigo* or "bespoken child,"[39] is a recurrent motif in the Sekkyō-bushi repertoire. Most commonly a *mōshigo* is an infant born to a formerly childless couple after prayers to Kannon followed by a dream-vision that their wish will be granted. In this case, however, Kannon appears in a dream to Umezu no In and tells him he will find a child to raise if he goes to Tennōji. Clearly, Zushiō is marked as the "child of Kannon," and Umezu no In has no difficulty recognizing him among the many youngsters he encounters at Tennōji. After a purificatory bath and change of clothing, Zushiō is adopted.

Following his adoption, Zushiō manages to exonerate his blood-father in the eyes of the emperor, bring his father back to the capital, and return to Tango to punish the evil deeds of Sanshō Dayū and Wicked Saburō. (Saburō is forced to use a bamboo saw to behead Sanshō Dayū, who has been buried in sand up to his shoulders. The grisly process takes three days and serves as punishment for their having killed Anju.) The Kokubunji priest and Kohagi are taken up to the capital. Zushiō next finds his mother on the island of Ezo (modern Hokkaido). She has become a *torioi*, a sort of living scarecrow employed to drive birds from the fields. In her sadness over the loss of her children, she has gone blind. Zushiō restores his mother's sight by pressing his Jizō amulet to her eyes. He returns with his mother to the capital. Now his entire family is reunited, including his fictive sister Kohagi and his fictive fathers, the Kokubunji priest and Umezu no In. The denouement of the piece, heavily stressing this-worldly punishments and rewards, concludes with the triumphant return of the

[39] That is, a child that is requested of a deity by its future parents. In the sermon-ballad texts the request is always followed by a prophecy that the child will be born. The object of entreaty for the granting of a child is generally Kannon, and particularly in southwestern Japan there was strong faith in Kōyasu Kannon, a folk amalgamation of Kannon and Kōyasugami, the "easy birth" deity.

reunited family to Iwaki and the establishment of the Branded Jizō temple in the memory of Anju.

Shintokumaru

Unlike *Karukaya* and *Sanshō Dayū*, the earliest extant *Shintokumaru* text has no *honji* framework.[40] However, the principal character, Shintoku-maru, is a *mōshigo*, granted to his parents by Kiyomizu Kannon. As such he is a "child of Kannon," and his story of trial, suffering, and reward, like the other sermon-ballads, may originally have taken the form of the "life story" of a deity.

Shintokumaru's trials were fated from birth, for he was born with the destiny of killing his parents. That is, he is a *mōshigo* with a cruel twist. In the dream vision in which Kannon appears in response to the prayers of a wealthy childless couple, Nobuyoshi Chōja and his wife, she[41] tells them of the evils each had done by killing animals in their previous existences. This evil accounts for their barrenness, she says, and she tells them to depart. The couple's reaction is remarkable. They threaten to disembowel themselves before Kannon, to pollute the temple, make others regard Kannon as an *arahitogami*, an evil deity, and cause the downfall of the temple. Cooler heads prevail, persuading the couple to remain, pray further, and make offerings, rather than threats, to Kannon. Kannon then reappears before the couple and tells them she will grant them a baby if they wish, but only on condition that one of them will die by the time the boy reaches age seven.

The child is born and his first thirteen years pass without disaster. Then one day the youth participates in a temple dance performance at Tennōji and there catches sight of Otohime, the daughter of a wealthy, powerful man. Instantly he falls ill, sick with love. An intermediary takes Shinto-kumaru's letter to Otohime. Despite her embarrassment, and with her father's approval, she responds, indicating her interest.

Meanwhile, Shintokumaru's mother, remembering that Kannon had foretold the death of one of the parents before the boy reached age three (the text is inconsistent, having given seven as the age earlier), says, "Even

[40] The earliest extant *shōhon* of *Shintokumaru* was published in Kyoto in 1648.

[41] Though the Indian antecedent of Kannon, Avalokiteśvara, was definitely masculine, representations of this deity took on an increasingly androgynous appearance in China and Japan. Particularly in the role as grantor and protector of children, Kannon in Japan has a definitely feminine aspect, and the logic of this particular story seems most coherent when Kannon is conceived of as a mother-surrogate of Shintokumaru. Nevertheless, the illustrations in the 1648 *shōhon* do not depict Kannon as appearing particularly feminine, and one could make a case for using the pronoun "he" here.

the great deity of Kiyomizu is a liar." Kannon is depicted as outraged by the slander and sends her messengers to take the mother's life.

With her dying breath the mother tells Shintokumaru to love his step-mother, whomever his father may marry. Marry he does, and soon Shin-tokumaru's stepmother gives birth to a son. The stepmother begins to scheme a way to insure that the family inheritance will pass to her son rather than to Shintokumaru.

Again Kiyomizu Kannon is called upon to intercede. Shintokumaru's stepmother makes a pilgrimage in the dark of night to Kiyomizu. She calls Shintokumaru an *ujiko*[42] of Kannon. She requests that her baby be made Kannon's *ujiko* as well, and that Kannon take Shintokumaru's life, or at least make him repulsive to others by causing a disfiguring disease. She then performs a rite wherein she drives 18 large nails into a tree before the temple. She travels about to various shrines and temples in the capital, continuing this driving of nails, to a total of 136. As a result, Shintoku-maru is blinded and develops leprosy, the spots marked by illness corre-sponding to the holes created by the nails.

At first Shintokumaru's father proposes isolating him in a *bechiya*, then, at the stepmother's insistence, he expels Shintokumaru from his home. A servant takes Shintokumaru to Tennōji and leaves the blind, des-perately ill boy at the temple, providing him with the necessary imple-ments to support himself by begging.

Encouraged in a dream by a vision of Kannon who tells him to sustain himself by begging, Shintokumaru wanders about the Tennōji area, where those who feed him call him Yorobōshi, "Stumbling Boy." In a second vision, Kannon instructs him to go to Kumano.[43] Bathing in the hot springs there will cure his illness, she says.

[42] Here Kannon is treated as an *ujigami*, the tutelary deity of a specific community. Shin-tokumaru's stepmother justifies her journey to present her child to Kiyomizu Kannon by saying that she herself is originally from the capital. On the other hand, she also calls Shin-tokumaru Kannon's *ujiko*, or protégé, despite the fact that his parents did not live in the vicinity of the capital. In this sense *ujiko* seems to indicate one protected by a deity, not specifically a member of a given community.

[43] The mountainous Kumano area of southern Wakayama Prefecture was revered as sa-cred space from before the time of the introduction of Buddhism into the area. Under the influence of *honji-suijaku* belief and the process of Shinto-Buddhist fusion, the principle deities of Kumano were interpreted as *suijaku* of various Buddhas. Most relevant here is the fact that the *honji* of the (female) deity of the Nachi shrine at Kumano was deemed to be Jūichimen Senju Kannon. Shugendō practitioners in the area contributed greatly to the spread of Kumano faith and to the encouragement of pilgrimage to the area, which became extremely popular during the medieval period. Itinerant female religious proponents of faith in the sacred power of Kumano, known either as *aruki miko* or *Kumano bikuni*, helped to spread popular tales pertaining to Kumano. Iwasaki, *Sanshō Dayū kō*, pp. 109–11 , 135, suggests that the dream vision encouraging Shintokumaru to proceed from Tennōji to Ku-mano may reflect the circuit followed by Kannon faith–oriented pilgrims. He states that both Tennōji and Kumano were part of the Saikoku pilgrimage circuit of thirty-three places

The blind boy sets off for Kumano but unknowingly stops to beg at the home of Otohime. Mortified when he realizes where he is, he forsakes his journey to Kumano, returns to Tennōji, crawls into the darkness under the veranda of an outbuilding of the temple, and resolves to stay there until he starves to death.

Otohime persuades her parents to let her go seek her "husband." Garbed as a pilgrim, she sets out after Shintokumaru. Failing in her quest, she is about to drown herself in a pond within the precincts of Tennōji when, at the last moment, she finds Shintokumaru, half dead. Otohime carries her emaciated beloved on her shoulders to Kiyomizu, where she bathes him in the waterfall. They pass the night in prayer at the temple and Kannon, again appearing in a dream, explains that she caused Shintokumaru's illness "because I was asked to." She instructs Otohime to look for a *toriboki* (feather broom)[44] on the front steps of the temple and tells her she can heal Shintokumaru by brushing it over his body. When Otohime finds the broom and does as she has been told, nails pour out of the spots on his body and his leprosy and blindness are cured. Both offer prayers of thanksgiving to Kannon.

Reunited with Otohime's parents, the young couple prospers. When Shintokumaru decides to offer food for the poor in gratitude to those who had sustained him, his father Nobuyoshi, now impoverished and blind himself, comes to receive alms. Shintokumaru recognizes his father, embraces him, and cures his blindness with the same feather broom that had healed his own disease. The stepmother and her son are ordered killed. Father and son together return to Kawachi, make offerings, and do good works on behalf of Shintokumaru's dead mother.

Interpretations and Comparisons

As mentioned previously, the plots of most sermon-ballads are not unique to this genre. Both *Karukaya* and *Shintokumaru* can be compared with the Nō plays to which they are related, and these comparisons help high-

sacred to Kannon. The *honzon*, principle object of worship, in the Kondo of Tennōji is Nyoirin Kannon. Iwasaki cites a twelfth-century document that listed Tennōji as the twenty-second stop on the circuit. The circuit underwent various changes with time, and Tennōji was no longer included by the time that pilgrimage became a widespread popular practice. Kumano, however, remained the starting point for the entire circuit. See James H. Foard, "The Boundaries of Compassion: Buddhism and National Tradition in Japanese Pilgrimage," *Journal of Asian Studies* 41, 2 (February 1982): 232–233, 248–249.

[44] *Kumano bikuni* and *etoki* used the *toribōki*, a small broom-like pointer tipped with pheasant tail feathers, to point out scenes in the religious paintings they explicated for their audiences. The mention of the *toribōki* here helps contribute to the image of Otohime as a *miko* shamaness, an intermediary or vehicle of Kannon, as discussed below. See Iwasaki, *Sanshō Dayū kō*, p. 117.

light the common, characteristic features of the sermon-ballad texts themselves. These comparisons illustrate the different casts, the different emphases, given to earlier legendary material when staged as Nō or reinterpreted as a sermon-ballad.[45]

The Nō Karukaya[46] begins with the journey of Karukaya's wife and son who seek him on Mount Kōya. The father's motivation in leaving home, his encounter with Hōnen, and the dream that led him from Shinkurodani to Kōya are not mentioned in the Nō. The tone of the Nō is more lyrical than the sermon-ballad, particularly in a long passage in praise of the vastness and magnificence of the temple on Mount Kōya. This is in striking contrast with the sermon-ballad, where the treatment of both Kūkai and Hōnen seems to indicate that the creator of the text had little or no understanding of either these men or their temples. A crucial difference between the versions concerns the events surrounding the mother's death. In the Nō, Karukaya at first hides his identity but then reveals himself to his son. The play ends as they perform the funeral service and join in prayer for the mother's soul. As in many other Nō, the reunion of previously separated parent and child occurs at the conclusion of the play.[47] The sense of isolation of Karukaya and his son is mitigated by their final reunion. In contrast, the forced isolation of Karukaya, and of Ishidōmaru as well, is the most important feature of the sermon-ballad Karukaya and is treated at far greater length there than in the Nō.

There is no honji element in the Nō, and no connection is made with Zenkōji temple. The structure of the sermon-ballad, though clearly closely related to the Nō, gives a very different impression. The sermon-ballad presents the personal history of a particular deity represented by a specific statue in a precise location. Because of its honji framework, the plot must be understood on two levels: the sadly moving experiences of Shigeuji/Karukaya and Ishidōmaru are those of sacred individuals. While their fate after death is described as "rebirth in the Pure Land," at the same time they become the "Parent-Child" Jizō of Zenkōji. The honji opening marks Shigeuji and his son as sacred. Their special status is apparent because the honji framework collapses time and injects a sense of their future into the narrative present of the inner story. The audience

[45] For a more extensive comparison of the two versions of Karukaya see Watsuji Tetsurō, Nihon geijutsushi kenkyū (Tokyo: Iwanami Shoten, 1955), pp. 272–286. Watsuji points out that the first listing of Nō plays no longer in the active repertoire, published in 1686, included the title Karukaya as nineteenth on the list, presumably an indication that performances of this play had only recently ceased.

[46] The text of the Nō Karukaya is in Haga Yaichi, ed., Yōkyoku sōsho (Tokyo: Hakubukan, 1914), 1:525–531. Though authorship has sometimes been credited to Zeami, the attribution is by no means certain.

[47] Other examples are the Nō Sakuragawa, Kagetsu, Hibariyama, and Yoroboshi, which is discussed below.

realizes that there is particular significance to the strange suffering of the father and son in this lifetime.

Their pain lies in their estrangement from normal family life. Throughout the piece family ties are broken, again and again, and the sermon-ballad is structured in such a way as to keep this element in the foreground. When Shigeuji first abandons his family and seeks out Hōnen, the Hōnen we meet is depicted in a manner far removed from historical reality. His reluctance to accept Shigeuji as a disciple points out the crucial tension in the text concerning family ties. This tension becomes even clearer when Hōnen gives Shigeuji the name Karukaya, a name associated with his former home area and one that can best keep Shigeuji aware of his ties to and separation from his family. The importance of Shigeuji's rejection of his family is evidenced by the fact that the structure of the piece is such that Shigeuji repeats the action several times. He makes his initial departure, insists to Hōnen that he has no family, reaffirms the rejection by his departure for Kōya following his prophetic dream, and, of course, remains resolute in never identifying himself to his son.

If one looks at the experiences of the son, Ishidōmaru, the pattern of familial estrangement is equally clear. He begins life as a fatherless boy. At age thirteen, just as he is reaching the age of adulthood and reason, he first recognizes his semi-orphaned state. Setting out in search of his father, he soon loses his mother and sister as well.

Though no acknowledged reunion takes place in this lifetime, one can discern in *Karukaya* a symbolic reunion that is realized through rebirth in the Pure Land. This is the larger scheme of the sermon-ballad. The intensity of the bond between father and son is never actually broken. Ishidōmaru's decision to seek his father is immediately known to Karukaya through his dream. Though not in life, in their deaths Karukaya and his family are reunited. First Ishidōmaru brings the cremated remains of his mother and sister to Karukaya, asking that they be kept on Mount Kōya; and finally, of course, the sermon-ballad's closing passage affirms the reunion, through death, of father and son in the Pure Land.

Karukaya, because of its setting and the activities of Shigeuji, seems to be the "most Buddhist" among the major sermon-ballad texts. Certainly, as a story of rebirth in the Pure Land, this is so. But when one compares this piece with other sermon-ballads, an underlying pattern of estrangement, death, rebirth, and reunion emerges as a common element of all three ballads introduced in this essay. A second comparison between sermon-ballad and Nō treatments of legendary material is again helpful.

As with the two versions of *Karukaya*, there are striking differences between *Shintokumaru* and the related Nō *Yoroboshi*.[48] In the Nō, the

[48] The text of the Nō *Yoroboshi*, by Motomasa, is included in Yokomichi Mario and

young protagonist, called Shuntokumaru, has been banished from home because of some unstated person's unspecified slander. From its opening moments the play emphasizes the father's search for his lost son. He imagines his son to be dead and proceeds to Tennōji to offer prayers on the boy's behalf. There he distributes alms and eventually is happily reunited with his son, one of a band of beggar boys, whom he recognizes while the boy is performing a narrative and dance describing the history of the temple. The boy is blind, but not leprous, his blindness caused by grief rather than the malevolence of Kannon or his stepmother. Though an earlier version of the Nō showed the blind youth begging at Tennōji in the company of his wife, this element is not present in the versions of the Nō in the current repertoire.[49] The focus, rather, is the parent-child relationship. The implication of the play's structure is that the boy's prayers to Kannon bring about his reunion with his father and the play's happy resolution. In this respect, Yoroboshi closely resembles the Nō Karukaya.

When one compares Shintokumaru to Yoroboshi, two major differences are immediately obvious. The suffering of the boy is treated much more extensively in the sermon-ballad, and the immediate cause of that suffering is more readily apparent. In the case of Shintokumaru, the boy's age is clear. He is thirteen. The sermon-ballad clearly reflects conflict between the generations associated with the sexual maturation of the son. The boy's first love, his father's immediate search for a new bride, and the arrival of a malevolent stepmother all occur at this same crucial juncture.

Here the apparent source for Yoroboshi, Shintokumaru, and another classic sermon-ballad called Aigo no waka is of interest. The source for all three is thought to be an Indian legend concerning Kuṇāla, the son of King Aśoka, which was transmitted to Japan via Chinese Buddhist tale collections. According to this legend, the prince was slandered by his stepmother after he rejected her amorous attentions. There may be a connection between this tradition and the classical Western Hippolytus triangle theme.[50] An additional element of concern about the continuity of the family line is evidenced in Shintokumaru in the stepmother's attempts to shift the right of inheritance from Shintokumaru to her own son.

Omote Akira, eds., Yōkyoku-shū, pt. 2, in Nihon koten bungaku taikei (Tokyo: Iwanami Shoten, 1963), 41:404–412.

[49] Kanai Kiyomitsu, Nō to kyōgen (Tokyo: Meiji Shoin, 1977), p. 341.

[50] This provocative suggestion was first made by Donald Keene in his article "The Hippolytus Triangle, East and West," in Yearbook of Comparative and General Literature 11 (Bloomington: Indiana University Press, 1962 supplement), in which he discusses both Shintokumaru and Aigo no waka as well as the later related Jōruri play Sesshu gappō ga tsuji. For a translation of a version of the Kuṇāla legend, see Matisoff, The Legend of Semimaru, pp. 168–72.

The Nō *Yoroboshi* includes a passage in which Shuntokumaru explains to his father that the West Gate of Tennōji—the location of the great stone *torii*—leads directly to the East Gate of the Pure Land. Clearly, the belief in Tennōji as a point of departure for rebirth in the Pure Land is reflected, though somewhat transformed, in both *Shintokumaru* and *Sanshō Dayū*.

The pattern of a symbolic rebirth is especially clear in *Sanshō Dayū*, but it can also be discerned in *Shintokumaru*. Having been cut off from contact with his natal family, Shintokumaru arrives at Tennōji blind and disfigured by leprosy. He hides in a dark enclosure under the veranda of a temple building. The symbolism suggests both death—the dark burial of a decaying corpse—and rebirth out of that dark enclosure—the womb. Shintokumaru's rebirth is effected by his bride, Otohime. Her purificatory bathing of Shintokumaru at Kiyomizu—similar to the bathing of both a corpse and a newborn child—initiates his new life, that of an adult married man. With the support of his wife and parents, he not only survives but thrives, ultimately restoring health and order in his parental family.

Among the three sermon-ballads compared here, the pattern of estrangement, death, rebirth, and reunion is most striking in *Sanshō Dayū*. Here the first hint of separation occurs when Zushiō realizes that he lacks a father and as a consequence leaves his familiar home area. Soon a second separation takes place when he is wrested away from his mother by the slave-traders. Finally, renamed by Sanshō Dayū, the boy and his sister are fully cut off from their family and personal history.

A process of new family-building begins. Anju and Zushiō make vows of brotherhood and sisterhood with their fellow slave and benefactor, Kohagi. For Anju, death is more than symbolic, but her death also initiates a symbolic process of rebirth for Zushiō, as becomes clear when he finds asylum in the provincial Kokubunji. The temple priest hides him by enclosing him in a dark leather basket suspended from the temple rafters. In the light of what follows, it is difficult to consider this anything other than a symbolic return to the womb. The temple priest becomes Zushiō's symbolic father. He carries the boy on his back to Tennōji, and, like a newborn baby, the boy who emerges from the basket is unable to walk.[51]

[51] The suggestion of womb symbolism here is further strengthened by the fact that the *oi* backpack portable altar carried by *yamabushi* is imbued with symbolism as "the mother or womb of all sentient beings," a womb "in which one is conceived and reborn during the period of ascetic confinement," while the *yamabushi tengai* that is tied up to the temple ceiling until it opens at a ritually critical juncture is a symbolic placenta. See H. Byron Earhart, *A Religious Study of the Mount Haguro Sect of Shugendō* (Tokyo: Sophia University and the Voyagers' Press, 1970), pp. 112, 143, 167–168. This is particularly interesting in

Sanshō Dayū is a story of the loss of social status and family; a closely related death (Anju's) and rebirth (Zushiō's) are followed by a return to family identity and full participation in society. The transformation takes place at the age of thirteen to fourteen. In the course of the sermon-ballad Zushiō is given a new name, is treated as a tabooed individual and kept in isolation, goes through a period of dark enclosure at the Kokubunji, and is purified and "reborn" at Tennōji, whereupon he returns to reunite his family.

Though it is unclear just what historical connection there might be to actual rites of passage, and though consciousness of that connection may not have existed in the minds of the urban audiences of the sermon-ballads, all three of the texts under discussion can be read as literary representations of such rites.[52] Birth, banishment, isolation, illness and healing, death and rebirth are the major themes throughout. The central characters are adolescent boys, and the continuity of the family line is commonly at issue.

The young women in the pieces—most of them "older sisters"—are interestingly similar when viewed as a group. Kohagi, Anju, and Otohime, through self-sacrifice, death, or the threat of death (certainly implicit in Otohime's fearless contact with Shintokumaru), help bring about the rebirth of their male counterparts. It has been suggested that these powerful female characters are reflections of shamanesses, women with the power to contact and "resurrect" the spirits of the dead.[53] Particularly in the case of Otohime, the suggestion is provocative. She, and only she,

light of Iwasaki's passing suggestion that the representation of the Kokubunji priest in *San-shō Dayū* is reminiscent of a *yamabushi*. Iwasaki, *Sanshō Dayū kō*, p. 75.

[52] Again, there are hints here of possible connections with Shugendō *yamabushi* practice. Earhart reports that in some locales youths participated in Shugendō mountain pilgrimage journeys as a form of initiation into manhood. Only then were they eligible for marriage. (See Earhart, *A Religious Study*, p. 104.) Though Iwasaki does not discuss the point extensively, preferring in general to analyze sermon-ballad texts as reflections of the difficult lives experienced by the creators of the texts who were themselves the object of discrimination, he does mention the initiation pattern in both *Sanshō Dayū* and *Shintokumaru*. Iwasaki, *Sanshō Dayū kō*, pp. 65, 113. Carmen Blacker has suggested that some of the earliest Buddhist tale literature in Japan has the substructure of a mantic journey of initiation. Among her prime examples are stories concerning journeys to Hell (Jigoku *meguri*) followed by salvation via the Bodhisattva Jizō. Carmen Blacker, *The Catalpa Bow* (London: George Allen and Unwin, 1975), pp. 186–197. One sees a similar pattern in *Sanshō Dayū* if Anju is interpreted as a manifestation of Jizō. The existence of a concept of Emma, prosecutor king of the underworld, and Jizō, the savior, as two aspects of a single deity is particularly interesting in comparison to the two-sided depiction of Kiyomizu Kannon in *Shintokumaru* as both the cause and the cure of Shintokumaru's suffering.

[53] Muroki, *Katarimono no kenkyū*, pp. 302–313, discusses such figures in sermon-ballads, particularly in *Oguri hangan*, and suggests that they had a hand in the development of the stories. Iwasaki, *Sanshō Dayū kō*, p. 129, discusses the image of Otohime. See also note 44 above.

is able to find Shintokumaru and return him to life. The image of her carrying him on her shoulders to Kiyomizu is especially striking. Like a possessed *miko*, she has accepted him as a burden.

In the Tōhoku area of northern Honshu, particularly around Osorezan, women with real or ritually feigned mediumistic powers who are known as *itako* or *idako* continue to be found even to the present, though in diminishing numbers. Whether they are today genuine mediums or merely pseudo-ecstatics does not really matter for our purposes, nor does the way they are perceived by modern, sophisticated Japanese alter the fact that traditionally these women were believed to have the power to contact and communicate with the dead.[54] Hori Ichirō emphasizes that these women today are not true shamanesses in that they simply learn techniques of pseudo-ecstasy. He comments, however, that "an initiatory death-and-rebirth motif" is preserved in their final initiation rite.[55]

In 1931, an ethnographer in Aomori Prefecture studying Osorezan *itako* recorded one of them reciting a narrative entitled *O-Iwakisama ichidaiki* (An account of O-Iwasakisama).[56] Despite great differences between them, and although the *O-Iwakisama* piece is rather garbled, its narrative structure is clearly related to *Sanshō Dayū*. Its villain is Sansodayū, the young man is Zusō, and the young heroine is Anjugashimen.[57] The story is told in the first person, the *itako* speaking as Anjugashimen. The medium's performance, then, serves to celebrate Anjugashimen and pacify her soul.[58] Though the history of the connection between these two narratives is far from clear, it is certainly not coincidental. In light of the *itako* presentation, it is possible to speculate that there may have been a time when sermon-ballads were also understood as first-person narratives and the chanter believed to have the power to contact the dead and tell their story. Particularly in some instances of fixed formulaic laments in the sermon-ballad texts, it is difficult to determine whether the chanter is commenting on, or speaking as, one of the suffering characters.

[54] Blacker, *The Catalpa Bow*, pp. 160–161, describes attending an *itako* ceremony in 1959 and comments, "It was not difficult to see that not a single one of the *itako* were in any state resembling trance. . . . The chants they recited, moreover, were easily seen to fall into different fixed forms. . . . On their audiences, however, the effect of these hackneyed effusions was pathetically touching."

[55] Hori Ichirō, *Waga kuni minkan shinkōshi no kenkyū*, vol. 2, *Shūkyōshi hen* (Tokyo: Sogensha, 1953), pp. 660–663.

[56] Iwasaki Takeo, *Zoku Sanshō Dayū kō* (Tokyo: Heibonsha, 1973), pp. 149–196. Iwasaki reports that another version of the story was also recorded in Aomori in 1967. In both versions, Anju (Anjugashimen) is described as the *honji* of the deity of Iwakisan, the most venerated peak in the area.

[57] This name is a dialectal variant of *Anju ga hime*; *ga* is the genitive particle and *hime*, originally "princess," was a common second element in girls' names.

[58] Iwasaki, *Sanshō Dayū kō*, pp. 77–81, 95. Also, *Zoku Sanshō Dayū kō*, pp. 149–196.

A prevailing theory in the analysis of sermon-ballads holds that this repertoire can best be understood as reflecting the lives of the creators of the narratives, the itinerant *sekkyōshi* of the Muromachi era.[59] The geographical settings of the sermon-ballads take the audience to the very places thought to have been the major performance sites for pretheatrical Sekkyō-bushi: Tennōji, Kōya, Kumano, Kiyomizudera, Zenkōji. At least until the late sixteenth century the performers were apparently fully itinerant, and the geographical range of their possible origins and the areas covered on their performance circuits were quite broad.[60] Geographical indicators in the texts have been taken as hints concerning the areas of origin of the chanters and the circuits of sacred places over which they plied their trade. Though I have not mentioned them in my plot summaries, *michiyuki* journey passages, often more than one per text, are a striking feature of the sermon-ballads, and the degree of accuracy they reflect has been used to judge the actual circuits followed by the chanters who originated the sermon-ballad plots.[61]

Insofar as they are known, the social origins of the urban sermon-ballad chanters were anything but elevated.[62] The sermon-ballads themselves may have originated as the literature of the very lowest levels of society, in terms of both their creators and, to some extent, their audience. The audience included anyone who chanced to stop and listen, perhaps to offer alms. Literacy and sophistication were not necessary for the enjoyment of a performance.

Be they *biwa hōshi*, *Kōya hijiri*, *Kumano bikuni*, *etoki hōshi*, or *sekkyōshi*, numerous and varied itinerant groups in medieval Japan were cast in positions of extreme social ambiguity. They were religious mendicants of a sort, but unofficial and of low status. They "entertained," but their entertainment was, quite literally, concerned with matters of life and death and the afterlife. As beggar entertainers, such performers, medieval *sekkyōshi* included, were awesome strangers, outsiders who arrived, performed, received alms, and moved on. Like the *itako* of Osorezan, they may have been understood as having undergone the rigors of initiation themselves and may have been thought to possess shamanistic abilities.

[59] This is the basic argument throughout the work of both Muroki Yatarō and Iwasaki Takeo.

[60] Muroki, *Katarimono no kenkyū*, pp. 17, 222–236.

[61] *Michiyuki* are a common feature of much medieval performance literature, but in no other genre are they so conspicuous as in the sermon-ballads, which often contain more than one journey passage per text. It is, of course, reasonable to interpret these journeys as reflections of the performance circuits of the sermon-ballad chanters, but it is equally important to consider the significance of symbolic journey motifs in initiatory rites of passage.

[62] Muroki, *Katarimono no kenkyū*, pp. 237–243.

The ambiguity of narrative voice in sermon-ballad texts helps suggest the possibility that itinerant *sekkyōshi* were understood to be, like the characters whose lives they "resurrected" in every performance, sacred sufferers, or living *kami* themselves. It was this context of belief that imbued the sermon-ballads with their undeniable power.

Contributors

JAMES H. FOARD is associate professor of religious studies at Arizona State University. He has also taught at Tokyo University of Education, Stanford University, and Hiroshima Shūdō University. Among his research articles are "Seiganji: The Buddhist Orientation of a Nō Play," "The Boundaries of Compassion: Buddhism and National Tradition in Japanese Pilgrimage," and "The Loneliness of Matsuo Bashō." He is currently completing a book on Hiroshima.

FRANK HOFF is professor in the Department of East Asian Studies at the University of Toronto. His publications include *The Life Structure of Noh: An English Version of Yokomichi Mario's Analysis*, with Willi Flindt, and translations of two anthologies of song from the late medieval period: *The Genial Seed* and *Like a Boat in a Storm*. He is currently writing on the ethnology of folk performance in Japan in the 1930s.

LAURA S. KAUFMAN is professor of art history and chair of the Asian Studies Department at Manhattanville College, Purchase, New York. She received her doctorate in Japanese Art History from the Institute of Fine Arts, New York University. Her book, *Ippen Hijiri-e: A Handscroll Painting of Thirteenth Century Japan*, is forthcoming as an Artibus Asiae Supplementum.

WILLIAM R. LaFLEUR is professor of Japanese at the University of Pennsylvania and holder of the Joseph B. Glossberg Term Chair on Humanities there. His books include *Mirror for the Moon: A Selection of Poems by Saigyō (1118–1190)*, *The Karma of Words: Buddhism and the Literary Arts in Medieval Japan*, and a forthcoming study of abortion and Buddhism in Japan. He is currently writing on the medieval poet Saigyō and the modern philosopher Watsuji Tetsurō.

SUSAN MATISOFF is an associate professor of Japanese in the Asian Languages Department at Stanford University. Her pervious publications include *The Legend of Semimaru, Blind Musician of Japan* and various articles on medieval literature. She is currently preparing a book of translations and criticism of sermon-ballads, including the three discussed in her contribution to this volume.

BARBARA RUCH is professor of Japanese literature and culture at Columbia University and director of the Institute for Medieval Japanese Studies there. Until 1990 she served as founding director of the Donald Keene

Center of Japanese Culture at Columbia. In addition to numerous articles on medieval Japan, she has also edited three books in Japanese on *Nara ehon* in European, American, and Japanese collections. Her most recent publications include "The Other Side of Culture in Medieval Japan," in *The Cambridge History of Japan*, and her book *Mō hitotsu no chūsei zō*, a study of neglected aspects of medieval Japanese literature, painting, and cultural history. She is currently directing an international research and publication project, "Women in Buddhism in Pre-Modern Japan: Research Strategies for a Newly Developing Field."

YOSHIAKI SHIMIZU is professor and chair of the Department of Art and Archeology at Princeton University. He has taught at the University of California, Berkeley, and was curator of Japanese art at the Freer Gallery of Art, Washington, D.C. His publications include *Japan: The Shaping of Daimyo Culture 1185–1868, Masters of Japanese Calligraphy 8th–19th Century* (with John M. Rosenfield), *Japanese Ink Paintings* (with Carolyn Wheelwright), and numerous articles on Japanese medieval art in scholarly journals.

ELIZABETH TEN GROTENHUIS is assistant professor in the Art History Department at Boston University. She received her doctorate from Harvard University, where she is an associate in research at the Reischauer Institute of Japanese Studies. She is the translator and adapter of *Pure Land Buddhist Painting* and *Narrative Picture Scrolls*, and the coauthor of *Journey of the Three Jewels: Japanese Buddhist Painting from Western Collections*. At present she is completing work on a book about Japanese Buddhist and Shinto mandalas.

ROYALL TYLER was educated in France and the United States. He received his Ph.D. in Japanese literature from Columbia University and currently teaches Japanese at the Australian National University in Canberra. He has translated several volumes of Nō plays, and his books include *Japanese Tales* and *The Miracles of the Kasuga Deity*.

Index